# Conversations on Sculpture

**Edited by Glenn Harper and Twylene Moyer**

LEARNING
RESOURCES
CENTRE

HAVERING
COLLEGE

A collection of artist interviews drawn from *Sculpture* magazine

*Sculpture* magazine and ISC Press are programs of the International Sculpture Center,
a 501(c)3 nonprofit corporation

## isc Press

19 Fairgrounds Rd. Suite B
Hamilton, NJ 08619, USA
www.sculpture.org

Distributed by
University of Washington Press
PO Box 50096
Seattle, WA 98145-5096
www.washington.edu/uwpress

Library of Congress Cataloging-in-Publication Data

**Conversations on Sculpture**
Edited by Glenn Harper and Twylene Moyer: with an introduction by Robert Hobbs

ISBN 0-295-98741-3 (pbk. : alk. paper) / 978-0-295-98741-5
1. Sculpture, Modern—20th century. 2. Sculpture, Modern—21st century.
I. Harper, Glenn, 1946- II. Moyer, Twylene, 1966- III. Sculpture magazine.
NB198.S35213 2006
735′.238—dc22  2006002409

Design and Production by osp catalogs
Printed on acid-free paper

COVER: Rachel Whiteread, *Embankment*, 2005–06. 14,000 white polyethylene boxes,
installation view of Unilever Series commission, Tate Modern.

Publication of this book was made possible in part by generous support from

NATIONAL
ENDOWMENT
FOR THE ARTS

VANCOUVER
SCULPTURE
BIENNALE

# Table of Contents

# Foreword

This book, *Conversations on Sculpture*, serves as a companion volume to *A Sculpture Reader*, a collection of articles drawn from the 25-year history of *Sculpture* magazine. While that first volume offers a wide range of critical voices writing about sculpture, *Conversations on Sculpture* turns directly to the source, focusing on what sculptors themselves have to say about their work. Over the years, the magazine has published countless interviews with well-known as well as emerging artists. By allowing artists to speak for themselves, these conversations not only provide essential documentation of contemporary sculpture, they also allow us to go beyond the finished product and enter into the active state of the mind at work.

Although the importance of artists' words should be self-evident, their statements have frequently been considered irrelevant by commentators. Between T.S. Eliot's Modernist extinction of personality and Postmodernism's death of the author, the words of the artist have been stripped of value. If artists are no longer considered privileged interpreters of their own work, what they say about their creations and their artistic process becomes suspect, a gloss to be approached with skepticism, a possibly misleading detour that leads away from the art itself and into the murky realms of biography and personal mythology. It then becomes the duty of the alert and cautious critic/historian/viewer to negotiate this tangle, to impose interpretive order on muddled confusion, to decipher what the artist really wanted to say.

Yet most of us who love art want to know what the artist was thinking, what lies behind a particular work and grounds its formal and conceptual realization. This is not the same thing as asking to be told what a work means: whatever answer we receive does not preclude alternative approaches. Perhaps the disconnect lies in different ways of explaining a work of art. Many critics and historians seek a definitive interpretation of content, a cause-and-effect accounting of imagery, form, and idea. But if we have learned nothing else from the interpretive games of theory, we should have learned that the work of art can support multiple meanings.

By dismissing the artist's voice as interpreter, we also throw out everything else he or she might say and lose a valuable opportunity to see inside the process of making. Readers of these interviews gain insights beyond any interpretation of meaning—in fact, many of the sculptors interviewed here are loath to discuss content. Instead, we enter the creative world of process and method, of influences and stimuli, of materials and ideas, watching as the raw material of thought takes visual form.

Throughout these pages, very different sculptors with very different styles discuss their creative process, and what emerges is the simple fact that whatever the final visual form, whatever the style of their work, their sculpture derives from a complex matrix of intellectual interests, sensory observations, and art historical dialogues. By discussing their longstanding interests, fleeting impressions, happy accidents, and creative frustrations, these sculptors

generously share with us the synthetic and free-ranging state of mind that allows diverse and seemingly unconnected fragments to coalesce into a coherent work of art.

We would like to thank the artists and interviewers for their contributions to *Sculpture* and for their permission to reprint these articles. We also thank Laura Dillon and Shira Billig (editorial assistants for *Sculpture*), the Board of Directors of the ISC, and the members of the ISC staff over the past 25 years. In particular, we want to thank David Furchgott (founding director of the ISC and founder of *Sculpture*); Jeanne Pond (the ISC director who brought both of us to the magazine); Jeff Nathanson (ISC director during a period when a number of these interviews were conducted); Michael Klein (the ISC director who founded ISC Press and originated the project that has brought this book and its predecessor to light); Johannah Hutchison (the current ISC director, who has ensured the continuation of the project); and the former *Sculpture* staff. And many thanks to all of the ISC members, readers, and supporters who have kept the magazine going for over 25 years.

—Twylene Moyer & Glenn Harper

# Conversing about Contemporary Sculpture

**by Robert Hobbs**

In this collection of conversations with prominent sculptors published in *Sculpture* magazine as early as 1998 and as recently as 2006, one is made privy to the thoughts of a wide range of artists. In these interviews, each artist articulates his or her rationale for making the type of three-dimensional work that continues to be subsumed under sculpture's rubric. Viewing this art form as a necessary yet limiting hurdle, artists in this volume have understandably sought a raison d'être for their goals in concepts that extend sculpture's traditional purview. However, they have refused to become entrapped in their own personal taste, which most would refute as far too idiosyncratic and unpredictable to be relevant to general audiences. Such high-minded adherence to historically based views are evident in Cildo Meireles's interrogations of the ideological wrappings entailed by culturally defined spaces and Yinka Shonibare's eloquent descriptions of the British- and Dutch-manufactured cloth employing Indonesian designs that many African nationals in the 1960s and '70s viewed as inherently their own.

The overriding question appearing in conversations with these artists, as well as with others included in this anthology, is how to make art that is deeply felt without being merely idiosyncratic and how to create socially relevant work without veering away from the three-dimensionality that all continue to regard as sculpture's absolute basis. In order to avoid these twin pitfalls, most of these artists have sought justification for their work in terms of a series of alliances that includes one or more of the following: (1) architecture and human scale, (2) language viewed as object and artifact, (3) the semiotics of chosen materials that they reinforce, redirect, or obstruct, (4) the terms of their selected space or site, which helps to set the terms of their work, and (5) the spaces between known variables that may extend social, conventional, and even philosophical orientations.

In a word, what each artist is seeking is an *allegory* that will superintend and justify his or her work, endowing it with meaning and relevance, while allowing exploration of a range of ideas of particular interest. Allegories in recent sculpture have often assumed the form of referential and generative narratives, which can refer to iconographic meaning, values, artistic tropes, and even aesthetic conventions as long as they are viewed as symbolic means for interpreting works of art. Although this quest for allegory in sculpture goes back to the mid-20th century when Modernism's tenets were beginning to be questioned, it was not recognized as such at the time because Modernist rhetoric continued to demand an aesthetics of presence and self-revelation and thereby precluded acknowledging allegory's manner of subsuming art under an overarching aegis. Admitting allegory as a goal would have substituted absence for presence and deferral for immediate and even transparent meaning.

In the early and mid-'60s, *metaphor*—the poetic conjunction of dissimilar elements into a singular hybrid—was beginning to be questioned as a dominant sculptural trope by such Minimalists as Donald Judd and Robert Morris.

They wished to obviate the strictures of virtual space, which had blanketed traditional sculpture in auras of suffused artiness at the same time that it precluded sculpture from taking a cold bracing walk in the world. Instead of creating such theatrical and virtual spaces as the one highlighted in Giacometti's *Hands Holding the Void (Invisible Object)* (1934), Judd and Morris wished to ascertain differences and similarities between sculpture and ordinary objects. While Judd focused on the special qualities of objects that made them into a new type of non-metaphorical sculpture, Morris began to mine ideas contained in the recently translated writings of the French phenomenologist Maurice Merleau-Ponty (1908–61). Wishing to depart from the grand Cartesian tradition initiated in the 17th century by the rationalist René Descartes, who had established a widely accepted basis for a mentally conceived universe, Merleau-Ponty re-inscribed the specificity of a body-centered approach. This phenomenologist's theories, in conjunction with a Marcel Duchamp revival well underway in the early '60s, enabled Morris to focus on interactions between actual viewers and the art context catalyzed by his seemingly sub-aesthetic objects. This interaction was predicated on viewing art in structuralist terms, i.e., looking at individual works of art in terms of overarching rules resulting in interstitial connections—a view in its ascendancy in the early '60s due to the popularity of Claude Lévi-Strauss's cultural anthropology. (This approach is somewhat related to allegory, even though structuralism's terms are usually implicit, being deduced after the fact, while allegories are consciously evoked and therefore generative.)

In the mid-20th century Merleau-Ponty's phenomenology ushered in an era of installation art predicated on integral relationships between human subjects and aspects of their habitual world, which were reconfigured to make them strange enough to elicit the type of eidetic reduction (bracketing) that phenomenologists have deemed necessary for understanding. This related emphasis on phenomenology and installation art paved the way for the hegemony of architectural sculpture and for sculptors who have been trained as architects. This collection of conversations incorporates men and women who studied architecture both formally and informally, including Alfredo Jaar and Maya Lin.

In regard to sculpture's affiliations with architecture, it's worth noting that Miroslaw Balka, who continues to use his childhood home as a studio, refers all of his works back to his personal history and chooses mathematical titles for his art based on his own size. In consideration of Balka's approach, we can readily conclude that both phenomenology and architecture play crucial formative roles in his art. The Cuban collective Los Carpinteros has similarly chosen to forge alliances between human scale and art by working in the gap between furniture and sculpture, as they create strange chests of drawers in the form of such objects as hand grenades. Both Balka's and Los Carpinteros's works extend outward to encompass viewers in their space, making their size and relationship to the work an essential component, thereby creating the type of dialogic exchanges between the two that Richard Deacon views as decisive for his art as well.

In addition to emphasizing spectators' integral role in the creation of works of art, Merleau-Pontian phenomenology has encouraged sculptors to think about the subject's place in reference to the work they create. Tim Hawkinson has described the perspective of his work as "being inside looking out," particularly when he maps his own view of his skin as if it were flayed. Intrigued with the curvature of the earth, Maya Lin makes us all subjects of our own planetary projection; in her sculptures she focuses on landscape elements, inviting viewers to walk through them and share their space. Maurizio Cattelan mentions "the possibility of changing masks and roles" and notes his interest, figuratively speaking, "in discovering the service entrance and the back stair in each building," thus underscoring the way that a phenomenological outlook has set the stage for all his art.

Beginning in the 1960s, all of these changes had enormous ramifications because the new initiatives seemed to remove the huge proviso of artifice from the field of art. Allegories, structuralism, and phenomenology, working separately and sometimes in tandem, permitted real objects and barely transformed materials to be brought into the realm of art as long as they were presented in terms of one or more of these overriding concepts that played on art's structure and/or context, as well as the viewer's awareness of it. Rather than having to make works that are self-sufficient by virtue of being self-revealing, artists could select prosaic and seemingly untransformed materials as sculpture, making their work appear fresh and direct. Their straightforwardness appeared to be on a par with the almost clinical, positivistic descriptions appearing in narratives by the New-Wave French writer and former agronomist Alain Robbe-Grillet, who similarly subjected his descriptions to off-frame allegorical structures such as the emotion jealousy in one of his most notable novels bearing this word as its title. This emphasis on the here and now in contemporary sculpture, which can also be viewed in terms of allegorical and/or structuralist terms, has taken many forms over the last half century. It can be found in the Merleau-Pontian phenomenological outlook central to Sue de Beer's furniture props that comfort viewers as they watch her gothic videos, the Kantian-inspired mathematical sublime inspired by Tara Donovan's use of ordinary materials like pencils and Scotch-tape multiplied into thousands of components, the objectification of individuality that serves as a basis for Ron Mueck's interplays between figures that appear as stirring presences before shrinking into the guise of mere objects, the reification of Tom Sachs's purposefully jerry-built bricolages with designer labels, and the metonyms giving rise to Marc Quinn's use of non-aestheticized materials like his own blood and feces, which refer back to the artist's putative presence and even more compelling absence.

These artists and the others interviewed in this book depend on their chosen materials—and not themselves—to refer to allegorical and/or structural meanings. Relying on a host of Eastern systems of belief to endow his materials with meaning, Wolfgang Laib regards his collected pollen, for example, as capable of healing without any spiritual overlay. He has stated, in almost a Zen fashion, "For me, the sky is much more important than trying to make a painting that is a symbol for the sky. For me, it's the pollen itself that is the miracle in which I participate in my daily life when I collect the pollen. It's not mine."

Similarly, Beverly Pepper invokes cast iron as her signature sculptural material. For Pepper, an American expatriate living in Italy and aware of the grand tradition of Etruscan iron sculpture, this material is commendable for its force and connotations of timelessness since it can remain buried in the soil for thousands of years without decomposing. Brought up in a family adhering to fundamentalist religious beliefs, Liza Lou plays on the contradictions of ersatz glass beads, which bring attention to dreary overlooked aspects of daily life such as "dust balls, dirty dishes, a closet full of cleaning equipment, a common backyard," thereby dramatizing the everyday at the same time she makes her highly artificial beaded objects—playing on a tacky form of transcendence—appear more real and even a little mundane.

While this book of conversations with sculptors contains remarkable insights into the ways that sculpture changed abruptly in the mid-20th century from being the "handmaiden to painting," according to Richard Serra, to becoming intimately involved with the physical world in many of its guises, this book is not intended to be a linear history of the period. It is a peripatetic and incisive journey of individual soundings, consisting of candid views playing off sustained analysis, deeply held values balancing momentary insights, and personality quirks dramatizing long-term emotional involvement. Some interviews are retrospective in their outlook, while others are involved with the challenges of specific works. And some are analytical and almost philosophical in their approach, while still others are intuitive. Although these exchanges can be read sequentially from beginning to end, they can also be considered spontaneously as one leafs through this volume and catches the flavor of first one exchange and then another. Perhaps, the most important contribution these discussions make to our overall understanding of contemporary sculpture is the extraordinary range of personalities involved in this endeavor. This book allows us sustained glimpses of a group of remarkable sculptors; at the same time, it helps to demystify recent art so that we can understand it as a route for thoughtful and sensitive individuals to communicate three-dimensionally through the semiotics of their materials their understanding of the present-day situation and its relevance for us all.

Robert Hobbs
The Rhoda Thalhimer Endowed Chair of Art History, Virginia Commonwealth University
Visiting Professor, Yale University

# Poetry Out of Chaos: Judy Pfaff

## by Jan Garden Castro
## 1998

Judy Pfaff's installations confront sculptural and architectural concepts—mass, scale, inner and outer space, multiple perspectives—yet they also contain raw emotional and sensory chords that may surprise and confuse viewers. Born in London, Pfaff earned a BFA from Washington University in St. Louis, Missouri, and an MFA from Yale. Her 1980 exhibition at Holly Solomon Gallery, "Deepwater," was soon followed by installations at the Whitney Biennial, the Hirshhorn Museum and Sculpture Garden, and the Venice Biennale. Her recent installation at André Emmerich Gallery displayed her continuing propensities to have fun, to explore materials and science, and to celebrate gut-level human emotions. She transformed the gallery by mixing welded steel, plaster, rubber, plastics, graphite, an uprooted tree, and other materials from architecture, art, and nature.

**Jan Garden Castro:** Your installation *Round Hole Square Peg* (1997) casts the pure geometry of the cube and heavy metal architectonic frames against flowing elements that interact with and open the gallery space. How was the work conceived?

Judy Pfaff: I moved upstate two years ago, and I live on the Roundout Creek in Kingston, close to the Hudson River. I look at simple things all day—the river flowing, the wind blowing, rain on the water's surface. Sometimes storms come through and the water rises, adding drama. I was trying to get that imagery into uptown New York City. As I was planning the installation, I realized that the gallery is not easy to see as a whole. Its many rooms each have their own feel and ceiling height. In looking at the floor plan, a kind of Greek cross appears. The shapes have something to do with the body: a strong center spine and right- and left-hand orientations. Discovering these elements gave me an understanding of how to proceed. As I looked at the space, one thing that dawned on me was that a window was behind the lead wall. Another theme—the flow of steel lines—runs through the whole thing. That's what I wanted to do with the holes and the lines—make the little rooms into one being, one entity.

**JGC:** Are those water lines on the wall?

JP: They are level lines, eye lines. The heights were determined by the heights of my assistants (Dylan Farnum, Barbara Spann, Rob van Erve, Stephan von Muehlin, and Nick Emmet) and that of Yugin, the son of Jim Yohe, the executive director of the gallery. The holes unify the entire installation: you can see through the walls. As someone passes on the other side, the hole fills up, then empties. Holes do that. When we were installing, we talked to each other through the holes. Yesterday, I saw André [Emmerich] walking by; you get flashes—a performance aspect, peeking, a relationship that can go through the wall. Penetrating something is a fabulous way of communicating.

There's an image in a Genet play of two men in prison. They have no contact with each other except for a small hole in the prison wall. To share a cigarette, one man blows the smoke through the hole to the other man. It's a moment of love and intimacy—so simple.

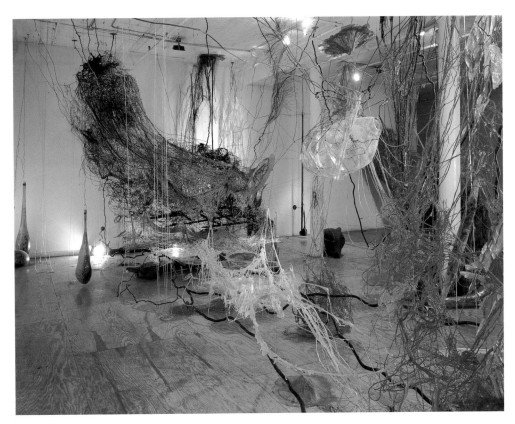

*Moxibustion*, 1994.
Fiberglass resin, blown glass, tar, bedsprings, lotus leaves,
and steel, 14 x 35 x 20 ft.

**JGC:** It reminds me of portholes on shipboard, and also of the Oriental tendency to make round openings.

**JP:** Yes, I look at a lot of books on Asian art. One of my first teachers, David Diao, was from mainland China. He told me that what I was doing was way too Chinese for him. My work extends out; it doesn't have an object center. You see through—through the piece, through the wall, through the window, and out. Its center is the world.

**JGC:** You also connect the imagery of large flows of water with the body's circulation.

**JP:** All of the big and little things collapse on each other. True metaphors are very liquid and seek many levels.

**JGC:** The installation has an incredible unity, and at the same time, each chamber has a different theme.

**JP:** That just happened. I didn't plan it. Structurally, because the rooms have drop ceilings, I started working with straight lines. As I was constructing, I thought, "That's a room, and in that room lives a sensation or a necessary mood." One room looks Buddhist and shrine-like. I was surprised by that reference. I thought of doing things to obliterate it.

It is easy to obscure imagery quickly just by pouring a bucket of black paint on it. I thought, "Let it go, Judy. So it's a funny Zen room. I'll figure it out later."

**JGC:** Jim Yohe compared one of the forms in the installation, a double square with a round, built-up circular clay image, to a three-dimensional mandala or a Buddhist stupa.

JP: The image of the stupa came about naturally. It began by looking at raindrops, all those concentric circles, and then by remembering that famous photograph of a drop of milk taken by Harold Edgerton, the scientist and photographer. Sometimes there's a ridge on the side of the circle as the drop falls into the milk, and sometimes there is a rising center. I was trying to do that. I thought, "Here I am making raindrops, and in the middle of it I have stepped into this fantastically rich architectural image, which I received from nature."

I found a book published in the 1930s by the Works Progress Administration (WPA) for plasterers, which showed sweep molds, circular forms, as mountings for chandeliers. The molds are made on a rod that goes from floor to ceiling. It's like a reverse potter's wheel. We put bearings on a template, and instead of the wheel turning, the template turns to score in the lines. We poured hundreds of pounds of plaster on the floor of the gallery, and it all set in 10 minutes. The mess we made was unbelievable. We had eight or nine garbage cans of plaster setting at different rates.

The accumulation of imagery in the installation goes from the most ordinary to the most elevated. That is a gift. It becomes a model for the universe, a cosmology. We could all feel it. At an earlier time, I'd have been too embarrassed to use references that I could not take credit for.

**JGC:** It is interesting that viewers circle the circular objects on the floor in a rectangular space.

JP: I studied at Washington University with Nelson I. Wu, who used to talk about shapes and the significance of circumambulation around them. People have to go to the right around them. I'm so short that I'm the only one who can move underneath the left-hand side. Without realizing it, viewers are walking correctly around the objects. I like that.

**JGC:** You have also built in the yin and the yang.

JP: Yes. It has always been that way, too. I arrive with an entourage of welders, tools, and equipment, but it always looks like weaving in a funny way. A friend said to me, "You make it big, and then you make it go away." There is an establishing of form and then emulsifying, softening effects.

**JGC:** The welding techniques were very sophisticated.

JP: Dylan Farnum was the TIG welder. Usually I weld, but for this project, I bought a TIG welder. The joinery is so smooth and clean that the steel becomes soft and liquid.

**JGC:** How long did it take to create?

**JP:** We had two weeks. I had planned a very different show. I had prepared many mural-sized drawings spliced with photographic panoramas of the river, casual images of the water's surface, boats passing, and the occasional duck. Rob, my husband, printed and prepared these images. Then I changed my mind. We did not even unwrap the rolls. Two weeks shrink when the whole format changes.

**JGC:** How long was the conception process, before you got to the gallery?

**JP:** This show was supposed to happen last year. I wanted the piece to reflect my new life on the river, but my studio warehouse in Kingston was not ready. It had no heat, no electricity, no walls, no windows, no doors. I knew I needed windows on the river.

**JGC:** Rob said that you reconstructed the Emmerich Gallery space inside the Kingston studio.

**JP:** I had never done that before. The dimensions were outlined in two-inch steel tubing inside my studio. I could see the gallery space in transparent volumes. It also suggested the subsequent aspect of rooms in rooms—and a structure to support other imagery.

**JGC:** Your use of color in this work is reduced.

**JP:** Yes. Hopefully taking the color out suggests the form and content. I have been using less color lately. I think, too, that most artists have complaints about the way they're seen in the world. My work has been written about as flamboyant, gregarious, and exuberant. In the past 10 years, I've reacted to the feeling that no one was seeing past the color. Underbellies—the structural, psychological, and metaphorical uses of color—were unread.

**JGC:** You had a coded color symbolism that wasn't received?

**JP:** Yes, and never addressed. I combined many systems, but I never talked about it. There's always mind-coded color, not just "I like reds." There was color that collapsed space, agitated emotions, directed the glance, and came from codified cosmologies. Structural things were happening in the color.

**JGC:** Let's talk about tantra and other color symbolism.

**JP:** Al Held was my teacher. In his early work, color was physical; in his new paintings, he is obsessed with colored light. For a short while, I worked in the shop that printed Albers's serigraphs.

Color has always been known to have a powerful, spiritual aspect—in Madame Blatavsky, in people who were influenced by Rudolph Steiner, Gaudí, and Kandinsky, and in religion. It can be ecstatic and clairvoyant. When it became formal, and when the Abstract Expressionists made it into an emotional language, it had yet another aspect.

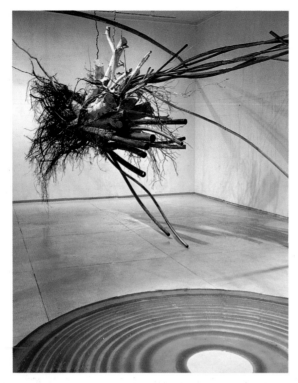

Light and color can contain content. Color has significant, subtle aspects in a Catholic church, a Buddhist temple, or any place that's reaching for higher ground. If the light from that rose window falls on you, you experience a powerful feeling. As sunlight falls on you, you feel it. Light and color are prime movers. I wanted it to have a living presence, but my color was seen as an explosion in a glitter factory. I was kind of horrified by that.

**JGC:** Your color in this installation seems very much of the earth.

JP: Also, the pink, the only real color in the show, is a shift from the steel to copper. A swath of acid produced a simple alchemical transubstantiation. The pink softened the silver and gray edge of the steel.

*Round Hole, Square Peg,* 1997.
Mechanical steel tubing, plaster, pigment, wood, tree stumps, cast rubber, expanding urethane foam, and pencil, dimensions variable.

**JGC:** You have literally and figuratively added weight and mass to your constructions.

JP: Yes. I've increased my tolerance for weight. I did a big piece in Philadelphia using what seemed to me to be huge, four-inch-diameter steel tubing to scale up what were, in the model, 1/16-inch lines. Steel tubing is pretty nasty—it's oily, it clanks, it's heavy. It took a lot of manipulation for me to see what it could do. In time, another nature is revealed—it appears light, liquid, and easy.

**JGC:** Your aesthetic challenges Mark di Suvero's. His aesthetic displaces or dominates, and yours somehow mediates between architecture and nature, sort of a crossover. You open up a space.

JP: He understands the center—the object. He establishes the tripod and then energizes it. He understands strength and weight. He also has a good time.

**JGC:** The small room with paintings and collages is a rich coda or ending.

JP: You can see how they inform each other. The paintings are on Indian Sanskrit ledger books. It's beautiful paper, in long rectangles with the folds burnished in. A lot of my imagery is informed by images of the body and herbs from old Tibetan medical texts.

**JGC:** Let's talk about some of the metaphors in the show: the stupa-mandala holy space that's spare, centered, and coming from a center; the tree room where there are images of loss and uprooted nature; and the flow into other mediums and dimensions.

**JP:** You're hitting on them quite articulately. I'm trying to figure out for myself why roots have always been, in some manner or form, important. That feels like me to me.

**JGC:** A human metaphor.

**JP:** A human metaphor. The tree, like the ginseng root or the mandrake, has always had an equivalence with the body. That's a given. And the roots mirror the tree. I'm saying this after the fact, so I may be making it up, but it seems like that's always been there.

Also, André walked through the show, and said, "Judy, I can tell your size." I walk through it freely, but everyone who's not five foot four is bumping into things. It's based on my body and how I move through space more than I thought. Everything is my eye level; those circles are my span.

**JGC:** By extension, the relation of the human body to the architectural body…

**JP:** Yes. I like that. Churches were done like that. They were based on cosmologies, on the ordering of the planets and the person. And the circle: I've got dots everywhere, but they're not like polka dots; they're like the sun and the moon. The same form can hold all this metaphor.

The answers are always easy. They are and are not. In *Black Elk Speaks*, the narrator, an Oglala Lakota, had visions when he was very young. It was a cryptic algebra. He could understand more at 60 than he could at 18. I tell friends who ask, "What does this mean?" that I don't know, but I'm confident that the answer is right in front of me. I do know. This stupid little hole puts air through the wall, and everything becomes transparent. I think, that was so easy. So there's something about the body and the way one is as a human being that makes things resonate and feel known.

**JGC:** Some of the circles come from precision equipment, but most of them, and the ripples and waves around them, are done by hand.

**JP:** Yes. And when we drilled the holes, there was this gift, this lateral hole, in the wall. Also, by the time I get out of a space, I have touched every part of it physically—like a child crawling. I am on the floor, I am vertical, I am on the ceiling: I have touched, destroyed, and mended all of it. Like taking a bath, I have touched all of it. There is a mutual relationship—the volumes and me operating in the volumes—that is fair and just in certain ways. When the piece works, that's the extra. It's like a good marriage. I like that.

# Memory, Monuments, Mystery, and Iron: Beverly Pepper

**by Anne Barclay Morgan**
**1998**

A major exhibition surveying 30 years of Beverly Pepper's sculpture was shown at the Forte Belvedere in Florence, Italy, in 1998. The show marked the first time that an American artist, and a woman, was invited to exhibit at this historic site. Forte Belvedere has hosted important exhibitions dedicated to such masters of 20th-century sculpture as Brancusi, Marino Marini, Henry Moore, Botero, and Mimmo Paladino. Pepper's exhibition featured more than 70 sculptures, models, drawings, and photographs.

**Anne Barclay Morgan:** How does it feel to be the first woman to have a show at the Forte Belvedere?
**Beverly Pepper:** I don't really think in terms of gender.

**ABM:** Does having so much work gathered together in one place affect you, and how you will work in the future?
**BP:** It's hard for any artist to be confronted by his or her life's work and not feel the mystery of the passage of time. Strangely, in a way, my work is about the passage of time. So it could be an interesting experience for me.

**ABM:** Your recent works are massive, but rather than having the verticality of your best-known work, they seem connected to the ground, even rising up from it. What brought you to this shift?
**BP:** They are connected to the ground—they come up from the ground. It's hard to see that indoors, on a hard floor in a gallery. If you put them on land, outside, I hope one can feel that the sculpture emerges from the ground.

**ABM:** Your work is heavily textured. How did that come about?
**BP:** I've been using textures to evoke a sense of erosion for more than 10 years. Those works evolved into wall reliefs—and in my site-specific works, into large walls as opposed to wall reliefs. Eventually I started dimensionalizing the reliefs.

**ABM:** How do you make them? You have said that you made New York City's Federal Plaza sculptures by hand. How do you make 40-foot sculptures by hand?
**BP:** I'm talking about the originals—not the actual casting. I've been working with plaster for the last 15 years. The way that I work, the surface is not predetermined. You make a gesture, you follow the gesture, you edit, and you follow yourself. The technical means of making influences me as much or more than art history. There is Styrofoam under the plaster. I have a way of cutting Styrofoam that gives me the freedom to work fast—I can simply draw with wire.

**ABM:** That still doesn't explain how you can do 40-foot works by hand. Do you use scaffolding or ladders?

**BP:** No, I work horizontally, and I have assistants to help with cutting the Styrofoam. The plaster is gestural. It cannot be predetermined, and that is what I do by hand—the forming and shaping of the work.

I frequently make works in two or three parts—two-part and tri-part things are part of my history. In a way, the spaces between interest me most. The early stainless steel pieces had space in the center. That void has been a constant throughout my work, though it has become increasingly narrow. Each work has a memory. One two-part sculpture is related to *Palingenesis* (1992–94), a site-specific work that I did in Switzerland. It is a memory of that sculpture. I don't jump from one thing to another, but I always

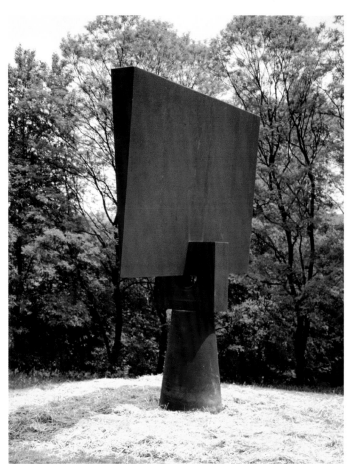

*Horizontal Wedge*, 1991.
Steel, 13.5 x 11.5 x 3 ft.

work on three or four things at the same time. There are pieces in my studio that I've been working on for many years. They are monumental wedges waiting to be brought to the next step. My massive works, not the columns, are in some ways a means to three-dimensionalize works that I have in the ground, against the ground. But there is no way to bring the ground into the gallery, so I gave the reliefs/sculptures four sides. However, this is not preconceived. While I am working, I am just looking for the moment of discovery.

**ABM:** And you chose cast aluminum rather than cast iron for these new works?

**BP:** I used cast aluminum because I wanted them to look like stone. I can't carve, and I am uncomfortable having stone carved for me. Some of my colleagues who are very good artists have works made by stone-carvers, but they have no aura, no mystery, no mistakes. When you bring something to someone and say, "Here, make this for me

10 feet high," the person who is doing the carving is not the artist, he or she is an artisan who must now respect each and every millimeter. I've had work done that way and it required my knowing exactly how the work would look when finished, before I experienced making the work.

What makes a work of art have mystery? There are times when the hand goes in a direction that the mind does not, and then they get together. It's an inner recognition that the mind is right and the hand is right. But you don't really know what the work will look like when it is finished. There are hairline differences that make a work unexplainable. I couldn't possibly do that with stone, so I tried to make these cast aluminum works as close to stone as possible.

**ABM:** Do you prefer to work in cast iron?

**BP:** I really think of cast iron as my signature material. Someone said that if you scratch me, I bleed iron. I understand iron. It has something that I need. I would like more brutality in my work. I'm not a brutal person, but you can get some of that brutality with your material. Iron is a tough metal, difficult to make look elegant. Wood can be exquisite, and I love wood, but I wish to avoid "taste," and iron is a great way to rein me in. I use the earth, I work with the earth. The earth is also very combative.

**ABM:** Iron is also such a historical material—it refers to past civilizations. People have remarked that the totem-like works installed in the main square of Todi look as if they could predate the 13th-century buildings around them. There is a history that comes out in your work.

**BP:** I hope so. That's memory again. I'm told that even the *Moline Markers* (1980–83) look prehistoric. I must have lived in other times.

I'm interested in iron and have done a lot of research. Iron transcends time. It is about "foreverness," continuity. In 1962, when I worked in a factory in Piombino for the famous "Sculpture in the City" exhibition at Spoleto, the men there told me that during World War II, when the Italians had no more metal for armaments, they would go to a field and dig up Etruscan slag to melt down to make guns. Iron lasts forever. It was first known only through meteorites, then it was discovered in veins in the earth. It went from being worshipped as a sky god to being worshipped as a deep earth god—Vulcan. It seems to encompass the whole universe.

**ABM:** How would you like your sculptures to age?

**BP:** I'd like them to acquire age. Iron is a litmus test for the environment. If you live in a non-polluted area, it will retain its rust color—deep orange-brown. In polluted areas, it turns dark. It's like the canary in the coal mine. Most patina cannot be controlled. Eventually the sculpture in New York will get quite dark and will have a whole other look. There is a certain predictability with bronze patinas, but iron is not an alloy, it is not created by man. That is a

little extreme to say. Elements have been added to the ore for the works in New York to make it ductile iron, which is more flexible and approaches the tensile strength of steel. But most of my other work is gray iron.

**ABM:** You had to change the work and use an alloy for the New York site?

**BP:** They passed seismic laws, so the sculpture had to have more flexibility. Les Robertson, the great structural engineer, told me that when the sun comes up in New York City, every building turns imperceptibly toward the sun, like a sunflower. And now even my sculpture does that.

**ABM:** Were you involved in the design of the site as well as making the sculptures?

**BP:** Yes, I designed both plazas, including the grass, trees, seating, and so forth. We opened up the Duane Street side to make another entrance, a long sloping stairway. You come up underneath, looking up at the columns. The original intent was to close the street and make it a pedestrian walk through the surrounding buildings of the government center. That would have set the work into a key thoroughfare. I did not choose the stone. The original walls remained, and it made sense to use it for the plazas. In commissioned art, there is always some restriction. It's a given. In this project, it was the stone.

**ABM:** Have you done other projects for the General Services Administration?

**BP:** Yes, one in Kansas City and one in San Diego. I don't have a project in America of the dimensions that I've had in Europe and in Japan, except perhaps the *Amphisculpture* I did in the early '70s for AT&T in Bedminster, New Jersey, and *Cromlech Glen* (1985–90) at Laumeier Park, in St. Louis. But I did not use cast iron in those projects.

**ABM:** You've talked a bit about your internal process and your feelings. Are they the starting point for your work?

**BP:** It's hard to explain to people that I really don't think like that. By now, my starting point is my last stopping point. There are always things around that are unfinished. At this point in my life, I'm never at the starting point—I'm halfway down the field, and I keep going. But also, I learned very early on, when I was working with factory-made sculpture, that you must know exactly how it will look when finished. The reason I do the fabrication in my own studio as often as possible, with assistants, is because we can control the imperfections. It's the imperfections that keep the sculpture alive. The idea of the hand is important to me—the accident, the emotion. I want the sculpture to have an interior life.

**ABM:** You've also said that you feel you don't belong to this century.

**BP:** Not quite the century—perhaps the last 15 years. It's just that there is so much going on that seems provisional. The art that has survived, even from the earlier part of this century, has not survived because of its connection to an ideology. It survived because of its power as individual work. I think that Minimalism and Conceptualism are great ideas because they provided road maps, but there are very few Minimalist works that survive as works of art.

*Cromlech Glen*, 1985–90, restored 2002.
Stone and sod, 200 ft. diameter.

They survive conceptually.

I find myself feeling bored when I go into a gallery and find 600 vulvas on the wall. I would much rather stand in front of the Venus of Willendorf or Egon Schiele's works, or go to the Museum of African Art. Art like that makes me want to go to work. There are people who think that today is a moment of great brilliance. Perhaps. There are times in your life as an artist when you pay attention to what's going on in your own period, and times when it is crucial to pay attention to other things.

Ultimately my litmus test is whether something makes me want to go to work. Does it make me feel something? A great work of art leaves you with questions, not answers. To me, when you finish something, you should find that there is something you want to know, something you have to search for.

**ABM:** The two-part aspect to your work is also there in *Manhattan Sentinels* (1993–96), as well as the importance of the space between.

**BP:** That is an evolution that came about very slowly. I realized that there is a dynamic that happens between two things.

They are very seldom exactly the same on either side of that space. What happens is that when you look at the work as a whole that space in between gives it a tension. I don't even know why I do it anymore. It's the way you cross your Ts. I can give you a rationale, but that's not why I do it.

**ABM:** In the two groupings, one group is placed in a circle and the other in an oval. The circle comes up often in your outdoor pieces, but I wonder about the oval?

**BP:** The shape of that terrace is a rectangle; the other terrace was modified into a square. The circle is far more a part of my vocabulary—the triangle, the circle, and the square. At the last minute, I removed a circle that was in the oval in *Manhattan Sentinels*. I think it's a great oval. What I love about it is the outside shape. Obviously designing an oval is more demanding than a circle. One of the satisfying things about working on commissions is that it pushes you outside your own frame into another. I wouldn't have done that oval without the constraints of the rectangular terrace. I find that kind of pressure very satisfying.

**ABM:** In your extraordinary park in Barcelona, did you also go through a process of change?

**BP:** Ah, those wonderful Catalans! There were many changes. It took almost five years to complete the park. There were large ceramic elements that didn't look right and had to be redone many times. Joan Ravantos, the ceramist, tried everything to get the colors in *Cel Caigut* (1985–91) (the large central element) looking like watercolor. It took a year before we had the first acceptable tile. But he went along with it because he realized that he was learning new techniques.

The massive wall of white with various shaped lines—I didn't know they were going to work. That was on-the-job experimenting. I had no idea. I was stunned. I had never done anything like that. But instead of leveling the ground for *Cel Caigut* they built it up. When I first saw it, I said, "Ruined. A disaster." I had to redesign the area and shape the grass. If I'd insisted that they take it down, they might have done it. But we worked together to find a way to integrate it. Actually, undulating the grass was a plus.

We ran out of money for the outside walls, which was just as well. They probably were too colorful. In any event those kinds of changes are challenging. I'm an artist. If I can't do A, that doesn't mean I can't do B or invent C. I like making things. If they say, "This isn't going to work," then I say, "Then let's make this work." I like projects. I said to my husband once that I'd much rather be Michelangelo than Leonardo. And he said, "How can you say that, you're more like Leonardo. You like the problem. You spend six hours taking some little object apart, and then spend the next six hours finding another way to put it together differently and still make it work—because you like the problem." It's true, I love the problems. When you give me a frame, it pushes me into being more inventive than I would have been. That's what is keeping my old brain young.

# Undetermined Pleasure and Unnecessary Beauty:
# Richard Deacon

**by Ian Tromp**
**1999**

Richard Deacon prefers to call himself a fabricator. Several aspects of his self-perception as a sculptor, as well as his conception of the place and role of sculpture, are wrapped up in this label. He says, "Material and its manipulation are core areas in what I do. 'Matter' and 'stuff' are the words I tend to use." But while Deacon's is a material art, there is also a kind of transcendence in it. He would not choose to speak in these terms, yet one senses a shadow of immateriality in his work. Though he remains determinedly uninterested in abstract philosophical topics, the work itself is allusive and imaginatively suggestive. Not representational in a mimetic sense, Deacon's sculptures inhabit a space between meaninglessness and meaning. His forms seem to swim into significance and then dissolve again or recede. There is a play of advance and retreat, as if the works could become almost recognizable, knowable, but then they pull back, leaving the viewer once again in an unfamiliar space.

Deacon emphasizes the importance of meeting the work "as if you are in front of another person and in…relation to particular bodily sensations." It is possible to derive two principles from this statement. First, the work is envisioned as dialogic—it functions within the interaction, the exchange, between work and viewer. Second, the viewer's experience of the sculpture is grounded in his or her own somatic apprehension. These principles suggest that we give attention to the ways in which the works interrupt our experience of space. By reversing the exchange, the emphasis is shifted—the sculptures are in the world and we have to walk around them, stand among or over them. This has the effect of making us relate our bodies to them on their terms, rather than seeing them only in relation to ourselves.

Ian Tromp: In a recent talk, you spoke of your working methods as "means of making something indescribable." And in a notebook entry, you describe your series of drawings "It's Orpheus When There's Singing" (1978–79) as "intentionally extremely representational," but then you say you have "difficulty in deciding of what they are representations." You seem to be saying that when you're working you don't really know what it is you're making.

Richard Deacon: I think that when we look at art, one of the things we want to do is to attribute meanings. We try to uncover what it is that the artist is trying to do in this or that thing. This is a mode of transaction that at its simplest is to do with a certain kind of recognition—we recognize that something resembles something else. We don't only do this in looking at art: seeing resemblances, recognizing that things look like other things, is part of how we meet the world, but it becomes very focused in looking at art. The question for me is whether resemblance can be detached from objects. That quote about the drawings has to do with trying to work out whether the conjunctions of resemblance, looking like, reminding of, referring to, are simple associative categories or whether they

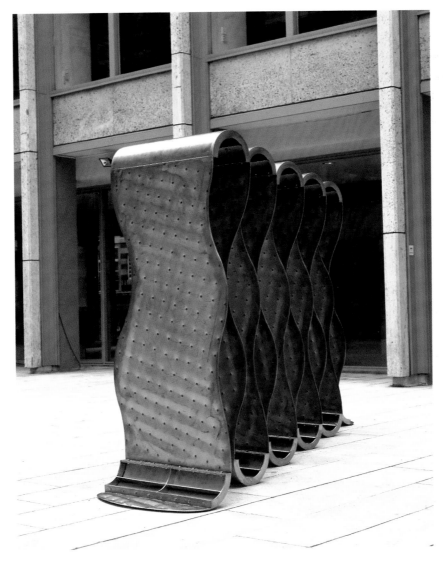

*Smile*, 1992.
Welded stainless steel, 74.25 x 31.5 x 149.625 in.

refer to something else. Metaphor is an example of a way in which objects can be put in relationship without them having any necessary resemblance: two things are put into conjunction and then you see the one in the other. It was the ability to evoke those kinds of responses—looking like, resemblance, and so on—that I had been trying to create. It requires a certain level of ambiguity, a certain level of giving and taking away at the same time. That's the kind of thing that I was interested in.

IT: You're distinguishing between a category of meaningfulness on the one hand and, on the other, specific relationships of meaning, or referring to, or standing for, something else.
RD: Yes, in general that's the kind of place that I'm trying to put forward.

IT: You've also talked about the importance of trying to be in situations where you don't know what you are doing.
RD: Yes, idleness is quite productive in that sort of way.

IT: You're interested in chaos theory, which is concerned with the appearance of form in the world. One basis of chaos theory is in chance, but it seems also to be procedural, as in computer-generated images that derive from mathematical procedures. You've just been speaking about chance, but have you also been affected by procedural or systems thinking in your form-making?
RD: Originally I got interested in chaos theory because it seems to imply the idea of interconnectedness, and then I became interested in the idea that order comes out of disorder. Now I would say that I'm much more interested in ideas around emergence, which is more related to complexity theory. Emergence says that it's inevitable, in any sufficiently complex system, that order will emerge. There are some kinds of systems in which randomness springs out of control, and there are other kinds of systems which are entirely constrained. Between those two kinds you have an interface, and along that interface you get emergence, which is where ordered complexity emerges. The classic example is the turbulent flow in certain liquids—there's a point where the liquid is moving too fast for there to be anything coherent about it and another point where it is moving slowly and it's entirely coherent. But there's a point between these two at which ordered pattern emerges, in the form of vortices, ripples, and eddies. This is what interests me, this openness that emerges between those two states—it's not to do with generating a pattern from a mathematical program, it's to do with the point of transition between order and disorder, where different kinds of ordering emerge.

IT: In looking closely at your work I was impressed by signs of making, unmaking, and remaking in different stages. For instance, *What could make me feel this way (A)* looks as though it had been joined differently at some time. I assume this is to do with individual sections being made separately and then jointed together—there are screw holes and marks where screws seem to have been.

**RD:** Some screws are taken out and some aren't. Screws are used to hold pieces in place; they come in and go out and they locate things. In that work, the diagonal strips were bent on the work, rather than off—the work was its own mold and its own former in a way that the other two large bent wood sculptures weren't. Fundamentally I tend to keep the screws in at the ends of bits of wood, because that's where the joints are the most fragile. I have in the past taken them all out, as well as left them all in. I want to get a balance of making them work in a way that isn't purely functional, so that they either appear as a part of pattern or excess or else their absence becomes notable.

**IT:** You were once asked a question about finish and you talked about levels of attention—you said that you left things neat or untidy on the basis of a judgment as to what level of attention that feature was going to get.

**RD:** I did say that, yes, but it's not so much to do with the level of attention that the thing gets as the level of attention that it needs—or a combination of the two. Saying "the level of attention a thing gets" implies a certain sense of covering over, or of only finishing up to a visible degree. One of the reasons that you have a skirting board in a house is to hide the awkward gap between the floor and the wall, and it allows for a level of craftsmanship that doesn't pay particular attention to articulating the gap more directly. But if you specify no skirting board then you need to attend to that. In most of my sculptures, the finish, irrespective of whether you can see it or not, is consistent throughout the piece. If those joints had been hidden, they would still have been attended to. The question was in relation to a small work, *Table (E)* (1999), and had to do with the difference between it and one of the bigger works, *After* (1998): Why was the jointing more elaborate on the small work than it was on the big work? The answer is that these are two different objects and the convergence of the ribs is a different thing in the two works. Whereas the ribs on *Table (E)* converge around a form, there's a sense of unfocused sequence in *After*, the joint is treated in a different way in *After* because it's one of a much larger series. You see each joint sequentially in *After*, but in *Table (E)* they gather around a middle. I could have pointed out parts on *After* where the detail had been very tightly attended to, for example on the steel fence that runs through it.

**IT:** Another aspect of making and unmaking can be found in some of the plastic works, for instance *Not yet Beautiful* (1994) and *From Tomorrow* (1996). I noticed that you'd drilled holes, almost as if the plastic sections had been sewn together at some time.

**RD:** Those works are made over formers. I've been using plaster formers and mapping the surface in order to eliminate three-dimensional bends in any of the pieces. I take templates of that mapping with pieces of paper, which are then used to cut the small pieces of rigid plastic. Once heated, the plastic becomes malleable and is located onto the surface to its corresponding pencil mark. But because it's quite hot when it comes out, and it's a manual process of pushing down and shaping over the surface, we devised a system of screw-pegs to hold the plastic down—screws set into the plaster and then a wooden peg that grips the edge. So the first piece you put down abuts on all sides to plaster—when you hold it down, the piece of plaster is perforated. A conundrum then arises in that the next piece

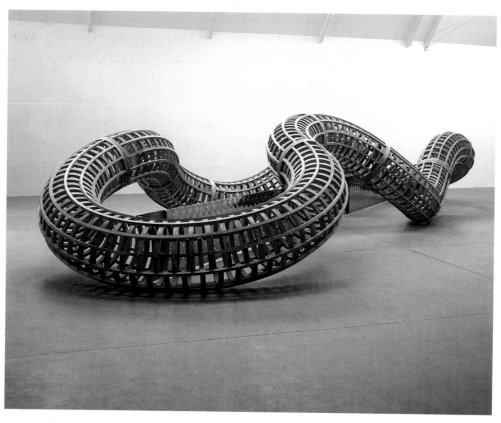

*After*, 1998.
Steamed beech wood, aluminum, and stainless steel, 62.25 x 142.875 x 378 in.

you put down has some of its edges butting up to a piece of plastic that's already laid in. For fear of loss of align-ment, rather than removing it and putting it back again, we drill through those sheets of plastic to provide a point to pull the edge of the hot one. You can't drill into the hot plastic because it's soft, so you have to pull it down with a peg. As the work goes on, you end up with corresponding holes in the work, which are a function of this business of holding down, and as it's built up the sections are welded together into a complex sheet. However, they're not completely welded together—there's a larger division of the form into however many parts will separate to allow you to take the solid away. And so if there are 10 pieces, each piece made up of fragments, those little holes become very useful because they enable us to do exactly what you described, to sew them. Using wire loops we sew the plastic back together prior to making the final weld and then cutting the wire. I liked what the holes did because they were quite like what we've said about the screws. I liked their absence. I did one on commission without mak-ing holes in it, just to see what it was like to do it without holes. It is a very different surface. It was very elaborate to make—we had to make the pieces oversized and cut them back to fit. It gets quite complicated, because I think

that in a way the more you finish things, the more the material disappears. It's particularly so with very picturesque materials like wood that become extremely beautiful the more you finish them. They tend to erase their materiality. In the plastic works, in fact, the transparent material is probably more beautiful than it could ever be when it first arrives—no amount of work you put into it improves it.

IT: Do you approach sculpture primarily from the point of view of material and form and the viewer's body meeting the body of the sculpture, or is there an affective or imaginative level on which your sculpture works?

RD: It's difficult to distinguish form from the imaginative ways one constructs form, so I think when it's successful the material is present, the form is present, the structure is present, the associations are present, and the sense of meaning—or the possibility of meaning—is also present. There are some things which are very concrete, but equally some things which are much less concrete—which aren't concrete at all—but should be present with the same force. What I think gives the sculpture its drive or its potency is a tension between what you can see and what you can't see, what you imagine, or you picture, or you construct, refer to, or associate with—all of those things. The sculpture retains its physicality while allowing a richness of readings, but it never ceases to be a particular kind of physical object, a particular identifiable physical object made of a particular material.

IT: You seem very interested in materials.

RD: I don't want to over-emphasize that, but yes I am. I'm interested in the fact that there is a continuity between the world and materials, that the material is of the world but also sustains an imaginative response, so that it points in two directions at once. I'm not less interested in the imaginative response than I am in the material, it's just that sometimes it's harder to say precisely what the nature of that imaginative response is.

IT: Most of the small works you make are in the series "Art for Other People." When did you start making these? Was the seed for them a kind of democratic urge in making art?

RD: I used the name of the series very naively to begin with, from a very simple impulse. I first made them in 1982, and it started very simply: I went to an interview and was making a real hash of talking about a group of works that I'd made, and when I came out afterwards I thought, "Well, I don't need to do this, I can make sculpture that does this." So they were made in a way like writing, like sending letters to people. They were intended to be non-contextually determined, so that you could take them anywhere and they could function anywhere. They're also not particularly gravity-dependent, so that they could exist on other kinds of surfaces; it doesn't really matter if you lift them up. If you lifted any of them and looked at them, the only one that would seem to have an underneath would be the flat, very highly polished wooden one (*Art for Other People #34*, 1997). What I also found interesting afterwards is that if you call something "Art for Other People," then of course when you look at it as a viewer you don't think it's for you—and you wonder who the other people are. You know it's not "me," because one is never "other people."

IT: You said that those works were individuated by being in relation to one another rather than by their size, which is the way you distinguished the bigger works—you pointed out that it's possible to see each one in its own space. You also talked about their color and said that their light was a very important aspect.

RD: In Liverpool they had an extraordinary number of different ways of responding to the light. Color is an element of that, but tone and intensity, dark and light, shine, shadow, transparency, translucency, opacity—those are all things that I think are present in quite a lot of the works. They respond to light quite particularly, and that's very intuitive.

IT: Do you make drawings as art objects in themselves, or do you make drawings as a stage in making sculpture?

RD: It goes in phases. Every five years I seem to come up with a group of drawings. When I was at school I made a lot of drawings. I loved to draw; I drew obsessively and continually. When I went to Central Saint Martins I stopped drawing completely and started writing. In a funny way, drawing and writing are very similar. Partly it was a contrary attitude, because I was starting to have quite strong beliefs about how you should and shouldn't make things and what it was that I wanted sculpture to be. I definitely didn't want it to be workshop practice—the idea that you drew something and then made the thing you drew seemed to me not what I was interested in doing at all, and I stopped drawing in order to not do that. Then I did a lot of performances, and there was a period before and just when I started at the Royal College when I began drawing quite extensively. That rehearsed a way that I started to make sculpture. And then I stopped again, until I went to the States and did the Orpheus drawings, which also rehearsed some process that I was trying to change or trying to make sculpture about then. I was trying to look for form, to make form that had ambiguity in it and that had multiple referents, so what we said earlier about representation applies here. And then some five years later I did a thing for the Serpentine Gallery, and I wondered what it would be like to have someone make something that I'd designed. So I tried to draw something completely, tried to describe something in drawing so that someone else could make it. It was a long process. And then I started to use drawing in a slightly different way because we were starting to work with quite a lot of steel—I drew things and then used the drawings as templates, so that they started to disappear into the work. And there was another group of drawings in two sets from 1990. One set was very interested in shape, working on the relationship between shape and line; the second was more concerned with detail, with texture and line. Both sets were paired with photographs and became an artist's book called *Atlas*. The drawings on the screens followed on from that really. The way I have been drawing has been fairly consistent over a while—black, non-tonal drawing.

IT: There are distinct styles within that: comic book styles, biological or medical, and architectural.

RD: I have an interest in the ways that drawing has been used. One of the interesting things about drawing is that it is used in a number of different ways, and it refers to ways of dealing with the world, science or archaeology, for instance. It refers to and also represents the ways those disciplines see the world.

IT: All the time we've been talking you've been playing with an elastic band—is that another way of drawing?

RD: I am planning to use this. It's on the table for a purpose.

IT: At one moment it looked a lot like the forms in *What could make me feel this way (A)*. So do you do that to come up with forms?

RD: I play with things. Like I say, I think idleness is a rich source.

IT: In your studio you've only got pictures of flowers.

RD: Yes, I've been trying to work out what it is about flowers. I've been thinking about flowers for the last six months or so.

IT: Is that to do with form?

RD: Actually, I don't know what it's to do with. It hasn't got to do with form, but I think too that it's got to do with something about pleasure, undetermined pleasure. I don't really know why plants are so beautiful—they don't have to be. It's to do with unnecessary beauty. This is new, and whether it will become anything, I don't know. There are mostly pictures of flowers and there are plants, but there are also plastic animals and toys.

# The Object as Protagonist: Los Carpinteros

**by Rosa Lowinger**
**1999**

Working under the name "Los Carpinteros," Alexandre Arrechea, Marco Castillo, and Dagoberto Rodríguez are among the most innovative and internationally sought-after Cuban contemporary artists. The group's elegant and mordantly humorous sculptures, drawings, and installations draw their inspiration from the physical world—particularly that of architecture and furniture. Los Carpinteros's pieces are part of the permanent collections of the Museum of Modern Art in New York, Los Angeles County Museum of Art, the Ludwig Forum in Aachen, the Museo Nacional Centro de Arte Reina Sofia in Madrid, the Centro Cultural de Arte Contemporaneo in Mexico City, the Museo Meiac in Badajoz, Spain, and the Museo de Bellas Artes in Havana. They have participated in U.S. exhibitions at the New Museum, P.S.1, Art in General, and Arizona State University. [Arrechea left Los Carpinteros in 2003, but Castillo and Rodríguez continue to make work together under the group's name.]

**Rosa Lowinger:** How did you come to call yourselves "Los Carpinteros?"

**Alexandre Arrechea:** Since we began working, our pieces were based on work with hand tools, wood, and other items used by a carpenter. Our pieces were like miniature furniture or souvenirs. For this reason people began calling us Los Carpinteros.

**RL:** Are you saying that you did not take on the name yourselves, it was others who gave it to you?

**AA:** We began signing with that name as of 1994.

**Marco Castillo:** We were looking for a name and gave ourselves a bunch of different ones like Equipo MAD—an acronym formed by Marco, Alex, and Dago. In the end, Los Carpinteros seemed perfect for us because we wanted to investigate issues of the way art is made, the way that an object is fabricated. To speak of a carpenter is to speak of the way something is made.

**AA:** We also wanted to identify with the guilds of tobacco workers, sugar cane workers, and carpenters. Giving ourselves this name implied a sort of guild affiliation.

**MC:** It was a form of conspiracy…

**Dagoberto Rodríguez:** …because it also had nothing to do with art. At the time that we began to sign our work as Los Carpinteros, the environment was charged with projects that were hyper-artistic, loaded with socio-cultural problems. We wanted to work from a more subtle position.

**RL:** In what manner was the prevailing work charged?

**DR:** For example, when we had our first important public exhibition at the Havana Biennale of 1994, there was a particular situation in Cuban art. All of the artists, the majority, that is, had emigrated from Cuba. The Cuban art climate had suffered terribly because of this. Practically the only artists that remained were students in the art schools.

*150230 cms3 de oscuridad*, 1998.
Wood and ink, 325.5 x 86.6 cm.

**AA:** The idea of being a carpenter, that is a common person, without great pretensions of other sorts, reduced the notion of the artist to something simpler. Of course, as artists we always aspire to a greater dialogue. But the concept of "a carpenter" was a form of subterfuge for us; it gave us something to hide behind and therefore to circumvent the prevailing climate of vigilance.

**MC:** It was a strategy for slipping in.

**DR:** We did not want our work censored. So we disguised it. We cloaked it in a mantle of manuality and manufacture…

**AA:** …and created a language that was as subtle as possible.

**MC:** Subtle and, at the same time, convoluted. We jumbled the means of communication and took the socio-political discourse to a more subtle level of cynicism.

**DR:** Our work began to appear as something that only reflected on the manner in which it was made; it seemed like art that reflected solely on art. But it wasn't.

**AA:** We also started to refer to the process of creation by putting ourselves into the work. We began appearing as protagonists in the works as a means of derailing the political discourse of the moment.

**RL:** It's true that art critics who write about Cuban art always seem to look first and foremost for political content.

**MC:** Cuba is a socialist country, a leftist country, The art being made in the '80s was very revolutionary in political terms. It was an art of the left. That was on the one hand. On the other hand, you had an art at that time, the time of our genesis as artists, that was intertwined with folklore, and although that was never of interest to us, it was also part of the prevailing artistic climate. We wanted to do something which would collide with that atmosphere. So how could we make work that would be aggressive in that socialist climate? Quite simply, we decided to make pieces that appeared conservative.

**DR:** Exactly.

**MC:** We began to make works like *Quemando Arboles*, which is a fireplace carved in mahogany. When we showed these pieces in Germany, people said, "These pieces remind me of fascism." Another piece in this series is *Havana Country Club*, in which we depict ourselves playing golf on the old, no longer extant, golf course of the Havana Country Club, which has been converted into the Superior Art Institute. In another country, say the U.S., pieces like this would have little meaning; but in Cuba they go against the grain.

**DR:** Cuba's socialist revolution is only 40 years old. All of the recent history of the country is colored by this fact. It's been very difficult to shed; it has marked all Cubans these past 40 years. What was our goal? I don't know, maybe this will sound odd, but the idea was maybe to forget that past, to put it aside.

**RL:** This early phase, when you three appeared as protagonists within the works, now seems to have been replaced by other imagery that is possibly also emblematic—for example, lighthouses, windmills, hummingbirds, and towers. At what point did you decide to remove yourselves from the work? Was this an aesthetic decision, or one based on other criteria?

**DR:** It was a total aesthetic change.

**MC:** The first thing we did was to stop painting. When we stopped painting, the portraits disappeared. The work stopped being a compendium of carpentry and painting.

**DR:** Another thing is that we did not want to create a social chronicle of the country because it could have seemed that we were devoting ourselves to painting clever situations that commented on what was happening. We did not want to do that and, for that reason, we stopped painting altogether.

**RL:** So it was an ideological decision as well as an aesthetic one?

**AA:** Clearly.

**DR:** Completely.

**MC:** Yes, but our work also has to be understood in terms of series. The fact that we stopped painting did not mean that we rejected what we did before. We simply began a series with other parameters. We started making furniture, that is, we concentrated on the idea of a piece of furniture, the metaphor of things, of thought, but all through the means of furniture and design. Pieces like *La Mano Creadora* (*The Creator's Hand*) and *Archivo de Indias* (*Archive of the Indies*) are adaptations of existing objects with determined functions that we reduced to furniture and design.

**RL:** The fact that you work as a collective, and sign as a unit, means that you renounce your individual identities as artists. How do your decision-making and your artistic criteria function?

**DR:** One of the reasons why we stopped painting is for reasons of authorship. The paintings documented how we made our art. There were always two of us in the pieces, and a third was the viewer, who painted.

**MC:** Our working as a collective of three was, at one time, a conceptual declaration. That discourse used to be important. Nowadays we are one author. The fact that we are three is helpful because we get involved in these crazy, technically difficult projects—like the grenade, *Estuche*, which we just completed, and the wooden lighthouse. It's as if the "threeness" is most important now on a practical level, it's not conceptual anymore.

**RL:** You choose certain images and repeat them in different materials—lighthouses and windmills, for instance. What determines the choice of materials? Does this have to do with making pieces in Cuba, where there are certain shortages of materials, or is it due to other factors?

**AA:** That depends. Sometimes the lighthouse is a piece of furniture with doors, sometimes it is a tent. The same obsession is worked out in different ways. For example, the lighthouse with doors, in which we speak of darkness, becomes the negation of the very idea of a lighthouse as something that emits light. In the case of the tent lighthouse, we are addressing the element as transportable architecture. In both cases, there is a confluence of ideas. But, for us, the primary obsession, the source of our obsession, is architecture. And, well, we might make a piece in Belgium as a tent because it's possible to get the tent material in Belgium, though the original idea for the tent arose in Cuba. And then in Cuba we might make it as a piece of furniture because we can get the wood.

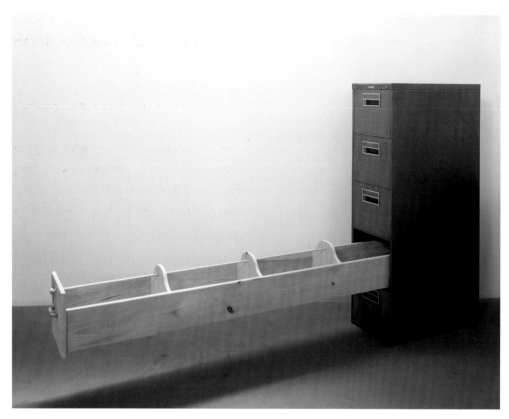

*Gavetón*, 1998.
Wood and metal, 130 x 35 x 255 cm.

MC: I believe that, like any artist, one has obsessions. You try to work out the perfect metaphor in a particular piece, but one hardly ever achieves that. So if you didn't get it once, you try to do it again, and it goes beyond whether in Switzerland or Belgium or in Cuba you can find thus or such material. We have ideas, and we try to do them in the right setting. We take advantage of opportunities to repeat and redo what we may not have been pleased with fully, taking it in a different direction.

AA: We also like to exhaust the possibilities of an object. And don't forget that we are three, and whereas any one of us can come up with the idea of working with lighthouses, each one of us will experiment with the idea in a different manner.

DR: We don't impose this on ourselves; it just happens as we go along, each one of us with our particular obsessions...

MC: But multiplied by three.

RL: Is there a particular material that you prefer to others?

AA: It's more apt to say that there are ideas which inspire us more than others. The material is incidental, no?

MC: I believe that we're inspired by materials that have to do with human labor. With traditional vocations of all types.

DR: But Marco, even a computer is a product of human labor.

MC: I am referring to vocations, to trades. We've never made anything with a computer. We've always focused on the traditional trades of plumbers and carpenters.

RL: When you create works in other countries, do the particular idiosyncrasies of that country influence your choice of subject matter or material?

DR: Although we generally tailor our projects to the economic necessities of a particular exhibition space, the concept is not generally affected by the country in which the piece is made or by the particular local audience that will view it.

MC: We want to make pieces that will function indiscriminately in many places. Not in all—but in many.

DR: We want to make works that will be understandable and capable of transmitting a sensation in Havana, New York, or Rome.

RL: Yes, but I am referring to the process of creation. When you are out of Cuba, does the fact of being out of Cuba inspire differently?

DR: Of course. We've had many surprises, pleasant surprises outside of Cuba. We've made pieces by discovering new materials in the environs.

MC: I'd like to add something—it's interesting to talk about the difference between making pieces here or there. Yes, we have surprised ourselves, but in reality, 95 percent of our ideas have been developed in Cuba. They are created here, in this studio. Later we might adapt or change them according to specific conditions.

AA: Sure, but there are also periods when we have lived and worked outside for longer durations, for example in New York during the New Museum exhibition. We were there for three months, and however you want to put it, that environment inspired us. We were faced with other phenomena. New York is another story, just as Germany is. Let's not forget how important design is for our work. We are greatly nourished by design, by magazines, by images in the streets. But as Marco said, we adapt this to what we developed in Havana.

MC: I said that before because I don't want people to comprehend our work as something done by travelers who go here and there to get inspired.

DR: That's exactly what I was saying.

AA: I'm just trying to support your idea [Marco's] by saying that yes, we are inspired by other places, but we use this to adapt the same ideas we came up with in Havana.

DR: The three of us are saying the same thing.

RL: I noticed a subtle change in the work that you did in your 1999 exhibition at the Vera Van Laer Gallery in Antwerp. It seemed to me that the irony and duality game was reduced or sublimated somewhat by a greater simplicity and elegance.

MC: That's not because of Antwerp. That's because we're getting old.

AA: The Antwerp exhibition was like an exercise of limits for us. That is to say, we forced ourselves…

MC: We forced upon ourselves a *pie forzado*. That's a kind of stylistic limitation that is common in Cuban music and poetry, like beginning every sentence with the letter "s." That sort of creative restriction often results in something unusual.

AA: Yes, exactly. We gave ourselves a *pie forzado* in order to try to take the work to a limit. An example of this is *Blue Point*. The piece consists of a simple row of threaded screws lined along a wall…

MC: …which gives a sensation of things that already exist and are very common.

AA: That piece surprised us.

RL: Why?

AA: Sometimes you work with materials that are what anyone would use, because a screw is a common item, not restricted to anyone, right? To exhibit it in such a simple manner—a row of them along a wall—is an act that casts doubt on the entire act of creation. It's a work that could be made by anyone, which places us in a vulnerable position as its creators.

RL: Actually, this departure seems prevalent in all of the Antwerp pieces. Also in *The Nap*, which you exhibited at the Iturralde Gallery in Los Angeles in 1998.

AA: That's right. All of those sculptures are more conceptual. More a matter of design than anything else.

MC: We had been working with certain hardware items, tools, making pieces that allude to labor, but we had always done this with a certain virtuosity. We made works that were extremely complex to execute and that only we could do because we would dedicate two or three months to the process of a single piece. The "change" in this exhibition was that we arrived at a minimum point. We worked with the most basic of materials, and the only thing we did was organize them. There was another piece in Antwerp that consisted of five vises hung next to each other at the same level, unified by a fine piece of copper wire. That piece spoke of risk, of danger…

AA: …because the copper wire was barely visible, that is to say, if you got close to the work you could actually run the risk of cutting yourself. The cable was practically invisible, but somehow the vises appeared connected.

MC: That piece was the limit of something of which we aren't even certain. It was a limit, it was danger, it was communication, a compendium of sensations but explained anew with the simplest of means. It was just five vises bought in a store, a copper wire—and it gave such a pleasant satisfaction, because there are works, like *Estuche*, that take us four months or more.

DR: Which, let me tell you, is not fun for anyone.

MC: Yes, but it's interesting as a form of laborious torture.

AA: There's also the idea of time there. Of time lapsing. We would never make a work like this outside of Cuba, although it might be easier technically to do so. We do it here, and it becomes a labor of time in which one is depleted.

**DR:** We're thinking of doing a project that consists of the representation of three seconds in three different sculptures. The sculptures would be pieces of furniture…

**AA:** …in which the temporality of our work would be explicit.

**RL:** Have you already worked this concept out in drawings?

**AA:** Yes, the drawing is in Spain.

**MC:** But the concrete idea of that drawing is that we are working with time, specifically the physical representation of three seconds, but by means of extensive labor and impeccable craftsmanship. The idea is to create a sculptural piece of furniture…

**AA:** …that could imply four months of work…

**MC:** …but would represent those three seconds.

**DR:** You could spend four or five months on the first piece, and then the next five months making the second, but it could also take an entire year, which would mean that for this three-second piece you would have taken three years.

**AA:** It's a little like carnival in Brazil or the Pageant of Remedios, where people spend all year preparing for a single day of celebration, no? For us, this temporality…

**DR:** …is discourse.

**AA:** Clearly, it's discourse.

**RL:** Since we're talking about drawings, in general, is it not true that the ideas that you realize as sculpture have their origin in your drawings?

**AA:** Yes.

**MC:** Sometimes.

**DR:** What? How?

**AA:** What happens with drawings in our case is very particular. In order to be able to converse, we need a drawing in front of us. At times a verbal dialogue is not sufficient. But this does not mean that each and every drawing ends up as a piece of sculpture.

**MC:** It's not like in the case of Christo, where the drawings are part of a conceptual compendium. In our case, the drawings are part of a working methodology. Since we are three, we need a way to communicate; and the drawings, in a sense, are the letters we write each other.

**AA:** I believe that is the perfect definition. The drawings are our correspondence.

**DR:** A drawing can be the origin of a fabulous conversation, and that conversation can result in a different work, and from that a third work can come out which has nothing to do with either the original drawing or the conversation.

**MC:** And which possibly we never even draw.

**AA:** Exactly.

DR: That is to say, the drawings are neither cause nor effect.

AA: It's like the conversations between Wittgenstein and his disciples in the forests outside of Cambridge.

RL: Your pieces appear to be based always on concrete objects.

MC: Do you mean not like other artists who might base their work more on the philosophy of things?

RL: Yes. It seems like the pieces are consciously devoid of emotional or philosophical content.

MC: It's not that we renounce philosophy; the philosophy that we try to convey is that which arises from the nature of the object.

DR: What do you mean by the philosophy that arises from the nature of the object?

MC: If we're talking about the grenade, we're not concerned with the sentiment that might surround the idea of a grenade. We present a grenade with a certain structure, and the metaphor is created only by the object. Sometimes working with objects that already exist reduces the philosophical model. And we deal with two concrete elements—a grenade and a piece of furniture. The reading flows from the combination of these two things.

AA: We need the consensus of three people to work out an object. And working up to that consensus takes the object to a certain neutrality.

MC: And concreteness.

AA: Exactly. That's why the pieces sometimes appear sterile. The filters and psychology of the group pare the object to its neutrality. A piece that can be enjoyed and accepted by all three of us gets to the point where none of the three influences has weight.

DR: What Alex is saying is interesting. We are the first who view our own work, that is, we act as the first "show," the first gallery. When the sculpture passes through our process of consensus, it's been modified, changed, or left intact for thus or such reason.

AA: I don't know if a neutral object can actually exist. Maybe it can't, but we search for it.

MC: The object itself tries to be neutral to be acceptable to us.

AA: What excites us is doubt. Like Descartes said, "Always doubt." For us, this is the broth of cultivation. Doubt, this is what we're talking about.

# Intensity of Form and Surface: Lynda Benglis

**by Erica-Lynn Huberty**
**2000**

Known for her exploration of metaphorical, biomorphic shapes (such as her "Totems") and subversive feminist commentary, Lynda Benglis has managed to balance controversy with critical interest, abstraction with content, gesture with mass. She is deeply concerned with the physicality of form and how it affects the viewer and uses a wide range of materials to render iconographic impressions of mass and surface. Born in Louisiana, she is the recipient of a Guggenheim Fellowship and two National Endowment for the Arts grants, among other commendations. In 1999, Benglis's work was the subject of a retrospective at Guild Hall in East Hampton, New York, which chronicled her career from the early 1970s through her recent work. The show included a little-seen "Beeswax Painting" (her first works), several pieces from her "Metalized Knots" series, and new work exploring what she terms the "Hot-Spots" of form and surface. More comprehensive exhibitions of these new works were later seen at Cheim & Read in New York, at the Weatherspoon Art Gallery in Greensboro, North Carolina, and at the American Academy of Arts and Letters in New York. These intricate, brain-like icons present a germ image to the viewer—the idea of the abstract unit as a contemplative image of power and physicality.

**Erica-Lynn Huberty:** How did you come to spend time in Ahmedabad, India?
**Lynda Benglis:** I was invited by Dr. Anand Sarabhai, whom Frank Stella and Robert Morris had visited. Dr. Sarabhai wrote me a letter and asked me to visit. He is a scientist, an important geneticist.

**ELH:** What was your interest in wanting to meet with him?
**LB:** Well, I was curious about India; other artists had visited him, and they had mentioned my name. I continue to visit there.

**ELH:** How do your surroundings there influence your work?
**LB:** I think what might seem complex to us in another culture is not complex in that culture. They have a tradition of intricate façades and organic volumes in the architecture; the art itself is often a relief form within the architecture. I think that encouraged me to explore those possibilities in my own work.

**ELH:** How have your surroundings where you live on eastern Long Island influenced your work?
**LB:** I've long been involved with the kinetic feeling of the ocean, the sense of the ocean and water, the wave forms, the patterns the waves play on the sand. Looking at all of this has affected my feeling of rhythm. And the idea of weightlessness or buoyancy in water has affected my sensibility.

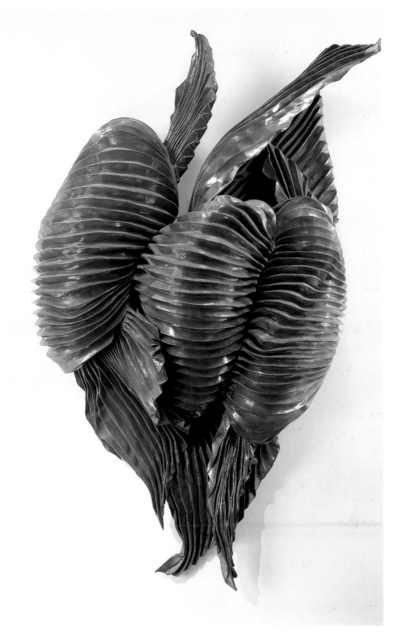

*Panhard*, 1989.
Aluminum over stainless steel mesh, 72 x 39 x 18 in.

**ELH:** You've said that you dreamed those shapes. Are you dreaming of waves and the feeling of the roll of the waves?

**LB:** You gather information in the feelings and forms of dreams. The sensation, for instance, of wrestling with the sheets was a sensation I had early on when I started to paint on canvas. I realized that what I wanted to do was wrestle with the material and contour the form through my body.

**ELH:** There is a painterly quality in your use of spilled latex and polyurethane that relates to Jackson Pollock's process and gestures. Can you explain the connection between that body of work and Abstract Expressionism?

**LB:** I asked Barnett Newman about Pollock in particular when I used to hang out with him. What I was most attracted to in Pollock, at that time, was the way in which he and the material were one. In other words, the hand-eye coordination. That definitely interested me. The stick he painted with was an extension of his arm. As I became more interested in viscous materials, such as the rubber latex and polyurethane, for me to describe the form through the physical material was a natural extension of Pollock's ideas.

**ELH:** You have made specific statements with your work at certain moments in your career—for instance, with your self-portrait pin-up used in the *Artforum* ad for the Paula Cooper show. How do you feel looking back on that particular statement now?

**LB:** Well, I think it was absolutely right for the time. The first pin-up I did was too passive—although I thought it was a kind of coy, mocking situation: you turned over the pin-up and you saw, "Lynda Benglis presents her metalized knots, Paula Cooper Gallery," and the dates. I thought it would be funny to allude to that; there was no doubt in my mind that I was the artist, just donning this posture. But somebody said, "Who did that to her?" and I realized I needed another image that alluded to the idea of the artist being self-motivated, particularly the feminine side of the artist—in other words, she directs herself, she's not directed by someone else. What was missing was the mocking of both sexes. Therefore, I used the dildo. For me, it wasn't a dildo, it was a symbol of male power, and it alluded to the male myth. I thought it would be funnier and more to the point to mock both sexes, and I was right because it frustrated and angered so many feminists as well as men.

**ELH:** Do you think the Guerrilla Girls changed anything?

**LB:** I think it was happening all over, and the artists were symbolic of that process.

**ELH:** There's so much about the media and self-promotion lately. How do you think the idea of self-promotion has affected contemporary art over the last 20 years?

**LB:** An element of that was always there, if you look at the Surrealists, and also in the history of American art.

**ELH:** Do you think it's intrinsic to American art?

**LB:** I think it's intrinsic to art that artists have always sought to mock themselves, to not take things so seriously. The ideas themselves are serious, but art is involved in play as well as dead-serious information. The ability to step aside and contradict oneself is the nature of art.

**ELH:** When did you know that you were an artist?

**LB:** Probably when I was about 18 or 19, I decided that's what I wanted to do and devoted myself to it. I decided to major in art—I was a painting major.

**ELH:** What was the first work that you did?

**LB:** The first works were done in clay and in paint, separately. When I came to New York, I was very interested in the Minimalist movement that was just occurring. Right away I started experimenting with the wax paintings. After several years of looking and thinking about what paint was about, what a surface was about, I developed in my thinking the idea that painting and sculpture are about surfacing and about form.

**ELH:** How does your work process begin?

**LB:** The sculpture itself is always a drawing for me. I draw in space. There's a linear element to the sculpture. There's a refinement as well as a texture that I'm interested in—and the idea of surfaces and surface light.

**ELH:** To what extent do you think organic and natural forms influence your work?

**LB:** Totally. They come from my inside out—not the outside in. I can't say, "OK, I'm pointing to this flower and this influences me," although whatever I do visually takes in influences in some way. Naturally, it's through an expression. In other words, I express proprioceptively—I propriocept through my perception—what I feel about nature, and because I am of nature, and I'm a woman artist, I feel this way.

**ELH:** You use a plethora of materials, an endless, changing list. Can you talk about some of your choices and why you used certain materials for certain pieces?

**LB:** For instance, I was attracted to rubber and wax because of ritual and skin. Rubber and skin mock and allude to the human situation vis-à-vis "mask" or the "wax museum," where human forms are represented. These materials have a life-like quality. They can imitate, they have a memory. You can mold with them, and they can be pigmented.

**ELH:** You've even pigmented some of your bronze works.

**LB:** That's right. It draws attention to the form and the surface. For instance, in the piece outside in the courtyard of the Guild Hall exhibition, I patinaed the outside but left the inside the color of the bronze. And the piece is significant in that. It's not what-you-see-is-what-I-made. It's the skin, the imprint, of what I made. That's why I called

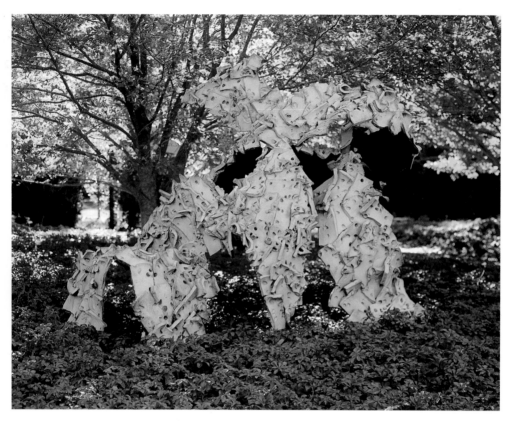

*Migrating Pedmarks*, 1998.
Bronze with black and white patina, 87 x 135 x 96 in.

it *Cloak Wave Pedmarks*. In other words, it was the cloak or wave of what I made. And my handprints are there. The newer work, which I'm extremely involved with now, is all about hot spots. It asks, "What is a sculpture?" It's the intensity of the form and the surface. It's a form described, it's a volume.

**ELH:** The new work makes me think of organs and the intricacies of the human body. The color in these works makes them even more organic, as though there were capillaries running through them.
**LB:** That's good.

**ELH:** Why are video and photography important for you, and how do they relate to your sculpture?
**LB:** I'm drawn to people. I have a very humanistic approach to the images I'm involved with, and I think of them as personalities. I like to travel and go to different places, and I've always had a camera, using a kind of documented process, either with video or with film.

**ELH:** There is a photograph you took in India of a horse—a particular spotted horse that you liked. And the largest spot on his back was like one of the forms in your sculpture. It's like he has one of your sculptures on his back.

**LB:** These are the kinds of things we're drawn to unconsciously, and maybe somebody else or something else might bring them out.

**ELH:** What is the relationship of the human body to your work?

**LB:** With the wax paintings, I was attracted to the scale and width of the torso, as well as the arm's length. Also, the way I work with the materials has to do with what the body, what I myself, can physically handle. I have a hands-on technique with everything that I do.

**ELH:** I wondered how much you are involved in the process of making your art—so much of sculpture can be about sending things off to a foundry or things being worked on by someone else.

**LB:** I work directly with my forms, which is evident in their individual handwritings.

**ELH:** In what ways do you take your viewers into consideration? Do you think about who is going to see your work, and what they're going to get from it while you are creating it?

**LB:** The viewers, particularly as you develop your ideas, are other artists or art-related people. But I discovered in India, particularly, even though I'm dealing with so-called abstraction, that the symbolic element of the abstract image is read into in all cultures. The element of power in the image is there no matter what, whether you imitate directly or you symbolically represent something. All cultures respond to this element of power; the condition of aesthetics may change culturally, but the idea of the spiritual element or the image having the condition of power, I think, is something outside of personal reference. These qualities can be had through referring to natural elements such as weight, texture, and color. All of these things are beyond the human condition, but humans, through their senses, respond to them. Animals—dogs, for instance—have attractions to a kind of gestalt familiarity through the reward system. I think that people have the same sense, except the attraction may be through the power of the form alone—the interest, the curiosity of a form.

**ELH:** You talk about metaphor in your work—particularly of power, birth, and rebirth.

**LB:** I've noticed that I'm interested in complex, dense form, the notion of the germ or the egg or the cell, as well as in the unit and what happens when the unit expands, sometimes in a wave—as in the polyurethane installations—sometimes in several knots flying or imploding. Or, as in an explosion, a mass of linear, neon jungle-gym scribbles of light and form. And the unit can also be a more situated icon as in a family unit situated together, such as the more complex knots and latex spills, which have a figure/ground relationship. The need to render the unit as a sort of contemplative image of power is there for me. It's not any longer a question of formality.

**ELH:** How does the concept of seduction relate to your work?

**LB:** I'm very interested in that. Not consciously, but in how far to go—where the work rides the line between being an element of seduction and an expanse into an unknown area. Both qualities need to be there for the work to be interesting.

**ELH:** What are the problems that derive from placing art into an exhibition space?

**LB:** I don't know if you could call them problems, which is a word used often in art terminology. You can go into a room and see the varied work of an artist, but you can tell by the rhythms and the personal handwriting—and this relates closely to music—that the work is still all by that particular artist.

**ELH:** It's interesting the way you had to deal with Dan Flavin's work in the opening exhibition at the Walker in Minnesota, where the light in his piece was utterly changing the color and texture of yours in the same space, and how that really altered the work permanently in the end.

**LB:** Exactly. It would have been a problem for me if I had decided I wasn't going to work with it. Artists don't create problems, they work through the situation. They recognize so-called problems, but the idea of the artist is to lead the way for the viewer to understand the spatial aspect as it is suggested between the object and the environment or the architectural situation.

**ELH:** What are some of your non-visual art influences?

**LB:** The experience of seeing or feeling, literally, underwater—anti-gravity, the element of floating. We've all experienced this in the womb, so it is part of my experience in art. Another one would be the phenomenon of how water or rocks or anything is imprinted. The sensation, but also the idea, of the gestalt of an image: What is a head? What is a figure? What is a torso? What is a line? What is a situation of weight in space? I'm very interested in the idea of the gestalt—what someone might recognize in the whole area of movement or the image being recognized. I've asked myself questions such as, "Why does my dog recognize a Jeep that's the same year and model as mine, even though it may not be my Jeep?" Or why he also recognizes my figure through movement—no smells, no voice. I find that extremely interesting. Science interests me. Recognizing patterns. And numbers, also, the ability to gather information in a numbering system and see it at once and know the number.

**ELH:** Can you talk about the new "Hot-Spots"?

**LB:** I refer to the general works as "Hot-Spots." They're germ images or icons and represent the same thing I felt in making the wax paintings. I think that distinctions between painting and sculpture are meaningless now. The real questions are: What is a work of art? What is the meaning behind the abstraction? What is it doing to me? What is it making me feel? That's what I'm asking myself when I'm making these. I also want to continue doing installational

works that relate to the wall. The changes in my work are continuing. I don't know where they're going, but the need to explore is there. In these new works, I'm looking back at where I have been and I want to present that as a statement for the present.

**ELH**: What made you come to that place now?

**LB**: I'm always in that place in order to present to the public a kind of situation within a context. I think the context may well be that I know how to make very large works, or that I may build with recycled metal, or make very small works that still have an intensity, for example. But the need, the point, is to have the right scale for the right quality of the work. It's both qualitative and quantitative.

# Just a Load of Shock: **Marc Quinn**

**by Robert Preece**
**2000**

Marc Quinn continues to shock the uninitiated with his subject matter and materials. Using unconventional processes and materials, he creates figurative forms such as *Self* (1991). Made by pouring nine pints of his own blood (extracted over a five-month period) into a silicone model of his head placed inside a refrigerated and transparent Perspex cube, the piece raises questions about mortality, time, material, and self-portraiture. First exhibited in London in 1991, *Self* was included in the media-saturated tour of "Sensation," which started at London's Royal Academy of Art in 1997 and moved to the Brooklyn Museum of Art in 1999. Over the years, Quinn's work has been dismissed by some as just a load of shock, and headlines such as "Invasion of the Body Sculptures," "Bad Blood," and "Severed States" haven't helped.

While Quinn acknowledges that his work may be shocking, he says that he is interested in unveiling a certain reality, using science as a means of facilitating a personal artistic statement. His 1999 solo show at the Kunstverein Hannover in Germany continued some familiar threads within his work, as in *Paranoid Nervous Breakdown* and *Final Nervous Breakdown* (both 1999)—and initiated new ones, as in his contentious marble sculptures. Recently Quinn had his first solo show in Italy at the Fondazione Prada in Milan. His work has been exhibited at Gagosian Gallery in New York; Jay Jopling/White Cube, the Tate Gallery, and the South London Gallery in London; and in Amsterdam, Athens, Paris, and Washington. His works are in the British Museum, Tate Gallery, Saatchi Collection, Amsterdam's Stedelijk Museum, the San Francisco Museum of Contemporary Art, and New York's Museum of Modern Art.

**Robert Preece:** It has been said that you don't consider yourself to be a shock artist. But surely you understand that your work can be shocking for some viewers.
**Marc Quinn:** I just think that if you use materials that have an ability to communicate directly, you open up a channel and you can work through that. So you are using the power of materials. By "shock," I mean that somebody uses something for no other reason but to use it, whereas I would use it to make the work communicate a different idea more directly, not to use a material for its own sake.

**RP:** With the marble sculptures exhibited in your solo show at the Kunstverein Hannover, the first thing I thought about was how *Gillespie* (1999) responded to antique sculpture.
**MQ:** It's more about looking at something, and what you bring to it from your knowledge of the context of art. And so, what is acceptable and aesthetic in art is very shocking and different in real life. I was in the British Museum, and I thought, "If you took these [marble sculptures, many of them missing limbs] literally, what would the modern versions look like?" But the sculptures are also celebrations of the sitters—they are heroic sculptures of disabled athletes. At first, these pieces appear to be fragmentary modern sculptures. Then when you see them close up,

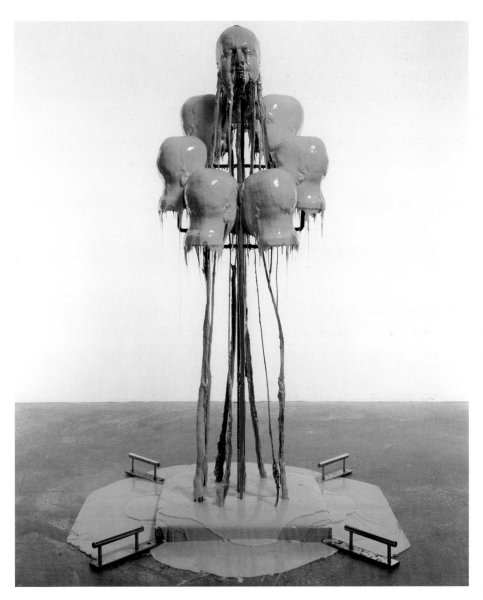

*Paranoid Nervous Breakdown*, 1999.
Stainless steel, concrete, and polyurethane, 120 x 120 x 183 cm.

you realize they are not fragments, they're wholes—portraits of people titled by their names, *Peter Hull* and *Jamie Gillespie* (both 1999). They're made of really white marble—from life casts. I made molds of them in my studio, and then I took the casts to Italy and worked with carvers in Pietrasanta who did the carving.

RP: Do you prefer to use certain materials over others at this point?

**MQ:** I use whatever material it takes to realize the idea. It depends on how things happen. The marble sculptures had to be made in marble, not plastic or plaster. I like to use materials for their intrinsic and metaphoric content as well. These sculptures use material in a traditional way—I guess that's why people used marble, because you can get an amazing luminousness. You use that to turn the thing inside out, to make a new form of expression, really.

RP: Which materials are more difficult to work with?

**MQ:** The ice sculpture, *Love is All Around You* (1999), is literally simple, but first you have to make the sculpture, make a mold, and then it takes 2.5 weeks to freeze. Every day you have to drill holes into the middle to let the pressure out. It then weighs 600 kilograms, and you have to move it into the gallery from cold storage, keeping it frozen, and take the mold off it. At any point, the piece can break and you never know if you'll get a good result until you get it. So, it's necessarily nerve-wrecking.

RP: You say it takes 2.5 weeks—how did you find that out?

**MQ:** Trial and error. I just started to freeze it, and that's how it worked out. But these sculptures disappear and that's the idea of it.

RP: So *Love is All Around You* eventually melts away?

**MQ:** It doesn't melt, it evaporates. Basically when you freeze-dry it, the sculpture evaporates. The water vapor moves invisibly from the sculpture to the cooling element in the refrigeration system, and it then gets defrosted and goes out into the gallery space. When you are viewing *Love is All Around You*, you are breathing in the artwork. You are literally taking it into your body, and it becomes you. So there's a physical relationship between the sculpture and the viewer.

RP: In addition to ice, you've used your own blood and excrement as materials. Are you comfortable working with them? Are you so used to them that they're just materials?

**MQ:** You have a different relationship to your own personal material than you do to other people's. When you go to the bathroom, you're not horrified and shocked. But if you walked in and found someone one else had just been, you probably would be. Your own relationship to these things is slightly different. It's not like I'm making it with other people's.

**RP:** Thinking about *Love is All Around You* and particularly about *Reincarnate* (1999), which captures a flower in full bloom, do you consider yourself to be a romantic?

**MQ:** No, I'd say a realist. You could say that, but you could also say that for them to last forever they have to be dead. So, there is a sense of beauty there, but it's beauty at a price. Both sides are always present, but I think it is good to make beautiful things as well.

**RP:** And you don't see these as romantic?

**MQ:** I don't know what you mean by romantic. I'd say that it's pejorative, as obscuring the reality of life by cloaking it in veils of poetry. I think celebrating beauty is definitely something I like to do—if you call that romantic, then yes.

**RP:** What was the technical process behind the frozen flower?

**MQ:** Working with the frozen material is like doing an experiment—different things come out of it. When you freeze something, it normally dries up. To avoid that, you have to stop the air from getting to the object. You can do this by casing it in something. Silicone is inert, so it doesn't attack things chemically, but it also has the quality of remaining liquid to minus 50. So you can lower the temperature to minus 20, and it's still a liquid. You drop a flower and it freezes instantly, and then the silicone protects it from the air. Basically, it's just experimentation.

**RP:** Will the flower piece last?

**MQ:** Yes, I have one that's three years old.

**RP:** When you did your research, did you have to figure this out yourself or did you consult?

**MQ:** I consulted, but I had to do it myself because no one had done this before, and so no one really knew. You can talk to scientists about different materials, but it's not a very usual approach that they're being asked about. This means that there is quite a long development period for some projects. It becomes quite expensive, but usually you get something out of it. I mean, I've built machines that have been disasters, but that's part of the learning curve.

**RP:** None of the previous writings on your work seem to talk about the scientific aspects of your artistic process or product. Does that seem curious?

**MQ:** Yes, I think it's an interesting area. The meeting of science and art is definitely interesting for the 21st century, and using scientific expertise and knowledge to preserve an artistic statement is very interesting. It takes things a step further. I'm interested in the fact that within science, you're dealing with properties of the real and physical world, and by using those properties you're really getting more in touch with the basis of reality and using that expressively. So, you are kind of using the laws of physics to express ideas.

*Peter Hull*, 1999.
Marble, 84 x 48 x 38 cm.

**RP:** Your father is a physicist, but do you have a science background?

**MQ:** Not really, but science is not that complicated. You've just got to get into it.

**RP:** You have an art history background. Is the way you think or talk about art different from the approach of artists who may have fine arts training but a less thorough access to art history?

**MQ:** I guess quite a lot of my work has references to art history, but sometimes I think that this is really bad. It's better to be pure and have no references. But the truth is that if you know your context then you're going to make more interesting stuff than if you just approach what's already been done—people who think that art history is the last 50 years.

**RP:** What would you cite as references, or threads?

**MQ:** Different bits have different connections—you could say that the materiality has some connection to Beuys, but then there are things totally unrelated to that. I'm more interested in making connections with the real world than with art history, except when I'm using it as a given, a readymade in the viewer's mind in a way. For instance, with the marble sculptures, everyone has a readymade in their minds of a marble with no arms and no legs. You're then playing with the cultural given. Those pieces would be very different to someone who had never seen antique sculpture.

**RP:** As an artist, do you ever question how art history is used as an explanatory tool? For example, the names used to contextualize your work include Piero Manzoni and Antony Gormley.

**MQ:** Yes. I don't feel any relationship to them really. With Manzoni, I can see the relationship to shit, but I can't see how there's a relationship to Gormley at all; his work is all about a contained figure, and my work is the opposite of that.

**RP:** Do you have any particular views about the writings on your work?

**MQ:** They're pretty much universally uninteresting. There are very few good writers about art, and you either get art-fashion writing with trendy views or you get very traditional writing. Occasionally, you get people who can write in an interesting way. Really, I think in a sense art writing needs to be renewed as well. It's in a pretty bad condition. David Sylvester writes really well about an earlier generation of artists—there are no writers that I can see who write in an in-depth manner nowadays—it just seems light, and yet, unbearably plodding. However, it's difficult to be an art writer or write about art. Where is your audience, and how do you reach them?

**RP:** Are there any things that have been written about you that you disagree with? For example, I saw two reviews in the *New York Times* and *TimeOut New York* referring to your Gagosian show, and I thought they were a little unfair.
**MQ:** Yes. They totally misunderstood—almost willfully—kind of inverting what it was all about. In a sense, art writing is also a sort of defining, excluding and including—not really talking about the work but creating a boundary of acceptability. It's like saying, "This is OK, and this is not worth thinking about." It's like creating a kind of pale beyond which are the other things, and within which are those things that tend to exist in language.

**RP:** *Self* has become a powerful icon, and when there is writing about you and your work, it is often put in the forefront. Do you have any views about the positioning of that one work, and how do you look at *Self* now?
**MQ:** Well, I think it's a great sculpture. I'm really happy with it. I think it is inevitable that you have one piece people focus in on. But that's really good because it gets people into the work.

**RP:** Did you know this when you were making *Self*?
**MQ:** Yes, it seemed pretty radical.

# The Subconscious of Civilization: Liliana Porter

**by Pablo Baler**
**2001**

The unsettling images and installations of Argentine artist Liliana Porter belong not only to the rare lineage of metaphysical Surrealism, but also, and more surprisingly, to a distinct literary tradition. In fact, Porter's photographs, "stagings," multimedia set-ups, and films can be read as short stories or fables that one could easily trace back to the insights and sensibilities of Lewis Carroll, Franz Kafka, or Jorge Luis Borges. In Porter's visual and spatial version of this narrative drive, you may find a porcelain Chinese choir singing an oriental version of "Hava Nagila," a piggy bank being threatened by a plastic soldier, or a merchandised Minnie Mouse kissing a picture of Che Guevara. Porter has stretched the old genre of the fable into facetious experiment, a sardonic laboratory of meanings where the fuzzy boundaries separating reality from representation are constantly being redrawn.

A New York resident since 1964, Porter has lived through the conceptual art scene of the '60s and '70s, Pop, and Minimalism, yet she has managed to escape the quicksand of conceptual art and all the traps of "cerebralism" and sophistication into which many contemporary artists keep falling. In Porter's works, we find a plastic duck, a postcard, a dog made of clay, a foam gaucho, or a rubber chick inhabiting a variety of nondescript, infinite backgrounds; but we also witness how, with a magical, invisible gesture of the hand, Porter imbues these mostly garish-looking artifacts with unpredictable poetic strength and turns the aesthetic of kitsch into an expression of surprising metaphysical weight.

Confronted with the army of toys, objects, and dolls that Porter seems to compulsively gather in second-hand stores, one is reminded of a line from Wim Wender's movie *Alice in the Cities*: "The flea market is the subconscious of capitalism," and one could even say of civilization in general. As a pearl hunter of visual arts, Porter has taken it upon herself to scuba dive into that abysmal sea and to emerge, each time, with new and fascinating treasures.

**Pablo Baler:** Since you settled in New York you have done prints, drawings, collages, photography, photo-serigraphy (directly printed on walls), multimedia set-ups, conceptual installations, and more recently 35mm films and video; but, despite the changing media, there is a constant exploration into the blurry boundaries between reality and representation.

**Liliana Porter:** Yes, my work went through different stages and different contexts, but there is, as you say, a constant, unifying thread that has to do with reality, illusion, words, objects, their names, and so on. What started as an interest in the mixture of one thing with its representation, for instance, the image of crumpled paper on paper that is crumpled, developed into something else. When I did a piece that was a printed nail on the wall and a real nail on the floor, it may have looked like a visual trick or that I was interested in trompe l'oeil, but I don't think so.

*Untitled with Lamp*, 2000.
Mixed media, dimensions variable.

After so many years of work I have come to the awareness that everything is representation. There is no solid line between the image and its representation, between the virtual space and the real space. In fact, I came to realize not only that everything is representation, but also that the only reality lies in the abstractions, in the archetypes, as Plato would have put it. So what I am now questioning is whether there is such a thing as real space at all.

PB: This philosophical interest in space may be the reason why, despite also being involved with two-dimensional representation, you have so much to offer to sculpture as an art form.

LP: Well, it is hard to define those limits too. From a totally objective point of view, I use the third dimension in my works: But should we understand sculpture exclusively in a three-dimensional way? The idea of virtual space has to do with sculpture as well. In general, when artists make sculpture they create shapes. In my case, I'm working with objects that already exist, that already come with a history, so what I'm doing is more like staging a theatrical situation. Of course, you always think in terms of space because you have decisions to make, but that is not as important in my case as the content or the inner relationship between real and virtual space.

PB: The work that might best respond to this interest could be your recent minimal installation *La Clairvoyance* (1999).

LP: Oh yes! That was a postcard of Magritte's *La Clairvoyance*, the piece in which there is a painter portraying a bird but he is looking over his shoulder at the model, which is an egg. What I did was just lay the postcard on the floor leaning against the wall and in front of it I placed a white stone; it really seems that the man is looking at the object outside. To me that's so extraordinary because we are used to entering virtual space, but we never have a virtual person entering real space.

PB: And, of course, you have also made several photographs taken from three-dimensional "stagings," where we have the sense that both virtual and real space are competing for prominence.

LP: Yes, they are photographs and sculptures at the same time. I sometimes like to combine both languages in one show—that is, to have both the actual "stagings" and their photographs. Whichever you see first, you create a memory of it, and when you see the second one, there is an interesting sense of recognition that takes place.

PB: Indeed, your objects seem to be actors playing roles in carefully scripted plays. How does the casting process occur?

LP: I find these objects or characters waiting for me. Sometimes people ask me what I am looking for, and it is very difficult to explain. Some people give me presents, and they are not what I'm really looking for. I try not to think of what it is that makes them work. What they have in common, I think, is that they all look sort of surprised or puzzled—they have a special look, and then in general they are not new, they are used. In this theatrical vein, I also have a series of pictures with shelves attached to them in which two objects or characters are looking at each other.

What works for me is when they are really dissimilar and yet they seem to connect, to establish a dialogue. I like when they come from different times. I'm sure that this means something. I don't know what, but it is something I'm trying to get at. I think the reason why we don't understand things is that we tend to order them, and we generally do so in the wrong way. I have the intuition that the right order is totally arbitrary and that it has to do with what we call disorder. But I'm not a philosopher. I arrive at ideas through my experiences in the visual arts, so probably I'm saying things that are totally obvious.

**PB:** Actually, it takes a philosopher's life to arrive at an obvious statement. You, on the other hand, may be after something fresh.

LP: Rather than any type of intellectual interest, what I do is to formulate questions. Mine is a visceral preoccupation about what is reality and what is representation. Since there is no set way to apprehend reality, I became more and more aware of the fact that one is what one builds, therein our responsibility to build something positive. It is always better to be happy. Happiness has a lot to do with accepting this game of creating meanings, and that is where humor kicks in.

**PB:** We certainly hear laughter inside ourselves every time we are confronted with your works, though it is also mixed with an indefinable sense of compassion.

LP: Maybe it has to do with the feeling I have that we come to the world without instructions: there is something maybe sad or incredible about the fact that we are able to function at all when we should be totally crazy. I think that's where the sense of compassion comes from. We are the ones who put the stories and the meanings on objects. This has a lot of implications, because it gives us a lot of power, a lot of responsibility. But, at the same time, it is almost frightening.

**PB:** Is the austerity of your images related to this view of meanings as provisory, arbitrary projections on reality?

LP: Definitely, because I do place my work in a neutral space, I do stage it in such a way as to not even allow the possibility of seeing it without re-creating it, without transforming it. These neutral territories may appear to be deeply sad or really entertaining, the ultimate stupidity or the keenest of philosophical inquiries. In fact, it doesn't really matter, because I'm mostly interested in realizing and showing that almost everything lies inside that region where you are the one who endows things with a particular meaning.

**PB:** And it accounts for those recursive infinite backgrounds as well.

LP: I arrived at that type of background a long time ago—a space that is not a place but all places and none simultaneously. I arrived at it intuitively, and then I realized that it is the perfect space where things can be left vague and undefined.

*Dialogue/Limit,* 1998.
Acrylic on canvas and assemblage, 60 x 63 x 5 in.

**PB:** How and when did you find the potential of kitsch to project itself aesthetically? Is there an instruction book that we could follow in order to launch a yellow rubber duck toward such unpredictable metaphysical heights?

LP: I found that potential little by little. The first toy I used was a little boat, but I used it with the idea of the journey— it was a poetic thing. At the time I was reading *Alice in Wonderland* and was into the metaphor of the boat. Then later, I started using the cube and the sphere, which are toys but also archetypes, and then the image of the traveler, one little guy with a suitcase, and the next one was an old, plastic Mickey Mouse. I liked the fact that it could or could not have a political meaning. It's great to use an image that we all know so well because it is something recognizable. But how I began to use toys I don't really know. I got here, though, not from the Pop side; it was more from the fact that toys are things of the past, and at the same time, they are metaphors, receptacles of meaning. It is exactly the same with art.

*Dialogue/Limit* (detail), 1998.

**PB:** You say that the running theme connecting all of your production is "the awareness of simultaneous, different realities and the queries this generates." Is this the result of an artistic sensibility or of an intellectual persuasion?

**LP:** It may be, among other things, the result of reading Borges; or conversely, my liking of Borges may be the result of my interest in those subjects. I will never know. At any rate, I think I work on two levels. One level is totally from intuition, which does not mean that it has no rigid law or logic. It is just that you don't verbalize it. The other level has to do with the articulation—never the other way around. I'm not the type who reads something and then says, "Oh, we should do this." Only after you've done something can you make sense of it.

**PB:** You talk about Borges and Carroll, and there is indeed a conspicuous literary lineage to your art. You also have a very narrative way of expressing your ideas. In fact, your pieces could very easily be seen as visual haikus, short stories, or fables. The funny thing is that they are fables without a moral.

**LP:** I don't really know if there is a moral. I have the intuition that there must be one, though. I think my work is more like an enunciation than a conclusion. It touches very few subjects, but it touches ones that have the potential of being "heavy duty." Just by being there, the images give the viewer the possibility of finishing the story, of completing the content. For instance, in my second film, there is a fragment in which a series of images shows a porcelain dog kissing a Nazi figure. There is no criticism there, but because of the soundtrack, which is very romantic, you realize

that there is the possibility of these two falling in love, and there is something about this non-judgmental thing that makes it more powerful.

**PB:** You said once that you would like to create in the way Borges used to write. I was never able to figure out what you meant, but I do find in your work subtle interconnections with Borges—the paradoxical conception of time, the exploration into the limits of language (visual, in your case), and the conflictive relationship between reality and its representation.

LP: I can read Borges over and over again—there are not too many things which you can read like that—and every time I read him I see something else. He is so intelligent and at the same time so very aware of the artifice of art. For instance, he may deal with a serious philosophical issue, but he belittles it by calling it mere literature. At the same time, he writes great literature and discredits himself by underestimating the scope of his art. I just love that. In "Aleph," while talking about the character Carlos Argentino Daneri, Borges says: "His words seemed so vain to me that I immediately associated them to literature." Borges has an awareness of the machination, the ruse which is literature and art in general. I would love my work to be in that sense like Borges's. But that is a goal, a total fantasy.

**PB:** You have been living in New York for the last 35 years. Is there a particular Argentine sensibility that you could still recognize in your work?

LP: My recent movies (*Solo de Tambor* and *For you/Para Usted*) have Argentine themes—the tango, the gaucho, the Argentine choir, and at the same time, there are fragments in Italian and English. At one point somebody asked me, "What are you going to do, write translations?" I realized that there is no need because nobody is going to understand the whole thing anyway, unless it was an Argentine person living in New York. In fact, it doesn't really matter. If you don't know the Argentine flag or an Argentine song, you may still know that the song has something to do with a march, with some country, and with the past because the toys and objects are from the '50s. There was also a little gaucho singing the English anthem. I was laughing during this part of the movie, because, despite the war with England in 1982, it is so much in the Argentine spirit—people would have loved to have a king.

**PB:** What type of works are you producing these days, and how do they reflect your current interests?

LP: The last things were the two films. I was never as happy as when I was doing them, and also I'm currently doing prints and shelves with objects. With the experience of the films, I discovered music, and so I have a plan to put a show together, kind of a staged play. It would be the natural next step after the films—photography, film, and then performance. I have some ideas already, but it is still too early.

**PB:** Could you predict what will grab you in the near future, some sense at least?

LP: I'm sure that I will keep doing the same thing, because I don't think I will ever solve the riddle, and that's a good thing because otherwise I would stop making art.

# The Language of Stuff: **Richard Wentworth**

**by Stuart Horodner**
**2001**

Richard Wentworth has played an important role in the development of British sculpture since the late 1970s, repositioning the readymade (industrial objects, either bought or found) into disarmingly poetic and curiously metaphysical works. In the mid-1980s, his manipulated tables, buckets, and chairs appeared on the international scene in the context of his generational peers and fellow countrymen Tony Cragg, Richard Deacon, and Bill Woodrow. Through procedures of joining, inserting, and pairing, Wentworth attempts to draw objects out, uncovering their various selves and rerouting what and how they signify. His activities go beyond producing discrete objects or installations, although he has done this consistently with great wit and dexterity. He resists the temptation to pump up the size of his work or to substitute permanent materials for challengingly conceptual ones. He has chosen instead a "broader is better" strategy, which has him photographing the streets in his London neighborhood and those of several other European cities. There he finds a continuous flow of urban flotsam: remnants of industrial obsolescence, commonsense solutions to daily dilemmas, and a geometry that lurks in abject spaces.

The University of Oxford and the San Francisco Art Institute recently honored Wentworth with the first 1871 Fellowship, a unique residency program for visual artists. Named for the founding date of the Ruskin School of Drawing and Fine Art and the San Francisco Art Institute, the fellowship allows British-based artists to pursue in-depth research, develop new work, and exchange ideas with colleagues and students in both the U.K. and the U.S. The selection of Wentworth (self-described as "an artist who might have been, in different weather conditions, a historian, anthropologist, architect, or urbanist") demonstrates the breadth and importance of his work. He embodies the kind of artist that the 1871 Fellowship organizers seek to recognize: an "adept synthesizer of intellectual, social, and political information in a global context."

**Stuart Horodner:** I came across a statement by Jean Baudrillard that reminded me of your photos: "To take photographs is not to take the world for an object, but to make it an object, to exhume its otherness buried beneath its alleged reality, to bring it forth as a strange attractor, and pin down that strange attraction in an image."
**Richard Wentworth:** I think it makes me feel slightly sick to my stomach to leave home saying, "I'm going to take a photograph."

**SH:** You may not leave the house to take them, but you have the camera and are in a state of reception.
**RW:** I would hate to make that sound like a High Art condition. One way of expressing this is that artists make their own luck. I'm interested in the idea that humans are mood. I know that part of mood is socialized. What are we doing now, we would not do nearly so vivaciously at 9:30 in the morning.

*The Loops*, 1999.
Book, assorted plastics, and metals on glass shelf, 70 x 25 cm.

One of the things I like very much about London in the morning is being on the bus and the bus feeling like a huge bathroom. It's just full of people who smell of the bath. Everyone's got wet hair, and the bus isn't really designed to accommodate it. In winter, it becomes a huge sauna. It's an incredibly collective thing. Everybody, within the last hour, hour and a half, has shared a common experience that was intensely private. They got wet: water coming through this huge urban structure and raised to a temperature that they find acceptable, to which they've added something—soap. They've brought themselves up to this condition which they regard as their public selves. So they go on from a very private condition to a very public one. This plays on two nouns that we use, usually quite lazily: one is "nature" and the other is "accident." What are these in a city? In a city, a blade of grass sticks up, tries to meet the world between two paving stones, and it says, "Oh, I found this little vestige of possibility." As a rule, something will come around and tell it not to be there—our constant decision that this thing is good and that one is bad: "Do not cut down that tree, I love it" and "Please come and remove these." The selection is intensely political. What could you say in a city is an accident? There are different orders of deliberateness. I see formalism wherever I look, and then I see all the ripostes to formalism. I find it incredibly poignant that the world is resisting. And I think that's the pump at the back of the photographs. The photographs, in a way, have to do with the rub.

**SH:** You've shown with Gabriel Orozco, who said something like, "I'm not interested in the work of art when you are looking at it in the museum. I'm interested in how it affects what happens to you when you leave the museum—how you look at everything else." I remember seeing several of your photographs in *Artforum* in 1985 and thinking that they were about finding, framing, pointing. Look at this, and look at this. And it was art with a small "a."

**RW:** I find it difficult to look at the forms of the world and not art historicize them. I don't mean that in an academic way, I'm not well enough trained, but it does sort of amuse me. I've only recently learned how important light is. I've taken so many appalling photographs, where I thought I'd done the work, but it's simply some illegible arrangement. The other thing is, of course, that I never really had any expectation that they'd be published. It's strange realizing that there is an appetite. I don't look at them at home, they're not on the wall. I like the fact that slides and transparencies are invisibilities. So, in one sense, they never become images. What makes them images is if I decide to show them to someone else or I decide to look at them with light behind them.

What I find stimulating is the residue of human agency. I'll give you an example. On Thursday, I had to go to a museum in Manchester. I'd been invited to curate a gallery, which turns out to be a fabulously compromised project. I thought it was, "You can do what you like and you can have as much space as you want," but of course it isn't. But in a way it's quite good for me to see what I can do wiggling on the end of a line.

I got a cab from the station to the museum. A large part of Manchester was rebuilt after the war, and I drove past a pretty derivative '70s building with a big enclosed courtyard area and overly designed steps that were probably

five- or six-sided. You can find them anywhere in the Western world. The idea is that you can leave in any direction. Actually it's a fucking irritating, stupid piece of form, but it stretched through the whole site, and I just glimpsed it from a speeding cab. Then I saw that balanced on these steps were four chairs and that there was tape that went incredibly, laboriously from the chair…what caught my eye was the drunkenness of the chair. Even as I say that, I realize that I've made a work, "The Drunken Chair." But I'm not someone who goes around, a trainspotter, collecting drunken chairs.

I thought, "I'll be late, all those heavy people from government, the meetings, it won't look very good. I bet it'll be there later." This is very typical—a very strong impulse, almost a sexual impulse, very fast response. Then there is another pressure that makes me procrastinate, makes me think, "It will be all right," and I might even think, "Maybe the light will be better." So I went to the meeting. Eventually I got out and went back to the steps; of course it was gone.

What was interesting was that I had a confirmation of why it had been like that. They'd painted the edge of the steps because the steps were so badly designed that you'd think you'd die on them. I photographed the white line because there was something very interesting about standing at the top and seeing the white lines range up across this stupid form. But actually, I was just angry with myself because I thought the dynamic of it was this mass of steppery and the attempt to signify forbidden territory. The white line was a warning. I'm articulating it for the first time now. The chairs were anchors to allow somebody to warn people that there were warnings that weren't yet cooked.

**SH:** In one of your catalogues there is a photograph of your studio floor.

**RW:** Quite an old picture. I'm very interested that people want to talk about technical things in relationship to artists. Why, for instance, David Smith didn't have assistants. It's all a bit romanticized, but, nevertheless, he did it himself mostly. He could make jokes about his signature—he actually had a virtuoso signing thing—but the work contains the authority of making. Thinking and making, making and thinking. When something is welded to something in a Smith, it's incredibly articulate. It's not like the other kind of welding that I know of, and it's absolutely unlike the welding of someone like Tony Caro, where you feel it's sort of gentlemanly: "Join this to that"—and it's joined. I'm not suggesting for a minute that it's going to break off, but with David Smith, you can have a feeling of talking to it while going round.

You have to learn by procedure. Half of the most interesting things in the world are the result of spilling the water and turning around—moments of recognition. We struggle to articulate ourselves, and you can often hear somebody say the same thing three or four times because they are in a constant state of criticizing the way they said it the first time. We don't like humans who say it right the first time, or we find it spooky. The process of articulating is trying to make it a little less inadequate than how we felt it was three minutes before. What I meant was the way you

*Roland Barthes' Desk*, 1997.
Wood, aluminum, laminate, and nails, 79 x 90 x 170 cm.

discover procedures. Morris Louis discovered that if you just add more of this, it goes more like that. And that meant a lot to him. Somebody else would say, "My paint's all thin."

Most of what interests me is anti-heroic. I didn't realize that until quite recently. All of these things [picks up a coffee cup] are where the interest in the domestic object comes from. We even say this is the lip. It's just dripping in anthropomorphic terminology. Give me an etymological dictionary and I'm very happy. It's like having money in your pocket. That money was somebody else's money and somebody else's money and what's more, it's worthless. It just stands for something.

**SH:** Which is why the mutability of language seems so related to what you're doing.
**RW:** Yes. I love that it's just tools that we stick together and spew.

**SH:** Robert Motherwell talked about having to find a "creative principle." For him, it was two parts—automatism and refinement.

**RW:** Yeah. By having things in the studio, and if there's enough of them, it raises the level to which they might tap me on the shoulder and go, "Psst. Did you notice that I've been sitting next to so and so? And when you were out of the room I spoke to so and so." I need that. Those processes are contained within the performance of the work. I've made a lot of pieces with broken plates. If you see them photographed they often look quite decorative, too gorgeous for their own good. But if you saw one in space, one of the things you should notice is that [putting saucers, cups, and glasses in a row] this point of contact is absolutely specific, that point is not. A lot of these works are made with broken half plates, so this is not a very accurate line. There will come a point when we could measure the table in objects. You can do this and have a narrative of points of contact and a form of measurement. It's got to feel like it gets from there to there with no question. Now that's not the subject of the work at all, but without it the thing doesn't work. What I'm trying to say is that some of the things that used to be part of the happenstance of working in the studio might now take place within a whole regime of working, and it can be miles away, using foreign bodies or materials.

**SH:** The sculpture *Roland Barthes' Desk* is not two things whispering to you in the studio, saying, "Hey, we've found each other." It's an object that needs putting together. In making this, how do the materials and the choice of title help to create a situation of cultural reach? The specific writer is brought to bear on the object, and one imagines him trying to negotiate the table.

**RW:** It's a particularly good example of something where I couldn't tell you—in the same way as you are Stuart, were you Stuart before you were born? Or Stuart when you were half the size you are now? The fact is that our titles and our selves get hopelessly bound up with each other. I'm not Michael, I'm Richard, and I inhabit that in some way. I can't tell you at what point that title met that object. The idea that I had the title and then made the work makes me slightly sick, so I suspect that I didn't do that. I wouldn't, I don't want to do that. I'm trying to suggest that there has to be quite a sophisticated relationship, how these things come together, and if it was the wrong way around it would feel illustrational and I would resist. I have made things in the past where I have, well, "attacked" isn't quite the right word, where I have "possessed" them. This is an embarrassingly Western thing to say. I like Nkisi figures, and the idea that every time you drive a nail in you could be invoking something is very powerful. Barthes wrote somewhere about the nail in relationship to a piece of wood. I can't remember whether it has a direct sexual dimension to it, but if you've ever put nails into wood, it really is the most extraordinary experience.

So there is a piece of furniture as a given. It's important that the desk has a certain authority and that it's somehow located in time. It's the kind of desk that could appear in a Jacques Tati or a Truffaut film. There's a bit of the International School, but it's not great furniture. It's that thing where bureaucracy comes with its own architecture. That kind of desk looks like a building. There's something pitiful about the fact that there's a ready-made geometry that the surface has obtained, and you feel that the person who's done it is struggling a bit. They clearly haven't got

enough of the material, and they obviously don't know how to put the material on. There's a perfectly good technical method of applying that stuff, and as a general rule, you try to have a piece big enough to fit. It's sort of like cooking with leftovers. The one thing that a desk has to be is a serviceable surface that is brought up from the floor and presents itself to you, and I've ruined it.

**SH:** As you have often done with tools and objects of use, such as buckets and plates.

**RW:** What is very important is that there are all sorts of things that have to be at about the same weight. The nails declare the desk to be made of some wood product. Something about its volume, something about reading it as a deliberate act. You're offered the possibility that this is some sort of accident, as if the nail machine went off, accidentally, but you can feel…they are not in rows, and there are neither a lot of them nor a few of them. I remember finding that very difficult when I was doing it, and I did it very fast. The only way I can do something like that is to do it. To have the nails in my mouth as if I were an upholsterer, as if I were doing a job. I'm doing something which is about doing a lot of jobs. I kept thinking, "I can't put the nails in and take them out." I'm not a cook, but I imagine a lot of serious cooking is like that: "I think this is about right. If it's slightly underdone, it's better than being overdone. I'm stopping." This is as near as I'm ever going to come to being an expressionist. Those nails are almost expressionist acts.

**SH:** I want to ask you about the dictionary pieces. I thought of a linguistic play on them—What do you do with a dictionary? You look up words. How do you make a "Wentworth dictionary?" You look down.

**RW:** That's very nice.

**SH:** You are offering an alternative language, a language of stuff.

**RW:** The thing that drives them is a constant anxiety about what it is that we do when we look. As this person just passed, did I think, "girl," or did I think, "green jacket?" Language is so turgid, it's so slow. As you turn your head there are multiple aspects of retinal recognition taking place. I don't even know what the terms would be. I've been thinking about that process, the miracle of selecting what we look at—ideas about prior knowledge and how drenched we are in it and how un-innocent. So, when we move, which is probably the most miraculous thing we do (I'm sure we ought to celebrate the first steps more than we should celebrate first words), we make narratives that we do not control. They are always new. If I go down the same street today that I went down this morning, it is still a new moment. The process of going across the terrain is filled with eventualities that I don't believe are accidental. We report to each other, "A funny thing happened to me this morning" or "You won't believe it, I bumped into so and so." We constantly make fables about these eventualities, which in a way, to me, feel deeply predetermined. You feel like you are a minor player. To be specific, you walk along the street and as a general rule, you don't pick up dog turds. But if you saw a gold ring, you would pick it up—which means, in fact, that you are naming everything as you go.

The dictionary pieces are mostly about the dictionary as a place where you go for consultation. You can check out things that you half-know and see if you are half-right. They are very beautiful, sort of poor man's Bibles, vessels of something we are completely filled with. The act of filling up the dictionary with things that are found in space and time is, in one sense, cheap and literal, but what I like is that it is not immediately detectable. It destroys the book, but it makes something else. Makes the book look bulimic. There's a limit to how much you can put in them. There are objects that can't be put in them. I was thinking, should I pick up a brick? There's a secondary thing. We read the world materially. If you go to a good second-hand bookshop, you can look at all the ways books are marked. You'll find leaves; there are shoelaces, candy wrappers, bus tickets. You'll find a Schwitters in the dictionary: all that collage-y, European, 20th-century stuff is implicated, and I like that. If you are working with other people, you can lay out all the material and you can ask a third party to name everything you supply. In English, which is a mixture of Latin, French, Celtic, Saxon, and more, there are often five words for everything. You can say cord, string, line, and so on. It's about the comedy of description and the pleasure of reality.

**SH:** Can you tell me about the recent curating? I've often thought of doing an exhibition of all of the things that don't happen, that we wanted but couldn't get, and the details of trying to get them.

**RW:** "Thinking Aloud" was a quite interesting thing to do. In fact, what was fun about the show was that it allowed everything to be exciting. But it also said to artists, "You're going to be exhibited next to something that is clearly not art, but it has some magnetic field around it." I wanted to include a drawing by Picasso of how to get to Le Californie (Picasso's home). It was, "Take a left here, take a right here, don't go up there." A friend of mine explained to the drawing's owner that I was honorable and that this was a Haywood-organized show, and all would be insured. But he'd gotten Alzheimer's and couldn't grasp why we wanted it. My friend told me, "He can't understand why you need the map," as if he knew perfectly well that Picasso was dead, so why would I want to go to Le Californie now?

# Making the Ideal Real: Wolfgang Laib

**by Sarah Tanguy**
**2001**

For the last 25 years, Wolfgang Laib has explored the enigmatic zone where what we know or believe to exist commingles with what is actually there and can be perceived with our senses. Using materials such as pollen, milk, rice, and beeswax—mostly natural or animal products that involve nourishment and preservation as well as cycles of life and death, give and take, and the ephemeral and eternal—he creates contemplative works that he himself describes as "challenging." The milk stones, for instance, require a ritualized commitment of cleaning and replenishing white marble slabs on a daily basis. His fragrant beeswax works, including *Somewhere Else—La Chambre des certitudes*, are also engrossing, offering a direct apprehension of the divine.

The son of a German physician interested in the East, Laib spent much of his childhood traveling in Afghanistan, India, Iran, and Turkey. He went on to study medicine, writing his dissertation of the hygiene of drinking water, but found the profession focused on the body at the expense of the soul. "Raised with Constantin Brancusi," bearing a "complex" relationship to Joseph Beuys, and friends with Mario Merz, in Laib's words, he fuses a love of nature with an awareness of Western and Eastern cultures. He now talks about art as possessing a spiritual healing function and, thus, being the answer to what medicine should be.

**Sarah Tanguy:** For me, your work is about embracing contradictions, creating a spiritual physicality that combines existentialist practice with Platonic and utopian aspirations. It's also about substituting an archetypal or primal definition of ritual that's connected to naturalism for one that in contemporary, Western life involves a more detached practice rooted in urbanism. In this regard, I love your phrase "cement desert." I wonder if you would comment on, for example, the difference between filling a stone cavity with milk and drinking coffee every day and rushing to go somewhere.

**Wolfgang Laib:** That sounds very beautiful, what you just said. The work I make is very, very simple, but then it's also very, very complex. For me, the simpler the work's statement the more levels it can have. If I fill up a stone with milk, and somebody else has coffee with his breakfast and tries to make a thousand things a day, it's the complete opposite. Those stones were my first works after I had studied medicine for six years, and somehow they contain so much that is the opposite of what daily life is today. For me, art is the most important challenge for everything, and I think such things can be the challenges.

**ST:** To get you to slow down.

**WL:** Not only to slow down but first to think about what you want for your own life, and also what you may want to change.

*Nowhere—Everywhere*, 1998.
Beeswax and wooden construction, 19.4 x 109.2 x 21 cm.

**ST:** For many visitors, your current retrospective at the Hirshhorn Museum and Sculpture Garden will be their first chance to experience your work. How do you anticipate the response?

**WL:** An exhibition in a museum or a gallery is a public event. Many people will come who have never seen my work and do not know what it is, and then there will be people who have known my work for 20 years. It's a very beautiful experience, especially in the United States, that people who are very far away from my work, and very far away from my world, see the pollen or milk stones and are so surprised. There is a spark, which initiates a whole experience—and that is very strong in this country. I think in Europe, somehow they think they know so much more and they are so much more enclosed; they see something new and are afraid. I realize that in every exhibition I've had here. It's always the case. People strive for something they don't have. That's something very beautiful.

**ST:** That urge.

**WL:** Yes, it brings them very far—even if they can't realize it in their own lives because their environment is totally different. If they see something completely different, they can be taken, something can happen.

**ST:** Along those lines, I think that much of the art you see now involves narrative or storytelling. And that's always an easy point of entry. But in your case, a portal might be your use of natural materials and their sensual qualities. Your iconic, distilled forms—rectangles, cones, houses, ships, and chambers—are also recognizable, so that in the end, while you're not necessarily telling a story, you offer ways of entering.

**WL:** Yes, that's also been very beautiful for me. When I show the pollen or milk in any country in the world, everybody knows what pollen is or what milk is. And it has nothing to do with German art or with European art. It's something so universal, any human being can relate to it without language or explanation.

**ST:** Do you believe that the idea of ritual continues to hold relevance? Or do you think that people, when they understand that there is a ritual aspect to your work, will interpret that as some kind of nostalgia for something maybe no longer relevant today? Along with that, so much of your work involves ideas of faith and certitude. Yet many people are running around with so much doubt and irony that they can't see the world with fresh eyes.

**WL:** Yes, the more irony and doubt, the more I feel that something like this is important. It's not an issue for all artists. Other artists, they do what is now. They have more irony. I think that art needs to challenge everything. Important art is always the opposite. Otherwise you don't need it anymore.

**ST:** I'm also thinking, because I have a background in dance and theater, that if you walk around with irony all the time, it's very heavy.

**WL:** We have enough irony. I think we needed the irony, but it's already long been achieved. So for this, you don't need an artist anymore, you don't need me anymore.

ST: How do you balance in your life the fact that you are very private and autonomous and that at the same time you are reaching out to other people?

WL: When I started out with my first works, the milk stones and the pollen, I was living in a very small village, totally isolated with my family. But at the same time, I had no experience—I had such a naive idea. I was so struck by these things because, for me, they were the most important things in the world, and I wanted to show them from the beginning to as many people as possible. It would have been sad for me to have them only for myself. It was like a message. I found the pollen and the milk to be so world-moving, to be culturally important. It's something very beautiful to have this experience collecting pollen for myself, but then on the other side, I wanted many other people to participate.

ST: You just mentioned your art as being participatory. I'm very interested in this. You also talk about your art as residing in the materials. So, I was wondering how you see yourself as an artistic agent because, of course, you are still making.

WL: The main difference is I'm not a painter who's using pigments to create a painting. I use the milk and I use the pollen or the beeswax, which I did not create. I participate in the most beautiful things in the world, which I could never create. I could never create the beauty of the pollen. The tragedy for me would be if I tried to make a painting out of pollen.

ST: To manipulate in that sense.

WL: I think that in most cultures, artists were not considered as individuals who had to invent or create something. They were participating in the whole, in the universe. So, for me, the sky is much more important than trying to make a painting that is a symbol for the sky. For me, it's the pollen itself—that is the miracle in which I participate in my daily life when I collect the pollen. It's not mine.

ST: Two of your main interests are the cycle of life and death and the interplay between the symbolic and the real, as Klaus Ottmann discusses in his essay for the Hirshhorn catalogue. Given this, what constitutes authenticity for you? When or how does the authentic experience or the authentic moment occur? Authenticity as a state when you lose your sense of yourself and linear time and merge with something larger; and possibly, through these practices of purification you might, as you say, "go to another level."

WL: Exactly.

ST: So the authentic is in the collecting, the putting together, the sharing.

WL: Yes, because it is *the* reality, which I feel I'm not even touching.

ST: But you're connecting with it.

WL: Yes. The milk and the pollen are there, but they're in a totally different environment—a much more abstract

*Rice House*, 1990.
Marble and rice, 19.4 x 109.2 x 21 cm.

and direct environment. To see the milk with the cow is one thing, but then I took it out and put it in a very abstract environment in order to experience it in the most authentic way. It's very rare that I would do something outside. A milk stone is not sitting in a forest, and that's not a compromise. I wanted to have this very intense, concentrated experience with the milk or with the pollen. So, the meadow with flowers where I collect the pollen is something very different from how you see it here, a real concentrated experience without any distractions, nothing else.

ST: But do you want the person here to think about the fields? To think about the whole cycle?

WL: Yes, of course.

ST: You say in a conversation with Harald Szeemann that *The Five Mountains Not to Climb On* is your principal work. Can you elaborate?

WL: These mountains contain many levels, many, many thoughts. And they're so small. The size of this work is somehow very important in contrast with the big ziggurats, which are really monumental works. These small pollen mountains contain most of what I did in other works. Somehow for Harald Szeemann and me, it was a work in which his vision and mine met. He couldn't believe that an artist could get so close to his own vision. I've made so many exhibitions with so many curators in my life, and such an experience is rare for an artist and for a curator. It's a pity. I would like this to happen more often, to be able to do something so together with a curator.

ST: When I saw that piece just now, I was struck by its vulnerability. It makes a very strong statement, and yet, it's so delicate. And, to me, this paradox expresses a wonderful sense of beauty. The other element that I love is the fact that the little mountains have some pollen around their bases. In thinking about your entire oeuvre, some of your works have clean edges and others go outside their "bounds," creating a gentle, oscillating aura.

WL: Yes, yes.

ST: And you're right. The more you try to ascribe words, the more the meaning proves elusive.

**WL:** I don't mind if other people do this, but for me as an artist, I think that I'm very shy and getting the details into words is a pity. But for other people, they can discuss this endlessly, and I don't mind.

**ST:** I was interested in the change in scale. The ziggurats are so much bigger. Does this represent a different experience for you?

**WL:** Yes, for instance, in one of my recent exhibitions at the Kunsthaus Bregenz, I had four floors. On the ground floor, I had a much bigger ziggurat than this one, and then on the floor above, I had these mountains. And somehow, I did the installation to have this relationship of the two—the big ziggurat and the small mountains together is exactly what I like.

When I started to make these big ziggurats, I somehow became afraid and thought that these monumental sculptures were what I never wanted to make. Harald Szeemann's first exhibition, in which I was involved and where we met, was about monuments. His title was—I don't know exactly—"Weak Like the Monuments, Strong as the Acorn." The pollen mountains were finally the main work of that exhibition. But now, when I make these big ziggurats and have the pollen mountains next to them, I see that this is exactly what they need. It's necessary to have both the fragility and the sense of size where small can be bigger than big.

**ST:** One of your most recent projects involves an actual mountain—*A Wax Room for the Mountain*. You have described it as "a small space dug out of the rock on a mountainside, having the dimensions of a human being, entirely covered in beeswax, and with a small wooden door. It would be a place that only a few people could visit." I'm especially taken by your choice of setting. The Pyrenees are old mountains with a long history. It's an isolated area, yet it also has several Romanesque churches, I'd like to ask you about the issue of permanence, seeing as so much of your work is temporary and gets re-created.

**WL:** It just opened in July. It was a very important experience for me. Exhibitions are important, and I love to do them. But then after some time, you also think that you would like some place that stays. And that is something that I've dreamed about for a long time.

# Real Living Art: David Nash

**by John K. Grande**
**2001**

Since the 1970s British sculptor David Nash has created sculptures and art installations the world over. He is perhaps best known for his sculptures that involve living elements, such as trees whose growth has been redirected. Among the most notable of these is *Ash Dome* (1977), a ring of 22 ash trees initiated near Nash's home in Wales and still growing. Another such project, *Divided Oaks* (1985), in the Netherlands, involves some 600 trees. Nash has likewise created sculptures that interact with animals, as in *Sheep Space* (1993) for the TICKON art and nature center in Denmark and more recently for an organic sheep farm in Virginia. His mastery of wood carving is not purely formalist: it often involves an extension or referencing of environment and history, as was the case in *Through the Trunk up the Branch* (1985) in Ireland and *Nine Charred Steps* (1988–89) enacted in Brussels, Belgium. Nash's work can also be seen as an ephemeral expression of nature's ongoing processes. For *Wooden Boulder* (1978), the oak sculpture was left to follow its own course down a slope and then into a stream. Over the years it moved hesitantly and according to the laws of nature and gravity, though occasionally intervention was necessary.

**John Grande:** I first became familiar with your work through *Ash Dome*, which reflects an art whose language integrates nature's living processes. The later *Divided Oaks* project has that same breakthrough quality—both involve a crossover into horticulture and, ultimately, a redefinition of the artistic process.

**David Nash:** In contrast to *Ash Dome*, the trees for *Divided Oaks*, which is in a park at the Kröller-Müller Museum in Otterlo, the Netherlands, were already there. The soil there is very sandy, and it is quite tough for plants to grow. There was a quarter-acre of very scrubby oaks that weren't growing. The site was offered to me because they were going to pull down all the trees. There were probably 600 trees. I thought that instead of pulling them all out and planting something new, I would work with the existing trees. I made a division through them, angling one side to the east and one side to the west. They began with an open space, and at the end of this channel, the trees crossed over. I had been invited to come and make something apt, some sort of interaction that signaled the presence of the human being.

**JG:** This kind of work demands some manipulation of nature. Do you prune the trees?

**DN:** It is called fletching. The very small trees, I simply pushed over and put a stake to hold them, while for the larger ones I cut out a series of V-shapes, bent them over, and then wrapped them so the cambium layer could heal over. This really woke the trees up. My intervention actually stimulated them, and they were obliged to grow. They are now growing and curving up.

**JG:** *Ash Dome* at Cae'n-y-coed in north Wales is another case of living tree art.

**DN:** *Ash Dome* was my first planting work, done on my own land on the coast of Wales. It is very different from *Divided Oaks* in that I made a decision to plant the trees to grow in a particular form. Compared with *Divided Oaks*,

which is a long way from where I live, *Ash Dome* is near. One of the most important aspects of *Ash Dome* conceptually is that I had made a commitment to stay with it over time.

**JG:** It involves a direct relationship with that land.

**DN:** There is that, but the Land Art of the late 1960s and 1970s involved gestures in the land, such as the work of Michael Heizer or Richard Long, whose work I was following and who was a sort of teacher to me. What I was uncomfortable with was the walk—that huge physical effort, and then the walk on. It stayed there, Richard knew where it was. Only the photograph was carried away.

**JG:** Not many people really saw it.

**DN:** Others saw it, but then what happens there? What really happens there? I just thought, for me, particularly when I am doing something that is planted, I have to be there. I have to make a commitment to stay with it. So this is a 30- or 40-year project—very different from a lot of the other ephemeral works. It will only work if I stay there.

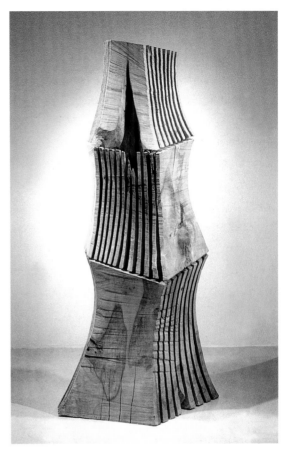

*Rip Out Column*, 1998.
Lime wood, 81 x 48.5 x 32 in.

**JG:** There is a long tradition of human intervention in the Welsh landscape. As with your works in nature, the landscape is never hands-off. You integrate the human presence into the landscape, and not in an apologetic way. There is a hands-on interaction between your sculpture and the natural environment.

**DN:** *Ash Dome* is very hands-on. It upsets quite a lot of people. When I began it in the 1970s, the environmental movement was just beginning, and I noticed that urban dwellers of the environmental sensibility tended to believe that nature gets along better without the human being, who is largely viewed as a parasite. The message is: "Don't touch!" If you live in a rural agricultural area, you see people touching the ground all the time. It's part of their livelihood, supporting the people in the urban areas. If somebody is touching nature on my behalf there is a dialogue in and with it. Part of the point about *Ash Dome* was: "Hands On!" It is a central irony that people love hedges but

don't like people to slash and cut and bend: "Ooh! Poor trees!" Part of the point was that nature actually gets on very well when a human being is caring for it and lives with it.

**JG:** Your living sculpture works are neither postmodern nor politically correct. The tree is a living element that can be worked with, adapted, and manipulated. The emphasis is always on the crossover between nature and human culture. The two are not at odds, but symbiotic and interrelated.

**DN:** When I first planted the ring of trees for *Ash Dome*, the Cold War was still a threat. There was serious economic gloom, very high unemployment in our country, and nuclear war was a real possibility. We were killing the planet, which we still are because of greed. In Britain, our governments were changing quickly, so we had very short-term political and economic policies. To make a gesture by planting something for the 21st century, which was what *Ash Dome* was about, was a long-term commitment, an act of faith. I did not know what I was letting myself in for.

**JG:** How has *Ash Dome* matured over the years?

**DN:** *Ash Dome* was made for the 21st century. It was started in 1977, when the year 2000 was a very long way to go, almost unimaginable. If I had started it in 1997, it would have been corny. My wife and I were actually with it at the moment of the millennium. We didn't stay all night but were there from 11 p.m. to about 12:30 a.m. I lit it up on the inside with some submerged candles so it flickered.

**JG:** Do your works have anything to do with ritual or performance? I am thinking about *Snow Stove* (1982) in Kotoku, Japan, *Ice Stove* (1987) in north Wales, and *Sea Stove* (1981) on the shores of the Isle of Bute in Scotland, for instance.

**DN:** No. They have absolutely nothing to do with ritual or performance. There is no shamanism. You can bring those associations to them, but my concerns are fundamentally practical. The spiritual is dovetailed into the physical, and the two are essentially linked with each other. To work the ground in a practical, basic commonsense way is a spiritual activity.

**JG:** The act of burning wood in your sculptures such as *Black Dome* (1986) links your process with a primordial cycle of regeneration. The carbon generated by forest fires, for instance, is a natural phenomenon that brings about regeneration of the soil.

**DN:** For *Black Dome*, I was one of 12 artists invited by the Forestry Commission to make public works in the Forest of Dean in Gloucester, an area with a long history of charcoal manufacture. There is a lot of iron ore there, and charcoal was used to smelt the iron. In the more hilly areas, there are flattened-out spaces where the charcoal burners built their fires, which carry an echo of this past activity. Only a certain number of plants will grow in these places because there is so much carbon in the soil. Knowing the history of the place, I conceived of making a mound from charcoal, a brittle material. We made 900 charred stakes that were to be graded into a dome eight meters in diameter and one meter high in the center.

**JG:** The charring became an action and the dome a reminder of the charcoal burning, the earlier human presence in this apparently "natural" site.

**DN:** The whole idea was that it would rot down to a mound of humus and that only certain plants could grow on it. What I hadn't anticipated was that people liked to walk on it. It got very trampled but survived. New safety laws came in, and it was decided that *Black Dome* was not safe for people. So it was prematurely covered over. It is now just a mound, which it would have become anyway.

**JG:** There is a language or grammar in your wood pieces, yet you do not dominate or formalize them too much. The weird juxtapositions of natural and carved forms and dimensionalities cause us to question our own presence in relation to this physical language of carving.

**DN:** Making objects, making gestures that are sustained in a certain place, knowing that other people are going to see it, encourages other people to be aware of it. All human behavior has moral or immoral qualities. Rothko said that his paintings were moral statements, and I really linked to that when I was a student. Every human gesture seems to have a moral content. It does stand for a human being's behavior. If somebody knows nothing of my work, and they come across a piece, I hope they will get a sense of the light touch, that there is something here that serves as a stepping stone for the mind into the continuum of that particular place. To varying degrees we spiritualize material by our work with it. Unconsciously we are creating a language that another human being can pick up on. We connect to the spirit quality that has been put into it. This isn't done by ritual, it is simply done by common sense.

**JG:** And the language of each individual artist reflects his or her own experience?

**DN:** Yes. Individuality within the global reality of the physical world.

**JG:** Your step and ladder pieces are unusual metaphors that maintain the integrity of wood and the natural undulations of trees, while integrating manmade forms. *Through the Trunk up the Branch* (1985) demonstrates this dramatically, offsetting a tree's base with a series of steps. In this case, the tree supports the structure, which symbolizes an ascent or descent.

**DN:** I was presented with a huge dead elm tree in Ireland that had been dearly loved by the owner. Together with an Irish woodsman, instead of cutting it at the root, I decided to cut it above the first big limb. I made about 10 sculptures from the top, and then I was left with a huge trunk and big branch. So it remained rooted, and the steps had an upward gesture. A neighboring farmer said he'd like to go up those steps and have a Guinness with God.

**JG:** Do you plan to do any more planted works or future projects that involve living elements?

**DN:** I am very wary of doing anything far away from where I live. When I take on a contract to do one, it is for a five- or 10-year period. I am paid half when I do it, and I am paid a fifth of the remaining amount on each return visit. Then I have a carrot: I know I have a budget that pays to get me there.

*Sheep Space*, 2000.
Welsh oak, dimensions variable.

**JG:** What sort of feeling do you have when you are working, when you are carving or making a piece?

**DN:** I am usually charged up by the idea, because ideas have energy. I am invigorated by it. I love the economy of means—when you cut a shape, you have another piece of wood coming away that you can use for smaller pieces. In the big projects abroad, just from the nature of how much I am trying to do, what I am trying to achieve, I have to work with other people. The social dynamic interests me very much. It is an absolute delight to get the right mood. Sometimes I have failed and the project has been very difficult.

**JG:** Do you believe that symbols play a role in your work? Does a work have symbolic power? Is it the viewer who brings the symbolic reading to a particular work?

**DN:** I have found that the *Cubes, Spheres*, and *Pyramids* that I have been making—triangle, circle, square—seem to have a commonality. People are very comfortable with that grouping. If I make or invent a shape such as a cross, people ask, "Why is that?" There are shapes and combinations that seem to be universally satisfying. I continue to make them because I am endlessly fascinated by these aspects.

**JG:** Did Brancusi's work play a role in inspiring the direction you have taken?

**DN:** It was a fundamental experience for me. I saw *Endless Column* when I was 18, when it was in the old modern art museum. I had heard about it from my art master. It was different from the other objects because it was jammed into the one place. I really liked that. It wasn't until I went back when I was 22 under other circumstances and saw the same place again that I realized how deeply this spiritualization had gone into me. I continued to revere it. Now there is a moral gesture. That is what made me decide I wanted to live in the space where I worked. I don't like to think of Capel Rhiw, my home in Wales, as a copy of Brancusi. If anything, it is like a magnification of that experience.

**JG:** Do some of your works have a practical element or build a functionality into the sculpture?

**DN:** Yes. Various people around the world have wooden toilet roll holders built into their bathrooms, and I have made handrails out of a branch. *Black Through Green* (1993), conceived for the Laumeier Sculpture Park in St. Louis, involved integrating a series of five-meter-long charred oak steps into a woodland area, the idea being that hikers would gradually erode a path down the center of the steps, while leaving the ends untouched. *Nine Charred Steps* (1988–89) in Brussels goes up a grassy bank, extending beyond any functional use into space.

**JG:** The land plays a great role in these works, and the siting must be central to your concerns. Usually they are modest integrations that don't dominate a place.

**DN:** Site appropriate. "Site specific" is not a good enough term. It is too loose. The land is absolutely fundamental and has to be in the front. I can't stand sculpture that uses the land as a background. I find it offensive. My most successful pieces are the ones that look like they have always been there. I consider *Charred Forms into Charred Stumps* (1989) in northern California to be my most successful piece. When we rolled the big charred sphere into the hollow charred redwood stump, it looked like it had always been there. Looking into a charred shape is like a "something," but it is also a "nothing." It suggests an enormous space. The whole point of these pieces is the nothing.

**JG:** When I go hiking in British Columbia, I see firesnags left after forest fires that resemble your sculptures. What distinguishes these found forms in nature and your created forms?

**DN:** It is interesting how one can sense the difference between a natural occurrence and a human gesture. In Australia, the aborigines cut the bark and take it off a tree as one piece. They stitch it up and make a boat out of it. The shape of the scar that remains on the tree is like a boat. Seeing that, I felt I was experiencing an idea incarnating.

**JG:** These aboriginal traces exemplify how you yourself adapt natural forms. There is no segregation of human activity from nature. Can you tell me something about how you began as an artist?

**DN:** Well, my career parallels that of Andy Goldsworthy. Unlike Richard Long, who immediately made his mark in the art world as a very young man, exhibiting with Konrad Fischer, Andy and I were not picked up by commercial galleries for quite a long time. We made a living as artists-in-residence and through artists-in-the-schools programs.

Arts funding in Britain is oriented toward making art accessible. We grew up with that. So when Andy and I were picked up by galleries, we were like bridges. We helped a lot of people who would not be able to come to contemporary art see some more difficult work.

**JG:** In *Standing Frame* (1994), at the Walker Arts Center, you reference structural form and natural form in a piece that echoes a Sol LeWitt work already in place there.

DN: It was made initially to be with the LeWitt. Martin Friedman saw something similar of mine in Japan. He saw the relationship to the LeWitt and commissioned me to come and make a piece on the same terrace. My piece is exactly the same height as the LeWitt, and the inside square is exactly the same size as his square.

**JG:** In the tree trunks supporting *Standing Frame*, there is an integrated vernacular—a straight pole and undulating tree branch supports. There is even a sense of humor. *Sod Swop* (1983) is a completely different piece, rather like the *Wall* (1988–89) that Goldsworthy made in Dumfriesshire, where an exchange takes place. With *Sod Swop*, you are taking something out and putting something in, and the result is equal.

DN: *Sod Swop* came about when I was asked to take part in an outdoor group show at Kensington Gardens in London. I wanted my piece to say something about where it came from, so the most basic way to do this was to bring something of where it came from—the land itself. The land that was removed went to Cae'n-y-cod in north Wales. We swapped them over. At the end of the exhibition, I wanted to swap them back, but they ran out of money. So I still have the London turf, which had five species of plant in it originally but has lots more now. I keep it as if it were in London, so I mow the grass regularly. The London piece was moved from the original temporary exhibition space to a permanent site. They don't cut the Welsh turf. They cut everything else, which is the opposite of what I do with the London turf.

**JG:** A greater economy of means can often express ideas and concerns more succinctly.

DN: When there are limits to materials, you rely on what you can make up out of yourself. You are only relying on what is available.

**JG:** Sculpture can be more effective when it is not neutralized to become an aesthetic object of contemplation. Placed in active areas, in farm fields with cows, for instance, where some other activity is going on, sculpture can be more meaningful.

DN: I actually did a study and documented with drawings where sheep like to go. I then made *Sheep Space* at TICKON in Langeland, Denmark (1993). A large tree had blown down, so I cut some big chunks of oak and hauled them over into a shady area. At TICKON, the sheep use these freestanding forms. Recently I made another such piece in Virginia.

**JG**: How do these works function?

**DN**: Sheep always need shade, and they need to be able to get away easily. They don't want to go into a hole. They also need to be able to get out of the sun, out of the wind, out of the rain. They go to different places according to what the weather is on a particular day. Over time, their continual presence wears an oval patch into the ground.

**JG**: So *Sheep Space* is about building a relation between the art and the animals.

**DN**: Yes. I wouldn't put them there if the sheep were not going to use them—they would just be chunks of wood. Of course, where the sheep go, the lanolin of the wool leaves traces and oils the wood's surface.

**JG**: *Wooden Boulder*, begun in 1978, is an ongoing process piece, a huge one-meter-diameter chunk of oak in north Wales. There are physical constraints on its movement, but the sculpture adapts and resonates with a physical energy.

**DN**: *Wooden Boulder* came from a massive felled oak, from which a dozen or more sculptures were made. I intended to move it down the hill to my studio, but it got stuck half-way in a stream. Initially this seemed a problem, but I decided to leave it there, and it became a sculpture of a rock. It has moved down the river nine times since then. Sometimes I had to move it on, as when it got jammed under a bridge

**JG**: Is there a distinction between earth-sensitive art of this era and most Land Art of the 1960s and 1970s?

**DN**: It's a generational thing. I think that Andy Goldsworthy and I, and Richard Long, and most of the British artists' collectives associated with Land Art would have been landscape painters a hundred years ago. But we don't want to make portraits of the landscape. A landscape picture is a portrait. We don't want that. We want to be in the land.

# High Technology and Elemental Materials: Fabrizio Plessi

**by Laura Tansini**

**2002**

Fabrizio Plessi is a video artist with a traditional art school training. His work balances primal elements (air, water, fire) and materials (stone and wood) with new technology to arouse irrational, elemental emotions. Plessi is considered a high-tech artist, but, in fact, he brings together video's potential (as an object, as well as an image with movement, light, sound, and colors) and traditional materials to create installations in which color and light are used with the sensibility and the skill of a painter.

Plessi's works do not tell stories; instead, they evoke a sense of timelessness. While Bill Viola interprets everyday emotions—anguish, joy, love, friendship, and hostility—Plessi deals with ancestral, instinctual reactions stirred by natural elements: water's eternal flux and regenerating power, fire's force and destructive menace, air's freedom and uncontrollable strength.

Plessi has become fascinated by luminous LED panels, which make light works visible during the day. In Venice he used such panels to cover the windows of the Museo Correr with waterfalls and fire tongues, as visible at mid-day as at midnight. At present he is working on a new installation commissioned by the Guggenheim in Berlin, where he will also install luminous LED panels on the Brandenburg Gate or the Reichstag. A new work for the Guggenheim Museum in Bilbao is also planned.

**Laura Tansini:** Why did you abandon traditional art forms for video technology?

**Fabrizio Plessi:** In 1958 I went to art school in Venice, and I was very good at drawing, a skill I continue to practice daily in my studio. But I think that what matters in any form of art are ideas. In the '70s, new technology was entering the art world, and I was deeply attracted to it. The challenge for me was to make technology part of my "language." It is very difficult to command, much more difficult than painting. It is not enough to know how to use technology.

**LT:** You use video in a very personal way.

**FP:** I was attracted by the potential of video technology linked to traditional art materials to create installations. I think that video is simply one more material that the artist can use with other materials to create a work in which past, present, and future are brought together.

**LT:** Your works deal with just a few elements, and water is one of the most important.

**FP:** It is true that water is very important to me. I was born in Reggio Emilia [a small Central Italian town in the

*Simulation of Waterfire*, 2001.
Installation at the Museo Correr, Venice, projections of fire and water on the windows
of the Ala Napoleonica during the Venice Biennale.

*La foresta sospesa*, 1999. Mixed media, installation view at the Kestner Gesellschaft, Hannover.

region of Emilia]; when I was 18 years old I moved to Venice, and I was shocked by this apparently flooded town. Venice and water have dominated my life since. My thoughts have become more fluid, more adaptable. My square, solid, plastic Emilian origins have faded away—I have become more flexible.

I think that water and video make the perfect combination: they are vital to one another. Water is an ancestral, primordial element; video is today's technology. Both are fluid, mobile, and unstable; both emanate a bluish twinkling. Besides, I love the flux of events, of things—that constant movement that apparently describes nothing. On the other hand, it represents life. I turn video into pure emotion.

For many years I thought about using tree trunks as an homage to Germany, to its forests. I thought of technology as the soul of nature. So I hid technological equipment and a television screen inside tree trunks—an electronic soul living inside the tree that controls its evolution. I chose nine trees, all the same size and in perfect condition. When I created *La foresta sospesa* (*Suspended Forest*, 1999) at the Kestner Gesellschaft in Hannover, I suspended the tree trunks 25 inches off the floor and filled the empty space with basins of black water. These became screens for images of heavy rain projected from inside the trunks, the rain that the trees soaked up during their lives and now gave back to earth. For me, this is a monumental work because of its meaning. It represents the cycle of life.

**LT:** Besides water and fire, you deal with air. To create *Mare di marmo* (*Marble Sea*, 1983–84), you used dozens of television sets, each one surrounded by irregularly cut slabs of stone. The exhibition room was swept by a strong howling wind, the same wind that rippled the waves on the television screens. What is the relation of air and stone?
**FP:** Stone is the allegory of the strength of our thoughts, the hardness of our ideas, which resist elemental forces; it represents our sheet anchor.

**LT:** When did you get involved with music?
**FP:** In the '70s I had many experiences related to different forms of art, including theater and music. At that time new visual art movements emerged, such as Fluxus, Body art, and Land Art. I was interested in anything new, but I never identified myself or my work with any of those movements. I have to continue my solitary way, a sort of diagonal road. I passed by all of these movements without getting really involved in any of them.

**LT:** Why the urgency to create works in the daylight?
**FP:** Daylight kills video. To see video we need a dark space. I feel like a miner who looks at a diamond in the darkness of the mineshaft, while his greatest desire is to see it in the daylight. I consider luminous LED to be the greatest revolution in video technology's 40-year history.

**LT:** LED panels are very expensive. Sony has sponsored some of your installations. How do you know where to find what you need? Have you worked with other sponsors?

**FP:** Unfortunately, Sony can only give me television technology. Now I am dealing with ENEL (the Italian electric company), which sponsored the installation at the Museo Correr. If ENEL will support me for the next five years, I will realize my dream to create urban installations visible in the daylight. I am thinking about an exhibition in Rome, at Trajan's Markets. I am passionate about architecture; I think it is the most important expression of our civilization. For me to bring new technology to a classical structure that contains and represents its time would be to link past and future. It is a challenge, and I am always searching for challenges.

# One Who Sees Space: **Maya Lin**

**by Jan Garden Castro**
**2002**

Maya Lin's sculptures, environments, and architectural projects flow out of a vision of a universe in harmony with itself, its different branches and modes of being. Her gift is creating work that rethinks human relationships to earth and time. She is Taoist in spirit, American in ingenuity. Her 1998 traveling exhibition, "Topologies," contained several small-scale works whose ideas she has further developed in large-scale projects, including *Ecliptic*, the redesign of a 3.5-acre park in Grand Rapids, Michigan, completed in September 2001. *The character of a hill, under glass* (2002), a curving floor for a winter garden at American Express Financial Advisors in Minneapolis, is her most recent finished work. And *Flutter*, a 20,000-square-foot earth sculpture for a federal courthouse in Miami, is underway.

Lin's book *Boundaries* (Simon & Schuster, 2000) navigates her career as an artist/architect and articulates the distinctions—and connections—she has drawn between each field. Site is an important aspect of her vision. Her public art projects evolve in response to a particular site and humanist mission. Lin's sculptural projects include *Ten Degrees North* (a water/stone table of the world from the perspective of 10 degrees north), which serves as the centerpiece of Lin's granite, wood, bamboo, and cane interior for the Rockefeller Foundation's headquarters, and the Penn Station solar clock *Eclipsed Time*. Of her deservedly famous Vietnam Veterans Memorial in Washington, DC, Michael Kimmelman has said, "It is the closest public art has come to an alternative to the heroic public sculptural ambition of Michelangelo or Bernini."

Lin's work often integrates a scientific and/or historic component into a living form, a reminder to treasure earth and stone, time and space. As she says, "I feel I exist on the boundaries, somewhere between science and art, art and architecture, public and private, East and West. I am always trying to find a balance between these opposing forces, finding the place where opposites meet."

**Jan Garden Castro:** How do you define your work as a sculptor?

**Maya Lin:** I see myself as a sculptor who incorporates spatiality into her work. I am less interested in creating sculptural objects than in exploring sculpture as built environment. In making these works, I think in terms of one's experience walking through them—I see them as spaces in relation to time. That's probably why I rely so much on writing and making models. Writing can help clarify the ideas within the works, as well as help me to see what the experience of a work will be. And as for the models, on any given day, models cover the floors—for everything from a detail of an architectural project to one of the sculptures. It's more labor intensive, incredibly cumbersome, and got me into trouble in my training as an architect. That's how I see.

*Wave Field*, 1994.
University of Michigan, Ann Arbor.

In my studio works, I often create an ambiguity between the work and the gallery space. For instance, I'm working on a series of landscape reliefs built up on Sheetrock and then cut and inserted into a regular architectural wall. I see my large-scale works as sculpture, although they exist, at times, in the same place as landscape architecture or architecture.

I prefer to make distinctions between my art and architectural work. Unlike Scott Burden, Siah Armajani, Mary Miss, or even Alice Aycock, I would say my sculptures are not architectonic in form. I consciously pursue ideas that are tied to landscape. My art studies and captures natural phenomena and landscape; in addition, I often use technology to see our environment.

JGC: You've spoken of growing up in Athens, Ohio, and visiting the Serpent Mounds, a spectacular earthwork that perhaps was one inspiration for *Wave Field*, which faces the Aerospace Engineering Building at the University of Michigan. I understand that you have another earthwork in progress in Miami. Would you talk about the process of engineering earth into a sculpture?

ML: The General Services Administration commissioned me to create an artwork for a federal courthouse in Miami. I'm very site specific. Arquitectonica designed the building, which is shaped like a boat in plan. At first, they thought

that I'd put an artwork down at one corner as an entranceway, but I became interested in the field that surrounds the building. It's about six times the size of *Wave Field*, which is 10,000 square feet. *Wave Field*, due to its size, has the sense of being an object until you walk into it, and then its scale takes over more as a field. I always wanted to explore a site that, due to its scale, already reads as a spatial environment. *Wave Field* is a water wave formation. The one in Miami is about sand patterns under the waves, so it's a very different pattern from the cupping of waves. Sarah, my assistant, and I have been studying dunes, rippled sand effects, erosion patterns in the earth. I've been experimenting with that in model form. I like to balance one or two projects at a time and learn what the differences are between them. I'm very interested in how the change of scale is going to affect how one reads this piece.

JGC: How has *Wave Field* held up? You distorted the grid of the wave, making it asymmetrical.

**ML:** It's holding up fairly well. It's a sandy soil mix that drains well. We've started experimenting with different soil compositions [for Miami]. Our biggest concern is that water will puddle in the low areas. We've formulated, with landscape architecture consultants, a sandy soil mix for the entire field that acts as a wick and distributes the moisture evenly. The indigenous soil in Miami is already very sandy, so we didn't have to experiment much.

Even though I based *Wave Field* on a symmetrical, naturally occurring phenomenon, the Stokes Wave, when I built the first conceptual model, it was uneven. But it had a magic or power that captured the photograph I was working from. When I built the second and third models, I made them symmetrical and they went flat. The model lost its life. You have to balance the forms carefully to make them feel natural. You push it slightly off kilter. That's why, I think, if a person's face were dead-on symmetrical, that person would look frightening and strange. What we see is symmetry, yet nothing in nature is technically symmetrical. So the slight differences between the left side and the right side are, essentially, what I'm striving for. I'm playing with what looks balanced. It's building in the mistakes. If you push it too far, the mistake takes over and begins to look premeditated. As we look around us, our eyes and our minds are interpreting and understanding, but if you try to intellectualize it, you can lose it.

JGC: That brings us to the winter garden for American Express Financial Advisors. You've used architecture and scale in two ingenious ways: first, to create the undulating topographic landscape in the exhibition "Topologies" and, currently, in the undulating floor of the winter garden.

**ML:** I can't believe American Express has been so supportive in allowing me to realize an idea I have been wanting to see for many years. I have certain visions that sometimes take as long as five to 10 years to realize; I have to wait for the appropriate site. For instance, at Am Ex, the artwork is about a landscape you enter. For a long time I had been wondering if someone would let me curve a floor. It had to be a wood floor, something that you naturally assume is straight. I kept envisioning how easy it would be to do because I built a curved roof for a house—the straight sections were just warped.

With *the character of a hill, under glass*, I took what I learned from *Untitled (Topographic Landscape)*. The substructure of the floor consists of cut, curved pieces; we made cardboard models, put the dimensions into a computer, and then studied the form point by point. The architects and the engineers kept saying, "Oh, no, you're going to have to put nail points down and screen concrete." I said, "We're going to lose the curve. We're going to build a honeycomb structure of particle board." Actually, it turned out to be plywood.

The floor is fabricated with the exact curve we built in model after model. It's actually a very subtle curve in an area just over 2,000 square feet. Some of the models are so big we had to dismantle them to send them out. Once the sub-floor is done, they lay thin sheets of plywood, and then the maple floor goes on. Maple will take the curve.

We take for granted a slight undulation in the ground plane outside. The question was, what happens when you take it indoors? The challenge was to take what I was working on with *Wave Field* inside. I first did that in "Topologies." I wanted to do it again as a permanent part of an architectural work.

JGC: In a way, you're using sculpture as a basis for architecture, and in another way, you're turning the architectural model form into sculpture.

ML: There's a dialogue between the way I'm working as a sculptor and as an architect. Another project I'm working on is a series of landscapes—riverscapes or dunes—made from joint compound on Sheetrock. To install it, you cut a hole in the existing Sheetrock wall, tape it in, and paint it over. I'm introducing a landscape work not as an object but as an intrusion into the space, a cut into the walls of a building.

JGC: Like *A Shift in the Stream*. Was that the first? Do you have others planned?

ML: That was the first. Yes, one client for a house asked me to put in a rippled dune artwork. Technically, it's still an object and could be removed. It is installed the way you would install a regular Sheetrock wall. I am interested in seeing architecture as a site to excavate.

JGC: Did you use a CAD program for the winter garden floor?

ML: Yes, but I don't understand it at all. My assistants coming out of school think in computer language. I make the physical models.

JGC: How did you handle the practical considerations of doing a curved floor? For example, for handicapped people, and in snow and in rain?

ML: Since it's an indoor space, we tried to make the undulations pretty gradual. As a precaution, we will put up a notice for people to watch their step. After all, it is an artwork.

*Untitled (Topographic Landscape)* (detail with *Avalanche*), 1997.
Particle board, 16 x 18 x 2 ft.

**JGC:** Did you work with landscape designers on the plantings?

**ML:** Absolutely. The trees on the inside are a type of olive tree. We went for something not too exotic that we knew would work. On the outside, I wanted to go with birches because, again, winter to summer, even with the leaves down, the white bark is stunning. I wanted it to be visually interesting as a winter space from inside to outside.

**JGC:** Let's move from your identification with earth-based work to stone and clay works. Your middle name, "Ying," means "precious stone."

**ML:** You don't pronounce the Y. Ying is a precious jade. Certain things are—no one ever plans them. It is ironic, in a way, that I work with stone and that is my middle name.

**JGC:** Do you want to discuss specific stone installations? Three of my favorites are *Sounding Stones* at the Federal Courthouse Plaza in New York, the open-air *Peace Chapel* at Juniata College in Pennsylvania, and *Ten Degrees North*.

**ML:** One of my favorites is the *Civil Rights Memorial*. It works with the notion of the spring, the water, the font, but the use of stone also signifies, to some degree, an agelessness, a timelessness, a coming together of history, linking past to present. Stone is an ageless medium—I'm drawn to that.

I think that my father being a ceramist gave me an affinity for earthworks and earth forms, and, again, the use of time. You can think of a stone or a rock as being as old as the earth itself, so what is its age? No matter what its form, it just survives. It's there. Some mountains are young and some mountains are old, but we're still talking about something that has a sense of time that other materials, to me, don't necessarily capture.

**JGC:** You used glass to create your installation *Rock Field* in "Topologies."

**ML:** Right. That's another of my favorites. Before the Pilchuck residency, I had done work with broken glass but never with blown glass. I'm not about fabricating. It's more an idea. The monoprints that I started pulling at Pilchuck were about the process of cracking a plate, not consciously making an image, so to speak. Pilchuck, the name itself, is taken from the beautiful, river-washed stones around there, and I started collecting them. I didn't know what I was going to do with them. It got to the point where people were leaving gifts of stones at my table. Spontaneously,

working with the gaffers (glass blowers), I would bring in these rocks and say, "Can we make a shape like this?" We talked about symmetry and asymmetry—a lot of the art of blowing glass, as in clay, is that perfect centering, the rotation of the blowing rod so it spins out perfectly. It was amazing to say to these expert gaffers, I want it slightly off. They had to retrain to become more sloppy, but, again, it has to be in balance to work at all. That's what I was looking for instead of that perfect, rotated, symmetrical form.

JGC: Have you used stone and clay in your studio work?

ML: In all of my models for the earthworks, I use plasticene, which is clay imbued with an oil so that it never dries out. I've been using clay since my college days. I know that's my father's influence. I never thought it was unusual: the plasticity of clay, the fluidity, a medium that has a way of never finding its shape. I haven't exhibited the clay works except as maquettes and studies.

JGC: You completed *Ecliptic* in Grand Rapids in September 2001. Could you discuss the use of science and fiber optics in this public space? And the theme of solid, liquid, vapor?

ML: It started when the Frey Foundation, a private foundation, selected me to put a work of art in downtown Grand Rapids. I asked them what the site was, and they had a corner of a much larger park area. I thought it was highly problematic, because the park was in bad shape, and I didn't feel that an artwork in a quiet little corner was going to change much. I pretty much told them that.

It turns out that the city of Grand Rapids was in the process of revamping the entire 3.5-acre park. I made a suggestion to the Frey Foundation that if they brought me in as an artist, I would then work with a team of engineers and landscape architects to redesign the entire park. The Freys donated my design as the artist. Nobody quite knew how that would work out because it was a real private/public interface. We all went into it figuring that it might not work contractually, and it all worked out amazingly well.

Usually, the artist is brought in at the very last minute when the buildings are built, everything's been bid out and effectively done. There's very little the artist can do except play catch-up. For me to be brought in at the beginning— it turns out that there was a bandstand and a restroom/service facility that needed to be designed—was a bonus. But the skating rink is what I was really interested in reworking.

My interest gets piqued by certain things. Grand Rapids is on the Grand River, and I began to think contextually of creating a work that dealt with water. It evolved into a sculptural piece about the three states of water—solid, liquid, and vapor. There are two fountains, one a water fountain, one a mist fountain, and the third piece is the ice rink. As it started evolving, there was a grade change of about eight feet from one corner of the skating rink to the other.

As you know, I am obsessed by the curvature of the earth. You also know that water has to freeze on a flat surface. But I could play with how the tiered amphitheater moves to create the illusion that you are skating on a slightly tilted plane. That became the core of the artwork.

We started to think about lighting the rink's surface, and Linnaea Tillitt, a designer, suggested fiber optics. I got a constellation chart of the midnight sky above Grand Rapids on January 1, 2000. It caught one moment in the millennial year when we were creating the park. In the end, the idea became larger than the states of water; it also plays with celestial navigation. The piece also deals with time—as well as this slight, subtle change in how one perceives walking on the curvature of the earth. This is the opposite of the Knoll furniture, which was about curvature. This one's about the tilted plane that you walk on.

JGC: Does the rink actually curve?

ML: No. The ellipse is flat, but the way the tiered seating is stepped—on one side it's above the ring and on one side it's below the ring—makes you feel that you're on a slightly tilted plane. The actual edge of the skating rink is a crisp edge—there's no rim. There is a skating handrail, but you can skate right up to the edge. It's a subtle play on perception.

JGC: You dedicated your book *Boundaries* to your family. You also said that your parents didn't discuss their past in China and that you were 21 when you learned that your aunt had helped design Tiananmen Square. Have you learned more about your roots?

ML: I have and I haven't. I have many books. Wilma Fairbanks just wrote a book on my uncle and aunt, Liang Sicheng and Lin Huiyin [*Liang and Lin*, University of Pennsylvania Press]. They are quite well known in China; a soap opera in Hong Kong is based on them. They were the preeminent architectural historians. They studied architecture at the University of Pennsylvania and at Yale and brought Modernism to China. They were architects in love with an ideal. My aunt died young. My uncle at first was for progress and hence the design of Tiananmen Square; later in life, he realized the importance of preserving the old China. Then he was at odds with the regime, which wanted to wipe away the old. It's a mixed blessing, I think. They traveled throughout China and documented the old temple styles in an amazing, beautiful book; it was a lost volume. Wilma and John Fairbanks found the volume and published it many, many years later.

JGC: Did you see any inspiring places in China?

ML: The one that was amazing was my father's childhood home in Fukien. I could never figure out why I am so strongly influenced by Japanese architecture. Going back to my father's childhood house, it's a Japanese-style house built on a river. He was influenced by this house, then he shared his aesthetic with us—he made all the furniture, the pottery we ate off of, so that's where the affinity gets connected.

**JGC:** That explains your houses with moving walls.

**ML:** Yes. Isn't it amazing?

**JGC:** Now that you're a wife and mother, does sculpture play a role in your family life?

**ML:** When I met my husband, Daniel Wolf, there was not a single square foot of floor space free in his apartment. You had to hop to get to the dining room table. He collected pre-Columbian pottery and minerals. There are still objects everywhere. My two little girls are growing up with sculpture, probably much more so than paintings or photographs: sculpture, pre-Columbian works, stone matates, minerals, Neolithic ceramics, and later bronzes. We haven't broken anything yet. I just bought some little puzzle toys that are very freeform. I can't wait to introduce them to clay.

**JGC:** How is *The Extinction Project*, which you launched in *Boundaries*, coming along?

**ML:** I'm officially involved now with the Yellowstone Foundation; I'm doing a work for them that ties into biodiversity and the history of the conservation movement. I started this summer. I've been collecting clippings, notes, talking to many scientists. Yellowstone will help me push it where it needs to be.

We're at a terrible moment right now. This country is going through something we never dreamed would be happening. But I hope that we don't lose sight of a larger picture about the environment, about global warming. I hope that we as a country can look at our energy needs and work toward a type of energy efficiency that will begin to deal with the enormous environmental problems caused by global warming and automobile emissions. We've lost sight of what most scientists say is an enormous threat—climate change is still there unless we quickly move to do something. I hope we become more energy efficient. I think we have to.

September 11th changed us—everyone. My love of creating disappeared; I think a lot of artists felt similarly lost. The one project that helped me through this time was a chapel that I am designing for the Children's Defense Fund. Working on a spiritually based project focused on helping others was the only thing that could get me to start making things again.

# Armed and Disarming: Tom Sachs

## by L.P. Streitfeld
## 2002

In 2001, Tom Sachs's reputation as art world provocateur took on new significance as a result of "Art at the Edge of the Law," at the Aldrich Museum of Contemporary Art in Ridgefield, Connecticut. Greeting visitors at the entrance, his *Involuntary Guestbook* set the participatory tone of a groundbreaking exhibition that examined the nature of transgressive art. Furthermore, Sachs's sawed-off *Connecticut Shotgun* was the subject of a mock trial in which a jury of museum visitors acquitted exhibition curator and Aldrich assistant director, Richard Klein, for possession of illegal firearms.

The charges were all too real to Sachs: in 1999, his dealer at the time, Mary Boone, spent a night in jail after being arrested for distributing real bullets at the opening of the exhibition "Haute Bricolage." Such controversy has both propelled and dogged Sachs's career. Five years earlier, he entered the art world in the wake of a public outcry that caused his *Hello Kitty Nativity Scene* to be removed from a window at Barneys, where he was under contract as a freelance retail stylist.

Sachs's studio-cum-factory is located on the border between Chinatown and SoHo in lower Manhattan. Like the artist himself, this no-man's-land exists on the razor edge between the functional and the fashionable.

**L.P. Streitfeld:** How long have you been in this space?

**Tom Sachs:** Eight years. I've been a professional supplier of art world commodities for the past six years. That is just what we do here. I've been making things since I was five years old, and I've been selling them since about 1996.

**LPS:** You seem to be dancing on that elusive postmodern edge. For example, you are creating crude handguns as an antidote to the sleek and sexy guns for sale in the marketplace, yet your guns are fashionable, as is the experience of coming here to watch you shoot them in your *Test Chamber–Ballistic Range*. Your 18-inch *Connecticut Shotgun* was the subject of a mock trial involving the assistant director of the Aldrich, which has undoubtedly upped its value in the art market. What is the motivation behind making and displaying handguns as art?

**TS:** My answer is going to take a different direction. I'm interested in the postmodern dialectic, including its demise. But what really interests me is bricolage and learning about making a gun, or a toilet, or a boombox. All this political, intellectual bullshit is really there to support me as a bricoleur, handyman, alchemist, a do-it-yourself—or whatever you want to call it—energy.

**LPS:** It's interesting that you include the word "alchemist" in the description of what you do.

TS: I did say "alchemist," because "bricolage" doesn't really have a translation that is friendly for an American. We live in a culture that replaces things instead of repairing them.

LPS: But "alchemist" suggests transformation and experimentation and perfecting imperfection through the work.

TS: Yeah, the idea of making something perfect in its imperfection. I like that.

LPS: Which brings us to duct tape and its meaning.

TS: It represents America's level of tolerance for fine craftsmanship, because it is used to repair things quickly and badly. I am being a little sarcastic

*Miffy*, 2002.
Bronze, 9.5 x 4.5 x 4 in.

when I say that. America doesn't tolerate fine craftsmanship. I used to alter my labels. I had a summer job in Westport, Connecticut. I had all this cash so I started buying records and hi-fi equipment and ski equipment, but I could never afford the very best stuff that my really rich friends had, so I would just paint my own labels onto them. After a couple of years of doing that, I started to learn first hand the stupidity and meaninglessness of brand loyalty and consumer greed and desire.

LPS: Your work has been compared to that of Duchamp, and your studio has been likened to Warhol's factory. How much have these two artists influenced you as role models?

TS: They are great artists. I think Warhol's process is really cool and so is Duchamp's. Duchamp, in a way, is someone who got caught, or blamed, or given credit. It is much larger than him, but he is the one who gets credit. History has a way of choosing these people—like Manson, Warhol, and Duchamp—these paradigms. I would choose Westermann over Duchamp or Warhol—or Stan Lee or James Brown.

LPS: Wasn't the essence of the Duchamp persona defined by an enigmatic silence? He simply allowed people to project what they wanted to project.

**TS:** I don't think I am that sophisticated. Maybe I am viewed as being more sophisticated than I really am. I just think that I am a regular person doing what I am doing at the right time. In the future this won't be so revolutionary, and in the past it would have been too weird. It wouldn't have made sense. There is an artist, Rhonda Lieberman, who made a Chanel menorah out of cardboard in the '80s—it is in the Jewish museum—but Chanel wrote her a number of cease-and-desist letters, and she stopped working in that vein. I didn't really know about that work when I was focusing on fashion, but she was doing it 10 years before I was. It was too transgressive for the time, and she got shut down. Now, people who work at Chanel buy my work.

**LPS:** It seems to be an unintended irony of your current position that you are being interviewed by *Sculpture*, and I couldn't locate you through a gallery because you don't have one at the moment.

**TS:** It is not the most important thing, having a gallery. *Sculpture* has always been—the first time I saw it was about 12 years ago—interested in the way artists make things. That is why when the first question you asked about my guns being valuable as commodity versus real guns or slick machine-made guns, my answer was supporting the importance of the making.

**LPS:** The authenticity that people are looking for right now...

**TS:** These are the real things to talk about. Robert Gober, for example. He can build things amazingly, but people never talk about that. The whole dialogue is around these ideas.

**LPS:** Meaning there is little or no discussion about process.

**TS:** And the process influences the end result. It always does. I used to say that I made process-oriented conceptual art, but then I got embarrassed that I was even saying "conceptual art" because it has been so sullied by the industry.

**LPS:** Your output isn't ready-made; rather, it is self-created objects that use designer labels—such as the *Chanel Guillotine, Prada Toilet, Hermés Poison Gas Masks*. Yet you seem to be trumping Duchamp in questioning whether what you are doing is art.

**TS:** It is the same argument. I'm playing the bricolage card more than the Duchamp card.

**LPS:** That identification, along with this workshop, certainly grounds you from the art world hype and the commotion that swirls around your name in the popular media.

**TS:** It is a laboratory. I've tried to make things elsewhere, but I have a good supply of screws here. Better than some hardware stores. And there are very few things here that have materials that are unique to themselves. For example, we use the same specific color of light on some of the paintings and sculptures we do. And we use always the

same kind of screws and hot glue, so these things cross over and the images cross over through the subject matter and between sculptures and paintings. They translate too. It is a language.

**LPS:** Despite the fact that your output seems to capture the postmodern dialectic, your artistic language seems to cut through the world-weary cynicism of the New York art scene. There's a certain irony in that.

TS: The hyper-aware, self-conscious aspect of modernity—yeah sure. Baudelaire talked about modern life as a cultural ailment. You can look at it that way, but you are going to get sick and your work is going to be unhealthy. But if you think about pluralism and a way of expanding meaning and placing something in a different context, then it is a way of being healthy. Postmodernism—this introspection—doesn't have to be a bad thing. Being self-obsessed can be OK if it is taken in moderation. It doesn't mean that you have to be a loser about it—these are difficult, difficult times to be precise intellectually. I think that is why there is such machismo, and political incorrectness is such a reactionary thing...

**LPS:** To political correctness.

TS: And that is equally embarrassing. The point I am trying to suggest is that it is more about being a person than being an artist. It is important to be sensitive to who you are, whatever you do.

**LPS:** Why is the obsession with *Hello Kitty*?

TS: I'm not obsessed. She is just a great icon of shopping and meaninglessness. It means absolutely nothing.

**LPS:** With this factory, are you also rebelling against the Modernist myth of the lone genius in his studio?

TS: I have a lot of ideas, and I only have two arms. Working with other people is a way of doing more things. What is great about working with Oksana Todorova is that she is better than me. When we work together, it is a way that the work can be even better. I foresee a time when the studio can exist without me.

**LPS:** The process is collaborative, which places it in the context of a new paradigm, but your name goes on it, right?

TS: I don't see what the big deal is. We work together. Tom Sachs is the brand. It is bigger than me, but it happens to be my name. I would have been Allied Cultural Prosthetics, but it has to be someone's name: Tim Rollins and KOS—people don't know Survival Research Laboratories, but they know Mark Pauline. Like Chanel. They need it to be Coco Chanel.

**LPS:** And this brings us to the fascism of the label with young artists coming out of school. The postmodern dialectic revolves around them, and they are told they have to have a label in order to sell their art. You are giving talks to art students these days. Are you being presented as a role model?

*Chanel Guillotine (Breakfast Nook)*, 1998.
Wood, steel, leather, nylon, and rubber, 147 x 122 x 125 in.

**TS:** I think it is about communication. Any time you have an idea that you want to communicate with someone, you have to simplify it.

**LPS:** You have called advertising the "devil's art." Like Giordano Bruno, you seem to believe that Eros is being subverted by these magical manipulators. Is that the statement running through your dialogue with fashion—that advertisers are to blame for this state of affairs?

**TS:** That is saying a lot. I would say that fashion is just one of the many tentacles of advertising. It is great when it makes you look good or feel good about yourself, but it is bad when it makes you feel bad, dumb, or fat for not having the right things. Advertising is OK when it brings information to people, but rarely is it done for the benefit of the consumer. And there is no reason it should be, because it is being paid for by the producer. I think that by its general nature it is misleading. The ad always, and without exception, promises more than the product can deliver.

**LPS:** Do you feel that the traditional role of art in society is being fulfilled by designer goods?

**TS:** I would say that designer products have replaced religion. I was thinking that there is nothing more romantic than going to the flea market with your lover. The anti-consumer consumer. You are outside the system but still shopping. Recycled goods are this soft warm thing, but it is still spending money and consuming. The mall is where we go and worship, and it is where we spend our free time.

**LPS:** What is the comparison with art?

**TS:** Art should be handmade. Handmade to extreme measures of quality. That is why I think people have such a hard time with the whole art photography scene. It is like printing money. It's like, oh wow, this is so expensive because there are only three of them. The other side of this coin is that there are three of them—one in my house,

one at MoMA, one at the Guggenheim. That context as a very specific thing has value, whereas someone buying a handmade thing means having more value because most things are machine-made.

**LPS:** Could your public role be prompting people to recognize this inexhaustible cycle of desire and consumption that depletes or ignores value?

TS: I don't know how to answer that one. I've been saying a lot about what I do, but ultimately it is up to the viewer. Because once you start to make art that has politics, then it is propaganda. There is great work in the 20th century in that vein, but it is just not what I do.

**LPS:** Do you agonize at all over the bad-boy label you have acquired in the media?

TS: I like to think that I make art in a jugular vein, just like *Mad* magazine.

**LPS:** You don't worry then about getting trapped in the projection?

TS: There is nothing I can do about it.

**LPS:** You employ 13 people now. How will success affect the humor in your work?

TS: It is much less efficient with all these extra people. You have to do things over and over again. And I have mouths to feed.

**LPS:** How do you justify the paradox of a Tom Sachs creation becoming more fashionable than the object it satirizes?

TS: They are more expensive [pointing to his Chanel surfboard hanging from the ceiling].

**LPS:** Does the entire postmodern epoch—its rise and demise—flash before you when you confront collectors worshipping art satirizing their designer allegiances? It could be very exciting to be in that place.

TS: It is depressing, like going to a zoo and seeing a tiger in a cage. This is where these things live happily? When they leave here they go into sterile environments where if they get dropped or breathed on, they have to go to the restorer. If they are here and get messed up, they are alive; but when they leave here, they die.

# Declaring Space: Richard Serra

**by Jonathan Peyser**
**2002**

Richard Serra's early sculptures from the 1960s focused on the industrial materials that he had used while working in steel mills and shipyards: steel and lead. Beginning with the thrown lead pieces in which he created casts from the points of impact, process, spatial engagement, raw physicality, and a self-conscious awareness of material have characterized his sculptural explorations. Since those Minimalist beginnings, Serra has become famous for that sense of physicality, now compounded by breathtaking size and weight. His "Torqued Ellipses" (1996–99), gigantic plates of towering steel, bent and curved, leaning in and out, create very private spaces from the necessarily large public sites in which they have been erected. "Richard Serra: Torqued Spirals, Toruses and Spheres," the artist's most extensive exhibition of major sculpture in New York since his 1986 retrospective at the Museum of Modern Art, took place in 2001 at the Gagosian Gallery.

**Jonathan Peyser:** Many of the sculptures in this show are made to be entered. Why?

**Richard Serra:** After I built the prop pieces in the late '60s, I decided to open up the continuum of space. I wanted to remove the work from the limitations of the object, or the definition of the specific object, as articulated by Donald Judd and Minimalism, which remained predicated on a gestalt reading. Having decided that, I then had to find a way of doing it. I built a piece for Jasper Johns, about 1970, with a small plate that I was using as a template to splash against. I placed the plate in the corner and realized that it was freestanding. Then I took a single 8-by-24-foot plate and just let it bisect the corner of a room (*Strike*, 1971), which divided and declared the space. You had to walk around the room to see the piece. You could not separate the perception of the piece from its site or, in a more general sense, from the continuum of space. Once I installed *Strike*, I decided that I might as well take four plates and bisect the four corners of a room. The result was *Circuit*, built for Documenta in 1972 from four 8-by-24-foot plates with an open central core. Once you stepped into the room, you were in the volume of the piece. After these installations, axiomatically propping elements and creating constructions that were precariously balanced but did not allow you to enter became less of an issue. Declaring, defining, and dividing the space became the principle that I continue to work with. The context became crucial.

**JP:** Was there any historical precedent that led you to this notion of having people participate by being able to walk through the art?

**RS:** No. Those causalities never occurred to me. I simply found that with prop pieces such as *House of Cards* (1969), but particularly with the wall props in Castelli's "Warehouse" show in 1968 where there was a lot of propping overhead to hold up what was underneath, the viewer had to maintain his distance from the pieces and could only relate to them perceptually. I wanted to break that distance and create works that you could walk into, through, and around, to open up the field. I thought that it would lead to a different kind of experience, and I tried to find a way to articulate that.

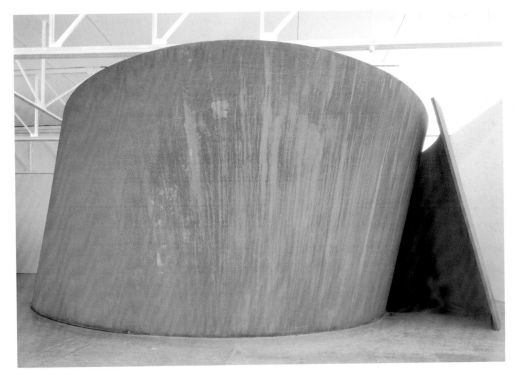

*Sylvester*, 2001.
Weatherproof steel, 163 x 492 x 380 in.

**JP:** What qualities or features of your sculptures compel us to react as we pass through them?

**RS:** I was in Kyoto maybe 35 years ago, at the beginning of the '70s. Looking at the temple gardens I found that they reveal themselves only by walking—nothing really happens without movement, which becomes the very basis of perception. Being in Kyoto was very different from being in Florence and looking at Piero della Francesca. Renaissance space is constructed by centralizing the focus. In the temple gardens of Kyoto the field is open, and your participation, observation, and concentration are based on movement: looking is inseparable from walking. The essential difference is not only the protracted time of looking, but the fact that you, your relationship to the objects perceived, become the subject of perception. Once I began to understand that this was a different kind of experience defined by an essentially different relation of viewer to object—in that you, the viewer, are the subject relating to an object in time and space—it shifted the focus for me. It sounds like a small thing, but I think it was primary for my development. I came back and built a piece for the Pulitzers (*Pulitzer Piece*, 1971) that extended over three or four acres and was based on walking and looking in relation to a shifting horizon. That development in my work would not have occurred if I had not been in Kyoto.

**JP:** I've been reading about the notion of bodily perception. Is this what you mean?

**RS:** My Kyoto discovery coincided with my reading of Maurice Merleau-Ponty, who talks about how your body grasps space in relation to time and how the body becomes the measure of your perceptions. He offered another analytical tool for breaking the frontal/parallel orientation of Minimalism. That said, I also have to say that for me Judd was an enormous figure. He was probably the artist who best digested Barnett Newman and as a result did the most empowering work, albeit still coming out of a gestalt planar reading. I found the gestalt reading of a confined specific object in a room to be a great limitation. I needed to open that space up and find a way of entering into, through, and around it.

**JP:** Your sculptures also feel communal. One frequently meets other viewers exploring the interior corridors. What do you think elicits this response?

**RS:** That's really hard for me to explain because I didn't anticipate the kind of response that occurred with the torqued ellipses. Up to that point there had been a lot of aggression or hostility toward the work, the kind of bashing that you get for doing something that people find overbearing or threatening. While the Dia show was up, I found people going back to the same piece several times, and I found another kind of collective or shared experience. All I knew was that when we built these pieces in the shipyard, the workers who first saw them finished were startled by them and kept going back inside. I think the ellipses provided an experience that they hadn't had before, neither in nature nor in architecture. It was new for them, and they wanted to figure out exactly what that experience was. You don't need to be educated in the history of sculpture to respond to work like this, because the understanding is basically behavioral and experiential. Even though everyone's experience is different given what they bring to it, on a very basic level those experiences have the potential of connecting and understanding. I watched a woman being helped out of her wheelchair to slowly walk into one of the ellipses and touch the walls. Things like that made me feel that there was something that people related to that was different in kind, if not quality, to the work that I'd made before, but I have no way of explaining it. These works are not predicated on images. I think that if works are predicated on images you collect the image: sometimes you can retain it, sometimes not. For me, the better works make you go back for the fulfillment of an experience that's not commensurate with what you've retained, therefore the experience always remains vital. There are works I continually go back to, whether it's Matisse's *Red Room* or a good Pollock.

There are other works in which there is a certain kind of closure once you've grasped the image. The ellipses and spirals do not deliver any particular defining image. If you ask somebody which image or images they retained they will invariably tell you that they retained an experience not an image. The artists I found empowering for my development included Pollock and Newman, who in their best works defy image retention. Experience is either evoked through line and process or through color and plane. My generation was probably more influenced by Pollock and Newman than the generation that came after, which was more influenced by Johns and Warhol, namely image.

Sculpture was able to evolve by developing abstraction, whereas painting seemed to dovetail back into representation because it was more vulnerable to be "media-ized," whether it was by introducing printing techniques or implicating photography. Most recent painting, with few exceptions, has referenced print media. The prime mover for representational painting has been "media-ization," whereas abstract sculpture remained immune from that influence.

**JP:** Do you think your work precedes language also?

**RS:** In some sense, yes. I started with a verb list, but that was about prescribing activities. I have a problem with image because I always thought that it was easy and that the photograph—as much as I think Warhol and Richter have made big moves through their particular use of photographs—was a limitation, the limitation of the ready-made. Once you select and work with a photograph, you're pretty much stuck with the surface and the given composition. There is not much more you can do with the dialectic of in and out, of figure and ground. I believe a lot has been lost since Matisse and Picasso because of painting's reliance on photography. But if you ask me if that's going to change, I don't think so. That's how we see the world now. But it does seem a compositional limitation to me. You either emphasize the dot or you blur the edge.

**JP:** You've introduced the torus and combined it with the sphere. Where does the idea for this shape come from?

**RS:** I got the idea in a steel mill in Germany, where they were forming spherical shapes. They used a torus as a forming tool to press a plate into a spheroid section. Basically, any doughnut is a torus. In any regular doughnut the inside and outside share the same radius, like the inside and outside of a ring. I thought I might have happened upon an interesting proposition in that, if you took a spheroid and a toroid section with identical radius they would probably lock together, but I wasn't sure. I couldn't study this combination because it didn't exist anywhere, neither in industrial products nor in nature.

I had a steel doughnut around, and I pounded some lead over it. I found that I could make the torus shape and the spherical shape, and I could align and configure them in ways that seemed interesting enough to go back to the steel mill and ask if they could make small toroid sections, an inch to a foot, for me to experiment with. They had never made toroid sections. But they thought they might find some application for toroids down the line, so they humored me and made a series of modules. I spent the better part of eight months working with them, seeing what I could do, how I could combine spheroids and toroids, which combinations made sense as sculpture. I decided that the most straightforward thing was to juxtapose them, to make different spaces to walk through. That is what happens in *Betwixt the Torus and the Sphere.*

The next logical, almost didactical, step was to join a torus and a sphere tightly into a closed volume that you could not enter. By showing *Union of the Torus and the Sphere* and *Betwixt the Torus and the Sphere* in one exhibition you

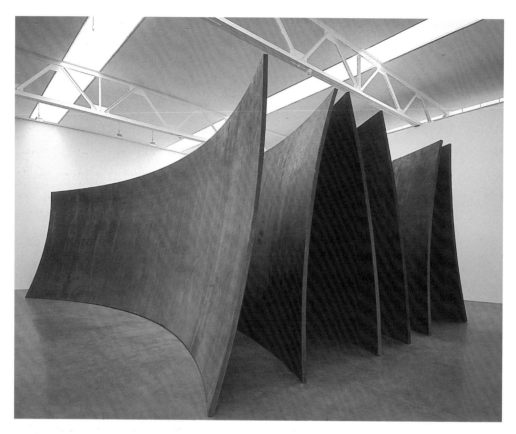

*Betwixt the Torus and the Sphere*, 2001.
Weatherproof steel, 142 x 450 x 319 in.

understood the permutations; the juxtaposition of the two pieces demystified the interior space of the *Union of the Torus and the Sphere*. Having walked through *Betwixt* you could infer the interior of the closed shape.

I had never built a closed form before. I was apprehensive about it because usually if you close a form and there is a void on the inside, it quickly degenerates into the realm of revealed/concealed, which seems to be a mainstay of Surrealism. I was wary of that association. I considered opening the form up to let people pass through it. But I had done that with conical shapes and was more interested in the extreme disequilibrium of the conjoined whole. It forced the experience of the skin, of the continuous differentiation of the skin. As you pass by, the volume bends concavely in or obdurately comes toward you. I wanted people to get close to the surface of the volume, to walk around it and sense its disequilibrium as a weight in space even though it was a closed form. I understood that I was up against tradition in several ways. The fact that you could not enter the piece also called up the recent history of the specific object. I had the piece erected in the steel mill and looked at it both open and closed. I finally decided,

with the encouragement of David Sylvester and Harald Szeemann, to close the volume. They both said: "Look Richard, there is no reason not to close this up. It may be a more radical move to close it than to leave it open." I made the decision reluctantly—let the chips fall where they may.

**JP:** Is that why you closely set it in a room with a rectangular shape?

**RS:** Yes, I put it in that room to bring people close to its volume, so that you didn't see it as an object, but as a continuous surface. I had been reading Deleuze and Leibnitz—both write about the fold and the continuousness of surface, and how one side is basically the unfolding of the other side. I got quite caught up in the idea of the fold. I think this piece is probably an outgrowth of thinking in those terms. A lot of people have commented on the tooling of that piece to me, they found that it was exquisitely put together, more so than most pieces I make. I didn't particularly care about that aspect. A lot of younger people in particular responded to *Union* in a way that they didn't respond to other pieces. I can't explain why.

**JP:** It has an overpowering quality about it, it subsumes you. You walk into the room, and you feel like you're underneath it.

**RS:** That was very deliberate. I built it for that space. When you enter, you're in its space, you can't avoid its surface.

**JP:** How do light (natural and artificial) and darkness work on and in your sculpture? In which light do you prefer the pieces to be shown?

**RS:** Basically, the forms themselves, through the way they lean in or open up, define a certain psychological continuance, and the light is an important factor. The light either creates shadows or floods the spaces, especially the centers, which accounts for the release you feel. If there were no release in the spirals, if they were just wound into tight concentric circles, they might not have been appreciated as much as they have been. The enclosed void is a space that undermines the notion of an axis mundi in that it has no center. The double ellipses (e.g., *Double Torqued Ellipse*, 1997) that preceded the spirals share the same center. In the spirals, there's no center, so when you walk into the interior space you find yourself trying to locate the center. You're continually trying to grasp where you ought to be—to no avail. The spaces are large enough to allow you to have a release and not feel confined, but you are kept off balance trying to locate yourself in the space. I think that accounts for their power and uneasy velocity.

**JP:** The word "haptic" frequently appears in discussions about your sculpture. How does it relate to your work?

**RS:** On a basic level it means touch. But, for me, it means psychologically extending yourself to the material through the space or psychologically extending the feeling of touch through the space, so that the space of the void becomes palpable as a form. Negative space becomes psychologically loaded, so that you could actually put your hand out and feel its presence. It occurs in some architecture such as Hagia Sophia, Le Corbusier's Chapel of Notre Dame du Haut in Ronchamps, and in some of Tadao Ando's work. Simply put, it is the difference in how you feel in a telephone

booth and how you feel in a football stadium. There's a way of controlling that difference in terms of a psychological response, which encompasses the need to reach out, touch, and experience that space.

When the word "haptic" comes up, it's not just in relation to the steel, but in relation to how the steel mediates the palpability of the space, the hapticness of the space. The space actually feels charged like you might be able to touch it, it affects your body: you're being implicated in it, the space becomes a substance. There are very few works in which space becomes the defining issue, in which it's not just a volume that's cut out by walls but a volume that connotes the content, the experience of the content as space.

**JP:** Are the exteriors as important as the interiors?
**RS:** Definitely. In the ellipses, spirals, toruses, and spheres you never have a total comprehension of the piece until you walk it. Anticipation and memory come into play. If you consider the early ellipses, they shift from looking like a flowerpot on one side to looking like a lamp shade on the other side as you walk around and follow the inversion. It's impossible to recollect what you have been looking at while you were walking. It's hard to reconstruct their shape because it doesn't break itself down into a narrative sequence of images. In a sense they are unknowable in the round.

**JP:** Why are these sculptures made from steel?
**RS:** I started working in steel mills while I was very young to pay my way through college, first Berkeley and then Yale, and I made good money as a riveter. I worked on the Crown Zellerbach building in San Francisco. I saw steel being used for almost everything you could think of in industry.

I always thought that sculpture had been the handmaiden to painting, that it derived its strength, from González and Picasso up to Calder, through cutting, folding, and arranging pieces in space through welding, which to me was like gluing: it was false since it ignored gravitational load. Having worked in industry and seen what had been done in terms of cantilever and counterbalance to satisfy the internal structural necessities of building, I knew that there was another way of coming at sculpture—not exactly by putting the principles of engineering to work, but by using them in a way that took the focus off the pictorial aspect and by using gravity, weight load, and balance to redirect the viewer to a different way of thinking about space and time in relation to material.

I don't get off on steel. It's just a material that I use to control and define space, something I've been around my entire life. I believe that the selection of material has to do with one's sensibility: how you know the world has to do with how you sense yourself in relation to material. Steel is a material that I've learned to use. I started handling it at a very early age, and I thought I could use it in a way that I couldn't use other materials—or let's say I didn't

have a feeling for using other materials. I worked with rubber, with lead, but steel ended up being the material of my choice. It's strange. When I see things written about me such as "man-of-steel," that's not how I see myself in relation to the material. I think of steel as something that's useful in terms of defining space, but I don't think of myself as being particularly enamored with it as a material in and of itself. For me, it's a means to an end. I happen to understand its potential, and I have a direct connection to it.

**JP:** You've created spaces that shape volume. To what degree has torquing made these new volumes possible?

**RS:** I think that without that minor invention none of this work would have been possible. Because if you take a cone, the radius changes as it rises in elevation, either outward or inward, depending on whether it's a flowerpot or lamp shade. Most architecture in the last 50 years that deals with curves, deals with cones or cylinders. No one has dealt with a torqued ellipse. In the torqued ellipses, the radius doesn't change as it rises in elevation. And that's hard for people to wrap their heads around, the fact that the radius remains the same as it turns. When you say that something turns on itself 90 degrees and its radius doesn't change—it's hard to picture what that actually means until you make a model of it. After I built the first lead models, we were very startled, fascinated with the potential.

The problem of getting the pieces built looked insurmountable. We went all over the world to find steel fabricators able and willing to handle the problem. We were worried that they might never get built, but I didn't want to go to another material. Had I gone to concrete it would have begged the comparison to architecture, and any other flimsy material (whatever that might have been) wouldn't have held the volume. We finally found a steel mill in Baltimore on the brink of bankruptcy; it was desperate and for that reason willing to take on the problem. We had to teach people how to make these torqued shapes, it was a long haul until we found a capable fabricator in Germany.

I had worked with conical shapes and combined them so that they created spaces that one could walk through. Think of a cone leaning toward you, if you just turn it upside down, it then leans away from you. Based on this simple inversion I built *Olson* (1986) and *Call Me Ishmael* (1986). Then I took that same principle and added two inverted plates, making an interior space and exterior passages that you could walk through (*Intersection*, 1992). After those pieces, I needed to tie the space together into one continuum. I didn't know how to close the volume, I think I was looking for something that would point me in that direction. I wasn't looking to be influenced by Borromini. I happened to walk into San Carlo alle Quattro Fontane in Rome through the side aisle and I misread the space. I thought, oh, isn't that interesting, he curved the space vertically, in its vertical elevation. When I got to the center of it, I realized that the vertical curvature was an illusion. Influence, whether it's in literature or art, is often based on misinterpretation. That's probably how every generation relates to what came before. Every generation misinterprets the language of the former generation and puts it to their own use.

That idea is certainly not my idea. Harold Bloom talks about it in *The Anxiety of Influence*, how Shakespeare is influential in relation to writers of later generations. Even though Bloom has a big Freudian subtext, I think that misinterpretation has a lot to do with how artists proceed decade by decade. The reason is that you can't really use anybody else's tools if you want to do something new. You have to use new tools or misinterpret the old tools and their use. Because if you don't, you're pretty much stuck in the academy. Misinterpretation and the use of new tools and production methods usually open up the situation. Artists who stay with the same production methods or the same tools as their mentors from previous generations get bogged down in the limitations and academicism of those tools and procedures.

**JP:** Did the earlier prop pieces generate or influence the torqued spirals, toruses, and spheres?

**RS:** I think that balance and gravity were basic to the work very early on. They are still prime concerns for me. How one body relates to balance and gravity. The early pieces were axiomatically aligned so that you could figure out what was holding what in place. Sometimes, when they made the most sense, the weight would be released. If they achieved perfect balance, you would think they were weightless. That's always interested me. If you take the spirals, which weigh upward of 120 tons, you never think about their weight. You get implicated in their speed and their movement. In some primary way, my concern with gravity, weight or weightlessness, and balance in the last pieces relates back to the early prop pieces. When you try to talk about new work, language seems very insufficient— in a sense it's true for this interview, a lot remains unspoken, and it takes time for language to grasp what's new. When you get into new work you don't have connections either to works that came before or works that come later. Works that come later often influence how we think of things that exist now. What comes later makes us think about an earlier expression that we didn't fully understand when it was first invented.

**JP:** How has the Gagosian exhibition been a departure point?

**RS:** The exhibition is a culmination of some work. There probably won't be too many more spirals. Maybe one or two more. I'm building one for the City of Naples. I think the toruses and spheres still have potential for development. The last piece I conceived is a vertical piece with seven torqued plates, in which the module changes systematically. The engineering term "node" applies to the point where a plate widens, which allows the plate to torque. In each plate the node is located at a different height, which means that the piece not only leans and torques, but it continues to turn as it rises in elevation. We just finished the model; the piece will be installed in Fort Worth next to Ando's new building for the Modern Art Museum of Fort Worth. That's a big piece for me. What we're working on now, and I don't have the model sections made yet, are sections of a bell shape—basically a flattened S, an S without deep curves. If you stand the S up, you have a plane with a concavity and a convexity: the lower half is a curve leaning away from you, the upper half a curve leaning toward you, or vice versa. These kind of shapes are used for the steel walls of nuclear reactors, but in a different scale and with a different bend than the one I want. The steel mill is making models for me, I'll see if they are useful.

# Into the Light: **James Turrell**

**by Elaine A. King**
**2002**

"James Turrell: Into the Light" (2002–03), a retrospective organized by the Mattress Factory in Pittsburgh, showcased Turrell's life-long investigations of light, space, and perception, including three pieces from the Mattress Factory's permanent collection and models from his monumental *Roden Crater* project. The show also featured outdoor daylight works such as *Sky Space* (an antechamber constructed for viewing the sky and its subtle atmospheric changes at all times of the day and night), projection pieces with artificial and natural light, and "perception cells," chambers that can be entered for perceptual experience (such as *Gasworks*, an optic light chamber shaped like a gas tank).

Turrell has been working with light and space since the mid-1960s, when he began using natural gas to create flat flames. He has used projected light to create perceptions of solid forms and employed artificial light to create various perceptions of light's presence. Since the late 1970s he has been constructing a series of observation spaces on and in Roden Crater, a 390,000-year-old volcanic crater with a 600-foot-high red cinder cone. Located approximately 50 miles northeast of Flagstaff, Arizona, it overlooks the enigmatic expanses of the Painted Desert.

Turrell's work induces introspection, prompting observers to look at their own viewing processes. His inquiries incite us to pause and probe our inner selves and encourage us to reconsider our own connection to and comprehension of the outside world.

**Elaine A. King:** I read that you are a Quaker. Has religion played a role in shaping your work?

**James Turrell:** I was raised a Quaker, and now I have come back to being active. I'm not sure whether that has impacted my art-making, because my work is not about specific issues—perhaps being a Quaker influences how I live my life and what I value. People tend to relate any work in light to the spiritual. I don't think this is actually correct, yet, in terms of our lives, we greet light in three major ways that aren't necessarily partitioned. There is a psychological aspect, a physical aspect, and a spiritual aspect. In terms of the physical, we drink light as Vitamin D, so it's literally a food that has a major effect on our well-being. The strong psychological effects of light can readily be felt in particular spaces. One can feel this in *Gasworks*—it expresses the powerful quality of light. In terms of the spiritual, there are very few religious or spiritual experiences that people don't describe with the vocabulary of light.

**EAK:** Your work also focuses on an architectural relationship between perception and space.

**JT:** I'm interested in delving into and exploring the architecture of space created by light. Mostly we have dealt with space by displacement or massing of form. While there is an architectural vocabulary referring to the space between, this has rarely been enlivened—it's more rhetorical than actual. The art that I make covers this ground between form and actually

*Milk Run III*, 2002.
Light, 9.5 x 9.5 x 24.5 ft.

forming space using light. For example, when the sun is shining, we see atmosphere—we can't see through the atmosphere to see the stars that are there. The same applies if you are on a stage with footlights and stage lighting—you can't see the audience. However, if you step in front of the footlights, the audience is revealed. The space is architecturally the same, but the location of the light actually changes the penetration of vision such that some people see each other and others cannot. It is a structured space without a massing of form. This quality of working the space in between so that it limits or expands the penetration of vision is something that intensely fascinates me. It means that the containing form has to be made somewhat neutral. What you're looking at is that in-between zone, not formed or made by the massing of material. This has a lot of ties to architecture, but not the sort of architecture that we use to build everyday structures. It certainly isn't how we light our buildings. Architects make a form and then they stick the lights in.

**EAK:** What criteria determine the structural configuration in relation to the selected hue or tone?

**JT:** That has changed over the years. I make this work for an idealized viewer. You might say that's me. The idealized viewer has changed and matured. He has become more circumspect. Color has to do with the kind of work I'm doing—whether I want opacity or translucency or transparency. How I want it to penetrate or to be stopped. The milky colors of a Japanese kimono are very subtle; in contrast, Korean culture evinces a brilliance of color with very deep saturation. I work between those two approaches—each has enlightened me. It's very different in light than with physical material: the first and most important thing one needs to do is to throw away the color wheel, because it provides misinformation. If you're going to work with light, you need to learn the spectrum. We're making an immense mistake by moving the color wheel into the computer. If you mix blue and yellow with the earth, which

makes pigment and reflects color, you're going to get something near green. But if you mix blue and yellow with light you'll get white, which surprises most people. We really need to look at the spectrum and have a different way of thinking about light. In general, we're a surface culture and tend to look at and speak about reflected light because of our tradition of painting.

EAK: How did you begin to use light as a medium?

JT: The history of art is a history of looking at light. Perhaps being American, I was interested in a less vicarious form that actually used light itself. I started out by dealing with a picture plane and the traditional presentation of light in painting. I can remember Malevich talking about how the paint was on the surface like the thinnest of membranes. If you put light on the surface, it's even thinner. But plastically, it's very effective in terms of the space it creates in front of it or beyond it. That was really a way to look at a more direct perception: rather than being something that's about light, it is light. The light is actually turned and directed right to your eyes. The light inside that space is invasive and penetrating. This direct experience of light is the difference between watching football and playing it. I think that we're an active culture in that respect, and so it was an easy step for me.

EAK: Have your experiences as a pilot inspired your general fascination with light?

JT: Yes, absolutely. The flight experiences were memorable and influential. When you actually get down to the practical, how to do it, you have to see how light works in space. When you are flying you get acute insights into how light functions.

EAK: Do you think that the infinite horizons of sky contribute to your need to work on a larger scale?

JT: A lot has to do with where light is and where it isn't. The way I work with light requires space. This was the biggest difference in approach between East Coast and West Coast artists' attitudes in the 1970s. I make work that luxuriates in space, and it takes up a lot of space.

I need room because of how light works in a space. Close-up inspection with light is very difficult—it becomes more of an object light. My work has more to do with "thingness" than most things do. That is, my work questions what it takes to make a thing, whereas others don't attempt to raise the issue. That's the most sculptural way it is. Basically, I don't think I work with sculpture because it feels to me to be coming out of a painter's eye in three dimensions. So, in terms of questioning what makes this object quality, I deal with that issue, whereas most artists just assume it. They have a thing, and they make a thing. They are making a thing out of something. I'm making something out of a thing to which we don't normally attribute thingness.

EAK: You make something from nothing—an illusion?

**JT:** Yes; however, I don't think it's all that illusory. Although light exhibits wave phenomena, nevertheless it is a thing—it is optical material. But we don't treat it as such. Instead we use it very casually to illuminate other things. I'm interested in the revelation of light itself and that it has thingness. It alludes to what it is, which is not exactly illusion.

I'll give you an example. We tend to think the sun rises. In fact, the earth is actually sinking or spinning down the other way. You probably have been in a train when the train next to you moves, and you feel like you're moving, but you're not. It just appears that way. At Roden Crater, I have one space where I remove all reference to level, so your only frame of reference is the stars in a circular opening. Actually it's elliptical, but you see it as circular. That's your frame of reference, so the strange thing is that you feel yourself tilting in reference to the stars. You can say this is an illusion, but that's actually what's happening. To get that sensation you have to have a different quality of light. In that way, it's not illusion, because that's the reality.

**EAK:** In 1966 you leased the Mendota Hotel in Ocean Park. For two years you sealed up its rooms, painted out the windows, closed off its doors. This pivotal work became known as the *Mendota Stoppages*.

**JT:** That is where I made the first series of projection works. When you seal up a space, it can get a little stuffy, and if you open anything, light will come into this perfectly bare room in a very strong and amazing way. I then began to open up the space, particularly at night, to different areas of light. All forms of light were available—the path of the moon, cars, street lights, and shop lights. I made a series of spaces where I could change the space by virtue of how I let in light. I made a whole new space out of the same physical space, which remained the same, although that's not what you encountered perceptually. The example I like to give is the experience of sound when you are wearing good earphones or have a good stereo system. You find yourself in a music space that's larger than the physical space you're in. It's the same when you're reading: you become so engrossed in the book that you're more in the space generated by the author than you are in the physical space where you are sitting. This extension to so-called "real" space is the space that we operate in all the time. Just look next to you at the stoplight and see that kid rocking back and forth with the music on. Is he in the same space you are? I don't think so. This extension to the physical, awake state, a kind of daydream space that we superimpose on it, is the space that we should really discuss, because it's actually the space of our reality. The arts, without a doubt, extend these spaces, whether it's in literature or in music or visual art.

**EAK:** Were the experiments at the Mendota Hotel the beginning of your journey into researching light?

**JT:** The beginning of my lifetime investigation of light began in those Mendota spaces, but more specifically with the *Projection Series*. It was the ability to change the space itself by how light enters from the outside that began to extend my ideas and art practice. It also spread into its space-making abilities in terms of seeing the physical confines as having little to do with the space that you could involve and activate. The more architecture begins to do this—

*Orca*, 1967, as installed in 1998.

and there are a lot of ways to activate that, not just with light—the more it will extend our being. Right now, architecture is caught up in fashionable signature structures.

**EAK:** Several site artists from the time you began working, including Robert Irwin, Michael Heizer, and Robert Smithson, felt that science and technology propelled them to look beyond the earth.

**JT:** In the late '60s, I became interested in James J. Gibson's idea of ecological psychology. Learning to work with this material, light, to affect the medium of perception was something that I had to get used to. My technology is extremely simple. My work might inform a scientist about art, but it doesn't in any way raise notions of science or technology.

Light is something that I had to learn how to mold and form, because it isn't formed with the hand like clay or hot wax. It's more like sound. You make instruments to create what you want. I learned to do that by trial and error. I used a big projector, and at first, it was really hard to form and control light. Gradually, I began to understand light as a substance that I could shape. I could see the evolution in the work. However, neither science nor technology influenced how I learned to work this material. The late '60s and early '70s were a contradictory time. On one hand, we were going to the moon, and anything was possible. On the other hand, despite technological advancements and euphoric attitudes, we were conducting a war in Vietnam and my generation was up in protest. Also, artists were zealously idealistic in thinking that people were going to buy and collect ephemeral work. There were a lot of losses along the way for artists who had amazing and wonderful talent but nowhere to actualize their ideas.

**EAK:** What expectations do you have of the viewer?

**JT:** I don't have great hopes for the viewer. As I said before, I'm dealing with an idealized viewer. If you come up to that, fine. If you don't, that's your business not mine. Many people seek to like what they're going to see—this is a terrible misunderstanding between artists and viewers. In no way do most artists I know seek to affirm the public's taste. If anything, we try to push the envelope—change it, mold it, and hopefully destroy it. I don't think that you should have any other expectations than you do when you go to a movie—you go because you are interested. Think about this: we go to the doctor's office and an hour or so later we're still reading two-year-old magazines.

Despite the wasted time and the fact that it's going to cost you, you still patiently wait and at the appropriate time remove your clothes, lean back, and completely submit. We submit in a lot of places in our lives. If you can't submit to art, to hell with you. You don't have to do this, and if you don't want to do it, don't even ask me or bother me—I'm really not concerned. I feel that my art is genuinely benign; however, I have had problems and lawsuits. Placing work in public is risky, but artists have to do it.

EAK: Why were you sued?

JT: Someone fell to the ground in a piece at the Whitney Museum—because of the perceptual effects. It's written up in *Art Law*, and it is a very interesting case. The woman who fell happened to be the wife of the Oregon Supreme Court Chief Justice. Her testimony is literally this: "There was this wall, actually it was a receding wall, I leaned against it, and it wasn't there." I have to say that these things do have a feeling of materiality and solidity, but it still looks like light to me. They possess a quality that accords materiality to light, but I don't think it substitutes for some opaque solid surface. I can come up with this different viewpoint partly because I don't function in the same situation as the general public—I am the maker not the observer. This is essentially a problem shared by all people in art. There are other situations in which the actual physicality of art, whether it's a work by Richard Serra or monumental construction by Mark di Suvero that moves, can actually injure someone. However, my work is just light and space. I think that people really ought to stand up to contemporary art. If they can't stand up to contemporary art, what can they stand up to?

EAK: What convinced you to purchase Roden Crater?

JT: I saw it as an occasion to embark on the kind of work that I always wanted to do; its expansive site posed numberless opportunities to experiment with light and perception. I decided on it in 1976 but couldn't buy it until 1979, when I bought an option to buy and then sought the funding. The Dia Foundation purchased it. When Dia failed for awhile, they returned the crater to me. I had to get financing for the surrounding ranch land. However, one can't get a loan in Arizona on vacant land. So I got a loan as a cattle rancher. Curiously, I used agriculture to fund art. The Skyspace Foundation was founded so I could accept the crater portion from Dia. Now Skyspace owns the crater.

EAK: The crater is an extraordinary place. Its extinct cinder cone appears to be dead, yet you've brought new life and meaning to this barren and quiet spot. How long do you think a viewer will need to spend at Roden Crater in order to experience it beyond a superficial spectacle level?

JT: The main thing is to make a journey, so that you go to something purposely and have time to settle down and empty out the noise and distractions of daily life. Often we can shift gears more quickly in places such as a church or a library—perhaps because they are designated places of silence and reflection. Most people by the time they arrive at the crater are pretty well set up for it. It would be wonderful if visitors could spend at least 24 hours, but it would be better to stay longer.

**EAK:** When I was sitting in *Skyspace*, I wondered why the very intense yellow light was chosen to illuminate the interior in contrast to the open sky.

**JT:** It is normal tungsten light that we've used in our houses for years. It was chosen in relation to the quality of blueness in the sky. There are different interior light choices in each of the pieces, but mainly we have the light on all the time, and you don't notice it much during the day. But then as the light changes outside, the light inside affects the scene through this opening.

**EAK:** Does this operate in the various chambers at Roden Crater?

**JT:** Only a few are like that. There are different combinations of light from inside to outside. There are places where you are changing as you come into the light, as in the dark spaces. There are places where the light is changing. There are also other places where the light inside is not changing, but the light outside is, as in *Skyspace*. And then there is space where everything is changing, as in *Rise*. I mixed it up in terms of the time-making quality. Sometimes we make the time, but other times things are slowed down and something else makes the time. Time plays a crucial role in this work. I like things that take place over time, but then it's interesting to know which things are stable or staying the same and what is changing. They all have that sort of a time sense, or sensibility.

**EAK:** Have you ever considered yourself as a type of a shaman? People have to slow down and step into a different mind-frame if they really want to experience your work. Perhaps you are trying to show people that there's another side of life. Is light symbolic for something other?

**JT:** I don't traffic in symbolism. I'm no more a shaman than any other artist. Part of the role of the artist is to direct attention and to precipitate change. It can also just be to make a nice piece. That is enough, definitely enough. In terms of spiritual context, I think you'll find quite a bit of that across all the arts. Think of the work of artists and architects in constructing grand cathedrals or monuments, places such as Chartres, Notre Dame, or St. Peters. In some way, art has suffered for it a bit. Architects today get to make their cathedrals not as religious centers but as signature art museums. That's one of the problems with religions—they've had this sort of brand name attached to them. Artists are dealing with different presences and powers, and this has always been true. It's no more or less true now than at any other time.

**EAK:** Your work runs counter to our society's attention span and to the art world's need for trends.

**JT:** Someone has to do that. Maybe I just can't keep up with constant change. I'm a slow guy. I like slow planes, so you can land in many places. There's also a measure of safety if you land where you would crash. In a way, that's true with art, too. Things that require more time give more back. I think it's OK to take time. It seems more direct, actually.

**EAK:** Because of the absence of specific subject matter and your use of pure space, light, and color, some people have compared your work with that of Josef Albers, Agnes Martin, and Mark Rothko.

**JT:** When you make the subject matter light and essentially use it as a pure entity, then you are showing its primal power. That is what the artists you've mentioned do. In *Gasworks*, light is the content and the form. However, if you then take light and try to use it to tell a story as film does, you lose all the power of the light.

**EAK:** It seems as if some of your earlier works were prototypes for the concept that architects are beginning to investigate regarding the consequence of light vis-à-vis space and form.

**JT:** There are some places that my work may inform architecture and is informed by architecture. I like places that you can enter and feel the presence of light permeating throughout. That bespeaks architecture, as does Plato's cave. These things for me are analogies for perception. We are housed in the structures we create. In that way we're like hermit crabs. We adopt one space, and then we go out and get into a movable one, a car, and we get out of that and move again into another one. It's something humankind is very good at doing: we make shells. We are probably as aware of the shells we make in forming cities as the coral is aware of making the Great Barrier Reef. Recognizing what we are and that we have these modes of perception and protection, I'm interested in how we open those things out to perception and where we locate certain spaces within our dwellings. For instance, we tend to put the kitchen on the eastern side of the house in a single-family dwelling. I certainly am interested in what architects do. Still, I'm an artist, and I play a very different role when it comes to space, light, and structure.

**EAK:** Do you feel that cities might be more livable and pleasant places if more attention were given to light?

**JT:** Yes, and fortunately that change is slowly becoming a reality. I remember seeing mercury vapor lights when I flew over L.A., and now it's all gone to sodium lights. The mercury vapor lights were greenish-blue, and now the illumination is a type of orange light because it's more efficient. But it's not a good quality of light. This will change again because of need and efficiency.

Eventually, we'll begin employing light that is changeable. We'll be able to select it knowingly, and, hopefully, traffic engineers who see light only in terms of the color wheel will not dictate city lighting in the future. It'll be pleasant to interact with a different type of light—it will make a big difference in the comprehension of our environment, as well as our attitudes.

# Exterior Form/Interior Substance: Xu Bing

**by Glenn Harper**
**2003**

In his native China, Xu Bing began his career with innovations in printmaking and with some of the first Chinese installation art, including what is perhaps his best-known work, *Book from the Sky*. He had been sent to the countryside by the Chinese government for re-education in 1974, and his experiences in a farming community are among the threads brought together in his subsequent work. Other important concerns in his work include the relation of language to experience and the nature of writing. His installations have been exhibited widely in China and the West, including Finland, Australia, and the United States, and he was the subject of a 2002 exhibition at the Arthur M. Sackler Gallery of the Smithsonian Institution. Xu now divides his time between China and New York.

**Glenn Harper:** Your sculpture and installation work seem to grow out of your sense of process in drawing and printmaking: printing a calligraphic text by carving a printing block, then presenting the printing block as sculpture. (The original root of the word "sculpture" in European languages is "carving.") You also present the tools of the calligrapher along with the scroll in *Book from the Sky*. Is this a conscious growth from two-dimensional media to three-dimensional media?

**Xu Bing:** My formal training as an artist was in printmaking, this is why so many of my works are related to printing. In fact, the printing process is the exact opposite of the sculpting process. Printmaking is about taking a material with elevations and recesses and printing from it so that a three-dimensional form is transposed into a two-dimensional form. It is true that the process by which an artist prepares/carves the material to be transformed into a print contains elements of sculpture, but in printmaking this constitutes the midpoint rather than the endpoint. Still, your observation is interesting—that this preparatory stage of print-block carving could be seen as related to early sculptural art.

In my exhibition at the Sackler Gallery, the implements and materials involved in the production process were exhibited with the artworks. But this set-up had nothing to do with considerations of two-dimensionality versus three-dimensionality or anything like that; it had to do with the overall concept of the show. The Sackler is famous for showing traditional Asian art. Museum officials and the curator chose me to be the first contemporary Chinese artist to have a large-scale solo exhibition there in part because they wanted an exhibition that would act as a bridge between traditional and contemporary art, that would show connections between them and also create an opening for greater focus on contemporary Asian art in general. In the planning and design stages, I thought a lot about how to take advantage of the particular [physical and cultural] qualities of the museum, so that the concept would include not only the installations themselves, but also the entire staging of this kind of art in this kind of museum. This is reflective of my work as a whole, because in my pieces traditional crafts, techniques, and materials co-exist with contemporary conceptualism. You could say that the traditional exterior is a kind of costume, as in the written characters I invented whose exterior form and interior substance are completely different.

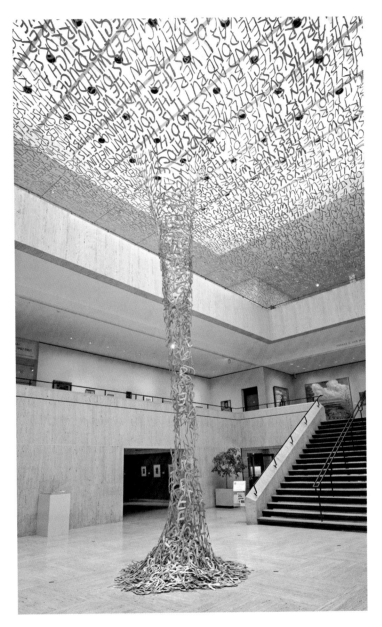

*Glassy Surface of the Lake*, 2004.
Aluminum letters and wire composing a passage from Henry David Thoreau's *Walden*,
installation at the Chazen Museum of Art, Wisconsin.

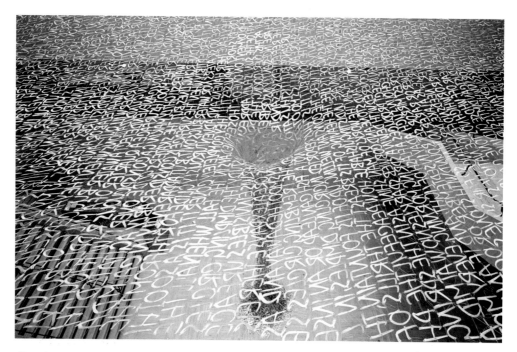

*Glassy Surface of the Lake* (detail), 2004.

The implements and materials I used to create my works look like traditional cultural objects, and they were, in fact, exhibited alongside genuine cultural artifacts from the Sackler's collection. This enhanced their falseness and gave rise to questions such as, "What is the true value of these objects?" and "What makes something modern?" Within these false objects, tradition and modernity are mixed together. That's why viewing these works from a simplistic dialectical perspective—that non-traditional equals modern—is to misapprehend them, because the point is that the traditional and the modern/contemporary exist within a state of constant and mutual transformation—you are within me, I am within you.

**GH:** Chinese viewers experience *Book from the Sky* differently from non-Chinese viewers (seen as text, but then apprehended as illegible), and the reverse is true of *Square Word Calligraphy* (apprehended as illegible, then becoming legible for English speakers). Does this shift reflect a change in your thinking?

**XB:** *Book from the Sky* and *Square Word Calligraphy* have different effects on people from different cultures, but the entry point is essentially the same. In both, the invented characters have a sort of equalizing effect: they are playing a joke on everybody, but at the same time, they do not condescend to anybody. For example, there is no one on earth who can read and comprehend the characters in *Book from the Sky*, myself included. *Square Word Calligraphy*, on the other hand, exists on the borderline between two completely different cultures. To viewers from

these two cultures, the characters present equal points of familiarity and of strangeness. A Chinese person recognizes the characters as familiar faces but can't figure out exactly who they are. To a Westerner, they first appear as mysterious glyphs from Asian culture, yet ultimately they can be read and understood. When I've lectured on my work people have asked, "Do Chinese people find it offensive that you've restructured Chinese into English?" And I've answered, "To the contrary, Chinese people should praise me for having restructured English into Chinese." The absurdity of *Square Word Calligraphy* is that it takes two different words from two completely unrelated language systems and fuses them together into one entity. If you use existing concepts of Chinese or English to try and read or interpret these characters, you won't succeed. This total disconnection between outer appearance and inner substance places people in a shifting cultural position, an uncertain transitional state.

**GH:** Are the characters in *Book from the Sky* derived from traditional calligraphy?

XB: On the surface, the false characters in *Book from the Sky* look very similar to traditional Chinese logographs. I chose to pattern them after the classic Song-style characters traditionally used in printing. This style of character was created and refined over a period of several centuries by traditional craftsmen, and it came to be adopted as the standard script for book printing because it is easy to carve and extremely legible. Consequently, it also came to be viewed as the most representative style of Han script. Once words are printed, they immediately gain recognition and legitimacy. These characters are devoid of any kind of personality and thus have no concrete implication or emotional significance. In *Book from the Sky* I wanted to create a huge, empty space free of meaning and content, without giving people any hint of specificity.

**GH:** When you began *Book from the Sky*, did you have Western ideas about language in mind? (The work seems to Western eyes to reflect notions of language from Nietzsche to Derrida.)

XB: Quite a few interpretations of *Book from the Sky* have made comparisons with contemporary Western philosophers, particularly Foucault and Derrida. In 2000, the Albany Public Library organized an exhibition called "Book-Ends: Imag'in'ing the Book—The Work of Xu Bing" and arranged for Derrida and I to lecture together, an event that attracted quite a large audience. People said that they found it interesting to have Xu Bing and Derrida "installed" in the same space. I remember saying to Derrida: "Although so many people have used your theories to interpret *Book from the Sky*, I had never read any of your books at the time I was working on it. If I had read them, maybe I wouldn't have bothered to continue. It would have been clear that there was no point in making anything ever again."

*Book from the Sky* was created in China in the mid-1980s, when information about modern Western thought was still very fragmented. The trendier academics would mention names such as Nietzsche in their lectures, but what they had to say was usually pretty vague. The primary materials that influenced my thinking were works of traditional Chinese philosophy and studies in the cognitive sciences. Another factor was my own understanding of culture and my reaction against the "cultural fever" that was sweeping over China at the time. This was the post-

Cultural Revolution period, and a long-denied yearning for knowledge had become an intense thirst for information.*
My feelings also had a lot to do with a strong identification with the Zen teaching that "words are unreliable." Actually,
the ideas of Western contemporary philosophers such as Derrida have surprising areas of similarity with Zen philosophy.

**GH:** You often refer, in your texts and interviews, to Zen or Chan Buddhism, especially in terms of its goal of upset-
ting habits of thinking. Is that sort of "defamiliarization" (to use a term from Western philosophy of language) your
goal in your works?

**XB:** That's correct. No matter what outer form my works take, they are all linked by a common thread, which is to con-
struct some kind of obstacle to people's habitual ways of thinking—what I call the "cognitive structures" of the mind.
These obstacles derive from intentionally mixing up different received concepts to create a sense of estrangement and
unfamiliarity. People construct concepts based on their familiarity with particular phenomena: thus concepts are really
just the product of cognitive habits. It's convenient to use fixed symbols to communicate and to act according to cer-
tain concepts. You could say that so-called intellectuals are just composites of a multitude of symbols and concepts.
It is just those people with the strongest cultural concepts who have been most discomfited by my work, and as a result
the most affected by it. This discomfiture and inability to grasp the situation force you to reorganize and readjust your
preconceived notions. Habitual ways of thinking are disrupted in the process of seeking a new basis for interpretation
and understanding. The laziness of habitual thinking is challenged, and the result is the opening up of a wider, untapped
cognitive space in which to rediscover long-forgotten, primary sources of cognition and understanding.

This approach is related to a kind of Zen training of the mind to receive enlightenment. The Zen term for it is *koan* [in
Chinese *gong'an*, meditation theme], a dialogue in which an answer is given that defies logic. One famous *koan* has the
student asking, "What is Buddha?" The Zen master replies, "Three bushels of hemp." In pondering how the Buddha can
possibly be "three bushels of hemp," the student's thought processes fall into a great empty space, without any kind of
support or foundation. Then one day he breaks through to enlightenment with the realization that the essence of Buddha
exists in every moment and every aspect of life. The Zen approach to enlightenment forces you to open up your mind in
the midst of something that completely goes against logic and common sense—in this way one achieves wisdom.

**GH:** The process of making *Book from the Sky* seems repetitive in a way that suggests a meditative or Buddhist
approach. Is that accurate in regard to your experience of making the work?

**XB:** Creating *Book from the Sky* was a process of great seriousness and commitment. This attitude was necessary
to the work, and it was also necessary to me psychologically. From the beginning, I was very clear about the impor-
tance of being completely serious, because when you take a pretense to the extreme, earnestly behaving as though
it were real, then true absurdity emerges and the power of the art is enhanced. Simply speaking, *Book from the Sky*
is a joke, a humorous gesture. But the idea of a person putting four years of intensive effort into constructing and

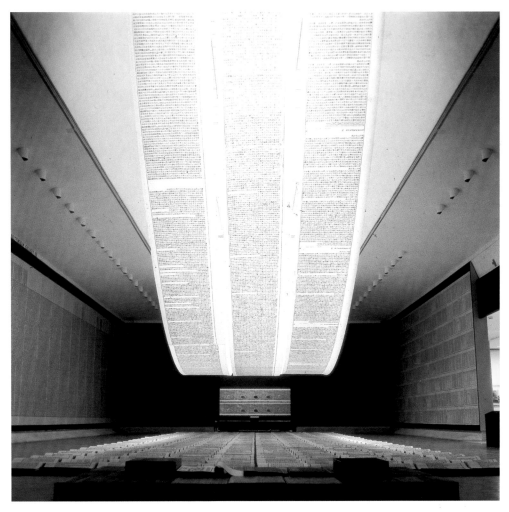

*Book from the Sky*, 1987–91.
Hand-printed books, ceiling and wall scrolls, and false character blocks, installation view.

completing a joke—this act in itself constitutes the substance of the piece. You have years of toil and the most intensive attention to detail going into the creation of "something that says nothing." So this work is also a contradiction: in deconstructing and satirizing culture, it also positions culture as something to be taken very seriously.

My personal need to create the work was also related to a particular cultural condition and moment, prompted in the first place by my reaction against the post-Cultural Revolution "cultural fever" that I spoke of earlier. I participated very actively in this trend: I was reading a lot and constantly engaged in discussions, but somehow I was falling too deeply into it, getting lost in it. I was increasingly put off and disappointed by the game of books and cul-

ture, like a hungry man who had eaten too much too fast and was starting to feel sick. It was as though I was stuck in some kind of video game loop, just going around in circles without achieving anything. My mind was confused, and I felt like I had lost something. I thought, "I need to make my own book to express my feelings toward books. I need to stop this endless game and do a concrete piece of work. I need to return to a calm, undistracted state of mind." And every day when I worked on those "meaningless" characters, it was like having a dialogue with nature. There was no intrusion of knowledge or of argument. My thinking in turn became clean and clear. This was not about creating a piece of art, but about entering the realm of meditation.

**GH:** How did your experience in a traditional Chinese art school (focused on established models, drawing, and print-making) lead you to works that focus on three-dimensional forms and ideas of language?

**XB:** You're the first Westerner to ask me this question, although in China people have often asked about this. That's because in Chinese art circles people know that I have a very good foundation and understanding of traditional art and methodologies. My early works were very much built on that foundation, so when I began to incorporate more modern ideas and approaches, many people expressed regret because they felt I was taking a wrong direction. But for me that kind of change is natural. From 1984 to '87 the intellectual climate in China was extremely active and vital, yet in those years I didn't do any significant piece of work, because nothing I did felt right. Reading books and thinking about issues is one thing, but trying to make art is a different story. To me, creating art is the expression of one's sensitivity toward the state of society and culture, which leads to a redefinition or re-creation of the existing methodologies. When society changes, thinking changes, and, naturally, art changes as well. One doesn't have to think about issues of modernity or whatever. Traditional Chinese painting theory expresses the idea that "the style of the ink-and-brush should change with the times."

As a result of my study of printmaking, I became fascinated with the concept of repetition. This was the subject of my master's thesis [at the Central Academy of Fine Arts in Beijing], and I also did a series of works based on the concept of repetition, which became the precursor to *Book from the Sky*. In fact, the visual impact of *Book from the Sky* is very much related to the repetitive quality of the printing process. Another major factor that influenced the change in my artistic direction in the mid-1980s was an exhibition of North Korean painting shown in Beijing. Most of the works were in the style of Socialist Realism, all bright flowers and smiling faces looking up at the Great Leader. Those works were like a mirror clearly reflecting what our own artistic environment in China had become. It was an opportunity to experience the realization that this art was a lot less intelligent than the eyes that were looking at it. I knew that I had to walk away from that kind of art and do something new, my own kind of art. But what shape this new art might take I didn't know. In China at that time there were no clear signs for someone who wanted to do contemporary art. Thinking about it now, I feel that the state I experienced of having left one place but not yet knowing the next destination was actually a pretty good situation to be in. That unclear, uncertain terrain has become a space where my art can grow and develop.

**GH:** *Book from the Sky* gave at least some viewers the impression that it was political commentary. Does this political interpretation distort your original intention, and has your own idea of the work evolved in relation to its reception by the public and by official institutions in China?

**XB:** Since the first exhibition of *Book from the Sky* [in Beijing] in 1988 there have been a number of interpretations, and they tend to vary according to the times. Before the Tiananmen Square incident of 1989, most readings of the work were positive: the general thinking was that the appearance of *Book from the Sky* was a sign that Chinese artists were finally beginning to produce modern art that would allow for a dialogue with the West. But after Tiananmen, the work became the focus of criticism. It was denounced as being "the prime example of the 10 wrong tendencies in new art." When *Book from the Sky* was first shown in the West [in 1991], most interpretations were also from a political standpoint, but later there was more focus on social, cultural, linguistic, and philosophical implications. As an artist, I don't usually think about political factors when I create a work; I am focused on more concrete issues—the methodology I plan to use, what techniques will work best. But at the same time I believe that since Chinese society is such a politically charged environment, and since I grew up in that environment, it is unavoidable that political elements will emerge in my work.

**Note**

\* Translator's note: The period was marked by a surge of interest on the part of Chinese intellectuals in traditional Chinese art and philosophy, as well as in modern Western culture, since contact with both had been highly circumscribed or forbidden during the Cultural Revolution.

Xu Bing's responses were translated by Valerie. C. Doran.

# The Relationship Between Thought and Matter: Antony Gormley

**by Ina Cole**
**2003**

Antony Gormley is one of Britain's most important contemporary sculptors, and installations of his work have taken place all over the world. In the 1980s, he pioneered the concept of casting the body in a variety of poses to evoke universal ideas relating to the human condition—a subject that remains a major theme in his work today. Gormley's sculptures range from the diminutive to the monumental. In *Field for the British Isles*, 40,000 miniature terra-cotta figures face the viewer, and this myriad of watching eyes is a haunting and emotional experience. In contrast, *Angel of the North* stands majestically near the A1 highway in Gateshead, North East England. Poised as though preparing for imminent flight, it is one of the largest human images made since ancient times.

This is a particularly significant time for Gormley. *Planets*, originally commissioned 15 years ago, was recently unveiled at the British Library. *Domain Field*, a new installation for Gateshead, will use body casts of 200 volunteers from the local community. Much of Gormley's work fuses the primeval with the futuristic, and *Inside Australia* is an epic installation in which 50 gaunt, blackened figures infiltrate an area of seven square kilometers like an alien invasion.

**Ina Cole:** In the 1990s, you produced a number of iconic works, which have become imprinted on society's consciousness. *Angel of the North* and *Field*, in particular, spring to mind. How do pieces such as these inform your future projects?

**Antony Gormley:** It's great to make works that have a popular impact, but it's not the only criterion. Of course all artists want to be loved, or certainly seen, but I don't think just because something is seen by many people that it's any better than something that's seen by very few. What one's looking for is the depth of the contact over time. What I learned with *Angel*, which is viewed by about 90,000 people every day repeatedly passing at speed, is that every time it's seen it has to communicate something: it can't be a one-shot job, a slow bleed is important. *Field* also works in that way. It has an immediate visual impact, but then you need to spend time quietly getting to know your own reactions to it, and your understanding of what you're looking at changes over time. So these two works are benchmarks, two different ideas about extendibility in time.

**IC:** A new work of yours, *Planets*, has recently been installed at the British Library. Central to this commission are ideas of geology and time. Can you expand on this?

**AG:** *Planets* is an evocation of the relationship between thought and matter. That might be what sculpture is about, an attempt to leave on the face of an indifferent universe some trace of human presence—a sign of thought and feeling. I think that a standing stone is a very early example of someone taking a naturally made object and putting

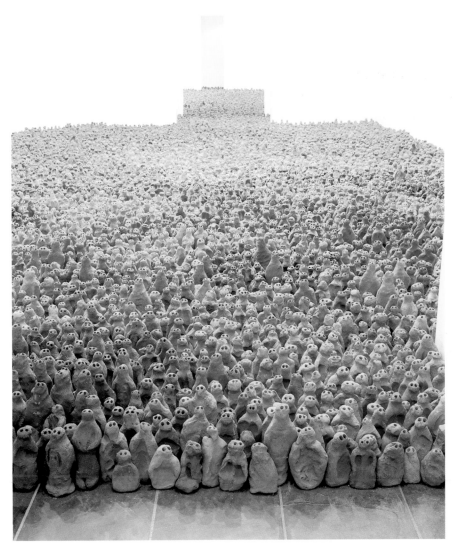

*Field for the British Isles*, 1993.
40,000 clay figures (approx.), dimensions variable.

it in a place where it becomes a marker in time and space, against which human life can be registered. I've taken that idea and made it more polemical. On the surface of eight ancient rocks (one of them is Cambrian, so it's about a thousand million years old, the rest are probably Devonian, about 350 million years old), which have themselves been formed by the action of several ice ages, I have carved the trace of the touch of eight different people, one to each rock. Each work is a testimony to a moment of lived time in which a living body and an individual rock were brought together. The bodies conform to the shape of the rock, as in Michelangelo's *Slaves*, rather than the other way around. That's very important; these are traces of people hanging on for dear life. It's an indication of the mind's dependency on the body and the body's dependency on the planet, and I think that has particular poignancy at the British Library, a depository of the fruits of human mental activity over millennia. Below these rocks lie shelf upon shelf of books—a sedimentation of the mind stacked like strata—and the rocks remind readers of our vulnerability and dependency on the physical world. There is a sense of time present contained in time future, time past contained in time present, that Eliot syllogism that sculpture can peculiarly engage people in.

Sculpture is silent, still, and in its best examples, it uses that quality to great effect in a world where everything is mobile. We need sculpture more now than at any other time, simply because it is a still moment in a moving world that asks the question, "What are you doing here?" You might also ask that question of the sculpture, but a good sculpture will always return the question to the viewer. The extraordinary thing about sculpture is how it can communicate over vast periods of time: I think that art has always been an attempt to make a bridge with what lies beyond the horizon of perception.

Stone has always been such an important material for sculpture because we sense that it comes from a time before mind. Now that we know the universe was created about five billion years ago, these rocks become messengers from a time before life. The challenge for sculpture is: How do you mark this material, which embodies the indifference of a universe to organic life that came so late upon it? Some of the most moving sculpture or art I know is not consciously art at all: the footprint on the floor of Peche Merle in the Dordogne—a 30,000-year-old petrified footprint of a young boy in the mud floor of a cave—or in the same cave, the outlines of hands where ochre has been blown around them, left like a sign across time.

**IC:** You are creating an installation for the newly opened Baltic in Gateshead. *Domain Field* will feature the casts of 200 people from the local community. You have been using your own body as a template since the 1980s, but how did you go about finding volunteers for *Domain Field*?

**AG:** Here I want to shift from bearing witness to individual identity to an engagement with the idea of the collective body. *Field* did it in terms of unformed, surrogate bodies—the virtual body as a potential, evoking speciesification prior to the development of humankind. Recently I've wanted to make works that deal with the local, the village,

and the second project I made after *European Field* in Malmö, called *Allotment*, deals very much with this. It's a collection of Modernist bunkers enclosing the exact dimensions of 300 living people from the city of Malmö. These bunkers are then used to make a virtual city in 15 blocks of around 20 rooms each, with two avenues and four cross streets. We used the media to ask for volunteers from between the ages of two and 95 to come forward and be measured.

At Baltic, I'm going to show *Allotment* in relation to this new work, *Domain Field*, which is an attempt to do what *Field* did, engage with the local community to make an evocation of the collective body. This time, it will be made out of the direct body molds of 200 living Gateshead people, of a similar age range as *Allotment*. A domain is a random matrix of stainless steel bars welded together to describe the space of the body, turning its mass into an energy field. It evokes the body through a structural principle that is neither architecture nor anatomy—it's more like the random matrices one might find in stochastic systems. When you come into the room you're not aware of individual forms, only that the whole room is filled with a mist of trajectories. Then, once you walk around them, you recognize the individuality of each work—the yearning energy and vulnerability of a child, the composed compression of an older person. I suppose that all of these projects are trying to make the everyday strange, so you see it again in a new way.

**IC:** You are one of seven children, so being surrounded by a community of people must be something you are used to. Yet you have said that as a child you had an overriding anxiety as to whether you belonged in the world at all. This is interesting in relation to the way that you position the figures in your installations—they often seem quite alienated from each other. Do you view society as a collective force, or is the reverse more appropriate in relation to your work?

**AG:** I'm intrigued by the twin facts of individuation—that we are all born with unique characteristics, but evolve through time and experience. We have a physical, genetic, intellectual, and emotional imprint that is all encoded, yet the individual is really only defined in relationship to others. My interest is in how these two models interact, because the shape the individual takes cannot be disentangled from his or her place within a collective, however mobile and interchangeable that collective may be. It's interesting being the last child in a large family because the possible spaces seem very limited. I was brought up in Hampstead Garden Suburb—a materialized ideal, a green nowhere, where everyone had their own perfect home, surrounded by a perfect garden in a street with perfect privet hedges, and people were civilized and wealthy. My family was more of the same; it was the '50s, the birth of the Nuclear Family. It was a well-organized organism, and to an extent I felt alienated by the way in which everything had been decided. There was not a great deal of room for originality. On one level I regret this, and on another level I think it was marvelous. It pushed me toward inventiveness, fantasy, and an attempt to try and do something that lay outside the expectations of this determined world. Having said that, I think my work continues to battle with these very issues about the social need for convention. We're at a point of crisis in terms of Western civilization,

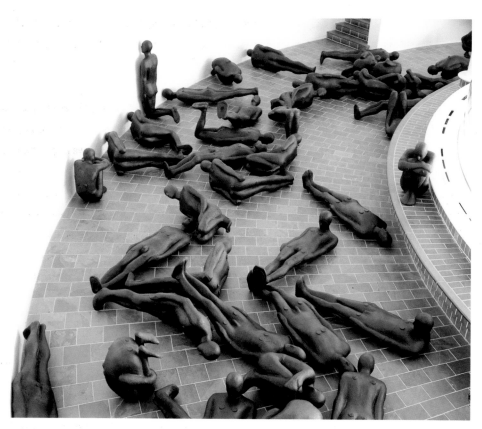

*Critical Mass*, 1993.
60 solid cast iron body-forms, installation view.

where it's very clear that in the exercising of the democratic ideal of individual liberty we are involved in a loss of community. I'm not saying this crisis is something art can necessarily heal, but it's certainly something art reflects—this tension between individual freedom and collective restraint. All of my recent projects have tried to make an analogue for the collective body; ever since *Field* this has seemed the most important task.

IC: Encasing your body with plaster has to involve an incredible amount of patience, both for you and your assistants. During the casting process you must have a heightened awareness of your physical state, the organic nature of who you are. Is being incarcerated in plaster a kind of temporary death, from which you are constantly reborn, a quest for immortality perhaps?

AG: Yes, obviously this is a passage every time I'm encased in plaster, every time I'm molded. It's a voluntary journey into the underworld and a rebirth, which has become ritualized and integrated into my way of living, a testament to a human life. It obviously means more to me if the work starts from a lived moment in real time and space and

uses my own physical existence as a tool, subject, and material. The process of casting is not prolonged, but it is an hour taken out of the continuum of existence. I use my own body not because it's me particularly, but simply because it's an example of a common human condition of embodiment.

I'm interested in the mind and body problem. In other words, that the body is finite, organic, and only capable of being in one place at one time, while the mind is capable of seemingly infinite extension into realms of imagination, which are not strictly speaking anything to do with the body. Yet the body is the place that we live; it's the material we have to deal with. Recently I've made a lot of work that deals with these issues of self and community of body and mind. From a very early age, I used to sit in the car or in trains and look out onto a '50s smog-filled London, look into lighted windows at dusk and think, "That could be my home, that could be my life," and I think I've transferred that to my sculpture. I realize that my life and my body are one possible location for human identity, and I like the idea that the sculptures are not representations of a particular person, but a potential place where life might rest. In a sense, they are all invitations for empathic inhabitation, from *Learning to See* to *Quantum Cloud*. By inhabiting the space of sculpture, you can in some way escape from your own condition into another's; through the works, viewers can experience feelings and thoughts they wouldn't otherwise have felt.

IC: People are clearly moved by your work. It has the power to evoke a host of different feelings, depending on the individual's own state of mind and life experience. Are people's reactions important to you, and do you take them into account when positioning figures for maximum impact?

AG: Sculpture for me is the most powerful way of transmitting and bringing out feeling in people. We haven't managed to evolve out of the need for transitional objects, which some people might call fetishes or totems, that in some way work as objectifications of our deepest fears or most potent desires, and sculpture can act as a catalyst for those feelings. There is no obvious place for sculpture to exist. One of the great attributes of sculpture is that it lives in the same space as we live, and what you have to do is somehow introduce the sculpture into that location in a way that is meaningful. By being a foreign body in space, something that is there on different material and structural terms to you, sculpture makes you more aware of your somatic experience, your own passage through space.

IC: Can you tell me more about your vast project for Western Australia?

AG: *Inside Australia* is an attempt to make an interior, as in the interior of a person. I agreed to do this project because Western Australia has some of the oldest rocks on the face of the planet. These Archean rocks are between 2.5 and 2.9 billion years old, so much closer than the stones of *Planets* to the Big Bang. In these rocks are to be found an enormous wealth of mineral deposits—uranium, iron, copper, and stranger, more recently arrived elements on the elemental table—iridium, vanadium, molybdenum, and titanium. I wanted to make a new alloy based on high-grade stainless steel 316 that includes as many of these new elements as possible, a kind of concentration of the elemental memory in these very old rocks.

The idea, then, was to use this material in the sodium landscape of an outback area, a salt lake, Lake Ballard, which is 70 kilometers long and 30 kilometers wide. Into it we've placed 50 sculptures called "Insiders." An insider is a residue, a kind of concentration of the body. We lost 66 percent of the mass and retained one third of the body volume, but only in one axis, so these stick figures are the same height as the original person, but vastly reduced laterally. The idea was to place the figures about 400 meters apart on this extremely white, optically acute, chemical landscape in the middle of the Australian summer, when heat shimmer is extraordinary, with the idea of dealing with issues about individual and community, the relationship of identity to place, and the idea of who I am and how that's constituted by others.

I wanted it to be a very physical experience. If we had succeeded in making all 100 figures you'd have had to walk about 42 kilometers to see the whole work. The idea of the piece is to provide a human measure for this geological landscape that allows viewers to walk out and sense their own bodies in space and time in a way they wouldn't normally. The site is fantastic. At the west end there's a raised mound about 40 meters high, from the top of which you can see most of the work, which covers an area of seven square kilometers. We would like people to go for 12 if not 24 hours, so they experience at least one sunset and one sunrise. The works are carbonized, so they are black stick figures that evoke, as in *Field*, the spirit of the ancestors, but also something futuristic, so that we are again put into the position of being strangers in a strange land, inhabited by evocations of existing human beings, so that we reconsider our own position.

IC: You have undertaken projects in Australia before. Is this one a permanent installation or situated only for a limited period of time?

AG: The future of this work is very uncertain. We surveyed a vast area of Western Australia before coming to the decision to use Lake Ballard as a site, and it would be a shame not to leave it there. However, there are all sorts of challenges to overcome. Who owns the land is a big question: the Aboriginal land claims underline the way this land was imaginatively inhabited, and this has now been destroyed by mining and pastoralism. These are the sensitive issues that the work reacts to and with.

IC: Do you feel that you have achieved your magnum opus, possibly with *Inside Australia*, or is there another project, unrealized as yet, which will exceed everything you have created so far?

AG: I don't know whether I believe in a magnum opus. Art is organic, unpredictable. A very small object can have a massive effect, completely changing people's perception about what is possible in art. Wait and see.

IC: You often speak of the space within the body in relation to your work. I assume you mean this psychologically as well as physically; yet most people do not feel that comfortable with their internal space. Do you think that apart

from our physical state there are different levels of existence, or do you think that we are purely organic matter, existing for a limited period of time, after which there is oblivion?

**AG:** It's difficult to know anything about what lies on the other side of death. It's another threshold we know very little about. Rather like the horizon, it's one of those things we dream about, what lies outside this stratosphere, and I don't want to predict. I feel the same sense of potential about what lies on the other side of life as about what lies inside the body. Darkness is often seen as a denial. It isn't. It's a zone of potential. People see death as the end of everything, but it could well be a beginning. It's an acknowledgment of the necessary relations between night and day. Most of the vibrant cultures of our time have managed to accommodate the notion of death within their notion of living. We live in a culture where death is the big no-no, the big trauma. The cult of youth and the cult of bodily beauty in some desperate way try to ignore the inevitability of death, whereas if you look at the great Meso-American cultures, Chan and Tibetan Buddhism, or the Egyptian Book of the Dead, there's no sense in which death was not acknowledged and celebrated in life. All of them in different ways have imaginative projections about continuity or the relationship between the living and the dead.

**IC:** We are living in a time of scientific advance and information overload, but the divide between excess and deprivation seems to be a widening chasm. Society is obsessed with the body, with not wanting to age and ultimately escaping mortality, yet people have never been more confused and dissatisfied. How hopeful are you for society's future?

**AG:** We're living in the Kaliyuga, the era of Kali, goddess of night, sex, and death according to the Hindus, and I think that just about fits. There is confusion, fear, but also an acknowledgment that in some way transformation is necessary. We don't know what the next state of human consciousness and human physical existence will be. It could be wipe-out; it could be total transformation. I like the idea that we have now globalized the world with the mind; the Internet is the physical manifestation of that. This is the noosphere, the encirclement of the globe by intelligence carried by the human organism. What that does in terms of the biosphere is not clear. It is evident that we need to transform our physical needs in order to achieve sustainability. We have a finite world with finite resources and the "there's-more-where-that-came-from" mentality will not persist without us becoming the agents of our own destruction. Transformation is absolutely necessary, and I believe that art is a zone in which we can imagine the necessary transformation.

# Simplicity of the Gesture: **Mimmo Paladino**

**by Laura Tansini**
**2003**

In his exhibition, "Paladino," at the Centro per l'Arte Contemporanea Luigi Pecci in Prato, Mimmo Paladino presented more than 100 works: large paintings and sculptures, drawings, prints, and new installations. For the artist, there is no distinction among these genres. Many of his paintings, large and small, include forms made with painted wood, papier-mâché, clay, pieces of organic matter (bread), bronze, and aluminum. He uses different languages in the same work. For the Prato exhibition, Paladino reinstalled several important works, organizing the parts in a new way. He played with a curved wall and lighting to give a work first shown at the 1988 Venice Biennale a more theatrical feeling than the original. *I dormienti* (*The Sleepers*) took on new resonance in the museum's amphitheater.

Paladino was born in 1948 in Paduli; he lives and works in Paduli, Milan, and Rome. In 1969, he had his first solo exhibition. In 1980, he was invited to participate in the "Aperto" section of the Venice Biennale curated by Achille Bonito Oliva, who used the show to launch his concept of the "Transavanguardia"—a movement that included Francesco Clemente, Nicola De Maria, Enzo Cucchi, and Sandro Chia. Since then, Paladino has shown internationally in galleries and museums. His outdoor projects include the permanent installation *Hortus Conclusus* (1991–92) in the Cloister of San Domenico in Benevento and the temporary installation *La montagna di sale* (*Mountain of Salt*, 1995) in the Piazza del Plebiscito, Naples—a constantly changing terrain, reaching as high as the church of San Francesco di Paola, in which he placed many of his bronze horses.

**Laura Tansini:** Your earliest paintings date to the beginning of the '70s, but it is only in the '80s that you started making sculptures. What led you to sculpture?

**Mimmo Paladino:** I would say the curiosity to experiment with materials that were unknown to me. This has always happened in my work. For me, trying a new material and accepting the challenge are always an interesting start.

**LT:** Many of your paintings are not simply color on canvas; they include small sculptures, pieces of painted wood, papier-mâché or clay reliefs, and found and readymade objects—as in *Film* (1985) where you used a bicycle. It is as if canvas and colors were not enough for you.

**MP:** For me, the gesture to get an object and include it in the painting I am making has always been very natural. I learned it in art school and from other artists older than myself: do not forget that when I was 16 in 1964, I saw the work of Rauschenberg and the other American Pop artists at the Venice Biennale. At that time, I was shocked by their "gesture," their freedom to include anything in the painting. In the '70s when I started painting, it was natural for me to assemble objects on the canvas.

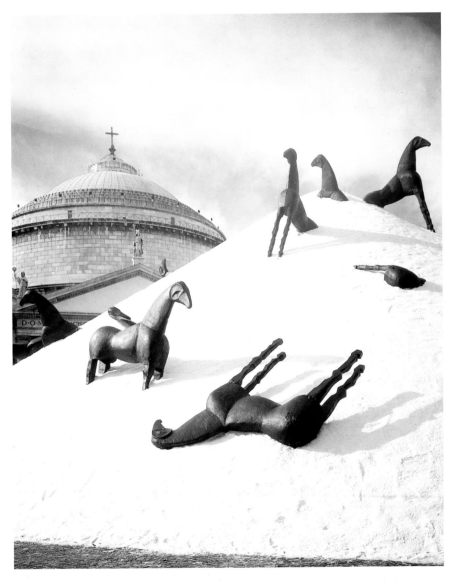

*La montagna di sale*, 1995.
View of installation at the Piazza del Plebiscito, Naples.

LT: Is there a difference between assembling objects on a canvas and making a sculpture?

MP: When I made my first sculpture, *Giardino Chiuso* (*Closed Garden*, 1982), I did not assemble found objects because I already knew that process, it was an experiment I had already experienced. What challenged me was to experience a new process and to start a new adventure, to walk a new road on unknown ground. I was curious to experiment with my capability to create a figure, an image, that before anything else was a plastic form. Looking back at the sculpture of the 20th century, I found the works of Arturo Martini very interesting, because they are first of all architectural forms. In my opinion, a sculpture is a plastic form, therefore it is much closer to architecture than to painting, much nearer to drawing, which is a language very familiar to me. I consider myself more a draftsman than a painter, even when I am painting.

Thinking of a sculpture, I "draw" it using the material instead of the pencil, without preparing the project in advance. I went to a foundry in Pietrasanta where I made the framework of the image I had in my mind, a sort of Charon on a boat—an archaic image that had to be architectural. A plastic form for the quality of the material but an architectural form for its volume in space, as in the works by Martini. When I make a sculpture, I am interested in building the form, not in modeling or carving. I am interested in a form built on a frame, as architecture, in respect of the need, the exigency of volume, space, and geometry.

LT: Although you are a contemporary Western artist, your sculptures have an archaic aura. They seem to be outside time, outside any cultural definition, outside any geographical specification.

MP: I think that there is nothing new in the work of the artist. Since the first beginning, artists always felt the need to occupy a space, a vacant surface, a volume—to make a "sign," to leave a "mark." When do you think the sign, "the reading" of the sign, becomes universal? In my opinion, it is when art—more than the artist himself—turns to primary elements, to the simplicity of the gesture, and not when art becomes an intellectual exercise whose target is to serve an ideology. That is also art and can be interesting, but I think that only when art uses a primary language is it eternal, undated, and understood by everyone. I am interested in an art that finds and interprets the root of humanity. Humanity has no cultural or geographical differences. I think that this form of art is the only open, free, universal art that "speaks" to everyone.

LT: Your figures represent humanity, not a single person.

MP: My figures are archaic "signs." Their faces are faces without any expression. When archaic man wanted to represent himself he used a trunk and made a ball of clay for the head, as children do. I am not interested in anatomical and expressive details; I am not interested in representing different noses and hair or if the person is smiling or laughing—all that does not matter to me. I think that to transfer, to communicate the essence of the message, the sign has to be essential. My forms are essential and archaic.

LT: Tell me about your relationship with your materials. Which one is your favorite?

MP: Many. I like wood; I often use pieces of it in my paintings. I also tried to carve a trunk, but it was too difficult for me and I let it go.

LT: I do not think it was a question of difficulty, the point is that you are not interested in carving.

MP: Maybe you are right, as I told you I like to draw and to build.

LT: Before a new sculpture do you prepare a model?

MP: No. When I make small sculptures for my paintings I use what I can find at that moment in the studio. I follow my inspiration. When I make big sculptures I work with clay or papier-mâché without preparing a model. I create the sculpture while I am making it. I draw a conceptual model when I use stone, because the basic work is done by others and they have to know exactly what I need. My stone figures are geometrically drawn. I intervene at the next stage when the stones are as monoliths. I finish them by adding my symbols (the little bird, the coffee cup, the dog, the horse) and marking or polishing in special ways.

LT: You use not only clay, papier-mâché, wood, and stone, but also iron and bronze.

MP: Yes, I cast some of my figures in bronze, though I do not like bronze so much. For many of my works, I cannot picture them cast in bronze. But sometimes it is necessary. If I have to use metal I prefer iron, but it is difficult to cast. *Il Carro* (*Cart*, 1999), *L'Elmo* (*Elm*, 1995), and the figure covered by birds, *Caduto a ragione* (1998, the title comes from a proverb that means "it happened at the right moment"), are made in iron. Clay, papier-mâché, and iron are the materials with which I prefer to work.

LT: You exhibited many of your sculptures at the Centro per l'Arte Contemporanea Luigi Pecci. Some were placed outside, and you created a new installation in the amphitheater for the terra-cotta work *I dormienti* (*The Sleepers*, 1998).

MP: Outside the museum I placed *Zenith* (1999), a bronze and aluminum horse with a prism on its back. To make it, I followed the old process: I built an iron and wood frame, and then I used clay. As with all of my images, this horse is the essence of the idea of a horse, without naturalistic references. Another outdoor work is *Assediato* (*Surrounded*, 1999). Inside the museum is *Il Carro*, and in the amphitheater are the new installations of *I dormienti* and *L'Elmo*. All of the forms in *I dormienti* are made from a unique form, but they are different because the original was broken, changed, cut, and new pieces added in order to create them all different one from the other.

When I planned the exhibition, I thought to display *I dormienti* inside the museum; but once I was there, I understood that the amphitheater was the perfect place. I positioned the sleepers on different levels and put the big *L'Elmo* on the highest level, giving it a dominant position. Now because of the new installation, *I dormienti* and *L'Elmo* become

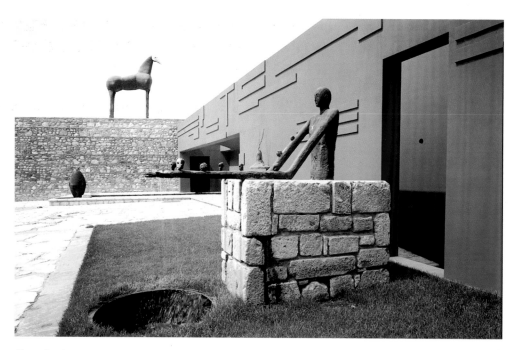

*Hortus Conclusus*, 1991–92.
View of installation at the Cloister of San Domenico, Benevento.

altogether a new work. The form and position of *I dormienti* remind me of people from Pompeii captured in the erup-tion of Vesuvius—an image that I have in my memory, an image that reminds me of death and sleep. Sleeping is the natural, archaic, universal "gesture" of humanity. As is death. All of my works, all of the images in my paintings and sculptures, are essential archaic signs.

**LT:** In your works, there is an archaism of eternal forms, but also a sort of heroism. The big elm in the amphitheater reminds me of a mythological hero.

**MP:** It is not heroism; it is the symbol of heroism. I do not represent heroism. I try to communicate the essence, the spirit of heroism. An oversize archaic elm reminds us of mythological heroes. It reminds us of the spirit of Achilles and of Hector. Besides, I think that an artist has to have a sort of heroic boldness. For an artist to prepare a new exhibition is metaphorically going to the war. He goes with all his instruments and weapons, he pitches camp, he faces and challenges judgment, sometimes he is misunderstood—but he cannot help doing it, he cannot escape his destiny to fight, to make known his ideas, his utopia.

**LT:** One of the sculptures in the exhibition, *Senza titolo* (*Untitled*, 2001), is a large prism, a geometric sign whose meaning is difficult to understand.

**MP:** The prism is the most complex geometric form. The Renaissance painter Paolo Uccello used the prism to study perspective. I added to the prism the form of a head, a head that I placed in a very precarious position. I did it to break the equilibrium of the prism with an intrusive form.

**LT:** In this sculpture, as in some of your other works, one perceives a sort of danger.

**MP:** An artist is always in danger because he is always prepared to challenge himself: I need to overtake today what I did yesterday. For an artist, danger and heroism are twin daily feelings. I challenge myself because I need to surprise myself. Through my work I need to discover new solutions that bring me to new unpredictable ideas. Trying to find new ways I also make mistakes, but I think this is the only way to progress.

**LT:** Do you think that mistakes are sometimes useful?

**MP:** I am convinced that mistakes open new doors and bring solutions never thought of before. To make mistakes it is necessary "to make," more than to think and to plan to avoid mistakes—an artist makes mistakes only if he has the courage "to make" and to find his way while making.

**LT:** In the future do you have a special project that you would like to realize?

**MP:** Yes, a space where architecture, painting, and sculpture have the same importance, are part of the same work.

**LT:** It sounds like a "Renaissance."

**MP:** Well, I believe that for art the Renaissance was the most important time. A time to grow and develop. The Renaissance is crucial, and we should keep it as a reference. Better than in any other time of history, man in the Renaissance discovered his place and role in space and the universe. I think of man as central to the universe. I have difficulty thinking in segments, in geographical, cultural, religious areas. For me, art is universal. I believe that the feeling and need for art are the same under any latitude and in any culture: they have existed since the beginning of our history and will never come to an end.

# American History Is Not What It Appears To Be:
## Liza Lou

**by Jan Garden Castro**
**2003**

Liza Lou self-consciously employs notions of seduction to examine American history, daily life, and the hidden values and terrors lurking beneath the glittering surfaces of the products we consume. Using glass beads, Swarovski crystal, and papier-mâché forms, she probes the varied ways that our culture conceals its dullness, as well as its dangers, with ingenious packaging. Her surfaces dazzle the eye and tease us with familiar brand names and images. During the past 12 years, she has created freestanding sculptures and major installations, including the boldly colorful *Kitchen* (1991–95) and *Back Yard* (1995–97). In contrast, the series "Presidents" and the installation *Testimony* (1999–2002) employ a monochromatic palette. *Testimony*, exhibited at Deitch Projects in New York, is a narrative with 17 works, including a "falling" *Man*, a menacing *Dog*, a blazing fire, a wood-grain-patterned *Map* of the United States, a hunter's *Trailer*, and a *Relief* of a drowned blonde child in her communion dress.

Accompanying *Testimony* was an evocative performance, *Born Again*. Dressed simply in black and using only a chair as a prop, Lou began by singing an evangelical prayer in a small child's voice. Slowly, she acted out the story of a four-year-old girl growing up in a family devoted to the ministry, the father preaching and the mother teaching. The girl is compelled to obey the word of God: "I once knew a little girl as vain as you and Jesus took her little face and smashed it through the windshield of a car." Using her body with a dancer's precision to evoke a child's physical and psychological states, Lou let viewers experience stories of violence and outrage, as well as stories of rapture, healing, and wonder.

Lou is a 2003 recipient of a MacArthur "genius" award. She has shown her works extensively in the U.S. and abroad, at venues such as the Kunst Palast in Düsseldorf, Germany; the Bass Museum in Miami Beach; the Renwick Gallery, Smithsonian Institution, in Washington, DC; the Kemper Museum of Contemporary Art in Kansas City; the Fundació Joan Miró in Barcelona, Spain; the Minneapolis Institute of Arts; and Capp Street Project in San Francisco.

**Jan Garden Castro:** We are sitting in the tiny viewing area of a 1949 Spartan Mobile Mansion trailer, one of the large works in *Testimony*. Its interior is entirely covered with black, white, gray, and silver glass beads; it features a kitchenette, living room, bedroom, furnishings, two rifles, two bottles of whiskey, two packs of cigarettes, a typewriter, a camera, and a body. Who do you imagine living here? What is behind this vignette?

**Liza Lou:** This is a trailer that was abandoned. Somebody had lived in here for years and then left it to rot. One has the feeling that things ended badly. I tore out the walls, the cabinetry, rewired everything, and built everything inside to scale within the space.

**JGC:** The book titles are great.

**LL:** There really is a *Shooter's Bible*. *How to Hunt Deer* is not an original title. *Men Today: Flesh Farm of Horror* is a magazine. I really had fun looking at male culture after doing so many pieces that reference women's work.

**JGC:** Is the man dead or drunk? We just see his leg.

**LL:** It's an unfolding story. We see the bottles of alcohol and a gun near his foot. I was interested in describing loneliness and despair through objects, and at the end of it, I decided that I had to leave a body. That was the last thing I did in the piece. There are clues: the vice grip, the knife, the ball of twine. Each object evokes something that might have happened.

**JGC:** The deer framed on a wall and books on deer hunting suggest an obsession.

*Trailer* (detail), 1999–2000.
Mixed media and beads, 144 x 96 x 240 in.

**LL:** You also see a deer figurine on the kitchen counter and deer silhouettes at the foot of the bed.

**JGC:** Does the monotone color scheme of silver, black, and white refer to television in the '50s?

**LL:** I was thinking more of film noir from the '40s and '50s. I wanted to imply that the viewer was part of the crime scene. Also, I was using this palette to talk more about sculpture. When you see a lot of color, you get distracted from the form. I was hoping that by taking it down in terms of that vibrant color, you'd start to see the actual shape of things: the sinking of the chair to look as though somebody's been sitting in it for a while, the slump of the sofa.

**JGC:** The crumpled Marlboro package is an incredible facsimile, as are his socks and his jacket on the wall.

**LL:** There are details that I had fun with: the Navajo blanket on the bed, the fringe on the bottom of the sofa and the curtains, the little horse motif on the curtains in the breakfast nook.

**JGC:** The old typewriter, the TV, which is on.

**LL:** The soundtrack of men arguing in the background is important to me. I was excited about doing a piece that limited access—watching people go in one at a time was thrilling for me. In the past, things were so colorful, accessible, and embracing.

**JGC:** Does the trailer go on the road?

**LL:** It gets towed on a low boy. It also can be towed on its own, but we don't do that anymore since the inside has become kind of precious. The funny thing is that, early on, trailers were a sign of leisure. A house trailer was a glamorous thing at one point and now, of course, it has a whole other connotation.

**JGC:** Jeffrey Deitch has remarked that you've invented yourself as an artist. How did you become an artist?

**LL:** I didn't come at art-making from the usual route, which is to go to art school and get an MFA. In that route, there are the systems of the court: graduating magna cum laude or being surrounded by professors and peers who appreciate your work. I had to decide early on to make art for my own reasons, because I wasn't receiving support from any structures or systems. I felt as though I had a rich inner world to delve into, and it seemed more interesting to me to go into that than to try to fit into a university situation. When you make art from your own place, you may have an opportunity to communicate something that you didn't imagine possible. Rilke, in his *Letters to a Young Poet*, talks about going within and finding yourself, and in that place of solitude, you connect with the universe.

**JGC:** At some point, either in or out of school, you started finding your own path. How did you educate yourself?

**LL:** It began in art school. Then at a certain point, I realized that school was about learning how to learn. Once I got that, I realized I didn't really have to be there. The sooner you can tackle life, the better.

**JGC:** Were there any particular influences as you were working on *Kitchen*?

**LL:** During the five-year period when I was working on *Kitchen* [first exhibited in January 1996], I referred to everything from women's history to Pop art to outsider art to needlepoint to mosaics—and, in terms of technique, of course, beadwork. In terms of influences at the time, I knew that I was going against the grain to be working on a huge, expensive project during the recession of the early '90s.

**JGC:** How did you manage?

**LL:** I waitressed, sold prom dresses, tap-danced on steam boats—you name it. I thought it was funny to hear artists complaining that NEA funding was drying up. If you're working out of a sense of necessity, you're going to find a way to do the thing you're going to do.

**JGC:** Did you invite friends to critique your work?

**LL:** I definitely didn't do that. I have friends who are writers who would tell me about workshops and critiques they were doing. I thought, "If I do that I'll be destroyed." I felt the less input, the better. What I was doing was so far outside what anyone else was doing, and it didn't look like art to anyone. I wanted to have the time to resolve things for myself.

**JGC:** Where did you work on *Kitchen*?

**LL:** I started in my apartment in L.A., working at the kitchen table; eventually, I moved to a loft downtown. Looking out of the window as I was working at 3 or 4 a.m., I'd see trucks stop across the street to pick up hookers, and I thought, this is just a stone's throw away from the idyllic life I'm creating. Hell and destruction were all around me. *Kitchen* was my response. Then a huge earthquake came in '93, and my studio was condemned. I had an hour to evacuate.

*Kitchen* was well underway. I had to leave the sink and the cabinetry I'd built. I could only take what was completed: the stove, the refrigerator, and the table. A bunch of friends came to help. We wrapped the work in blankets and threw it into the back of a Ryder truck. It's very hard when you have an idea that takes up space. When you're a painter, you can roll up your canvas and go. For a sculptor, it's incredibly cumbersome. It's hard finding the space and time to make work, let alone to grapple with the things you're trying to say as an artist.

**JGC:** What did you do?

**LL:** I ended up finding an affordable studio in downtown San Diego. Three years later, I finished *Kitchen*. Those three years were a turning point. I realized that making art is not as much about what you're doing as what you're not doing. Neighbors would comment, "I see you come in but never see you go out." I was pretty driven.

**JGC:** From *Trailer*, I'm under the impression that your work contains secrets that the viewer can't quite see.

**LL:** The work is about overload. There are many secrets. For example, in *Kitchen*, there's a whole mosaic with a quilt pattern and a poem [by Emily Dickinson] "Against Idleness and Mischief," but a wall covers it, so you can't see it. You can pick up a bowl, and the inside and underside are covered.

**JGC:** How did you develop the theme of *Testimony*? Could we talk about the *Man* who is receiving the spirit—is he seeing a dove that is also the Holy Ghost?

**LL:** The dove could represent the Holy Spirit. Hopefully there are multiple meanings. In Christian iconography, you see the dove descending on the head; in this case, the bird is coming out of the mouth, out of the body and into the sky.

**JGC:** This figure is balanced in an incredible way. The notion of a "being" between earth and air seems new.

**LL:** I wanted to contain that kind of difficulty in an object. My challenge was to say many things with one piece.

*Kitchen*, 1991–95.
Mixed media and beads, 8 x 11 x 24 ft.

**JGC:** It goes with the theme of *Testimony*. Is the little girl drowning in an open grave the same girl in your performance? Is she related to the *Man*?

**LL:** Everything in the show is everything I've been thinking about, so it's all intertwined. *Relief* is inspired by the Ophelia painting by John Everett Millais. I riffed on that by making her a child wearing a communion dress. I'm alluding to the Victorian obsession with photographs of dead children and also to the glass reliquaries that you see in chapels in Italy. Doing a piece under glass had all kinds of references for me.

**JGC:** Being in a lower room by itself gives *Relief* a special intensity. The performance *Born Again* addresses many contemporary issues, including evangelical fervor, escapism, poverty, and child abuse. No other performance artist has addressed these universal dilemmas so directly.

**LL:** For me, that work operates on many levels, but the basic theme is one of transcendence, and the capacity for the human heart to survive, to heal, to love, to triumph. This transcendence is the same operating principle that my sculpture aims to achieve, which is the metamorphosis of subjects not worthy of visualization—dust balls, dirty dishes, a closet full of cleaning equipment, a common backyard—so that the work celebrates a victory over the wrecking ball of the ordinary. Writing that piece, I was interested in telling a story about a world in which nothing is what it appears to be.

I always deal with denial and fantasy. I have tried to transform everyday life into a kind of retina-squelching vision that makes your eyes ache. The counterpoint to my sculpture and over-the-top installations was to stand alone on a stage and tell my story. As Emily Dickinson says, "Tell all the Truth but tell it slant."

**JGC:** You told Alena Williams [*Tema Celeste*, May/June 2001] that your beadwork is inspired by the mosaics of Ravenna and in St. Peter's in Rome.

**LL:** The material is not the message. I started out as a painter. When I discovered beads, it was like walking into an incredible paint store. It was one of those moments. To this day, I don't consider myself any good at working with beads; it's just that I have a vision for them. It's garish material, and I try to balance that.

**JGC:** Could you discuss the making of your "Presidents" series, which I understand is ongoing. You told the *San Francisco Examiner* that you were cynical about all past American presidents except for Abraham Lincoln.

**LL:** He was a great president; however, to be quite honest, I'm cynical about good old Abe, too. The more you learn about history, the more you start to be cynical about everything. "Presidents" is a never-ending project, and that appeals to me. I add a new portrait every four to eight years. I was invited to show the series at the Smithsonian's Renwick Gallery during the 2000 presidential election. When the time came to go to Washington for the opening, the Supreme Court had not yet elected our president. Meanwhile, the show must go on, so I drew an outline based on the heads of both Gore and Bush and filled in the face with solid white beads, and we hung that in the gallery for a few weeks. When the Supreme Court finally announced its decision, the museum shipped the portrait back to my studio where I picked off all the white beads with a chisel, filled it in with George W's features, and sent it back to them for the rest of the exhibition.

**JGC:** How does it feel to be given a MacArthur "genius" award?

**LL:** It doesn't change anything, and yet it changes everything. I've been working for a long time on the periphery, and I still am. It doesn't change that. Having said that, it is an incredible honor. It feels daunting.

**JGC:** I like the casual way your "wooden" beams lean against the wall. Would you talk about your use of wood-grain patterns?

**LL:** Taken on its own, wood grain becomes abstract painting, and I was interested in pushing that. For the map of the United States, the wood grain can represent topography; I like that double play. It represents a map, but you never find out where you are.

**JGC:** What are your current inspirations?

**LL:** These days, I'm most inspired by literature: that thick language of Toni Morrison or Gabriel García Márquez, the poetry of Pessoa. I was reading Faulkner's *Absalom, Absalom* as I was working on *Relief*. Language doesn't always have to lead you somewhere. It can be a labyrinth. Did that happen or didn't that happen? Is he dying or is he alive? That's the same realm in which art hovers—a place in which literal meaning is up for grabs, where you are out into the stratosphere of feeling, memory, and association.

# The Progress of Big Man: Ron Mueck

**by Sarah Tanguy**
**2003**

Australian-born, London-based Ron Mueck is as enigmatic as his sculptures. From a distended baby, stuck to the wall crucifixion-style and bearing an unnervingly intelligent demeanor far beyond his age, to a smaller-than-life, sick old woman, who curls up in a fetal pose under a blanket, Mueck's works command an uncanny ability to amaze with obsessive surface detail and intense psychic discharge. Engaging and wildly popular, they expose our need to validate our humanity, even as they thwart our attempts at full disclosure.

Mueck first gained international attention with *Dead Man*, a naked, half-scale impression of his father shown in "Sensation: Young British Artists from the Saatchi Collection" (1997) at the Royal Academy of Arts in London. With no formal art training, he perfected his skills in the commercial world of special effects, model-making, and animatronics. In 1996, he presciently created for his mother-in-law, well-known British painter Paula Rego, a figure of Pinocchio, the quintessential embodiment of truth and lies. Saatchi saw this sculpture, and smitten, began acquiring Mueck's work.

Since then, he has been making silicone or fiberglass and acrylic sculptures cast from clay models—a bold adaptation of traditional conventions in defiance of computer-assisted design. A solo show at the Hirshhorn Museum and Sculpture Garden in Washington, DC, in 2002, featured the museum's own *Untitled (Big Man)*. More recently, exhibitions at the Museum of Contemporary Art in Sydney and at the National Gallery in London included work conceived during Mueck's two-year residency as Associate Artist at the National Gallery. One of the sculptures, *Pregnant Woman*, an eight-foot-high Ur-mother with arms crossed overhead, feet squarely planted, and a downward glance, was purchased by the National Gallery of Australia, in Canberra, for $461,300, the highest price paid at the time for art by a living Australian.

To get bogged down in a debate over naturalism, realism, and illusionism when trying to sort out the hows and whys of Mueck's oeuvre is to miss the point. More interesting is a discussion of his standing in the history of figuration. A certain freshness and sincerity of vision distinguish him from the blasé irony of many of his contemporaries who also explore strategies of realism. Above all, Mueck is a master at orchestrating tensions that both attract and estrange. His figures invite close-up inspection of blemishes, hairs, veins, and expressions, taking you on a psychotopographical journey. If you stare long and deeply enough, you experience a horrific beauty. Yet the very same verisimilitude creates a weird distance that is as equally penetrating of our current existential state.

**Sarah Tanguy:** How and when did you get the idea of manipulating scale with your figures?
**Ron Mueck:** I never made life-size figures because it never seemed to be interesting. We meet life-size people every day.

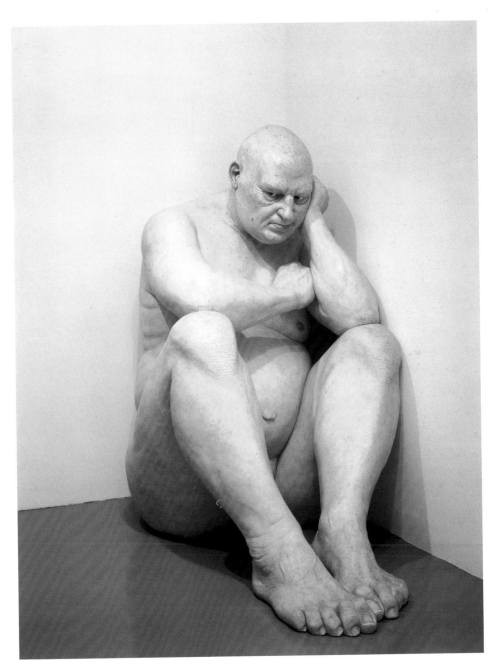

*Untitled (Big Man)*, 2002.
Pigmented polyester resin on fiberglass, 81 x 46.25 x 82.25 in.

*Two Women*, 2005.
Mixed media,  33.5 x 18.875 x 15 in.

ST: So you alter scale to raise the emotional and psychological impact?

RM: It makes you take notice in a way that you wouldn't do with something that's just normal.

ST: With *Big Man*, did you know right from the start that you wanted it to be super-scale?

RM: He didn't start big at all. I had sculpted another piece—a small figure of a man wrapped in blankets. I didn't use any reference or life model with him. He's sculpted completely from imagination. At the time, I had just started an artist residency at the National Gallery, and they were doing a life drawing class with the public. I joined in and did my first life drawing in one of these classes, which I quite enjoyed. Coming back into the studio and looking at the sculpture, I thought, "How would it be different if I did exactly the same thing but working from life?" I don't normally work with live models—I use photographs or references from books, take my own photographs or look into the mirror.

I tried to find a live model who matched the little guy wrapped in the blankets. I located one who was physically similar, got him into the studio for three hours, and found that he couldn't actually curl up like that. His limbs weren't flexible enough. His belly was in the way. It meant that he couldn't achieve the pose. I was also not used to having a model in the studio. I found it quite intimidating, because there's another person demanding to be related to. And this guy was naked and completely shaven. He didn't have a single hair on his body. He was quite disturbing.

I thought, "Right, what am I going to do with this naked man?" I asked him to sit in the corner while I figured this out. He suggested some poses that he might be able to strike for me, and he took on all these ridiculous classical poses that live models like. They were so phony and unnatural, and I realized there was nothing at all I could do with him. As I was summoning the courage to ask him to leave early, I glanced over at him in the corner waiting for me to make my mind up. He wasn't quite as belligerent as the sculpture ended up, but he was in that position. And I thought, "That looks good." So that's how I came about the pose.

I did a clay study of him, about a foot high. At that point, I thought perhaps that might be the final size of the sculpture. After I got a little way into sculpting this foot-high version with him there, he left. I didn't get him in again because I had all the information I needed without any further input from him. I then carried on playing with the sculpture a bit. In the process, I took photographs of what I was doing, as I often do, because I find that if I photograph the work I can see it with a fresh eye. You can do the same thing looking in a mirror. If you look in a mirror, you see all the imperfections and asymmetrical things that you just can't see otherwise because you've been looking at it too long.

While reviewing the photographs, I sketched a little figure on the photograph with a felt-tip pen—a little person, standing and gazing at the maquette. The scale of what I had sketched made the figure about eight feet high. It was

kind of intuitive. I had doodled this little man because in the photograph you couldn't tell the size of the figure. With him there, I could see that the sculpture worked as a big thing. He looked like a bull of a creature. I thought, "Well, maybe I'll try it that size." Once I decided on the scale I was going to aim for, I snapped some photographs. I took a profile view and squared that up—just drew lines all over it and squared that up onto paper. I then did a drawing of him on brown paper the size that would suit him—seven or eight feet tall. As soon as I sketched that out, I thought it would do. Working with the drawing, I made a chicken wire and plaster armature. Afterwards, I lined up the armature to see if it would fit within the profile of the drawing.

**ST:** Is the yellowish material the plaster?
**RM:** I use a very hard dental plaster rather than plaster of Paris, and it does have yellow pigment in it. After I put the plaster on over the chicken wire, I also paint shellac over the plaster, which stops the plaster from sucking the moisture out of the clay. It might be the shellac that looks yellowish or brownish.

**ST:** What do you do after the clay?
**RM:** I also spray that with shellac, again to seal the clay so it doesn't dry out when I create the plaster mold. That's what makes it suddenly look so dark brown. I construct a wooden structure to support the mold and hold it rigid because the mold is a very thin layer of plaster with Hessian scrim. And it's quite fragile. Then I paint layers of colored polyester resin into the mold. There's a little bit of fine-tuning. When he came out, the color was a little bit "new-born." He was very clean and pink. I just weathered him on the surface. I gave him some age spots, veins, and things would have been too hard to figure out in reverse.

**ST:** One of the traits you already mentioned that both attracts and repels me is his lack of body hair.
**RM:** The model was a "smoothie" as they call them in the live modeling trade. It was very creepy. I had intended to put some hair on the figure, but in the end, the creepiness suited the size. I did think, however, that hairs on those big arms would have been quite nice actually—big, hairy gorilla arms.

**ST:** How long did you work on *Big Man*?
**RM:** Four weeks. I had a deadline: a week sculpting, a week molding, a week casting, and a week finishing.

**ST:** That was fast.
**RM:** That was too fast.

**ST:** Is there a difference between when you work with a live model and when you work from a photograph, a found image, or your imagination?

**RM:** There's no denying that I have more information readily at hand when I have a live model. Even when I have had a model, however, what I have to do in the end is to consciously abandon the model and go for what feels right. Otherwise, it becomes an exercise in duplicating something. Sometimes what feels right is not what actually is right. With *Big Man*, his feet were too large for his body. I ended up distorting the work in order to enhance the feeling of the piece rather than to make it look precisely like a particular person.

**ST:** Is there a difference for you when the human form is in its entirety or when it's a fragment, as in your self-portrait *Mask*?

**RM:** The only way I could do a fragment was to make it a mask, because a mask is a whole thing in itself. I couldn't do a decapitated head or half a body. I have to believe in the object as a whole thing. A bronze bust is an entity because, for starters, it's bronze and it's not pretending to be anything other than a fragment or a sculpture. But my things are pretending to be something else as well. A mask is complete already. This is just a different kind of mask. It's a realistic mask.

**ST:** I'm curious about the relationship you have with your sculptures. Do you see them as human beings, almost? Or more like mannequins?

**RM:** I don't think of them as mannequins. On the one hand, I try to create a believable presence; and, on the other hand, they have to work as objects. They aren't living persons, although it's nice to stand in front of them and be unsure whether they are or not. But ultimately, they're fiberglass objects that you can pick up and carry. If they succeed as fun things to have in the room, I'm happy. At the same time, I wouldn't be satisfied if they didn't have some kind of presence that made you think they're more than just objects.

# Serene Disturbance: **Pedro Cabrita Reis**

## by Michael Stoeber
## 2003

In a 1953 essay, Martin Heidegger wrote that in Old High German the verbs "to be" and "to build" originated from the same root. From this the philosopher concluded that one does not become a human being until one has settled down. For the Portuguese artist Pedro Cabrita Reis, there is also no question about the fundamental meaning of the house in the cultural life of human beings. Reis, who represented his country at the 2003 Venice Biennale, uses the topos of the house as a recurring motif in his paintings, sculptures, and installations. He alludes to the house more than he represents it. In fragmentary form, it symbolizes the damaged nature of the contemporary human condition, as does his preference for poor and worn-out materials that accumulate past and present traces of a life already lived. Reis's elliptical manner of representation is as precise as it is poetic; the sensual aura of his works is consistently checked by lucid intelligence. There is not a second that he does not operate with the accuracy of an engineer. Nothing is left to coincidence, everything is part of a complex strategy and a coherent artistic discourse. Reis's ability to fuse philosophical reflection and aesthetic composition into a successful alliance constitutes the magic of his work. His work was also shown in a comprehensive exhibition (2003) at the Kestner Gesellschaft in Hannover, Germany.

**Michael Stoeber:** The last time we saw each other, you and your assistants had just returned from a Hannover scrap yard and were very happy with what you had found. What was it that made you so happy?

**Pedro Cabrita Reis:** Picasso once said that it is not so difficult to begin a painting, but it is difficult to complete it. The harmony one strives for as an artist, the reconciliation one desires between the idea one has of a work and its ultimate realization—I have to feel them physically. When I succeed at this, when a mental concept successfully assumes bodily contours, this is a reason for great joy. I made only the basic structure of *Serene Disturbance*, my main work in the large hall of the Kestner Gesellschaft, in Lisbon. I wanted to complete it in Hannover with materials from this city, a method I regularly practice with my installations. It was an occasion for great delight when I found the right materials and the installation began to correspond exactly with my idea.

**MS:** Does your choice of used and commonplace materials place you in a certain tradition, line you up with artists of the Dada or Arte Povera movements?

**PCR:** I have never thought about that. I choose my materials because they have a certain degree of reality, a hardness that has nothing to do with realism but a lot to do with attitude, with form, with feeling. I select these materials according to the temperature they have for me, according to the moods they radiate—or according to certain ethics or morals, according to their politics. For me, in a political sense, plastic is very conservative. It is rightist. I do not know why. Glass is obviously a very cold material, but when I break it and glue it together, bandage it, it becomes quite hot. I do not see myself in a particular artistic tradition, rather I use these materials to develop a very unique nomenclature.

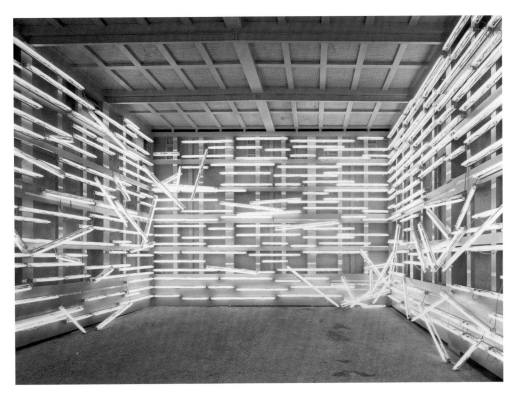

*absent names*, 2003.
Mixed media, installation view of work at the Venice Biennale.

MS: Do used materials have a higher temperature for you than new materials?

PCR: Because I understand upholding memory as a basic theme of my work, memory with whose help survival becomes possible for people, I would say yes. But that is in no way canonical. I also use new materials. I have only one basic rule in my work: never say never. Whatever occurs to me, whatever I see, if I think it fits, it can enter into one of my works. Many artists work this way: they look at reality and continually scrutinize its suitability, whether and to what extent it can become part of a work of art. This is exactly the way I work. The pages of my sketchbooks reflect what my eyes have seen.

When I speak about the temperature of used material, it has nothing to do with any kind of romanticism, with a romantic transfiguration of materials. I have a very precise idea about the function that the materials I have selected will fulfill, and I have a very precise idea about my role as an artist: I consider myself responsible for people and their history. I administer the treasure of life that has been lived. It is my duty to uphold the image of human beings as well as to create it and pass it on to coming generations. Art continually gives us the great opportunity of recognizing ourselves in our limitations and in our possibilities. That is its fantastic potential. I see this as a legacy of art

and culture. It does not matter where I go, which country or which cultural relics from which time I look at when I am there: it presents me with an image of human beings and ultimately with an image of myself.

**MS:** When you talk about the meaning of memory and history for your work are you referring to collective rather than individual experience?

**PCR:** Both. The artist administers and designs a territory where collective memory shows itself in pure, perfect form. Memory becomes meaningful for the individual in this form. James Lee Byars called this wealth of meaning "the perfect moment." Of course, collective memory is nothing more than the sum of individual experience. Everyone's history is the history of the individual, no more and no less. As an artist, to feel one is the trustee of time and history and thus the trustee of human beings has nothing—and I repeat this with resolution—nothing to do with romanticism or any kind of transfiguration. Only the memory of that which was sharpens one's view of that which is and will be. Memory supplies us with the necessary measure of knowledge for the present and the past. If an artist has a "task," then, as I understand it, it should be the following: the artist creates the perfect moment in his work. Memory is concentrated in it in a collective form that knows how to touch each individual. This memory is like a magic mirror in which we are able to look into both the past and the future. We see what we once were and what we will become. Memory as a form of insight.

**MS:** How is this related to the occurrence of the "perfect moment" in art?

**PCR:** The perfect moment is the moment of a successful balance between form and content, past and present, self and the world, which art, as I believe, continually envisages. What touches me even today when I look at a painting by Velázquez that describes a world no longer ours? It is this perfect harmony, the balance of the painting that includes everything it shows and is involved with it. A kind of epiphany appears in it, which will remain valid for all time—or at least for as long as human beings maintain their receptivity to the perfect moment of such balance.

**MS:** What is the connection in your work between the function of memory and the house as a recurring leitmotif?

**PCR:** I am not interested in the traditional image of the house, its social and political function. I am not interested in the house as architecture, as a conglomeration, as history, as a shell and a form of protection against inhospitable nature. For me, human beings do not belong to nature—metaphorically speaking. Nature is God's problem. Human beings come later, after nature. Human beings design themselves according to two parameters: one is the horizontal, the horizontal line. It establishes an attitude or idea of distance. The other parameter is the vertical. It establishes an attitude of closeness, an idea of intimacy, and is first experienced in the shadow a human being casts. Identity is not originally produced through experiencing the other; rather, it is produced through the realization of one's own shadow. Together, the vertical and the horizontal establish a system of order, a map that teaches us where we stand and where we are in the world. The house marks our location on this map and in the world. For me, the

house is proof that human beings are equal to God and do not belong to nature. When I draw a square in the sand, then it is a cosmogony, a creation of the world and of the self. The building of a house is the most exquisite example of a human being's appropriation of the world and of reality. Building is an exemplary form of recognition. This is also where the point of convergence with memory lies. Above and beyond this, the house is even more than the appropriation of reality—it is a form of creating the world. A world counter to nature. Culture versus nature. For this reason, I am not very interested in the social dimension of architecture. Architecture interests me more as a philosophy, theoretically and practically, as an instrument for explaining the world and as an instrument for creating and designing a world.

MS: In an interview you not only dismissed sociological and political interpretations, but also claimed the Benjaminian notion of the aura for your works. Nonetheless, critics continually place them in a social context—*Cidades Cegas (Blind Cities)*, for instance, identified with the *favelas*. How does this misunderstanding arise?

PCR: It has something to do with the so-called open dimension of the work of art. However, I do not think much at all of the widely held view that a work of art can be used for all kinds of interpretations. I would appreciate it if my work were interpreted the way I see it, according to my dictionary. I understand, of course, how someone viewing *Serene Disturbance* would feel reminded of the *favelas*, of those living in makeshift houses on the periphery of the big cities. But that view only perceives the most superficial contours of the work. It is very easy to maintain that every work of art is in some way political. Of course, I can consider Velázquez's portrait of Philip IV as political. But do I do him justice by doing so?

MS: How would you like the viewer to understand *Serene Disturbance*?

PCR: The melancholy this work exudes is important. The source of melancholy is always loss, ultimately the fundamental loss of God's protection. We stand alone. And, for me, the very first thing this work speaks of is this, this existential loneliness and homelessness, before any political or social demand. There is a split in humanity. It separates the lonely, the rejected, and the forgotten from those who are not.

MS: That sounds like class theory.

PCR: Yes, but not in a Marxist sense, in an existential one. People who are excluded from society can die of sadness. Examples of this have been handed down to us from the Australian aborigines.

MS: How is one to interpret the material context of *Serene Disturbance*, the play between ephemeral light and compact materiality?

PCR: All of the compact materials are associated with the functions of a house: sinks for washing the dishes, stalls for showering, aggregates for heating, beds for sleeping. All of the elements are used, laden with traces of life.

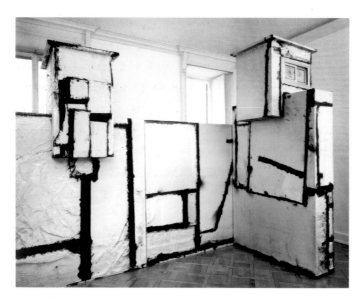

*Cidades Cegas Eco* (*Blind cities the echo*) #5, 1999.
Plywood, tar, aluminum, roofing felt, window frames, and acrylic paint on glass, installation view.

Above and beyond this, everything is fragmented—symbols of the disunity of the contemporary *condition humaine*. The extreme stillness and silence and the extreme desertedness of the work support, I hope, my intended expression and impression of melancholy. The work is an apparently paranoid visual labyrinth. Above and beyond this, it is hermetic: one cannot get in, but one can also not get out. The light underlines the malignancy of this universe in so far as the house represents a compressed picture of the world. Light traditionally means enlightenment, reason, something positive—optimism and belief in progress. But one can also torture, murder, and rape in a "reasonable" way. The work thematizes the perverse side of reason. Bestiality as the black sister of humanity. When I installed this work, I wanted it to be silent, evil, and sad and to convey precisely these emotions. It is intended to make the viewer shiver in its hopelessness. When one stands in front of the work, it is as if one is facing death. You cannot run away from it. It is unavoidable.

MS: Your black triptych in the last room, perhaps paradoxically, stores light?

PCR: Through the reflection of the radiating parts. This kind of reflection is the original form of representation. It allows us to see. There is a reason for my continual use of glass as a ground for my paintings. The radiating ground simultaneously pulls the viewer into the picture. But, for me, the triptych has a further function. It is like a winged altar, also a kind of portable altar. Not in a religious sense, but in a philosophical sense. I am not a nihilist. I believe in sense and meaning—not necessarily meaning as brought forth by God, but a meaningful existence, in which there is room for progress and higher development. We human beings are creatures in search of meaning. This is the way I understand this work. Perhaps as an expression of a hedonistic religiousness, a hedonistic belief.

MS: Is there something that connects *Serene Disturbance* and *Black Monochrome/Landscape Triptych*?

PCR: The aura. The wonder of knowledge and insight. In my opinion, this is what all aural art is about. The differences between the works could not be more obvious. When I stood in the Kestner Gesellschaft for the first time and

saw the rooms, it was clear to me that I would exhibit two works there that could not be more different. I had already created the triptych and exhibited it once before. *Serene Disturbance* is new. The two works, which are simultaneously visible to the viewer, operate both with and against each other in this visibility. They are not intended to be viewed singly, but rather in dialectical tension with one another. The elegant domed architecture of the exhibition space was important for *Serene Disturbance*. I wanted it to lay itself over the work like an octopus or a spider and to emphasize the claustrophobic character of the work. In addition, the room had a considerable influence on the size of the work. There is a strange ambivalence in *Serene Disturbance*. What is it? A model, an inhabitable reality, or a sculpture? The house-like boxes assume an alienating intermediate position. The white paint and the light also react to the room. The white of the boxes absorbs the white of the room, the light partially relieves the work of its weight. However, both the inhospitable white of the boxes and the cold neon light also counterpoint the floating, dancing white of the room.

MS: What almost immediately leaps to the eye about the triptych is its great beauty.

PCR: Beauty is the desire for harmony, a harmony that we need. Beauty is the appearance of the divine. We experience God in beauty. Beauty is sense and meaning. The world suddenly makes sense in beauty, things fit into one another with meaning. We experience redemption in beauty.

MS: Like in art?

PCR: Yes, in happy moments. I am searching for beauty. I search for it through my work. I believe that this is my task as an artist. I cannot imagine having any other task. Sometimes I appear to be successful. Not that I wanted to create this beauty in my works. Rather, when I am fortunate enough to be successful, my works have the power to allow beauty to be created in the soul of the viewer.

MS: Is there an alliance here between aesthetics and ethics—in the classical sense of a connection of goodness, truth, and beauty? Is there something moral about beauty for you?

PCR: The word "moral" does not belong to my vocabulary as an artist. Ethics and morals create a foundation for certain codes of behavior. They deal with fear and exclusion. In contrast, beauty is absolute. It knows no constrictions whatsoever. It always aims at the entirety of our existence. If you will allow me to formulate it in a paradoxical way: beauty is too moral for any form of morals.

MS: Do your works—not only those being shown in the Kestner Gesellschaft—form a whole? Are they fragments of a great confession?

PCR: Maybe in the sense that my work as a whole is contained in each individual work, and each individual work always has its sights on my work as a whole. I hate things that happen unexpectedly and things that remain incomplete.

I tend toward control. Every artist wants to convey his way of seeing and understanding the world. This impulse is perhaps the secret center of my works.

MS: Where do the concrete impulses, the stimuli, for your works come from?

PCR: It varies. It can be scraps of conversations on the street that I accidentally pick up. Or an object that catches my attention, perhaps a chair in an odd position, for instance in relation to a table. Or light that I perceive when I am driving my car. The smile on a person's face. A sudden silence in the middle of a conversation. All of this has to do with a special atmosphere that things or situations have for me. It is basically this atmosphere that interests me and that I deal with in my work. This atmosphere can be positive or negative. I do not place any elaborated philosophies or images of the world in my works. My reasons are extremely modest.

MS: Are literary references important? I am thinking specifically of the installation *Petrarca's Room*.

PCR: It is no different with literature. Often the melody of a sentence or the reverberation of a word is sufficient for me. They create echoes in my mind and lead me to my own work. Here, too, it is more a matter of atmospheres than specific references. I was very impressed by Stendhal's *Le Rouge et le Noir*. Do not ask me the name of the protagonist or about the plot. I have forgotten everything except for the atmosphere of the book, which I recall as being extremely sensuous.

MS: Could you say something more specific about your wall installations in the Kestner Gesellschaft?

PCR: All three works operate with window and door elements and light. Neon light that is gentle and domesticated by a honey-yellow. Not the cold light from *Serene Disturbance*. Here, light has a reconciling and illuminating quality, which the title of the work already indicates: *Light in the Window*. A light that radiates in the general darkness. I used my now adult daughter's crib in the construction of *One of my Children*. What could be a stronger argument for saying yes to the world than the conception and birth of a child? Also yes to oneself, to one's own existence. And the third work, *Everywhere, anywhere, elsewhere*, shows a door, the symbol of passage and initiation, of becoming a human being. Everything I do as an artist has to do with experience: reality is the undercurrent of every work of art, in that it re-emerges transformed, as a kind of fictionalization of what is real.

# Industrial Poetry: Cildo Meireles

**by Joel Weinstein**
**2003**

Few artists at the turn of the 21st century have been as persuasive, for as long, as Cildo Meireles. Yet his works are never easy to unravel. They can seem obvious and mysterious at the same time—sometimes threatening, sometimes seductive, and often both at once. Over the course of his 40-year professional life, he has managed the political, the poetic, and the purely formal with a rare acuity and grace, never slipping into pedantry or shrillness.

Born 54 years ago in Rio de Janeiro, Meireles spent his youth in Brasília, a planned "city of the future" that he considers a grand experiment dismayingly well-suited for the brutal military dictatorship that took over the country in 1964. He came of age artistically during the cultural and political tumult of that period, when Neoconcretists like Hélio Oiticica and Lygia Clark were subverting the cool, rational conventions of Constructivist-derived Brazilian art—and attacking hierarchies of all sorts—with utopian, tribalist ideas about sensuousness, the primacy of space, the bankruptcy of objecthood and authorship, and art as a participatory activity.

Meireles has become known for often disturbing walk-in installations, like *Volatíl*, in which the visitor trudges through ankle-deep ash in gassy-smelling darkness until rounding a corner and coming upon a lit candle. He maintains that the evocations of the interaction between observer and object constitute his work and not the object itself, yet his pieces are invariably refined. With their rigorous, even stately, simplicity, they express elegant conceptions about the world and about ideas.

His materials include dirt from the Brazilian outback, the emptiness of an art museum, thousands of miles of string, and tens of thousands of coins. In his most notorious work, *Tiradentes*, in which several live chickens were incinerated as a way of discrediting the dictatorship's co-optation of one of Brazil's most beloved historical martyrs, Meireles claimed for his material life and death itself. Ultimately, however, the point seems to be apprehension, bafflement, wonder, and other qualities of ordinary human experience, and in this way he is a true heir of the Neoconcretists.

Meireles came to Miami in July 2003 for the installation of *Strictu* at the Miami Art Museum, where the piece was shown for the first time in the U.S. *Strictu* consists of a room lined with stainless steel poles, around which a length of chain winds across the floor toward a small wooden table and chairs. Attached to the ends of the chain, immediately in front of the table, are sets of handcuffs and lead prison balls. The room is almost dark. A lamp hanging above the table illuminates a piece of paper on which several statements are typed: a quotation from a Ku Klux Klansman and some admonitions from the artist concerning "cultural, curatorial, and artistic authoritarianism."

*Strictu*, 1999.
Stainless steel poles, chain, iron balls, handcuffs, keys, lamp, wooden table, two chairs, and typed statements, dimensions variable.

**Joel Weinstein:** Let's start with *Strictu* since that's why you're here. It includes a piece of paper with this Ku Klux Klan statement, "We want to steal their time. We want to steal their space. We want to steal their mind," and the line, "*Strictu* takes a position against all such perverse and absurd illusions." This line puzzled me. Your work usually favors ambiguity and free audience participation. I was wondering if you see the statement as a part of the installation, like the handcuffs or the balls or the chain, as an example of artistic authoritarianism.

**Cildo Meireles:** The piece itself was already done, the idea to have someone in handcuffs, submitting to an itinerary that was not the spectator's choice. I was watching TV—I had to write a few words for a catalogue for a show in Germany, and I had two or three days to do it—the TV was on without sound, mute, and when I saw those images of racial conflict, I turned on the sound. There was a big discussion in New York at the time, concerning permission for a KKK parade. This was the end of 1999. When a guy came on, giving a speech at a KKK meeting, it sounded so precise in an ideological sense, so clear, that it could have been applied anywhere by a conservative or right-wing politician or sympathizer, a militant. At the same time, it fit very well with the idea of the piece. I was trying to deal with something that I always thought was one of the main characteristics of *artes plasticas*.

**JW:** You mean the visual arts.

**CM:** That's the point. From the beginning of art history, there was a period when art and religion were mixed. After a time, we could see in prehistoric drawings in caves what was religion and what remained art. Later, in Greece, art and architecture were taken to be the same thing, and after a time it became clear which were architecture questions and which were art questions.

When I first presented my proposal for *Eureka/Blindhotland*, I used a quotation from a French Jesuit priest named Teilhard de Chardin, who was trained as a paleontologist, a philosopher. One of his books, *The Human Phenomenon*, addresses the question of the first man. Who was he? Where? Why? The quotation says, basically, "The first man is always a crowd." Because what exists, in fact, are the conditions, the total condition, for something. Some idea crystallizes. When this time comes, we're going to see it popping up everywhere, almost at the same time, without any kind of logical or operative link.

For me, the main question and the central lesson concerning art is the fact that it is not something done for and through eyes, sight. If you have a piece of art, it should raise questions and answers for someone who has no eyes. That's why I prefer the Latin word *plastica* instead of "visual." It's a little bit more generic, let's say, and doesn't lock the field into one sense.

Coming back to *Strictu*, another thing that's very interesting for me concerning art is the fact that if we read a book, if we watch a movie, if we listen to music, in some way we become a function of time. We depend on time. We cannot instantly read a book, watch a movie instantly, or listen to a music album instantly. Art, *artes plasticas*, has this

kind of generosity concerning the audience. You can just, in a glimpse, know if you want to spend more time or make a U-turn and go to the next thing.

*Strictu*, when I first showed it, played with this in the sense that once you wanted to participate, you had to follow an itinerary that you didn't decide. The piece was in a group show. You were supposed to make a circuit that was already established. You're going to go this way and you're going to go there and then you come back. This imposed a space restriction, and it imposed a waste of time. Then the text fit like a glove, and that's why I used it, because of its strong capacity for synthesis and because in some way it was as if it were done for the piece. If I had to verbalize it, I couldn't do better than that.

**JW:** I'm interested in the political dimension of your work, and how, at the same time, you've been able to make seduction and sensuality integral to it. Is this something that's particularly Brazilian?

CM: I don't believe much in nations, nationalism, that kind of thing, but I do see a particular characteristic of Brazilian culture, which from the beginning has been a blend of different races and people. It may also be because of my experience growing up in Brasília, which worked as a kind of unified field of differences, with its different regions and aspects.

**JW:** And was this a very conscious part of Brasília's being built?

CM: Yes, one of the hypothetical meanings of building Brasília was the integration issue. But the fact is, because I grew up in the hippie period, we did not believe in this thing we see today, this so-called globalization. It was a much more general idea, not concerned with the great force of a structure based on economics. At that time, we had the word "planetarian," which I think is much more concerned with spirit, soul, feeling, heart, and human generosity than having everything under control for economic reasons.

This is partly a matter of time. We live right now in a kind of inertia. It seems like everything still works like it used to, but, of course, everything's changed and it will take awhile until a majority of people realize that. But I think all of the things that were in the air then—from Jim Morrison to the Beatles to Buckminster Fuller to the global home—all of those discussions informed the work.

While some of my works have had a political component, I always try to avoid pamphleteering. Something could work as a statement, but you finally see that it was an attempt to do an artwork. It has to be connected with the history of the art object, concerned with language, with both aspects, not only with politics.

My approach also comes out of specific Brazilian circumstances. We knew about works of other artists of that period. I, myself, while a student in Brasília, was very interested in artists who touched on a totally new way of thinking

A Través (*Through*), 1983–89.
Nets, voile, glass, paper, wood, Venetian blinds, garden fencing, iron fencing,
aquarium, barbed wire, chains, chicken wire, rope barriers, cellophane, 590 x 590 in.

and doing art, like, of course, Marcel Duchamp, Piero Manzoni (who I really love), and Yves Klein. When I started showing regularly outside of Brazil, when I was asked about influences, I would say the Brazilian Neoconcrete movement, Hélio Oiticica and Lygia Clark, mainly. A few years later, someone put the question to me, "But what was your main influence?" And then I said, "Of course, it's very clear. Marcel Duchamp, Manzoni, the material of Yves Klein.

**JW:** Could you describe what you saw in Duchamp?

**CM:** From the beginning, I was attracted to Duchamp because of the way he used material. His material was already revolutionary because he was using art as the material of art. And this was very different from using ink or paint or tools like a brush to make art. This opened the possibility for working with art in a totally different way. Finally, he was using ideas as materials. I remember discussions with friends in '65 about the field of art and the field of science, or rather, the philosophy of science. I'm referring to the idea of "anti-": anti-material, anti-mass. It's an idea that came out of physics at the end of the 19th century, hotly discussed among scientists in Paris, something that was the opposite of what we call reality or matter or mass. It was very vague, but it fascinated us as young students. We tried to come to a thing that had this idea behind it, the idea of *arte total*, something that dealt with totality, the totality of sense.

By the time I left Brasília and had my first solo show at the Bahia Museum of Modern Art, I had read about Oiticica and Clark in magazines. I saw how they deconstructed the painting—they started as painters—and the way they came to the space. In the case of Oiticica, it was the way he shifted sculpture history by changing the place of the subject. I'm speaking about who experiences this thing, who looks. The space became totally new because you were conscious of it from a new position, wearing a sculpture instead of looking at it. Instead of walking around it, you were inside of it. This approach was not only visual, it became tactile in a definite way because of the fabric. And Clark, with *Bichos*, came from a Constructivist tradition, but suddenly she brought it to a totally different space, in a totally new way. It reminded me of the Russian Constructivists, like El Lissitzky, the experience of the *Proun*.

It was fantastic, almost the same movement. You come from the walls to the space of the exhibition. It was the *Proun*. For me, Neoconcretism had experiences very connected with El Lissitzky's experiences. I think that the Neoconcretists extended these experiences by introducing a new sense.

**JW:** Some of your well-known pieces, such as *Oblivion*, *How to Build Cathedrals*, and *Tiradentes*, which is very powerful though frightening, use Brazil's colonial period as their material to some extent. What role does history play in your work?

**CM:** They concern the physical territory of Brazil. One would be a line that I extend along the entire coastline of Brazil and then retrieve. There is a group of works that I do with ropes, and these would be very formal, very poetic, like one where I would place four or two sticks on the ground, in a beach area, say, and a string that goes to the sea so you won't see where it ends up. I would also like to circumscribe the area where a rainbow appeared. Then there is *Bandeirantes*. *Bandeiras* were expeditions [during the colonial period] into the interior undertaken by individuals, not government people. One of these *bandeirantes* made an expedition that established practically what we have as the official boundary today, which defines the states of Amazonas, Pará, Mata Grosso, all the west of Brazil, all the boundaries of the other South American countries. He would stop and create a little village or a town, establishing this boundary physically. He was 22 when he started, and 50 years later, when he was 72, he arrived at his destination. This is something that artists like Ann Hamilton or Richard Long would do, or those artists connected with Land Art in the '60s.

I want to re-create this line physically, with a plane, unrolling kilometers and kilometers of line. Another thing is the map of Brazil as it is today. You have the extreme points: south, north, east, west. The idea was to change this, go to these exact points, and either add some land or remove some land. And there is a kind of vertical boundary. The highest point in Brazil is Pico da Neblina in the state of Roraima, at the boundary of Brazil and Venezuela. I want to take away one centimeter and replace it with a diamond of two centimeters, so I'll make it one centimeter higher. In all the schoolbooks, instead of having around 2,876 meters, they'll have to have this plus one centimeter, created with something that comes from Brazil, whether it's gold or a diamond. Frederico Morais wrote that my work comes from geography to history, and maybe there has been a passage from more formal or geographical things to something more connected, linked, to history.

**JW:** It seems like *Tiradentes* was very much the use of history to make a statement about the moment.

**CM:** Yes, and as far as possible to try to make a contribution to the discussion of the art object. This was always there. *Tiradentes*, besides speaking specifically about a historical fact, tried to discuss the metaphor as material—what we have taken as a subject for discussion throughout art history: death and life. Its theme became the material. There was always a language thing behind it that I tried not to use—like *Insertions*, which could be taken as an

immediate socio-political thing. But at the same time, for me, it was discussing space itself as conventionally defined, as a gallery or museum or whatever. I tried to displace this notion of space. I tried to deal with the idea of authorship and *anonimato*; I tried to deal with the idea of scale, the individual and huge structures; I tried to deal with the idea of wrapping something, how by doing this, you also wrap ideology with it.

**JW:** Looking back over your career, do ideas of authorship, scale, and space still have the same urgency?

CM: In some works, yes. In a way, *Strictu* is a little bit like that, though it doesn't have immediate connections with my early work. But at the same time, there are notations from different types of work. Some of my pieces do deal with socio-political issues, like the work I did at Documenta. For me, it basically has a lot to do with poetry. That's the way I classify it when interviewers ask me: "Where do you put this? What is this? Installation? Performance?" Maybe you should call it "industrial poetry." The main thing is that you are facing something that's happening and you try, in a kind of haiku, to synthesize that thing with a minimum of resources. It is work that tries to establish micro-economies and structures that deal at the beginning with the idea of unemployed people or, again, with the space of the work of art.

**JW:** You have ideas that don't get realized for years and may never happen.

CM: *Red Shift*, the first part—there are three—was from 1967. I was doing the first model of *Virtual Spaces*. I was making notes one day, and I made one that said, "Let's imagine we enter a room where everything is red, by chance or by obsession, it doesn't matter." It's a little bit absurd, but it's not impossible. I wanted to use only objects that are naturally red. Any item could be red. It could have a pattern of red, going from dark purple to light pink, say. This was 1967. The first time I did it was in 1984, 17 years later.

I like the idea of *decantação*, decantation, in chemistry. I like it when I take notes, when I pick up a book. Sometimes someone invites you to write and you have something that can fit the thing, and sometimes you, yourself, like to go back just to have the pleasure of working with an idea. Because, you see, there is only one moment when you are right. There is a moment, which is the best moment for the author. It's when it first flashes into your mind and you don't know what it is, exactly, what its form is. It just passes through like lightning. And then you try to catch it, to not lose it, just take a quick note. And then you go back, and then you start to get the formal aspect. All of the things that come after this lightning are a little bit boring. To make it real is the worst thing, to try to figure out what it is, and to put it on paper and describe it and realize it finally and do exhibitions and speak about it and sell it. It's not as fun as when you first get into a hammock, when you are buzzing with whatever comes into your mind. This is a good moment for art; at least for me, it's the most enjoyable moment.

# To Live an Idea: Mario Merz

**by Laura Tansini**
**2003**

Mario Merz, who died shortly after this interview, studied medicine at the University of Turin and turned to drawing in 1945 during his incarceration for anti-Fascist activities. By 1950, he was working with oils, and in 1954, he had his first solo exhibition at Turin's prominent Galleria La Bussola. By the late 1960s, when he began to pierce his canvases with everyday objects such as neon tubes, bottles, and umbrellas, he had become broadly associated with Arte Povera, an art movement characterized by its protest against consumer capitalism and the destruction of nature by modern society. In 1968, Merz made his first igloo sculpture, a metal frame covered with various ordinary materials such as glass, wax, mud, and the neon tubing that was to become a key motif in his work. In the early 1970s, Merz began to incorporate the Fibonacci sequence into his work in the form of numbers and spirals. By the time of his solo museum exhibition at the Walker Art Center in 1972, he had added stacked newspapers and motorcycles (among other consumer items). Diverse and varied, Merz's work was often tailored to a specific exhibition location, either through size or the incorporation of objects indigenous to the site.

Since 1970 Merz's work has been exhibited in important private galleries and museums worldwide. His solo exhibitions outside of Italy include Whitechapel Art Gallery, London (1970); the Musée d'Art moderne de la Ville de Paris and the Kunsthalle, Basel (1981); the Guggenheim Museum, New York (1989); the Fundaciò Antonio Tàpies, Barcelona (1993); the Stedelijk Museum, Amsterdam (1994); and the Fundaciòn Proa, Buenos Aires (2003). Merz was the recipient of a 2003 Praemium Imperiale International Art Award, which recognizes lifetime achievement in the arts in categories not covered by the Nobel Prize.

Merz recently completely two permanent outdoor works for the City of Turin. In 2000, he created a Fibonacci work, *Il volo dei numeri* (*Numbers Fly*), for Mole Antonelliana, the city's highest building and most visible civic symbol. *Il volo dei numeri* consists of 16 neon tubes of numbers from one to 987, each number measuring about 50 centimeters high. The second commission is the monumental fountain *Igloo-Fontana* (2002), which incorporates a pre-existing pool.

In April 2002, Merz installed a spiral made with neon tubes in Rome's Forum of Caesar. *Un segno nel Foro di Cesare* (*A sign in the Forum of Caesar*) marks the first time that a contemporary artist was invited to create a work in the very heart of Rome's archaeological area. Also generated by the Fibonacci sequence, this spiral reflects Merz's thinking about the meaning of time and space, linking the historical past with the present and future in a dynamic mathematical order.

**Laura Tansini:** Why a spiral at the Forum of Caesar?

**Mario Merz:** The spiral is associated with numbers: increasing the dimension between number and number, the spiral changes. A spiral is a drawing, a drawing subject to numbers. Being subject to numbers, the spiral changes

*Un segno nel Foro di Cesare*, 2003.
Site-specific installation at the Forum of Caesar, Rome.

its aspect. It has a very strong impact in space. The square has to "attack" space. But the spiral, on the contrary, can start from a very small dimension and develop to infinity. In astronomy, interstellar space can be calculated through the spiral. As to my work at the Forum, I moved my spiral from the sky to the grass, which is a very particular grass because it covers ancient tombs and supports 2,000-year-old ruins. Now it also supports my spiral.

**LT:** A spiral communicates movement, speed, and energy, but also continuity. Am I correct in saying that with this spiral you link past, present, and future?

**MM:** My spiral lies in a square area that has boundaries, therefore it is in a space marked by historical time and by spatial time. For this reason, it cannot be delocalized from where it is: it is strongly connected to this site, to this grass. It is a work created for this architectural space. The architecture intensifies my work, a work that captures time between 2,000 years ago and the contemporary moment. It is historical time, hence it is human time.

**LT:** Both extremities of the spiral are segmented, why?

**MM:** In a spiral, segments increase to infinity. I could start a spiral 50 kilometers away from here, and then I could develop the spiral another 50 kilometers and end it on the roof of a building. The peculiarity of the spiral is that it does not have a fixed place—it can find its place anywhere.

**LT:** Your work is strongly related to music, mathematics, and astronomy.

**MM:** Everyone has experiences with music and mathematics, but I would not say that having experiences with sound and space means to be a musician or a mathematician. I also have experiences, but in this case what I made is a sculpture, a light-sculpture, a sculpture easily seen at night and invisible by day.

**LT:** Why make a sculpture that is almost invisible in daylight?

**MM:** During the day, cities present an enormous quantity of material, which sometimes becomes aggressive and brutal. But, at night, this heavy material diminishes in aggressiveness, and a work made of light takes over. Thousands of archaeological finds cover this area, so you can understand that to install a bulky artwork in this space could be disturbing. This is why I created a spiral that cannot be perceived during the daylight hours; one can only see it at night when all other "presences" disappear in the darkness.

**LT:** Why, when you had such a large archaeological site, did you choose this specific grass?

**MM:** I found this square of grass interesting because in an urban reality like Rome, this bounded grass has an aesthetic reason to exist.

**LT:** Changing cities, let's talk about *Igloo-Fontana*, the permanent work you recently created in Turin.

**MM:** *Igloo-Fontana* is a very particular work, which I based on the architecture of a street, a street that I found: I did not plan it, it was there. In a word, I worked with a pre-existing situation. It is a difficult architectural environment, dominated by a heavily trafficked avenue. I had to think a lot about what I could do, and at the beginning, I thought it was not possible to find a good solution. Then, step by step, idea after idea, I found the solution of using a large pre-existing pool of water. I can say that this work is the result of cooperation. Cooperation had to exist between the architects and engineers who planned and made the street, the pool, the lighting, and me—the artist who had to create a work to go with, but also to compete with and dominate the pre-existing elements. I think that today cooperation is a pre-eminent element for human possibilities. At the time of Romanticism, a "mark" was enough to be present in the world, but today cooperation is one of the most necessary of human possibilities.

**LT:** As I understand it, the size of *Igloo-Fontana* was not decided by you—it is the size of the pre-existing pool. Once you decided to create your work in the pool did the whole project become clear to you?

**MM:** Yes, I decided to use and include the pool, to make it part of my work. Therefore, the perimeter of *Igloo-Fontana* is that of the pool. Along a high-traffic avenue, the pool of water was strong in itself because of the presence of the water. I created a work that takes advantage of this spatial strength and of the strength of the water—the flow of the running water in the pool, the speed of the water spurting from the copper pipes—to contrast the powerful flow of the car traffic.

**LT:** I saw *Igloo-Fontana* during rush hour. Even surrounded by hundreds of speeding cars, the presence of your work is so strong that the cars disappear, they do not exist anymore.

**MM:** I created a work that is not in a good site for contemplation. I had to compete with speed.

**LT:** Inside the pool, there is an igloo covered with slate where you wrote the names of the four cardinal points with neon tubes. I presume the igloo means home and the cardinal points show the direction to take. Will you tell me about the igloo, which is a recurring form in your work?

**MM:** I worked on the first igloo throughout 1967. It measured two meters in diameter. Later, the diameter increased to three meters. Then, in subsequent years, it increased to four and then to six meters. The dimension of the diameter brings out form, structure, and size, anthropologically correct size. Even the initial two-meter diameter indicates to the person seated within the capsule how, in order to live an idea, the artwork becomes, in and of itself, its sole support. The small building (lord of the space, atom of the space) supports itself in space; on its own, it creates its own interior by way of being the measure of anthropological space, and on its own, it creates its exterior. It creates exterior space by the fact that it is the measure of an interior space.

I made the igloo for three reasons. First, the abandonment of the plane as a projecting or mural plane, with the resulting idea to create a space independent from the fact of hanging things on the wall or dislocating them from

*Igloo-Fontana*, 2002.
Mixed-media work installed in Turin, Italy.

the wall and placing them on a table. Hence the idea of the igloo as the idea of absolute space in itself: it is not modeled, it is a hemisphere resting on the ground. It was important that the hemisphere not be geometric: the semi-spherical form created by a metal structure was covered with sacks or pieces of shapeless material, such as earth, clay, and pieces of glass.

**LT:** Another permanent work, *Volo dei numeri* on Mole Antonelliana, was commissioned by the city of Turin. Did the choice of Mole Antonelliana as the work's support have to do with its architecture?

**MM:** Fibonacci numbers can easily go up along a vertical space. In terms of vertical architecture, there is nothing better than Mole Antonelliana. It is very expressive by itself; it is not simply a vertical wall.

**LT:** Tell me about your use of the Fibonacci sequence [published in Pisa in 1202 by Leonardo Fibonacci, who introduced Arabic numbers into Europe].

**MM:** The Fibonacci sequence follows a very simple idea: add two preceding numbers to form the following number.

Thus the sum of 0 + 1 equals 1; then 1 + 1 equals 2. And 2 + 1 equals 3. Written in sequence, then, they are: 1, 2, 3. Then the 3 is added to the 2 to make 5. The 5 and the 3 make 8. Thus the sequence extends but also expands rapidly, like the growth of a living organism: 1, 2, 3, 5, 8, 13, 21, 34, 55, etc. It is an operation without end, but in its scope of expansion the organic ferment of development is renewed as proliferation. They purify the space into a larger space, which is the space of infinity. It is the proliferation of numbers. Numbers reproduce themselves like humans, bees, and rabbits. If they did not reproduce they would cease to exist. The series is life. Numbers themselves (1, 2, 3, 4, 5, 6, 7, 8, 9) are the enumeration of dead elements. But the Fibonacci sequence is mathematics in expansion. That is to say living mathematics.

**LT:** Why do you usually write Fibonacci sequence numbers with neon tubes?
**MM:** Luminosity is the visibility of the whole. Rendered in luminous numbers, the sequence is perceptible as a whole, that is to say, it is proliferation. It is a visual material like the paint for a fresco.

**LT:** What about the materials that you use in your work?
**MM:** The materials depend on the site where I create the work. I always try to find in the place what is best for that work. I am not interested in previous experiences, I am much more interested in experimenting and introducing new material. In Rome, I chose grass in an archaeological area and included it in my work. The grass is the base of the spiral: I consider it a material that I used in the work. I can say the same thing for *Igloo-Fontana* in Turin. The pool and the water became the primary materials that I used to create my work.

# Measuring the Clouds: **Jan Fabre**

**by Michaël Amy**
**2004**

Jan Fabre lives and works in his native Antwerp. Contemporary art aficionados know him for his powerful figurative or abstract drawings executed in blue ballpoint and his sculptures fraught with surface ornament. Fabre's early drawings and sculptures of the 1970s reveal his abiding interest in performance art. The drawings often explored themes or motifs for a range of performance pieces, and the sculptures frequently arose out of live acts involving the body. Fabre's works, which treat the weighty subjects of life, memory, and death by indirection, often come across as great feats of physical endurance.

The drawings, consisting of dense, monochrome fields of all-over hatching marks, eventually grew in scale. They were displayed either freestanding, with their rectos and versos exposed to view like pieces of sculpture, or glued onto forms ranging from bathtubs and sheds to the vast *Castle Tivoli* at Mechelen (1990), near Antwerp. The copper thumbtacks that Fabre employed in the early sculptures to encase representations of his body, as well as accompanying objects, eventually made way for (usually green) iridescent jewel beetles. The latter were affixed to invisible armatures of wire mesh, suggesting three-dimensional things such as a urinal, a microscope, a Latin cross, a dress, and a hooded mantle. Today, the artist encloses voids with thin slices of human bone mounted on wire-mesh supports.

Fabre's interest in performance art is reflected in his manifold activities as actor, author, choreographer, and film and theater director. This Belgian artist with seemingly inexhaustible energy is also the co-founder, publisher, and co-editor of *Janus*, a quarterly magazine on art and culture. Fabre has had over 50 one-person shows since 1984 and has taken part in numerous group exhibitions including the Venice Biennale (1984 and 1997), the Bienal de São Paulo (1991), Documenta IX (1992), and the Istanbul Biennale (1992 and 2001).

**Michaël Amy:** *Beekeeper* (1998–99), in the collection of the Provinciaal Museum voor Moderne Kunst at Ostende, depicts a hooded mantle built up of hundreds of glowing jewel beetles. The mantle appears to hover in space, alongside the wall to which it is attached. What is the meaning of this work, and where does your interest in beetles come from?
**Jan Fabre:** That sculpture depicts a male angel, a monk of sorts. It is based on Bruegel's drawings of beekeepers. A beekeeper is a protector who accompanies one and serves as a guide. I am interested in man and, consequently, interested in angels. An angel is original, perfect, and unique, and man is the opposite of all of that. With that sculpture, I aim to express the idea that man wishes to improve and seek what is perfect, unique, and never changing. Man fails in his attempt to achieve this and has to rise again to the challenge. I have confidence in man. In my work, I seek to create a more perfect human image—an ideal place or space. I believe that this is possible. My work rejects all forms of cynicism. So much contemporary art is deeply cynical, so much of it is overly concerned

with power and commerce. These languages are foreign to my thinking about art. There is an alternative to an art permeated by the society in which one lives. In many of my recent sculptures, I seek to render the body spiritualized—the body reduced to a shell. We have internal skeletons, and beetles have external skeletons. My sculptures are bodies built up of hundreds of scarabs, in other words, hundreds of skeletons.

Beetles have survived for millions of years. They have adapted themselves to their changing environment. They possess information, they have the greatest memory. These creatures can be understood as the oldest computers, the oldest memories. I load the empty space of my bodies with that memory. The body you mentioned is a shell made up of memory older than the human body. Jewel beetles appear in Flemish *vanitas* paintings. They symbolize our passage to death, though death understood in the sense of a positive energy field, death as something that keeps us awake, death as a concrete object, like a table, which you can accidentally bump into, hurting yourself.

*Sanguis/Mantis (harnas)*, 2003.
Metal, leather, and cotton, 202 x 75 x 75 cm.

The monk-like figures I have been working on have their origin in my writings about a fluid body, a body consisting exclusively of blood. I have been thinking about what would happen should our internal skeleton be projected outward and become an external skeleton. One consequence would be that we could no longer be wounded, which would lead to the development of a whole new range of thoughts and feelings. We in the West, for instance, would no longer believe in that man who walked on top of water. My spiritual voyager, who no longer works and only has free time and thinks, is my hope for humanity. In our society, we do not get paid to dream—dreaming is forbidden.

Well, those figures dream and think, and they are invulnerable. These ideas have led me to the use of human skeletons, which I acquire in India and Leuven and saw into thin slices that can be sewn together. These slivers have the visual characteristics of Bruges lacework, a transparency of sorts. A year ago, I arrived at a new type of external skeleton, a new skin, which comes out of my thinking about the spiritual body. We are presently creating a new type of man in this technological age. How can we return to our innermost selves? My work has a lot to do with the Middle Ages. I find medieval thought beautiful.

MA: Do you believe in angels?

JF: I believe in the model of the angel—we need role models. I even believe in the model of the church. I believe that the church is necessary, which does not mean that I will be subjugated to its authority. We need to reclaim spiritual places in our society. I create spiritual realms through my art.

MA: You mentioned Pieter Bruegel and Flemish *memento mori*. How important are the early Flemish masters?

JF: Many of my sculptures are based on the observation of Old Master paintings. I find early Netherlandish painters of the order of Jan van Eyck and Hugo van der Goes great masters in terms of their powers of plastic conception, their spatial thinking, and consequently their sculptural thinking. I recently made two lambs of gilded bronze, one dead and the other alive, which are inspired by van Eyck's *Altarpiece of the Mystic Lamb* in Ghent. Gold appears in Old Master painting: I use it in a sculptural manner. These recent sculptures can be traced back to my work of the late 1970s, namely to depictions of myself covered with copper thumbtacks that have a gold-bronze look to them. Now, I finally have the means to produce bronze sculpture.

My other great source of inspiration is the animal world. My father took me on drawing trips to the Antwerp Zoo. I was influenced by Karel van Lat and Alfred Ost, who were not great artists, though they were undoubtedly skilled draftsmen. These excursions explain my interest in biology and the other sciences. My greatest sources of inspiration are Edward O. Wilson and Barry Bolton, philosophers of sorts. Bolton studied ants—insects that lead social lives—and Wilson is the author of *Consilience: The Unity of Knowledge*. When I look back at my work, I realize that for the past 20 years I have been using a conciliatory language. By this I mean a merging of elements from different disciplines guided by theory and practice. An understanding of entomology can, for example, lead to new interpretations within the visual arts. Or vice versa. Once you manage to reconcile the kinetic qualities of beetles and the kinetic qualities of humans, you obtain new interpretations that can be applied to each of these species. I have allowed the subjects that I have studied over the years to influence each other. I am not an eclectic artist, I am not a multimedia artist: I have always been very aware of what is performance, what is theater, and what is visual art. I owe a great deal to my parents. My father also took me to the Rubens house—he taught me how to appreciate painting. My mother translated French literature into Flemish for me. My interest in words and images can be traced back to them; drawing and writing are the foundations of my work. I think as I write, and I draw as I think.

I am interested in the independence of the artist. This strikes me as one of the characteristics of the Belgian artistic tradition. Artists I admire, such as Ensor or Magritte, are one-man movements. There is actually something rather bourgeois to that sustained involvement with one's own world, plans, strategies, and thought patterns.

MA: Your use of human bones or wrapping columns in slices of ham (at the Rijksuniversiteit Gent for the "Over the Edges" exhibition, 2000) may raise moral concerns. Has your work been censored?

JF: My "meat pier" was based on a 1978 work made by gluing thumbtacks onto a representation of my body, following a performance in which I had used sandpaper to remove the skin from one of my legs. At the university, my idea was to skin the legs of the house of reason, which was clearly an unreasonable act, while being at the same time an act of exploration, of research. That work was successful in that it forced people to engage with social and political ideas. It was also visually striking, for the ham resembled slices of marble. It was an old idea of mine, which I was suddenly able to carry out on a large scale. Some people found the whole thing scandalous, but for all the wrong reasons. There was no censorship involved. However, certain groups became increasingly aggressive, and at one point, private security guards had to be hired to protect the work.

MA: Does *The Man Who Measures the Clouds* (1998, Stedelijk Museum voor Actuele Kunst, Ghent) have its source in the world of dreams? Do dreams play an important role for you as sources of inspiration?

JF: No, they do not. That sculpture pays homage to my late brother, who was a dreamer. It expresses the feeling of planning the impossible, which is what the artist does. That figure symbolizes my trade. Artists attempt to get a grip on things, but it never quite works out as planned. Life is so fluid and flexible: today, we are no longer where we stood yesterday. The artist measures. He or she establishes connections—mental, physical, political, and philosophical rapports. I am constantly measuring these types of relationships—that is my duty as an artist. As an artist, I constantly measure the clouds.

*The Man Who Measures the Clouds* represents a frozen action—an homage to death and to the artist. The man is shown standing precariously on top of a library ladder placed at the edge of a crate, while holding up a school ruler. It's dangerous to be an artist—both literally and figuratively speaking. The history of this work can be traced back to the early '80s, when I made a version out of clay. The ornithologist Robert Stroud has strongly influenced me. In The *Birdman of Alcatraz*, when he is finally released from prison, Stroud states: "I am going to measure the clouds," with the full understanding that it is an impossible mission.

MA: How do you delegate work in colossal endeavors of the order of *Castle Tivoli* (1990) or *Heaven of Delight* (2002), your recent ceiling for the Hall of Mirrors of the Royal Palace in Brussels?

JF: *Castle Tivoli* was a drawing/sculpture and a sculpture/drawing that you could penetrate or walk around—

*Heaven of Delight*, 2002.
Beetles on ceiling and chandelier of the Royal Palace, Brussels, installation view.

it was a vibrating piece of drawn sculpture. In my work, I have sought to achieve the independence of drawing as a self-sufficient medium. I want to rid drawing of its personal signature. What better to achieve this than by creating a colossal drawing—a large energy field—with 30 assistants in which the hand of the artist becomes irrelevant. *Castle Tivoli* raises questions as to what exactly is a drawing and what exactly is a sculpture. It was the culmination of that particular period in my career. I was involved with *Heaven of Delight* for three years, although actual work on the ceiling took three months. This sculpture/drawing consists of 1.4 million jewel beetle shells. My first drawings in blue ballpoint were created by following insects on paper—the splitting of space. Next, I proceeded to replace the ballpoint line by the insect itself. The shimmering ceiling at the Royal Palace is the apotheosis of my development involving the beetles. That is why I am currently conducting research on the body, that strange laboratory we wake up with every morning.

My work is concerned with the release and the absorption of energy, with electricity. I still do a lot myself. I register energy, time, and intensity. I am interested in the act of making. I could have drawn over a photograph of that cas-

tle in Mechelen, but instead I chose to cover the entire castle with blue ballpoint. The process of making, or letting others make, gives me tremendous pleasure. I cannot get away from that—I love that physical experience. My nerves cannot be tamed. As far as the ceiling is concerned, I first created a wide variety of forms and patterns by gluing beetles onto small surfaces. Then I told my 29 assistants that they could start inventing forms, knowing full well what they would come up with. This process allowed me to discover who was good at what type of pattern. Once I had this information, I could assign different areas of the ceiling to different assistants. Those thousands and thousands of beetles form drawings within the larger drawing, as in my large ballpoint drawings. My sculpture seeks to conquer space.

MA: Where do you get thousands and thousands of beetles?

JF: I obtain the scarabs from universities and through the open market. The *Sternocera acquisignata* used in the Royal Palace is a non-protected species that appears abundantly in certain countries. In Thailand, the beetle is fried for consumption and its shell is discarded.

MA: Your work can look extremely delicate. Is it ephemeral?

JF: I use strong materials, which happen to have a fragile appearance. The color of those beetle shells will never fade because the outer integument contains chitin, one of the strongest and lightest materials on earth: it was used for objects destined for the Mir space station. Scientists are once more studying the world of insects. I love the durability of things. I create for the future. I believe that my work contains many riddles and layers, which will reveal themselves more clearly to the beholder in, say, 50 or 100 years. Only then will my work be better understood. I find it such a beautiful thought: we live in a society where no one is concerned with durability, while artists are precisely engaged with issues of durability. Durability is a rather old-fashioned concept. You are no longer allowed to believe that your work will have value in, say, 100 years. I believe, on the contrary, that its significance will increase. I would stop making art if I believed that my work could hold no future meaning.

# As You Spend Time With It: Tim Hawkinson

**by George Howell**
**2004**

For an artist who likes his privacy, Tim Hawkinson was busy on the day I met with him in his Garment District studio in downtown Los Angeles. A shy, soft-spoken man with a quick wit, Hawkinson doesn't often agree to do interviews. But a PBS film crew had just spent the morning shooting his scale model for *Überorgan*, a warehouse-sized installation featuring bagpipe-like air bladders that was shown at the Massachusetts Museum of Contemporary Art (2000) and at Ace Gallery, New York (2002). Hawkinson is much in demand. His work has been included in the Whitney and the Corcoran Biennials (2002), in a major survey hosted by The Power Plant (2000) in Toronto, and in various shows throughout the U.S., Europe, and Japan. He has garnered well-earned critical attention for his work, which combines a tinkerer's ingenuity with philosophical heft. With a gift for illusion, Hawkinson is like an intrepid explorer out to rediscover the known world, and what he finds is equally charming and unsettling.

**George Howell:** When were you at UCLA? Did you study with anyone who got you started in the direction you took?
**Tim Hawkinson:** I was there from 1987 to '89. I was really impressed and influenced in my thinking by the work of Charles Ray, Chris Burden, and Paul McCarthy. But I was still doing a bit of painting, playing around with the relationship of two and three dimensions. I worked with the older painting faculty, like Elliot Elgart, Lee Mullican (Matt Mullican's father), and Roger Herman, who is still there. Do you know Charles Ray's early work? These were really sharp, abstract objects; *Ink Box* was the most famous. It is a three-foot-square black cube filled with black ink, so the top surface is liquid and dangerous. Another is an eight-inch-diameter disk that looks like a pencil-inscribed circle on the wall, but as you spend time with it, you realize it's actually a disk spinning at 30,000 rpms, or something ridiculously fast, so that you can't see it moving. I was really interested in some of those ideas.

**GH:** You seem drawn to visual illusions. I saw pictures of huge metal trumpets for *Überorgan* and then discovered that they were cardboard tubes covered with foil.
**TH:** I've worked a lot with aluminum foil over the years, starting with the illusionistic pieces. Is that what you are referring to?

**GH:** I was thinking of *Knight* (1998).
**TH:** Initially I made that piece as a hanging suit of armor that would quiver in an air current. But it was caving in on itself, and I ended up injecting it with urethane foam, which turned it into a totally different piece. But I really like the foam oozing out from all its cracks. Even before the knight in armor, I was doing illusionistic work like *Volume Control* (1992), which was aluminum foil on a panel. It's perfectly flat, but it has the appearance of an undulating surface. It uses the same technology that I found in kitschy souvenir cards. I think it's called "laser art"—the pattern

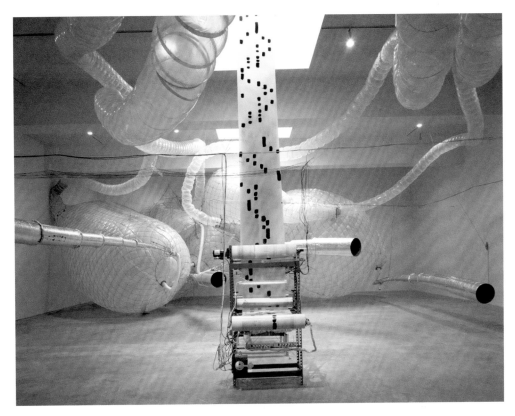

*Überorgan*, 2000.
Woven polyethylene, nylon net, cardboard tubing, and mechanical components, dimensions variable.

is printed on a foil surface, and by alternating the direction of concentric lines in the pattern, you can manipulate the reflected light and have it either reflect the light or shadow in the ambient environment. I started with a disk of aluminum foil and cut it into concentric rings and shifted each ring a few degrees to create a diffusion of light.

**GH:** The illusory quality of some of the pieces reminds me of the way that Bruce Nauman creates something that looks fairly innocent, and then you realize there's a kind of entrapment going on. Roberta Smith described you as fitting into the "diabolical sublime" of contemporary art. Do you think of your work as diabolical?

TH: Yes, to an extent. I don't know that I implicate the viewer to the same degree that Nauman does. I'm engaging the viewer, but I'm not trying to trap anybody, or really fool anyone.

**GH:** I was thinking of a piece like *Shatter*.

TH: I took strips of mirrored Mylar and drew a "shatter" with them against a white surface. I expect people to read

it as a shattered piece of glass, and it has a threatening presence. Hopefully people are using their eyes—although once you make a read on something, you end up relying on that initial impression sometimes. When you get up close, you can see that it's just film and very vulnerable and moving in the air.

**GH:** The work in the '98 Ace Gallery show played on a fetishistic or mystical notion of skin.

**TH:** Yeah, I don't know what it is about skin and surfaces like that, but they keep coming up. It's a surface, but also a container.

**GH:** You've done a whole series of inflated figures, ending up with *Überorgan*, that play off skin, skins as inflatable bags. Would you talk about the history of those inflated figures?

**TH:** I think it started as an investigation of volume, mapping, and measure for *Untitled (Chicken)* (1986). I took a chicken out of its skin, trying as much as possible not to rupture the skin. I made an armature that resembles a football with bed springs sticking out of it as a way to preserve the skin in something like its original form. I was thinking about volumes, the inherent geometry in a fractal part of a volume. In *Spoonball* (1991), the spoons create a volume through the geometry of their bowls, as in *Dorito Polyhedron*. I combined those early volumes with an almost fetishistic interest in Elmer's Glue peeling off of skin. You know when you're in grade school and making little projects? It's more interesting, actually, to let the glue dry on your hand and peel it off. Taking that research to its logical conclusion would be an entire figure made of Elmer's Glue or, in this case, latex because it's easier to peel off and seal. That was the basis of the first latex *Balloon Self-Portrait*. I did a couple of others, including *Fathead* in the studio clothing and then another one, *Insomnia*, an inflated sleeping bag with a head sticking out.

Doing *Balloon Self-Portrait*, I was curious about the play on the positive and negative. The skin is turned inside out, and you can see the fingerprint side of it on the outside. You get all of that really detailed information, an accurate depiction of my body, but at the same time, it's distorted by being inflated. An inflated volume is so different from one on an armature of skin and bone.

**GH:** In a way, isn't *Überorgan* an inner space projected outward?

**TH:** Yes, *Überorgan* looks like an extrapolated digestive track. And, in the space at Mass MOCA, the ceiling has open beams that almost suggested a rib cage. They really felt like lungs.

**GH:** With the inflated skins, there are two ways you can go: as breath and creative inspiration, but then there's the mechanical side, too. There's a big gap between those two aspects. Do you think about both sides when you are working on a piece like this?

**TH:** When I work on a piece, I see the more poetic interpretation, but, obviously, I'm concerned with the practical

stuff: How much psi do I need to activate this reed? Will that amount of pressure blow up the balloon? It would, without that netting around it. I don't know if that really answers your question, but I'm aware of that spiritual interpretation; I like that, but I don't really follow you when you say there's a gap between them. You have to have both—you have to have the practical to support the poetic. The physical construction is all I really present to viewers, and beyond that I like to leave it open. I might have my own way of regarding the piece, but I don't expect that interpretation to be shared or logically picked up by anyone else. We all have our own experiences we bring to a work. I wouldn't talk about my interpretation of the work because it creates a bias, I guess.

**GH:** *Emotor* looks like a self-portrait, but is it on latex or some stretchable material?

**TH:** No, it's not stretchable, although it's great that you thought it was. It's all just photographs, three copies of the same head-shot that I cut up. They're superimposed parts: the eyelid is a complex hinged structure, all very mechanical, with sliding tracks and pins to give it as much elasticity, or what looks like elasticity, as possible. The nostrils operate like camera apertures so they can open and close, sort of flaring. It's like a two-dimensional puppet, and it's all controlled by a random combination of about 20 possible on-and-off signals. It reinterprets this random information into something that we are trained to read and make sense of because it's a face making expressions.

**GH:** You've used yourself as the basis for many of your pieces. Why you as opposed to someone else?

**TH:** As you can see in a lot of my work, I'm using easily located material. If I don't find it in the alley, I can easily find it in a hardware store. If I was going to use anybody, the most available person would be me, just sitting here. I guess it comes out of that simplification of materials and the idea of viewers putting themselves in my skin, not to become "Tim" but to experience the piece through their own bodies. A lot of the work has the vantage point of being inside looking out. It was important to experience that piece in time, and some of the other pieces, too. They take up a little bit of time—they change, that's part of what they are. *Emotor* comes out of these earlier pieces such as *Signature Machine*, *Ranting Mophead*, and *Tuva*, which was a little more abstract. Do you know the Tuvans of Central Asia? It's a culture that practices a kind of polyphonic humming or chanting called throat singing. This machine could sort of polyphonically chant. There was one constant bass tone, and, by manipulating the resonant cavity, I could create different, higher pitched harmonics that reflected off the bass tone. It's hard to hear the whole range of harmonics, it's sort of "ooomongghuuonggh." I used to be better at it. It was something I would practice in the car, alone. So I started doing that a little bit and realized that the geometry of the mouth can be suggested, in this case by using plastic bottles and shifting their relation to each other.

**GH:** That really looks like a precursor to *Ranting Mophead*.

**TH:** Yes, there are a few pieces with two parts linked by an umbilical cord. You have a mechanical device that's driving

*Signature Machine*, 1993.
Desk, motors, found wood, and metal, 37 x 28 x 24 in.

or creating an event at the other end of the cord. And so the face piece was an extension of another piece that was talking. The face suggests emotions.

**GH:** I read that in one of your first pieces, you took a can of alphabet soup and rearranged the alphabet.

**TH:** Yes, I alphabetized the noodles—another obsessive ordering piece. I found that there were many times more lowercase Ls than any other letter, but what happens is that the other letters, like the Ms and Ns, break down and create lowercase Ls.

**GH:** Like genetic soup in a way?

**TH:** Exactly. For *Ranting Mophead*, the end product was transformed by the process of making it—all the unforeseen turns that process takes. Initially, I just wanted to make something that could talk, that could form some words. Based on a really limited vocabulary, it ended up saying strange things like "I want to mop your violin." It could pronounce the vowels, but it had a hard time with certain consonants, and so I created this vocabulary based on its limitations. The things it was saying were really part of that process.

**GH:** I made an association earlier between you and Bruce Nauman. His work is full of puns and twists in language, but you tend to shy away from language, per se. Are you more interested in creating information structures?

**TH:** I don't know, I don't like to get too specific. Maybe it's really out of that. I don't use words a lot. I'm not a big telephone person, and maybe I'm more comfortable with wordless communication, through the work.

**GH:** I could imagine that the reason you don't want to do interviews is that you might feel pushed in a particular direction or forced to interpret things.

**TH:** That's exactly right. It's good that you said that because that's part of my phobia about giving lectures and slide

presentations. I would be forced to look at my work as a body and start quantifying it, and I like to keep all of that in the past, sort of vague, and try not to be influenced by it. When you revisit your work, you start to notice things, and that can influence your decision-making in the future. I'm not trying to be "dumb" about my work, because I'm plenty aware of it and the thought processes, but I like to stay focused on the present and future and keeping them open.

GH: *Drip* has been described as a sea creature. Was that your description or the curator's?
TH: I think it was mine. Although the Corcoran commissioned it, they didn't know what they were getting, and I saw it as a thing that looked like an octopus.

GH: The interesting thing was the mechanical structure, like the machine in *Ranting Mophead*. It looked like a complicated way to distribute random signals.
TH: It was ridiculously complicated, and to think you can do all of that with a little chip. I mean, what's the point? I wanted to figure out how to make a drumming machine, a random pattern generator. But the patterns weren't so random that they didn't feel connected; they felt almost danceable. So I used a gear train to get different patterns or frequencies, and all of this other stuff sampled the frequencies and remixed them so that they'd fall within a rhythm. But it's funny that here's a piece in the middle of the gallery that you're supposed to be looking at and then there's another mechanical monster in the corner that actually gets all of the attention—it's the really interesting thing to look at.

GH: You seem to relish a complicated, almost behavioral mechanism, a structure that causes behavior.
TH: To me, the machine is as interesting as the event it causes to occur. I guess in the earlier work, I was hiding the mechanical stuff, but then that felt a little dishonest and I thought I would just let it all hang out. The machine is really of the piece, anyway, so I'm just giving it equal presence. I really do like figuring out how to make things, but the making is really not aestheticized—all that stuff is there for a reason, it's not a Rube Goldberg contraption. Not having studied engineering or electronics, that's just how I solved the problem. And I think that's sort of interesting, too, just as an artifact. Not artifact, but as a document of that pattern of thinking.

GH: Is *Überorgan* the most complex project you've done so far?
TH: It's certainly the largest and has the most presence. Maybe the machine for *Drip* is the most complex because it takes some of the technical stuff I learned in making *Überorgan* and introduces other things, and maybe the potential for failure in that machine is greater.

GH: It sounds like you know a lot about music. Do you have a music background?

TH: No, I don't know anything about music theory. I'm really interested in sound, and so when I hear something that I'm interested in, I do a little more research, like with *Tuva* and the polyphonic sound-making. But I didn't study it.

GH: The sound makes the work inviting, though a lot of your pieces create a psychic dislocation. Do you think of sound as a way of greeting or accommodating the viewer?

TH: Well, no. In the sound pieces, the machine is supposed to make that sound—that's what it does. The sound that you're hearing is the whole purpose of the piece. To say that the sound could be greeting the viewer, that seems more like a by-product.

GH: For *Überorgan*, did you use hymns?

TH: Yes. There is a 300-foot-long, player piano tape loop with dots and dashes that the machine reads: old church hymns, music from *Swan Lake*, sailor's hornpipes, the theme of the Olympics, and then an improvisational piece by Doug Harvey. None of it is really recognizable because switches and other things reinterpret the sounds. Plus, this organ only has 12 tones; normally an instrument can go into other octaves. So it's based on certain recognizable melodies, but good luck recognizing them. I grew up in the Presbyterian Church, and I chose "A Mighty Fortress is Our God" and "Amazing Grace." They had a strong impact for me and a relation to the organ. The spiritual aspect is not something I'm going to present because I want people to get it on their own.

# Mapping Traces: Rachel Whiteread

**by Ina Cole**
**2004**

Rachel Whiteread's meteoric rise to prominence in the 1990s cemented her reputation as one of Britain's most important sculptors. Her work involves casting the space within and around objects, using materials such as resin, plaster, concrete, and rubber to create negative impressions of her chosen object. She made her first architecturally scaled work in 1990 with *Ghost*, the cast of an entire room. In 1993, she was commissioned to make *House*, the cast of the inside of a terraced house in East London. Her commissions have come under much public scrutiny—none more so than *Holocaust Memorial* for the Judenplatz in Vienna (2000), which marks the genocide of the Austrian Jews in World War II.

*Room 101*, recently unveiled at the Victoria and Albert Museum in London, is a cast of the actual room that inspired George Orwell's nightmarish vision of the future in his novel *1984*. Whiteread's current projects include a number of experiments using new materials.

**Ina Cole:** You have achieved an enormous amount over the last decade and your reputation is assured, yet you've said that you now feel you have arrived at a pause. How do you intend to use your period of respite in the planning of future projects?

**Rachel Whiteread:** I'm at a stage where I've worked incredibly hard for 10 years and simply need time to take stock of things and start thinking about how other projects will happen. In the last couple of years, we've moved house, moved studio, and had a child. It's been a lot to deal with, and it's now time to very quietly get back to work. I decided to get involved with The Snow Show in Finland. I'm making a large work in snow and ice, which I think will be an interesting way of moving forward and may lead to something else.

The BBC recently asked me to make a casting of a room at Broadcasting House, a room that George Orwell apparently used as his office—*Room 101* from *1984*. I couldn't say no: the room was about to be demolished, and this was a way to make an imprint of it. I made an enormous sculpture, which is now on show at the V&A in the Cast Courts. So, things like that have been going on over the past nine months or so. Now I really want to get back to the intimate process in the studio that sometimes gets taken over when you're making large pieces and end up producing your work, rather than physically creating it.

**IC:** You recently turned a former synagogue in East London into your home and studio. Why did you take on this project?

**RW:** We were originally looking for a site to build a studio and house, but we realized that it was just impossible; developers know what every square centimeter is worth, and there's no way we could have afforded it. So we found

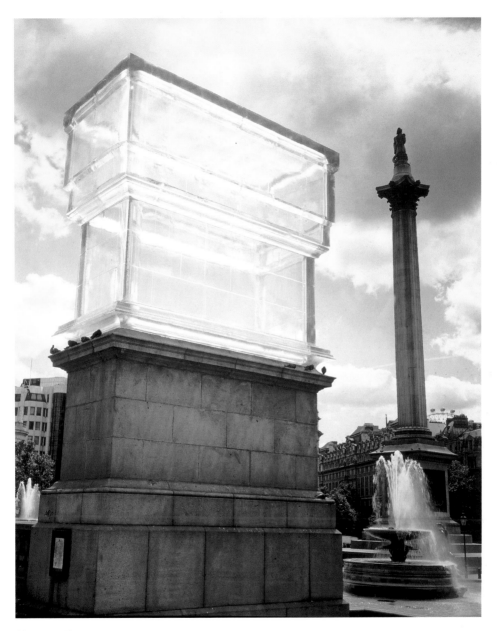

*Monument*, 2001.
Resin and granite, 9 x 5.1 x 2.4 meters.

this building, which was in a very disheveled state. It had been used as a textile warehouse for a long time and we weren't sure what to do with it, but we knew that we wanted to try and live and work in the same place. I've lived in this part of London ever since I came back from Brighton 15 years ago. It's really changing now, with a lot of construction going on. There are a lot of artists living around here and a varied community, which is what I particularly like about it.

**IC:** *Untitled (Stairs)* consists of casts taken from your new home. They are poised at an incomprehensible angle, exaggerated by the fact that you're looking at the space where the stairs were, not the stairs themselves. How did your fascination with staircases come about?

**RW:** It really started a long time ago when I made *House*. I work in a linear way, and when I made *Ghost*, I thought it would be interesting to explore the possibility of casting an entire house—*House* came from *Ghost*. When I made *House*, I thought that there was something missing. I was slightly irritated by the fact that I'd left the walls in and that the staircase hadn't been taken out. It was like the mold hadn't been completely taken apart. About eight years later, I finally worked out how I could do it. I'd been trying to cast stairs before that, but I didn't have the right materials or the expertise. I also didn't have the staircases. There was a possibility of doing it with certain buildings that had been demolished, but it just didn't feel right.

When we purchased this building there were three staircases in it, which was fantastic, and I just worked with those. We made the first one, and I was so excited by it that we ended up casting all of them. It's very difficult to turn a space into an object in your mind, so we made models and played around with them, trying to work out which way they would go and how they might sit. When the actual object was cast and put in the studio, it did something I hadn't felt for a long time with a sculpture—psychological and physiological things where you felt upside down and things felt upside down or turned on their heads. It really excited me as a very simple act of making something, rotating it, and finding the right way up for it. I enjoyed mapping this building, and I also made some casts of the floors and the two apartments, which felt like a way of getting to know the building and understanding it.

**IC:** You have been working in London for a long time, yet the spaces you cast are often private spaces where one might hide. Do you feel that the faster city life becomes, the greater the need to hide or to create impenetrable barriers?

**RW:** Maybe, but I think I need London. I lived in Berlin for 18 months, and that was a much quieter city. I made more work there than I've ever done anywhere because I was on my own and really able to concentrate. I definitely need quiet times when we go to the country and take a deep breath, but I also need the hubbub of city life around me. I use it as my sketch book. I don't know if that will change, who knows: you get older, you change, life changes. When I made *Monument*, for example, I was trying to create a pause in the city and place something that felt very quiet in Trafalgar Square.

IC: Could you imagine living and working in more tranquil surroundings, or is it the contradictory need to create a private space within the urban environment that gives your work such potency?

RW: I get as much from the hubbub as I can from anywhere else, but I am essentially a private person and need time to stare at a white wall—I don't mean literally, but meditatively. When you become more successful, it's much harder to find that time and to plan ahead. I'm trying to work out a way of changing, of going backwards and remembering when I was working in the depths of the East End and cycling to the studio. The freshness of that time was easier, and I'm trying to find that place again.

I've done a lot of traveling over the past five years. I recently went to Brazil for an exhibition of my work organized by the British Council. When I'm traveling I take photographs, walk around markets and back streets, and drive out into deserts. That time really is research—you know it's going to feed back into your work. I've also been walking in Wales over the past couple of years, and there are a lot of reservoirs there. I've become fascinated with these great cast bits of water, these manmade, rather dreadful but necessary things, which are essentially incredibly poetic forms. I just wanted to go and look at places and think about making sculpture. I'm still absorbing all of that. It definitely feels like a thoughtful time at the moment.

IC: Do you feel that you're standing on the outside looking in, taking time to observe aspects of life that often otherwise go unnoticed?

RW: Yes, but I think a lot of artists do that; it's part of being an artist. You seek out things that are hidden, draw them out of the environment. I do that, but I also scratch around with the residue of cities. What's odd about living around here now is that a lot of the second-hand shops and resource places where I used to get things have all changed and moved further out. We're living right on the edge of Brick Lane market, which is a very established market, and sometimes you can't even get out of the door for people selling their wares. We've designed this building so that we're living on the roof, looking straight onto this ever-changing East End environment.

IC: Your work has been compared to that of Donald Judd, Bruce Nauman, Carl Andre, and Gordon Matta-Clark. However, you pushed the boundaries in making the invisible visible, which was remarkable, particularly in monumental projects such as *House* and *Holocaust Memorial*. The demolition of *House* caused a public outcry. Were you saddened by its destruction, or did you feel that ephemerality was important to its meaning?

RW: I don't think I would have liked *House* as a permanent piece because it wasn't made with that in mind. I would have liked it to stay up for a year, and it only stayed up for about four months. The main reason I was sad when *House* was demolished was because I felt that I never really had a chance to see it properly—making work in the street is very different from making work in the studio. I was quite ill by the time I'd finished. It was all just crazy: I used to go to the site virtually in disguise and sit in the car around the corner, and every time it would be mobbed

*Untitled (Stairs)*, 2001.
Mixed media, 3.75 x 5.5 x 2.2 meters.

by people. There was an unfortunate set of circumstances, mainly because of one particular council member who wanted it demolished. He thought that the middle classes were lobbying for it, and it wasn't a middle-class neighborhood. We ended up renting the ground that *House* was on from the council, so it could stay up for an extra month or so. I suggested that we make a children's park there, and they said no, they didn't want any memory of the piece. However, people continue to tell me their memories of seeing *House* and I'm very proud to have made it, but I am sad. I don't think it completely lost its dignity, but its dignity was rather hijacked.

**IC:** *Holocaust Memorial* was a difficult and emotive commission. There has been much speculation about the problems of this sculpture, involving politicians, local residents, and factions within the Jewish community. Why did the piece become so contentious?

**RW:** Mainly because there was a political struggle in the city, and the ministers involved were always changing. Some of them were desperate for it to happen, others didn't care, and it just went on and on. Austria is a strange

and complex place politically. I got absolutely frustrated in the end when I was just used as a political pawn, and I refused to go over there. We worked like that for four years. Without the guidance and support of the architects, Jabornegg & Palffy, and of Andrea Schlieker as liaison, I wouldn't have managed to complete the project. However, I'm happy to have made it, and I'm proud that it's there. It hasn't been graffitied, extraordinarily, and I think it's well received in the city, but I haven't been back since it opened and there would have to be a very good reason for me to return.

**IC:** How important is the historical casting of space to the development of your work? I'm referring to feats such as the excavation of Pompeii, Egyptian sarcophagi, and the making of death masks in the 15th century. Are these issues you think about?

**RW:** In the past, yes. Casting has now become the language I make work in, but when I was looking for that language I was definitely looking at sarcophagi. I've never been to Pompeii, quite intentionally, because I don't want to be disappointed. The image I have in my mind is probably stronger. I had a period when I went to look at volcanoes, which for me was as interesting as going to look at a pyramid. It doesn't necessarily have to be a manmade thing; it can be completely elemental and unpredictable. I recently saw an exhibition called "Body Worlds," which was extraordinary. The work was dreadful, but there was something fascinating about it as well. There were casts of blood vessels and a whole artery system in the body, which looked like fantastic sea plants. It was the casting of the body's interior that really interested me, rather than the fact that it was a macabre 21st-century circus.

**IC:** Nineteenth-century sculptors referred to the stages of casting in bronze as life, death, and resurrection: the object is destroyed through casting, only to live again in bronze. Your objects remain in the stage where they have shed life yet retain the potential for transformation. Do you feel that you always maintain control of how a work is developing, or can things happen in the process that sometimes surprise you?

**RW:** Yes, definitely. If I'm in the studio and an accident happens, I'm very happy to embrace it and make decisions based on it. If accidents happen in the foundry, it has to be destroyed and done again. You go from the plaster, to the mold, to a wax, to a metal, and I think that in those stages there are already enough changes. I have to be very clear as to what the end result is going to be, and it's really satisfying when you make something in the studio, send it off, and later it comes back and it's exactly as you wanted. When I made some of the early rubber sculptures, I wasn't sure of how they were going to work. They were cast flat, and I was literally wrestling around with them in the studio. Then they would slump against the wall and that would be perfect—they found their own home. Those things become part of your language, and in order to work with a full deck of cards I had to spend 15 years developing the language. I'm now working with all those different elements, and by taking a pause I hope to start playing again. It's a linear but organic process: I'm always thinking in a straight line, but these little things happen along the way. The casting process has to be structured because you can't make a seven-ton sculpture and think, well that hasn't worked. But the language will always change and develop.

**IC:** Are there any materials or methods you haven't tried yet that you intend to use in future projects?

**RW:** I'm just about to start on a whole bunch of new material samples that I've got laid out in the studio. I've done a lot of research in the past, and I'm sure I will continue with it because I'm always curious about materials. I don't think of a piece and then try to find the material: they're equally balanced, and I'm playing with the two things all the time. For The Snow Show, various artists and architects were paired to make ice and snow sculptures, which will be dotted over two areas. It's going to be very bizarre, I have no doubt. The show will be up for a couple of months before it becomes too dangerous for people because of the weather. I'm going to spend time with the architect in the studio. We're working on an idea that involves an inside-out, upside-down architectonic structure. I'm currently working with models and drawings, but it's all in the early stages so I can't be too specific about a description of the work.

**IC:** Your idea of casting space began when you cast the inside of a wardrobe where you used to hide as a child. By making a void solid you are effectively shutting viewers out, you are sealing off the space they would normally enter. Is this just part of the process, or is there also a psychological intention?

**RW:** My very first show consisted of casts from a wardrobe, a dressing table, a hot water bottle, and the bed, *Shallow Breath*. These four elements sat in the gallery as though it were a bedsit. I'm not from a wealthy background, and it was simply a memory of my childhood, of my grandparents and my parents. Some of those early works were autobiographical and very much to do with my childhood and my father dying. After all these years it still comes from there, but it comes from all sorts of other places too. I think that the staircase pieces are as psychologically loaded as *Closet* or *Shallow Breath*. I always use the word "physiologically" because I think it's something psychological, but also something to do with the body—how you use space, how space is connected, how you sit on a chair and put your legs under a table. It's something I use all the time and will continue to use, whether it's about absence or presence.

**IC:** You have said that you need to make the sculptures. Where does this urgency come from?

**RW:** If you're creative and have an idea you know will work, it's almost like an addiction and you have to make it.

**IC:** You have called what you do "mapping, a process of making traces solid." You are in a sense immortalizing the spaces that you, and all those before you, have entered. Do you think of your casts as tombs, containing the ghosts of previous inhabitants, as well as traces of yourself?

**RW:** Yes, that's a very rounded way of looking at it. With *Room 101*, all six sides are cast—the floor, the ceiling, and the walls. It's the first time, other than with the staircases, that I've made a room that's not solid: there's an interior to it, yet it's completely sealed and does feel tomb-like. *Ghost*, for instance, didn't feel very tomb-like because it didn't have a ceiling. I never try to make something look like a tomb: I make it as I want the object to be and then

it will have these other associations and connotations. When I saw *Room 101*, it was a plant room full of all the gubbins that kept this big building breathing—all metal work and pipes. Everything was ripped out, and I was left with a blown-up, pock-marked room. It was at the beginning of the Iraq war, so it felt like a response to that—it felt like a room that had been bombarded with shrapnel. When you look around London and inspect the outsides of buildings, they often still have pockmarks all over them. So, it looks very much like that, which felt quite Orwellian.

# Sculpture to Enlarge Our Reality: Tony Cragg

**by Laura Tansini**
**2004**

Tony Cragg was born in Liverpool in 1949. His high school studies were science-oriented, and in 1966, he got a job as a technician in the research laboratory of the Natural Rubber Producers Research Association. During the two years he worked there, Cragg discovered his interest in art. For him, making art was and is an endless investigation into the nature of matter and objects, an obsessive speculation he carries on as a scientific experiment. His main concern as a sculptor has been to enlarge and enrich our language, the language of objects, of nature, of reality. In 1968–69, Cragg attended the Gloucester College of Art and Design in Cheltenham, and, in 1969–72, the Wimbledon School of Art. In 1972, he entered the sculpture course at the Royal College of Art in London. After graduating in 1977, he moved to Wuppertal (Germany) where he still lives and works. Cragg is considered the first of a new generation of British sculptors to appear in the 1980s. Since then his works have been regularly exhibited in galleries and museums throughout Europe, the U.S., Canada, and Japan. In 1988, he represented Britain at the Venice Biennale, and in 1989, he was awarded the Turner Prize.

In spring 2003, Cragg had two major exhibitions—one in Germany and the other in Italy—for which he edited a book (published in Germany by Richter Verlag and in Italy by Mondadori Electa), a survey of 30 years of his work. A conversation with Cragg is a conversation about the reality of objects, about his search for new materials both natural and manmade, about new forms in sculpture, about a new and wider language of sculpture, and about the responsibility of artists.

**Laura Tansini:** Many of your works (the plastic and glass sculptures) are made with manmade found objects. What is the reason for using objects?

**Tony Cragg:** I make no distinction between manmade material (objects) and natural material. The objects I use in my works, for me, have equal value to natural materials. I use objects because of my need to go beyond the utilitarian reason of objects. Using objects, I try to push our reality a bit further. This is of vital importance to our culture, because generally we are concerned about the things we produce and how the environment and the reality we create for ourselves look. But all of the objects that we use are produced for utilitarian needs and demands, an enormous limitation of reality.

I think that we should not leave the shape of the future to politicians and businessmen—there should be some other activity, even if it is only a very small activity, such as sculpture, to find new forms, alternative shapes that would help to produce better imaginations, better dreams, better fantasies, because we would have a better, stronger visual language. That is what I really feel sculpture-making can do. To get out of this dull reality we have to make the shape itself: challenging the material, looking at the shape and learning from things, and having the opportunity to touch

*Changing Minds*, 2002.
Bronze, two pieces: 850 x 130 x 130 cm., 650 x 340 x 270 cm.
Work installed at the Hobby Center for the Performing Arts in Houston, Texas.

all of these different things, to feel their difference—in a word to learn from them because they all have qualities, they all have something. This idea of extension into space with material is actually the new potential of sculpture. Material is everything for me.

We have an enormous range of materials that we can use now. At the end of the 19th century, there were very few materials to make sculpture; now we have a wide variety of instruments. In terms of the form, most 19th-century sculpture was figurative, and sculpture remained figurative up to the middle of the last century. For me, sculpture has just begun, just now, and I think that it has the possibility of becoming something completely new and very important. Making sculpture is not about making some sort of adornment for the world. It is an investigative medium in a direct sense. Sculpture can bring changes of all sorts in all areas of human life. I make a lot of experimental things as I am going along.

LT: In fact, you keep changing objects, forms, and materials.
TC: My first student works from 1969–70 (*Line of Boxes, Stacks of Bricks*, and *Stacks*) were very heavily influenced by Arte Povera and by a new generation of artists. We had different interests but were starting to use materials in what seemed to be a very primary way—it was a driving energy to find new materials. This was in the early '70s. I used no glue, no screws, no constructive method to make them; they had to be in a sense natural so you could see the "gesture." What I could achieve with my one body and with those materials made a performance. Ten years later, I made my first works with plastic objects, and those works are definitely in a direct line of searching for new material— I felt it was a sort of "punk" material.

LT: The plastic pieces you used were found pieces?
TC: Yes, I used to go out and find them on the beaches.

LT: And with those pieces of broken plastic objects you created images?
TC: Yes, there was always a relationship of image, material, and object. The pieces of plastic were a material, but when you look at the ensemble you actually find the object. This really fascinated me.

LT: When you use the same plastic pieces in a new installation do you change the form?
TC: I always tried to keep to the first idea: the dimensions are the same, the amount of material is the same, and in installing it I see where the part goes. But it is a fluid thing. The plastic works were a result of looking for materials, for the strange, almost sub-cultural object lying on the beach, something of our civilization lying there. Plastic has always been associated with something cheap, a substitute; yet it is a material that we can use to extend, to follow our will—it is actually something fantastic.

LT: Some of your plastic works reproduce human silhouettes, others reproduce images of toys or of bottles.

TC: All of my plastic works reproduce images. In the "Container" series (*Red Container, Blue Container, Yellow Container*), as well as in the "Cowboy," "Policeman," "Robot," "Japanese Bottle," and other series, the form I created with the plastic pieces reproduced the form of the plastic object I used in the work and exhibited in front of it. I found a little yellow cowboy on the beach and the image is a cowboy, or the Japanese robot and the image is the Japanese robot—it is a link between the material and the image. The "Self-Portrait" series represents me as part of the work: me standing on a chair while doing it (*Self-Portrait*, 1980), me looking at the work (*Britain seen from the North*, 1981). In my works, images and materials are always related.

LT: At that time you were particularly involved in the concept.

TC: When I was in Berlin, the feeling of the time was in a gesture, a happening. It reflected what people thought of sculpture. For me, sculpture is much, much more important than copying a figure. I mean, it is so boring—not boring, but not interesting—a limitation on the possibilities of making new forms. Sculpture still had too much reference to the figure. In my works of that time, the human figure is made up of little plastic bits. Looking at all these little plastic things, I realized that someone, somewhere in the plastics industry, made thousands of decisions about form and shape and color and I started getting involved. From figures made with plastic pieces you get bits and bytes of information going backwards and forwards, and with this information you are looking at human beings and feelings.

I worked and exhibited without a studio then, working in the galleries. It was very exciting: I traveled and had possibilities to see things I had never seen before. The performances that I was involved in went on for four or five years. It was very exhausting, and it became a kind of Faustian situation. I knew I could not go on doing that for the rest of my life.

I felt that you can only grow to a certain point, so I decided to go back into my studio and start to take more responsibility for the forms. I discovered that finding new materials did not really drive me anymore. I wondered what I could do if I took this world of objects as a subject, how I could modify it, how I could start to change a little bit of this straitjacket reality. Life was very boring, culture was very boring sometimes—one room after the other and always the same flat boring surface—repetition is incredibly high in our society. Newspapers are bad quality, television is awful, the media outlets are pretty bad, so I started thinking about what I could do, how I could get outside of it all. For example, if I take this pen, what can I do to make it more interesting, more exciting, to have more psychological meaning, to have more metaphor? That is how I started again. You can always modify the object world around you a little bit—that is a kind of sculptor-attitude.

LT: In the 1980s, you also used pieces of furniture for your sculptures, as in the "Element Plane" series. Do you see any connection between readymades and your works?

**TC:** A big part of our world, our environment, is made of things we use, so somehow I tried to change them into a kind of constellation, creating a new reality. Of course, these pieces have nothing to do with the "readymade." I am challenging ready-made, I always wanted to challenge this system. The readymade was a cold intellectual gesture, which was important in a way, but now for me this Duchampian strategy is reaching a dead-end, and I want to change the reality of objects, to give them a new language.

**LT:** From where does this strong need to modify our "reality" come?

**TC:** I would not say "modify" but enlarge, enrich our reality. There is an enormous difference in the way other people (non-artists) make things. They make things because they are

*Eroded Landscape*, 1998.
Sandblasted glass, 150 x 200 x 130 cm.

thinking about the recipient, and they make something that in the end could be aesthetic, but the main thing is that it has to work. Our society is based on the production of material goods for human beings because we feel better wearing shirts, sitting on chairs, living in buildings, and driving cars. These are material extensions, existential utilitarian extensions. It is our culture. If you think of how much sculpture was made in the world this morning and compare it to the production of objects, you know that sculpture-making or art-making is an extremely rare human activity. It is a rare human product, but it has a strong impact. Everything else is existential: even the attempt of society to bring art near to design, to bring art near to architecture, is an aggressive attempt by utilitarian aesthetics to take away art, something that otherwise cannot be controlled, and so reality is reproduced by utilitarian criteria. Therefore there is nothing really strange in our rooms, on the streets. As an artist I have no consumer, I am on my own and have to struggle to get the material I need and a space for these strange things I am making. These strange things are an attempt to use another language. In a world where everything is limited because of our existential necessity, it is an attempt to open up—to open up the language, to use a little bit more of the form, to use a richer language of thinking.

LT: When you started working in your studio what material did you use?

TC: Plaster. But the forms were so complicated and fragile in plaster that I thought to make them in some other material. I thought I had to do them in bronze—at that time bronze to me was a terrible idea. Probably it was part of being British and maybe having a Henry Moore complex. I did not want to make them in bronze, but to make those particular forms you can only use bronze because of their complexity and thinness. It occurred to me that using bronze was a perfect material justification to make a complicated form.

LT: So you like modeling.

TC: I like to model. In the early '80s artists said, "We do a drawing, we make a model, and somebody will make it, let it be made." Me too, I thought it was a good idea. I made two small models for two sculptures and sent them to the foundry. When the works came back, I had no feeling about them—they were strange, they meant nothing at all to me, and I realized that I had to follow the work in progress. I do not want to make two or three decisions about the size, the material, the form, and then have it made. I want to make hundreds, maybe thousands of steps from small to big and go back and go forth until I arrive at what I think is the right thing. This is the sculpture process for me.

When you are young you do not know how to make things, but you have energy and you want to make gestures: young people's work is full of energy and aggressiveness. But now that I am at a different period in life, I've started to learn more about how to use the material. Now I have a method that suits me and that enables me to make things which I could never have thought of or have dreamed of making when I was younger. I do not want to sit on the sofa and think and then make a few decisions; I do not search for a quick solution. I want to have a complicated extension of materials through a work in progress that often starts with small sculptures, models in easy materials like polystyrene, wood, and clay, then goes into bigger forms and then a little bigger, and is always changing until I find the right solution.

LT: Are you interested in creating works in urban spaces or in the landscape?

TC: I am interested in making sculptures that can survive outdoors, but I am not interested in landscape, I am not interested in buildings. I want to make sculptures on my terms, in my studio, in the foundry. When they go out the door, they have to be in a perfect state. Where they go in the world after that is less important to me because I do not want to have to make works referential to architecture; we went through that in the 19th century.

LT: So place does not inspire you.

TC: No. The place changes, the sculpture remains. What I find really interesting is that if you put a sculpture out in public, any sculpture in a public situation, suddenly you find that sculpture is very important—it creates reactions, sometimes positive, sometimes aggressive, because people are dealing with something unfamiliar, not the bloody dead reality that they know. That is what interests me about outdoor works.

**LT:** Your work seems mainly related to identity and reality.

**TC:** There are several things. One is the idea of a relationship between nature and non-nature, the artificial. When you go through the landscape, any landscape you like, you think you are in nature. It is a ridiculous idea—landscape is a completely manmade construction. Wherever you are, everything is modified. If a bird builds a nest, the nest is his house and a material extension for that bird, for its survival. People think it's natural. But if I do the same thing, if I build a house for the same reason, nobody thinks of that house as a natural object.

The second thing has to do with knowledge and information. If you look at a tree now, it is a tree; a hundred years ago it was apparently the same, a tree, but people then did not have the quantity of information we have now—they did not know about its chemistry, about its evolution. We deal with the visual impact of the world, we have the limits of our eyes, of our brains, of our restricted knowledge, but the quantity of information that we do not perceive is enormous. We need languages for this information; sculpture is a way to find more languages. There is a thing I call the secretion of cultural material, our material extension. The whole of the city is a kind of communal secretion, something by which we extend ourselves—a large-scale bird's nest. The mechanism of this secretion interests me, but I am also interested in its limitations, the limitations of reality.

I look at a room like this, full of objects like the animal population in a park. We know the pig, the horse, the sheep, the elephant, but what about the millions of animals that could exist but we do not know? You are not afraid of a pig, you could be afraid of an elephant, but if you met a "piggyphant" you would be terrified because it would be a new reality. In sculpture, I am really looking for a piggyphant. My initial interest in making images and objects was, and still remains, the creation of objects that don't exist in the natural or in the functional world, that can reflect and transmit information and feelings about the world and my own existence. They are not intended as dogmatic statements but as propositions. The impulse comes directly from my observations and experiences in the world around me and only rarely from literature or cultural history. Celluloid wildlife, video landscapes, photographic wars, Polaroid families, offset politics—always a choice of second-hand images. Reality can hardly keep up with its marketing images. The need to know both objectively and subjectively more about the subtle, fragile relationships among us, objects, images, and essential natural processes and conditions is becoming critical; it is very important to have first-order experience—seeing, touching, smelling, hearing—with objects/images and to let that experience register. Art is good for that. My interest in the physical world is survivalistic at one level, but it will also lead me to dreams, to fantasy, and to speculation. Freedom, the big freedom, is not to climb mountains or to fly, to discover new continents or planets—the real freedom we have is in our heads. The only way you can get any freedom is to have a language to imagine things, to fantasize, to dream, to have ideas. That is really what I am interested in. It is a modest freedom, but it is the only one we have.

# The Responsibility of Privilege: Alfredo Jaar

## by Anne Barclay Morgan
## 2004

Artist, architect, and filmmaker Alfredo Jaar lives and works in New York. His installations and individual artworks have been shown around the world. He has participated in the Venice, São Paulo, Johannesburg, Sydney, Istanbul, and Gwangju Biennials, as well as Documenta. In 2000, he received the prestigious MacArthur "genius" award. He holds the Winton Chair in Liberal Arts at the University of Minnesota in Minneapolis.

Jaar has had major solo exhibitions at the New Museum of Contemporary Art in New York, the Whitechapel Gallery in London, the Museum of Contemporary Art in Chicago, the Pergamon Museum in Berlin, and the Moderna Museet in Stockholm. Recent public projects have been located in Montreal; Skoghall, Sweden; Tijuana-San Diego; and Fukuroi, Japan. The first installment of his project, *Lament of the Images*, was unveiled at Documenta 11 in Kassel, Germany, in the summer of 2002.

**Anne Barclay Morgan:** Four years ago you made your last works about the genocide in Rwanda. What made you finish that project?

**Alfredo Jaar:** I completed the task that I had given myself, which was to explore issues of genocide and indifference and express as much as I could about them and to circulate the work as widely as possible. *The Rwanda Project* has traveled around the world and has been seen by thousands of people. There are two major publications. Furthermore, I had exhausted my own capacity to deal with the subject, having completed nearly 30 works in six years. I felt the need to move on. Of course, this is a luxury that most Rwandans will not be able to afford: How can you go on living after witnessing a genocide? I wasn't psychologically prepared for another such project. So for the last three years, I have been doing site-specific projects around the world, which are much more short-term exercises. You get into a very specific situation and you intervene.

**ABM:** Have you been doing permanent works or temporary public projects?

**AJ:** Both. Some have been permanent, as in Barcelona and Fukuroi, Japan. Others have been temporary: in the U.S./Mexico borderland, Montreal, Skoghall, and Matsudai, Japan. In general, I prefer to do ephemeral public projects that give you opportunities to take risks and experiment. I can try things that I have never done before, like the performance in Tijuana, where I organized a large-scale event with music, images, and poetry. I don't want to repeat myself. I prefer to try things that I haven't done before.

I have always resisted permanent works because I don't feel capable of speaking to subsequent generations who will find works in their midst created by someone from a previous generation, a previous time, a previous context.

*The Cloud* (detail), October 14, 2000.
Public project at Valle del Matador on the Tijuana-San Diego border.

In all of my public projects, I have requested the right to create a permanent structure with a flexible content, to create a situation in which certain elements can change over time, according to the situation. Something always remains, but that is not what is most important. The piece allows for flexible change, as in the project in Barcelona, where easels are anchored in the ground and are therefore fixed. But every single day when you walk by that square, the work is different. One day you might find nothing, on another day you might find only poetry, or very loud political manifestos, or the sweetest little drawings by children. The square becomes a place of continuous change and exchange, in the sense that people can leave their projects for someone else to take home. I haven't done more permanent pieces because institutions are generally reluctant to let me create a space that could change over time. They want to do something and move on. My public projects demand continuous attention. In Barcelona, the project was made possible because a school adjacent to the square agreed to sponsor it and supply paper in the reception area. Anyone who wants to use the piece goes to that office and gets sheets of pre-cut paper to place on the easels. The school accepted my demands, and that is why the work exists.

**ABM:** In your permanent projects in Japan, how did you integrate change?

AJ: In Japan, a local curator is in charge of each *Bunka No Hako* (Japanese for "culture box"). These structures are not museums, but "boxes of culture." I curated the first show in collaboration with a local curator, but after this they will be on their own. I structured the piece in such a way that they have to change the works every three months, with every season. They just have to find the right work for the right context and the right time.

**ABM:** Is it stipulated that only contemporary art can be shown, or can historical works also be included?

AJ: The curators will be free to choose. We started by showing contemporary art in one wing of the culture box and historical art in the other. They might continue that logic, or they might change it. The idea is that they respect the logic of the place with a single work of art on each side and no more, because in this case, the work of art is just a pretext to come, not only to look at art, but also to look at the landscape and find a place of silence, of meditation, of reading.

When we were building the first culture box, I made a selection of five different haikus by an extraordinary female Japanese poet, Chiyo-Ni. A local calligrapher spent an entire day writing these haikus directly on the walls. We documented all this on video. When I visited the space early the following day, it was not yet open to the public. The culture box was empty, with just the poetry on the walls. I started crying because it was overwhelming. It was a beautiful small space filled with poetry. I thought that we do not need any more art. These structures should just remain as houses of poetry. What if we put them in the landscape and people go in just to read poetry? The poetry would stimulate thinking. People would sit on the bench and look at the landscape and that would be more than enough. I felt that the space was overwhelmingly filled with meaning, with only these few words. We had to include the artwork in the end, and I was really happy with it. But I kept thinking about those houses of poetry.

If I find the right context one day, I will build these poetry houses, because I think that today we need to be offered these kinds of possibilities. These places slow you down, and that is the whole point. People rush around in their lives. They don't have time to think; they don't have a place that conveys a sense of "welcome," a place to do nothing. That would be very revolutionary—a place of nothing. All of my projects are exercises from which I learn something, and I apply what I have learned to the next exercise. From this exercise, I learned that sometimes you don't even need art, you need "nothingness."

This reminds me of John Cage, one of the artists I most admire. Cage was looking for silence. He found a lab where he thought he could experience total silence. He went in, and they closed the door behind him. He was hoping to find 100-percent silence, nothingness. To his big surprise, he started listening to his heart. He was shocked. He discovered that there was no total silence. It does not exist. It is always about yourself.

**ABM:** When you moved to New York in 1982, you first worked as an architect. With the creation of the culture boxes, you returned to architecture.

AJ: What has been happening in the field of architecture over the last 10 years is more interesting, I am afraid, than what has been happening in the art world. Quite a few times the thought has crossed my mind that I should drop everything in the art world and just go back to architecture. Until now I haven't had the courage to do that. But finally, I found a way to create buildings as an artist. The Japanese project and the Swedish project deal directly with architecture. It is my way to send signals to my former life and to connect with that field.

**ABM:** Your Swedish project (2000) is ephemeral, with all the components of architecture.

AJ: Yes. The Swedish project was a very good synthesis. I was invited by the City of Skoghall to create a public work. Fifty years ago the largest paper mill in the world built this town for its workers, complete with a church, a school, and a hospital. They built everything, a real "company town." Today it has grown substantially, but its economy is still dependent on the paper mill. On my second visit, I discovered that they were missing one thing, a place for culture. Instead of using city funds to create a public art project, I talked to the paper mill about funding my project, since it made sense for them to fund the first place for culture in the city. They accepted. I designed the first Konsthall in Skoghall, and we built it out of paper. We invited some 15 young artists from around Sweden to create works focusing on paper. The entire community came to the opening. And exactly 24 hours after the opening, we burned it.

**ABM:** Was the art inside?

AJ: Yes. The artists were aware that this would be the building's fate. Most of them incorporated the idea into their work. Why did I burn it? First of all, I've always wanted to burn a museum. This was my big chance, and I did it.

*Emergencia*, 1998.
Metal pool, water, fiberglass maquette, and hydraulic system,
pool: 36 x 288 x 278 in. Maquette submerged every 12 minutes.

But more seriously, as an artist from New York, I did not want to impose an institution on this town. The idea was to offer the community a glimpse of what contemporary art can be and do, and once they had it, to take it away. The project suggested to the community that if they have the political will and go to the paper mill and to the mayor, they can create a permanent cultural space of their own.

Midway through the construction, a popular movement was born, asking me not to burn it. They realized that a cultural space was missing, and since I was building it, we should keep it. I was thrilled by their reaction, which was exactly what I was hoping to trigger. But my response was, "I hope this is the seed of a movement that will create a new, real museum. But we have to burn this one because this is an important, fundamental aspect of my project." They insisted, "No, let's save the foundations, the basic structure, and we will replace the paper with real walls." My reply was that it would be less expensive to create a new structure. This one was made in order to be destroyed; with the first rain it would collapse. I had worked closely with the fire department in order to design the structure so that it would collapse inward.

Then a second movement was born. They saw the need for a new playground in the city and wanted to save the wood from the project for it. This one was a tougher issue for me. I was a little worried because I knew I was going to burn wood that could be used for something else. Even though no one ever remarked that the paper mill destroys trees worth a dozen potential playgrounds every day, I was still hurting inside. But I thought that the spectacle of the burning museum would stay in their minds until they saw a real museum built in their community. During the discussion, something marvelous happened. I said, "Listen, it is very important conceptually that I complete my project. It has to burn. But I would be happy to design a playground for you at no charge." Exactly one year after completing that project, I received a call from Skoghall, asking whether I remembered my promise. They were ready. So I went back, and the city offered me a major site right in the middle of downtown, 11 meters by 40 meters. I am designing a permanent playground, a forest where children will be able to climb from tree to tree on elevated bridges. I've never done anything like this, but why not? As I said, I want to do things I have never done before.

**ABM:** You have incorporated sound into some of your works.

**AJ:** Yes, the first time I used sound was in a 1980 performance based on a photograph by Susan Meiselas. I also have a permanent installation in the Hiroshima Museum of Contemporary Art that incorporates music. Music is also part of a performance I did about Rwanda. And recently, I used it in a performance piece on the U.S./Mexico border. After I returned from Rwanda, I realized that sound was the most powerful and simplest tool for self-healing. That is why I used sound in the performance about Rwanda, where I offered the audience a place of healing and mourning through sound. Music has always been a fundamental aspect of my life. Nietzsche said, "Without music, life would be a mistake," and I really believe that. I hope to continue to use music when I think it makes sense.

**ABM:** Your work communicates so much through the way you place text, images, and objects in a space, for example, by putting text at eye-level in just one line on a black wall. Space becomes a language in your work, just as much as text or image.

**AJ:** As an architect, I have always been aware of the language of space. I have always done installations in which I am not just showing images, words, or objects, but an entire space is speaking. The language of the installation is the language of the space, which the installation articulates.

**ABM:** In Barcelona, your exhibition about Rwanda was shown in a 12th-century cloister. A sense of history was present even though you were dealing with a contemporary political situation.

**AJ:** I was lucky to be offered that space. It was already very meaningful. It was just a matter of letting the space speak, of creating the right kind of atmosphere for the work. It was important to have a sense of complicity with the space and not to disturb it.

**ABM:** You make videos to document your work. What about making a work that is purely film?

**AJ:** I started producing documentaries of my recent works in order to preserve them as lived experiences. In the case of the performances, it is the obvious way to do it. These documentaries are my way to go back to film, to experiment with the editing, which allows me to understand new technologies and slowly experiment with the language of film. Hopefully, I will find the means to go beyond documentaries and do another kind of film. I am a frustrated filmmaker.

**ABM:** Are you content with the title "artist"?

**AJ:** I think I am content. I am a frustrated journalist. I am a frustrated filmmaker. I am a frustrated architect. I have all these frustrations, but I think the word "artist" is the one that embraces all of them. An artist can do film, architecture, journalism, anything. "Artist" is the most open and generous word.

**ABM:** In *Lament of the Images* for Documenta 11, you transformed a large, rectangular room.

**AJ:** That piece is very simple. As you enter the room, you find three illuminated texts on a wall. They were created by placing windows inside a wall, inset with panels laser-cut with text and flush with the wall. Everything is painted gray. You don't see the panels or windows, you just see a wall. Light from behind the panels shines through the words. These are texts of light. After you read these texts, you enter a 22-foot-long dark corridor. At the end, there is a strong light. When you reach the second space, you are blinded by a huge screen of light, only light. There are no images. The piece is a philosophical essay on the crisis of representation today, a poetic meditation on what is seen and what is not seen. It is a search for light in the darkness. It is a lament of the images.

**ABM:** How did you choose the political situations that you reference in the three texts?

**AJ:** When I was in Cape Town a few years ago, I visited the prison where Mandela was kept. One of the guards, a former prisoner, took me to a quarry where Mandela and other political prisoners were forced to work for years digging lime. The apartheid regime used the lime just to turn the roads white. But obviously they were trying to destroy him physically and mentally. The lime blinded him and hurt his lungs, but he survived. A few months later, I read a story about Bill Gates, who owns a few photo agencies and one of the most important photography archives in the world. The article described how he planned to bury his millions of images in a lime quarry. I jumped: Mandela working half of his life in prison in a lime quarry, going blind, and then a billionaire buys all these images that represent the history of humankind and buries them in a lime quarry. The third text focuses on the tragedy in Afghanistan, which started in response to the tragedy in New York. Before the bombing, the U.S. government bought all the satellite rights to images of Afghanistan and neighboring countries. So I started connecting these three events.

**ABM:** In some recent projects you've shifted your attention away from exposing injustice to coming up with solutions, or healing, or closure. Your performance *The Cloud* (October 14, 2000) in Tijuana was a sort of memorial service for immigrants who died trying to cross the border. For the families of those who died, the performance offered a resolution.

**AJ:** Yes, I agree. It is the result of my frustration with representation. Artists represent things, but at a certain point we should go beyond representation. We should create spaces of interaction, meaningful dialogue. In *The Cloud*, I wanted to create a space of mourning, a space that would go against the grain of local events, where death had become banal, where people die every day simply trying to cross the border. It is not even reported in the news because it happens so often. The performance was an opening, offering a space of silence, of mourning, of meditation—a space where the victims' relatives were able to come together and perhaps connect with each other. I don't think it is a solution, just a much-needed moment. Artists have the privilege of being able to create these moments, and we should use them.

**ABM:** Speaking of privilege, how do you view the artist's responsibility?

AJ: Every day I come to the studio and I think. I just meditate and think and analyze situations. This is an incredibly privileged position. I make my own schedule. I select the context, the framework, the focus, the objectives. Duchamp said that art is about freedom: I have an amazing amount of freedom. But I have always thought that with that privilege comes a certain responsibility. Because society has given us the time and the means to think, to speculate, to ask questions, to propose solutions, to try things, to experiment, our responsibility is that we give back to society. How do we give back? By engaging the audience in important issues of our time, communicating, offering a space of discussion, dialogue, and interaction. It is really about offering audiences something that no one else in society can offer them, not the media or the entertainment worlds, not their professional lives. That is what is unique about what we can do. It is very difficult to accomplish this, but we can take people to places they have never been. I don't mean physically, but mentally. We can ask hard questions, we can suggest difficult answers. All that is part of our privilege.

# The Shadow of Life's Mechanisms: Miroslaw Balka

## by Robert Preece
## 2004

Worn medicine balls—used in Poland for physical therapy exercises—slowly turn counter-clockwise threaded on a steel rope, evoking the passage of time and the unflattering effects of aging. Center stage, there is a slowly rotating wall that will hit you—without warning—if you don't watch out. And concluding the experience, a room with gray, sooty, ash-covered walls makes viewers enact a similar rotation, reminding us of our common future state. These are some of the works that Miroslaw Balka unveiled at a recent exhibition at London's White Cube gallery.

Titled "Karma," Balka's show featured sculptural installations expressing timelessness, repetitive cycles, continuity, and progress/stasis. At first, the works may appear rather abstract, yet they are very much grounded in the artist's body and life. He has described his work in terms of releasing the energy contained in simple materials. Over the years, Balka has moved from a realistic representation of the human body to a more Minimalist conception, using a wide variety of media.

Exhibiting internationally since 2001, Balka has had solo exhibitions at the National Museum of Art in Osaka, Japan; the Kröller-Müller Museum in Otterlo, the Netherlands; the Zacheta Gallery of Contemporary Art, Warsaw; the Stedelijk Museum voor Actuele Kunst (SMAK), Gent, Belgium; Dundee Contemporary Arts in Scotland; the Douglas Hyde Gallery in Dublin, Ireland; and the Barbara Gladstone Gallery, New York, among others. He has also contributed pieces to group exhibitions at various museums and galleries around the globe. Born in Warsaw in 1958, Balka graduated from the city's Academy of Fine Arts in 1985. He works and lives in the Polish capital.

**Robert Preece:** How would you describe the work in this show compared to your previous work?
**Miroslaw Balka:** These works investigate the same issues, but I'm discovering different layers. That doesn't mean that I consider this to be "progress." I consider it to be like an archaeologist's work. I'm digging into my life, my history, the history of the places that surround me, the history of the people who surround me—and the works are visualizations of these relationships.

**RP:** You deal with a level of abstraction in relation to your body, through measurements, for example. Could you tell me about that? Because when you dissect the elements and principles of your works, the connections aren't always obvious to viewers.
**MB:** That's true, but I think that while the presence of the body—and the body of the work—looks very abstract, the shadow of my body can be very realistic. Because the dimensions, in most cases, correspond to those of my body.

*354 x 58 x 79*, 2004.
Steel, medicine balls, and rotating mechanism, 354 x 58 x 79 cm.

Because the materials very often come from my personal history. As a result, these abstract works lose their abstract presence. They can then be recognized as much more realistic.

**RP:** This occurs with some of your titles.

**MB:** Yes, for example, the titles that indicate the measurements of the works. At one level, the works are very abstract. But when you look closer, you start to recognize some proportions of my body. I'm 190 centimeters tall, and each hair rope piece is this length, but it is hanging. So, on the "outside" what you see in the title is not clearly visible. But the dimension "inside" is important to me. Also, with *18 x 60 ø* (2004), "60" refers to the width of my arms, and the height is a single jump (when I had a problem with my Achilles tendon). The dimension of the rotating wall for *270 x 449 x 12* (2004) relates to the existing wall in my office, 1:1. It's like a wall go-go dancing with the pole. I mainly choose numbered titles instead of using words because I prefer a "cooler" approach. But when you look closer, the work is actually much "warmer." I always say that these works are not abstract, or pure abstraction, because my intention when making them was never about the shape or the color. I'm always using a much more emotional beginning, my background, when making art.

**RP:** This also occurs with some materials that you use. For example, the brown linoleum is from your studio.

**MB:** Yes. And my studio is the house that I grew up in. In my work, I draw from "real life" or from "real relationships"—not with the sun or the universe but with the lamp or kitchen, for example. Also, in this show, the top part of the steel for the hair rope piece comes from the water pipes in my studio.

**RP:** And what about *354 x 58 x 79* (2004), the work with worn, leather medicine balls rotating on a steel rope?

**MB:** What's important in this work is the use of medicine balls. When you roll them, they lose their round shape. They become imperfect. Also, they are heavy, and they are used for healing your body. This function was an important beginning for using these balls. Then I tried to make a kind of column, perhaps a detail of an endless column, rotating to the left—against "time," moving counter-clockwise, coming back in time—and referring to other rotating elements moving counter-clockwise in the show, coming back to the essence.

**RP:** Since your work, in general, is very personal in some way, how does this work relate to you with regard to "going against time" and "imperfection"?

**MB:** My body is becoming a shape that I would not like to have. I look in the mirror. I'm now 46. The medicine balls are related to my body in terms of the activity of my body—the imperfection. Everything in my work is about my body, but few aspects of the work relate to my body in that way. Instead, I aim to create the presence of my body. I'm more skeptical of the world now than I was 20 years ago. I see my position within it better. I see the mechanisms of life better. My work is a shadow of this observation. It is not a direct reflection.

**RP:** "Coming back to the essence." Does this describe you now?

**MB:** No. That sounds too bombastic. "Coming back to the essence of life": it's like movement without progress. Instead of making a straight line and seeing the future with capital letters, it's just thinking of today with small letters. With small steps. Not running. Turning around. It's like everyday life.

**RP:** Upstairs in a separate room, you are exhibiting *Dead end* (2002–04).

**MB:** The height of the ash surface is the dimension of the reach of my hand when standing, about two meters.

**RP:** Why ash?

**MB:** It's the final presence of our bodies in life. Downstairs, the works are rotating by themselves. And upstairs, the viewer's body is rotating in this space. What you experience watching the work rotate, you actually perform in the room with ash-covered walls. And you feel it, at a different level.

**RP:** Why did you title the show "Karma"?

**MB:** It's a word originating from the East, but it is very international now, with reference to a strong presence and philosophy. These works are rotating, have some traces, but they are from life and are the future. They are about working for something better.

**RP:** What kinds of exhibition situations are best for you?

**MB:** The best is when the gallery is small, because the dimensions are closer to the conditions I work with—the works are related to the interior. I work with the dimensions of 4 x 4 x 3 meters, so I see the works—if they are made in my studio—in this space.

**RP:** Was the SMAK show in Gent (2001) more difficult? The spaces were larger and distributed in different parts of the building on two floors.

**MB:** No. This wasn't a problem. For example, in the large room on the second floor, I decided to install *1750 x 760 x 250* (2001), a construction in the shape of the exterior wall of my studio, covered in ash.

**RP:** You describe your education at the School of Fine Arts in Warsaw as not Bauhaus-oriented. Yet your work shows an acute awareness of foundation-year principles that focus on formal elements and the way they interact.

**MB:** Actually, I came to this "level" through my personal experience. When I was studying, I was making different things—but never anything based on a construction—more from, say, a symbolic discussion of beauty based on interpretation of, say, a sculpture.

*1750 x 760 x 250*, 2001.
Hardboard, ash, water, tinplate, and brass, 1,750 x 760 x 250 cm.

**RP:** What are you currently planning?

**MB:** I don't make plans. I just confront the space, the situation, and I try to formulate the best way to present my work and the installation in the space.

**RP:** What are the current issues in your professional practice?

**MB:** I never wanted to become professional. I prefer to not be so perfect in my activity. I think that professionalism is killing the freshness of the artist in some way. I never wanted to have an assistant who would answer all of my letters, for example. Some of my friends who are artists have workshops, and they just give their drawings to assistants every week and then they check on the progress of the works. I'm very much concerned about the entire development of my art. I want to make these objects myself, and I want to focus on artistic production. I am also concerned with the people surrounding the exhibition. Becoming a successful artist is very much about meeting people. At every exhibition, I meet a lot of different people in addition to the curator. The exhibition is very much about personal exchange. Every curator you work with is a different human being, so the exchange is important.

**RP:** What decisions did you make when installing this show at White Cube?

**MB:** Before the show, I had my leg plastered for about two months because I tore my Achilles tendon. I had surgery. I started to lose contact with what I was doing in my studio. I usually work with a certain rhythm, and, during this time, I could only read in bed. The cast finally came off, and I had only one month to work. As so often happens with me, because I work very closely with the site, I changed quite a few things in this show at the last minute. I knew I had to work on things here at the gallery to get everything into the final shape that I wanted. I finished one hour before the opening.

**RP:** The London art scene is very mass media-oriented. And White Cube leads this with some of its artists. How do you see yourself within this culture?

**MB:** I'm here for five days, so I concentrate on the show. The show is most important, and the other things are not so visible to me. Of course, I know that the position of White Cube is very strong. And it's good for my works. My part is to make a good show and present my best work at the moment. The rest is part of their work.

**RP:** So you are not affected by it or really interested?

**MB:** Yes.

**RP:** So you don't want the TV cameras. For example, BBC London news has been running a lot of features concerning White Cube artists lately—Damien Hirst, Tracey Emin, Gavin Turk, and Antony Gormley.

**MB:** My art is not so geared toward that. My works always look much better in person.

# Public Art is Dangerous: Dennis Oppenheim

**by Daniel Grant**
**2005**

Over the course of a much-honored, 40-year career, Dennis Oppenheim has created sculpture, conceptual art, Land Art, and public art, with a long string of public art successes installed throughout the United States and Europe. But controversy has also surrounded his public works: *Blue Shirt* (2002), commissioned for the new parking structure at Milwaukee's Mitchell International Airport, was vetoed by County Supervisor Scott Walker; *Device to Root Out Evil* (1997), donated by the artist to his alma mater, Stanford University, was refused by the school's president, John Hennessy (it subsequently found a home along the Vancouver waterfront); and *Marriage Tree* (2000) was purchased by the University of Virginia Art Museum but denied installation anywhere on campus by the school's Public Art Committee. These projects were evidently rejected by well-placed individuals worried about public reaction.

The concerns raised against Oppenheim's work are not the same issues that defeated Serra's *Tilted Arc* more than 30 years ago. Between the age of Serra and the age of Oppenheim, much has changed. Professional art authorities, now viewed as elitist, have a smaller role in picking public artworks. More and more, panels consist of community leaders who want representational art—works that people can quickly understand, that express traditional themes (public pride, family, leadership) or provide a non-judgmental narrative of some local event (firefighters who died in a blaze, for instance). Oppenheim's work may employ recognizable imagery, but it is far from neutral. Even compromises on his part, such as repainting the figures in *Marriage Tree* to lessen its interracial subtext, have not solved the recent problems. Whether a church, a shirt, or a wedding cake couple, Oppenheim's public artworks present a challenge, posing open-ended questions for viewers who stop to think about them.

**Daniel Grant:** Does controversy alter your approach? You changed the title of *Church* to *Device to Root Out Evil.*
**Dennis Oppenheim:** It was an obvious ploy; it didn't really help. It was executed mid-stream, after the work surfaced. There seemed to be a difficult situation, and it was thought that something that wasn't detrimental to the work could usher it in with a little less furor. However, it has never been my motive to be controversial. It's not part of my repertoire in terms of the conceptual framework. I don't say, "OK, let's really make this difficult," even though it's often these radical, difficult, revolutionary works out in public that are later seen as the best.

Artists want to believe that their audience is enlightened. Often, there is a naiveté on my part when I venture into these pieces. I do a lot of public commissions: at the moment, I do more public commissions than other things, but I'm getting a little homesick for museum work and gallery or studio art. I would say that 90 percent of my proposals are rejected. Rejected may not be the word: I just don't win the competition. Often it's because they like something else better, but sometimes it's because of the difficulty of the piece. I can understand that.

*Device to Root Out Evil*, 1997.
Galvanized structural steel, anodized perforated aluminum, transparent Venetian glass, and concrete foundation, 9 x 15 x 20 ft.
Project originally for the Venice Biennale.

It's a confusing topic. At the moment, architects seem to be the darlings of the cultural milieu. They are getting away with amazing things, and we all know that their situation is steeped in bureaucratic entanglements. Artists, who work in studios, are not used to that—we're not used to competing for everything, and we're not used to having juries decide what we want to do or can do. So I'm a little suspicious that when an artist proposes radical work he's going to be rejected because the architects are already doing it.

Maybe, in the 1960s, public art decisions were made by architects, however, they were not always ready to put challenging work in their buildings. It was often said that architects weren't going to frustrate a building for the sake of an artwork. They certainly weren't going to allow an artwork to dominate it. Yet good work could have some of those elements. All of these juries, with people from the real world coming into the commissioning panels, could be a good thing; it may be that this is going to challenge the art elite.

In Europe, decisions on public work are generally made by museum curators. The mayor wants to know what to install, and the curator says, "Why don't you put what's-his-name?" That throws public art into the same sort of political dynamic as museum art and, all of a sudden, it's relegated to the same sort of power structure. It's funny to see juries reject really famous artists and, instead, select a local person who is not accomplished at all. This is all post-*Tilted Arc*. We face a group of people in which the art-savvy portion is a minority. It's easy to say that this person from the security department is going to want conservative work and this person from the maintenance department is definitely going to want work that is not in the least bit problematic in terms of longevity: it's easy to say that, and it's partly true. There may be a panel with only one obligatory art person, and that's an artist, and all these other people are going to want representational work.

I'm not happy with the kinds of contortions I'm going through in the name of reinventing myself. I've changed course many times over the years within a domain of so-called studio art: I've been through Land Art, body art, installations, and public art. I used to say that installations were difficult, not easily commercial—they're expensive, and you execute work that is thrown away afterwards. After you do that kind of work for a long time, anybody who has wanted to support you has done so. You enter a kind of desert, and that's the time when some people turn to public art, because it seems to be somewhat separated from the other world. It has features not necessarily represented in gallery or museum art. It's not supported by galleries, and it's also not supported by critics, because they feel that public art is decided on by juries that don't know anything about art, so why should they bother to review it. So, public art has some forces against it. Within this atmospheric fusion of architecture and sculpture there are some new laws being written—I'm just not sure what they are.

DG: What do you mean by "contortions"?

**DO:** I never thought that art was easy, and I never really felt that I had full control of it, except for fooling myself for short periods of time. I felt that a lot of it is uncomfortable, moving from one thing to another, coming to the end of something—you're trying to find a new pathway. The idea of earthwork was very against the idea of public art: Land Art didn't last long, all you had was a photograph—there was no way of putting it in front of a building, and artists at that time were not willing to talk to bureaucrats. Robert Smithson collaborated with an airport for works to be placed out in the landscape, but the idea was never realized. Public art only became visible for me as something to move into in the mid-1980s. I had done a lot of installations; I had done a lot of museum shows. It is a paradoxical situation: it seems that in public art you should be able to do better work. Why is it that the more critical work is done in museums? Some of these projects are interesting contextually—they're not all airport lobbies. It remains a bit of a mystery to me, frankly.

It can be very frustrating. It's hard not to harbor negative feelings about the individuals making the decisions and their lack of insight, training, and experience in art. You find yourself whittling your work down to the point that you no longer want to do it. I'm aware of entering into projects that I've tamed, and it's uncomfortable—almost everything, to a greater or lesser degree, has been compromised. Some people wouldn't consider that a bad thing, architects wouldn't, they come into this from a different channel. Fine artists, especially those like me who grew up in the 1950s, after Abstract Expressionism, are volatile individuals who don't want anyone to pressure them in any way. Coming from that, and then from Land Art, I'm not the most democratic person in the world. It's hard to ask the general public to do anything. Architects are better equipped to analyze the process.

Sometimes, I just end up losing it. Things cross your mind that you're a bit uncomfortable with. For instance, when you're approaching a commission, you think, "I'm going to waste my time unless I get this commission. If I know that what I'm doing now is not going to be acceptable, then why should I do it? If I do something, I should do something that might have some chance of being accepted." That's problematic, because you're already talking about compromise. That's why Land Art was so wonderful, you just went out and did it. In public art, the public sector is a necessary evil.

**DG:** How do you respond to criticism and attacks?

**DO:** Everybody wants everybody else to like their work, understandably, but of course that's not possible. There's a lot of masochism in art, in sculpture particularly. I think sculptors are really at home with a great deal of pain. Some of it comes from the fact that if you are rejected 90 percent of the time, year after year after year, your reaction to criticism is going to change. First, you are going to become quite mute and dormant regarding assault, criticism, and rejection.

Rejection from the public sector, from individuals who have power like a mayor or a county supervisor, wouldn't be as bothersome as negative criticism from an enlightened critic who would know how to delve into the nuances.

*Bus Home*, 2002.
Steel, structural acrylic, epoxy paint, and concrete foundations, 36 x 100 x 50 ft. Project for the Transit Center, San Buenaventura, California.

You can always say that the public sector is too conventional. I can't be totally free from a certain knowledge that if you turn a church upside down, you will elicit certain reactions. I always say that I was only interested in the formal aspects of this work. Well, that could be true but, still, to place *Marriage Tree*, which shows an interracial couple, in an area associated with Jefferson…well, you could certainly expect something.

When I begin some of these works, I simply don't acknowledge some of these things that later could be construed as blasphemous. Sometimes being an artist means a lack of attention toward other things. I've never wanted to stir things up, unless it was on the level of art discourse.

DG: Is public art really for the public, or for the art world?

DO: Things are changing. In the past, I used to think that unless I did an uncompromised artwork for the public, a work that was interesting as art, which means that it could be esoteric, I was cheating the public. If I didn't do that, I would do something that I felt they would be happy with. I felt that if artists were pulling their punches to appease the public, they were cheating them, because they weren't showing them advanced art. The best thing you could do for the public was the best art that you could do—that's what I used to think. Now, when I sit down and dwell on where I want art to go, into these cutting-edge, non-physical states, it becomes very impractical, atmospheric, and intangible. Architects can get like that, too; they get to the point where they can't build anything and can only be theoretical. When I know I have to build something, I sometimes shake myself and say, "Oh, come on, let's make it concrete, let's apply it to something." But when I think of very difficult work that's hard to have in the public realm, hard to reckon with, it's difficult to see it having any prospect of a future right now. The paradox is, that's what artists are supposed to do. They're supposed to challenge conventions: that's their job—to jump on a horse and travel on it the rest of their lives into unknown territory.

DG: Some people say that the problem with public art is that it is permanent rather than temporary.

**DO:** Kaspar Koenig once said that the best public art is a snowman; so, he's really a jump ahead of Tom Eccles, the director of New York's Public Art Fund. Everybody likes a snowman, everybody can relate to it, then it disappears back into nature. I guess if *Tilted Arc* had only been up for five years, the crowds who worked in the federal building would have just learned to tolerate it. Maybe, in the course of events, people will learn how to live with some of these things. But most of these one-percent commissions call for permanent work.

**DG:** What happened to *Blue Shirt*?

**DO:** It was never built. We worked very, very hard to get it accomplished. I brought in an attorney. I was exposed to a lawsuit; they could have sued me any time they wanted for the next 20 years. Some people in Milwaukee were really supportive. There was a division between the right and the left, and I wanted to resolve it. All the attorneys said that I'd spend a lot of money, but I wouldn't win. Yet, in the midst of all this, individuals in the city offered to take the piece and put it on their buildings, none of which were really right. *Submerged Vessels* took the place of *Blue Shirt* in Milwaukee.

This is why when Stanford rejected *Device*, I decided not to pursue it. It was a donation. I went to Stanford: it was an incredible school, and I don't want to discolor it by having a big fight. The art department there is really quite important. We are going to talk about another work, but it's difficult because you know that, just as in Milwaukee, there is a person out there who rejected a work. You might get rejected again. It's not the greatest atmosphere in which to work.

I'm not a commercial artist. I've never had an extensive market since it's never really been important to me. But I know that when I read about individuals who are bucking the system, I always find myself supporting them. My guess would be that artists reading about my problems would support me.

I'm not very good at speculating about how controversies might help or hurt me. People who want to steer away from a rocky course would be a bit concerned about an artist who proposes work of my kind. The Milwaukee situation took quite an effort on the part of the supervisor: I was awarded a contract, I was approved by his selected committee. It had gone a very, very far distance before the trouble began.

**DG:** *Tilted Arc* came under attack partly because it was abstract art. One might think that figurative art would appeal to more people, but your case suggests the opposite.

**DO:** It often happens in representational work that content is so easily visualized that the public can construe something distasteful. It's more difficult with abstract art. *Tilted Arc* is a highly resolved gesture, with tons of theoretical substance behind it. Unfortunately, it was met by individuals who found it physically obstructive. Those objections,

however, were not like the objections to *Blue Shirt*. The very specific association—blue collar—bothered people. You may ask why I didn't think of that. Why didn't I think that they might construe this work in a negative vein? It goes back to what I said before, you just go into a work thinking other things, and, frankly, you don't want to believe that's what will happen.

When a person projects into an artwork, abstract or representational, artists react. Some of them say that what you see in their work is OK. Others might say that they don't want to be responsible for somebody else's projection— they have their own orbit in which the work was construed and manufactured. That's how I felt about the work at Stanford, that there was a lot of projection going on.

If you ask art world authorities what makes a work important and successful, they might talk about getting a certain kind of satisfaction on a cerebral or spiritual level, an unusual kind of entry into something they couldn't get on any other day. That's from looking at work that's not easy for the public. You want the public to have access to that, but then, when I go to a classical music concert, I'm sure I'm not getting all the meat of what's happening there. I'm not a connoisseur. You know you're not an expert in things, so you can sympathize, empathize with a public that finds art extremely strange, even something representational. They basically don't have access to it. If we take our clues from the kind of combustion occurring in architecture, it's a bit of a renaissance right now. We're seeing buildings that are really quite extraordinary. So, why is this art form—architecture—off and running, and public art is treated as a problem?

Public art is dangerous, especially if it is big. With a gallery show, you can forget about it, like it never happened. With public art, it's there forever. It's truly not the place to take risks. Well, it is a place to take risks, but to win them in a good way. There are a lot of unknowns. Most of this stuff is too big to really see in advance; you can make models— but usually you're not going to see it until it's too late.

# Questioning Beauty: Silvia B.

**by Barbara S. Krulik**
**2005**

In the Netherlands, it is common to refer to criminal suspects with the initial of their last name to protect their privacy. Likewise, people with whom one is on casual terms often write their first name and last initial. Silvia B. has chosen her professional name and thus has exploited the duplicity of familiarity and anonymity. In the development of her artistic persona, she provides insight into the types of contradictions and extremes found in her work. She has founded the smallest museum in the world (Museum Van Nagsael) and has recently completed a monumental commission (*Ultra*). She works with animal and human forms and often merges them in enticing and disturbing ways.

Silvia B. was trained in fashion design and sculpture (1983–86) at the Rotterdam Art Academy (now the Willem de Kooning Academy) and is active in the Dutch alternative art scene through her participation in artists' initiatives such as Het Wilde Weten (The wild knowledge). This collective took over an abandoned monastery, turning it into studio spaces, guest studios, and project spaces for invited artists. In addition to her own projects, Silvia B. organized exhibitions and projects with members of the group.

Silvia B.'s early works focused on site-specific installations. In this interview, she explains how and why her work has evolved into freestanding objects. Her recent works challenge many of the concepts and canons of beauty, as well as the elective interventions and enhancements that have become common in contemporary Western cultures.

**Barbara S. Krulik:** What are your hybrids, and why do you make them?

**Silvia B.:** I made figures between man and animal, between kid and toy, between sexes and between ages, like *Almost Perfect* (2004), a skinny teenager. Her skin is sutured together, like some sleek designer cat suit, the stitching more emphatic on her face with its fashionably oversized lips. Her pose is stilted, self-conscious of her budding breasts and tiny penis. I very much like that sort of ambiguity. Doubt is a great state of being, the starting point of all thinking. I see it as a sign of the times: room for androgyny in people; new scientific developments like genetic manipulation, cosmetic surgery, and Artificial Intelligence.

**BK:** Do you see it as anomalous that your works are so meticulously made?

**SB:** Well, I want to entice people to come very close to the objects. Therefore, I try to make the sculptures as beautiful as possible. Once I have the viewer's attention, the next level of sensation can be introduced—the disturbing sensation. The highly crafted aspect of the work keeps it from becoming a joke or a prop. One needs to be very careful with approaching the realm of fancy fair amusement.

*Almost Perfect*, 2004.
Leather on synthetic materials, suture thread, artificial hair, lashes, and eyes, and wooden clogs, 160 x 75 x 30 cm.

On the other hand, I am also aware of my tendency toward perfectionism, but I can't help it, can't stop myself. I am a control-freak. For example, I wrote in the proposal for *Ultra*, "She will get a *coupe soleil* of bird-shit in her hair and her own shadow in rust on the pavement." A Dutch critic laughed her socks off, because she saw that I didn't only describe exactly what *Ultra* would look like when it was finished, but also over time.

**BK:** How did the commission for *Ultra* come about?

SB: It is a one-percent-for-art commission. In 1997, the City of Groningen asked Richard Deacon to make a proposal for the space. They loved it, but it cost twice the allocated budget. Eventually they started a new round. In 2002, I was asked to submit a proposal, along with Hewald Jongenelis/Sylvie Zijlmans from Amsterdam and Steven Gontarski from London. Mine was chosen because the committee thought that it would be a strong presence against the architecture. They also liked the fusion of historical and contemporary styles. In the autumn of 2003, we agreed on the final design, and I started making her. In October 2004, she was unveiled. I worked full-time for two years on the project.

**BK:** Should a piece of commissioned art look so fashionable?

SB: Friends thought that I should give *Ultra* an air of timelessness. But I very strongly disagreed with them. I love to see the styles of clothes, hair, and posture in ancient and pre-modern sculptures because they tell us so much about humanity's relation to the world, both physically and spiritually.

**BK:** There is a 19th-century feeling about her.

SB: It came to me that the *fin de siècle* phenomena of the past two centuries show a lot of similarities. New technologies were celebrated. Social progress went hand-in-hand with public threats like war and terrorism. Extremes were in vogue in both periods: fascination with freaks of nature, technology, and exotics. Exaggerated forms in clothing were also hot: the "queue de Paris" (overdraping and bustles for dresses) was trendy during both periods—think of contemporary designers such as Vivienne Westwood and Comme des Garçons.

**BK:** *Ultra's* bust resembles porcelain.

SB: Porcelain was a new technology in the West at the end of the 19th century—hence the great popularity of porcelain dolls, with fragile faces and cloth bodies. Today, I love to see tight doll-like faces on the bodies of living older women. The style-clashing eclecticism of the architecture in the project stimulated me. Its parade of forms and color made me think of the carnivals that were popular at the end of the 19th century. As for the practice of exposing freaks: today, anti-beauties are again very attractive, but they are self-made, like the French performance artist Orlan and Marilyn Manson.

She is maybe human, maybe doll. A wink to Gepetto or Pygmalion? Every sculptor must think of Gepetto while making a naturalistic human figure that could possibly start breathing. And, like Pygmalion, one tries to reach perfection to

the standards of one's own reality. But now, in these Photoshop and A.I. days, you can't know what's real anyway and that makes it even more exciting.

**BK:** How does *Ultra* reflect our time?

SB: We are super-proud of our new technologies and at the same time terrified of them. How could we live without our digital technologies? And wasn't the start of the new millennium much more exciting with the threat of the "bug"? So we show off with all of our new extensions (like cell phones and iPods) and expose our prostheses and orthoses (bras, glasses, braces) and at the same time prepare for survival, longing for nature by wearing military outfits, combined with tribal accessories like piercing and tattoos.

*Ultra* is like a little person: she shows us her corset and crinoline, proudly worn prostheses. The arm extensions are like opera gloves. She has customized her looks so that she really is a giant diva, giving herself a touch of the tribal with the piercing and mocking her greatness with her childish hairpins. I like the fact that imperfection is considered more beautiful now than perfection.

**BK:** Your sculptures avert or close their eyes.

SB: I do that to give the viewer freedom to gaze. If they were real, you wouldn't. I also like them to be content with themselves, self-assured, living in their own world, not needing our approval. In *Les bêtes noires*, the little sisters also have their eyes closed. I like that they deny you all possibility of entrance; they are a unity—everybody else is shut out. Also, in the blackness, the closed eyes help to stress the feeling that you can't see as you would want to, even if you're on your knees two inches from them.

**BK:** You talk about the sculptures as if they were real and had made the choices.

SB: I like to think of them as having their own existence. Do you think that is strange? Do you feel uneasy with it?

**BK:** So you create an atmosphere of confrontation, disturbance, and uneasiness?

SB: Yes, attraction and repulsion are very important to me. They drove me to my project *La vie est si gênante*, an installation of an ever-growing collection of animal and insect curiosities in which animal parts are transformed into knick-knacks, fashion accessories, and all manner of paraphernalia. These objects are meant to prettify our homes, but they are proof of brutality and cruelty—my "collection of animalities," as I call it.

I went, literally, hunting in flea markets and felt torn between sensibilities: as a sculptor, I love the sensuality of the animal materials and the craftsmanship, but the little girl in me hates that animals were killed to become ashtrays. The objects come from a time when nobody thought that hunting could lead to extinction—so a nostalgic sweetness

*Ultra*, 2002–04.
Cast iron, polyurethane paint, stainless steel, and Cor-ten steel, 825 x 435 x 1,000 cm.

surrounds them too. Environmental correctness came later. In most countries, bringing home such souvenirs is forbidden now.

**BK:** Would you say that you make socially engaged art?

**SB:** I definitely want to make art that is about now, our present day. Usually I do not make statements. What I do is exhibit my own questions. This collection is a pile of questions about ethics and aesthetics. To add to the indeterminable state that pile brings, I present little baby faces in ceramic without any hierarchy in the collection. They have animal features and sometimes the features of kitchenware. Of course, this is about us not doing such things to our own kind. That is indeed leading the viewer in a certain direction, and it makes this project a little different. However, it is more subtle than a demonstration placard.

These little sculptures balance on the line between art and kitsch and are very hard to distinguish from the other objects, thus adding again to the aesthetic question-pile.

**BK:** Why are the hybrids mostly children?

**SB:** I think that children are more engaging. If I did them in large scale, as adults, they would be more confrontational. Since they are children the cuteness and innocence conflict more with the aberrant, the viewer's thoughts and feelings become more disordered. A viewer will behave differently with a child: to try and understand, one literally has to bow or kneel.

**BK:** You like to work in different scales—a huge head on the street, little children, and a giant diva. Why?

**SB:** I think that approaching something of another scale makes one more open. One's prejudgments are on hold when something seems to come from another world.

**BK:** Tell me about the smallest museum.

**SB:** The museum is famous for being the smallest in the world, scale 1:15, and so is the organization. The museum has no invitations, no openings, and no cash flow. It is, therefore, close to the basics of art: the pleasure of the making, the exhibiting, and the viewing of art. Van Nagsael is open day and night since it is located in a show-window between a vintage clothing shop and a design store.

**BK:** What do you get out of it?

**SB:** We are directors. Rolf Engelen, a colleague of mine, rules in the odd months, and I am director in the even months. (Each exhibition's duration is a whole month; the first of the month is the installation day.) And we satisfy our longing for new ways of showing art and our interest in public space. The museum is half of an artwork in public space that is to be completed anew every month.

**BK:** Do you see the museum as a work of art?

**SB:** Yes, since both of us are sculptors, we see the museum as an extension of our separate practices. Engelen's objects can often be used as furniture or integrated into existing interiors—he likes to provide the space for you to decide how to use them. My interventions in public space used to blend so seamlessly with their surroundings that you would stumble across them almost by chance (before *Ultra* that is). Museum van Nagsael fuses the two— a space you're invited to fill, and an art venue for the discerning eye.

**BK:** Your choices about how, where, and what you exhibit have had a self-effacing quality.

**SB:** I've made sculptures that integrate so well into their surroundings that you had to discover them. The Museum Van Nagsael is an example. For a small traffic circle, I made a giant bronze head of an old man, sinking into his ruff. Only from one perspective can you see his severe expression. From other points, it is just a bronze ball. And even after discovery, one would think it had been there for ages. In a garden center, I made a shy, 14-foot-high, long-legged child. Covered with creeping plants, it holds itself tight against a tree, completely in its shadow. It really is hiding. And one could say that in the presentation of *La vie est si gênante*, the ceramic baby sculptures dissolve into the collection too.

Once, in a medieval castle, I organized a large group exhibition. In *Cry me a Castle*, I tried to make a "solo" exhibition with a collection of borrowed works from other artists. It was intended to express the special castle-feeling, and I did it much better with a collection of works near to my own than I could have done with only my own. I placed the works in atypical locations—rafters, window sills, the dungeon—places where one wouldn't look for artworks, but where they drew attention to the structure of the castle itself.

**BK:** Now you make freestanding sculptures. What changed?

**SB:** I started to make sculptures that didn't hide. I was fed up with the fact that I never had anything to show when I was offered a regular exhibition. Because I only made site-specific works, all I had were souvenirs, parts of sculptures that were nothing without the environment. Now, the sculptures have become even more audacious, for instance, opening their eyes. Also I am growing out of the children. *Sweet Honey* and *Almost Perfect* are adolescents, and *Ultra* is a young woman.

**BK:** Indeed she is, and it isn't easy to hide her is it?

**SB:** That's right, she is a 27-foot-high diva.

**BK:** How does your background inform your work?

**SB:** I started out studying fashion. Fashion trends immediately reflect our feelings on political, social, and religious topics, which is what interests me about them. But I discovered that sculpture was as interesting, and I wanted to combine them. I was impressed and inspired by Oskar Schlemmer's *Triadic Ballet*. The combination of the two directions was unusual and not appreciated within the institution of the art academy. I quit after 2.5 years. So, in terms of sculpture, I am almost an autodidact. I tried hard to forget about fashion for years and to be a "serious art person," because I thought that my background and looks didn't do me any good at all. Luckily times have changed. I feel free to expose my fascination with trends now. I love all of the extreme accessories that come with them, like muscle cars, strange breeds of cats and dogs, hairstyles for horses, wigs and make-up for men, cosmetic surgery, braces, glasses, cell phones, and socks for iPods. My "collection of animalities" started me in this direction. With all its other qualities, there is also black humor. It opened up possibilities to make art on the edge of fun and reminded me of my pleasure in making Punk outfits when I was 18.

**BK:** Back to imperfections, beauty, and the human condition.

**SB:** Like I said before: my art is now very close to Victorian fancy fairs, special-effects props, and Wunderkabinets. I find it exciting to make art so close to entertainment.

**BK:** And now that *Ultra* is completed?

**SB:** I'm embracing my fashion roots and making a line of gloves. I am going to present them on a separate Web site www.skinover.biz; my regular Web site is www.silvia-b.com. They are soft sculptures that you can wear, like putting on someone else's skin with his freckles, hairs, and tattoos.

# Magnetism and Drama: Maurizio Cattelan

**by Andrea Bellini**
**2005**

Maurizio Cattelan was born in Padua in 1960. Self-taught, he did not attend art school but worked as a gardener, mortuary attendant, and designer, among other things, before turning to making art. In the '80s, he started his career in Forlì (Italy) where he knew some local artists. His works often combine sculpture and performance and reveal a refined sense of the paradoxes of transgression. He identifies the vulnerable aspects of the art system, and of reality in general, in order to highlight them, without ever falling into the naive trap of thinking he can subvert a system of which he is part. Cattelan likes to play the role of the loser, even if he definitely seems a winner: he is one of the best-known Italian artists to have emerged internationally in the 1990s, and his reputation continues to grow. He has had solo exhibitions at the world's most distinguished museums, including the Museum of Modern Art, New York, and the Museum of Contemporary Art, Los Angeles. Cattelan has participated in five editions of the Venice Biennale, as well as in many other collective exhibitions such as the Whitney Biennial, Manifesta, and "Apocalypse" at the Royal Academy in London.

**Andrea Bellini:** Maurizio Cattelan, to interview you is not the easiest thing in the world.
**Maurizio Cattelan:** Well then, don't.

**AB:** I'm just saying that it's not easy to interview you because on various occasions you've declared that you have no ideas and no theories. So, I'm wondering why someone should want to interview you.
**MC:** Actually I do everything possible to discourage interviews. It's not that I am opposed to them, it's just that I don't think I have anything interesting to say. I'm more curious about other people's opinions. In the end, without others, without their ideas, without their stories, you don't really exist and neither does your work. That's why one should listen to others rather than to oneself.

**AB:** Let's talk about your work, your sculptures.
**MC:** It feels strange to talk about sculptures. It's not so much a question of means as of images. I never even use my hands to create my work, just my ear glued to the phone. More than anything else, I listen to the murmur of images, and that's always louder than the echo in the phone. I'm more interested in images than in sculptures. Imagine: I never took a chisel in my hands, never even had a studio.

**AB:** So what are images for you?
**MC:** They are a statistical variation of the real. I'm interested in reality, the one we see every day: a thought, something you saw on TV or read in the papers, something that left an impression while surfing on the Web. Images have

*Untitled*, 2004.
Mixed media, life-size.

the strength to summarize the present and perhaps to transform it into an anticipation of the future. Perhaps my work is just a magnifying lens that allows you to see the hidden details of reality.

**AB:** But it's also a fact that your images are always three-dimensional, that they occupy a physical space. Why?

**MC:** Every time I start a new piece I consider a space, a precise location where it will be located. I can't work in emptiness, I would end up getting lost. I've been working this way for a while, and it intrigues me how there is only one solution for each space, one single answer that works.

**AB:** What do you mean by one answer? Help me understand.

**MC:** I'm always chasing new challenges, new possibilities, and new locations. I'm not only interested in the art public, but also in those people who just happen casually to pass by. Art should not be a space shut in on itself, but rather a magnetic field that attracts the energies of artists into space, and possibly into the cities in which they circulate. I'm searching for that magnetism, like a chemical reaction. Atoms don't join casually with each other, that's why there is only one answer, one single reaction. I studied a little chemistry, and I believe that it is a matter of positives and negatives, or something like that. And then you also need luck, lots of luck.

**AB:** Right, I remember: the story of the electro-technician.

**MC:** I did many things before becoming an artist. I was looking for a way to gain more freedom, to escape the authority of time. I don't think that I succeeded in doing anything different from anyone else. I simply invented a system that can give me the freedom to say what I think or what other people think. That's what really interests me about art: the possibility of inventing images that trigger reactions, that become a mirror of our time. There's not a big difference between a TV antenna and an artist: both are mechanisms of circulation, signal-amplifiers. More than an artist, I feel like an antenna installer.

**AB:** You talk about reactions. Therefore the scandal that your works provoke is only an accident.

**MC:** I never purposely decide to create a scandal, to provoke. Images sometimes manage to anticipate the future, and maybe that's what scandalizes the public—not to recognize themselves in what they see. I'm not really interested in provocation. I am interested in people's reactions, though: a work of art is not complete without the comments, the words, and the ideas of whoever happens to be in front of it. They are the ones who create the work. I don't do anything: art doesn't exist without points of view and different interpretations. Maybe even you and I don't exist.

**AB:** And what about the pope? Wasn't the pope, hit by a meteorite, a specifically Catholic provocation?

**MC:** I don't think it was a provocation. And certainly not anti-Catholic, coming from me, who grew up singing in the church choir between saints and altar boys. The pope is more a way of reminding us that power, whatever power, has an expiration date, just like milk. In the beginning, the pope was supposed to be something else.

**AB:** How was it supposed to be?

**MC:** In the beginning, he was supposed to be standing, with the crucifix in his hands. When it was finished and I stood in front of it, I felt as if something was missing, that the piece was not complete. What it needed was very simple: it lacked drama and the capacity to convey the feeling of being in front of something extraordinary and powerful. It didn't have the sense of failure and defeat. That piece doesn't have much to do with religion. I'm more interested in the actual people playing their roles than in their historical personalities.

**AB:** A secular piece then, how curious. And what about Hitler kneeling in prayer? Was that a publicity stunt?

**MC:** I like publicity—beautiful images, lots of girls. But I don't think that Hitler was a publicity stunt. He wasn't trying to sell anything. On the contrary, it was a rough image about peeling off masks and roles. At the beginning I thought he should be naked, like the emperor in the fairytale. But then I realized that it's always more interesting to mix the cards and pick the right one.

**AB:** So what role does chance play? To me, it doesn't seem that you leave anything to chance in what you do.

**MC:** Chance is always part of it. Take, for example, the work I did for Milan, in Piazza XXIV Maggio. The Trussardi Foundation invited me to do a piece, and I chose to work in that piazza and on that tree, which looks just like a tree out of a fairytale, imposing like a skyscraper in the midst of loud and constant car traffic. To be honest, I also chose that piazza because of the fried fish kiosk on the corner. The idea in my mind was to do a piece that would be like a small urban legend with a tragic ending. Perhaps a way to reflect on the present, with its tensions and nightmares. In any event, a few hours later, the sculpture no longer existed in the piazza; it only remained in newspapers and on TV news. That's what "chance" has to do with it.

**AB:** Listen, I don't mean to be blunt, but even in that case some people said you were a real con-man. You've organized fake biennials in the Caribbean, you attached a dealer to the walls of his gallery with Scotch-tape, you copied the show of another artist in every detail, you sold your space at the Venice Biennale to a publicity agency that was launching a new perfume, you denounced the robbery of an invisible work of art of yours to the police, you slashed Zorro's "Z" into a painting, imitating Fontana's cuts, you had a 300-year-old tree grow right through a flashy new Audi car. Who is Maurizio Cattelan, a court jester, a liar, or a con-man?

**MC:** A jester? I've been trying to say serious things for a lifetime, but nobody ever believes me. A con-man? I never robbed anyone, never committed perjury, never committed immoral acts. A liar? I don't believe in a single truth, only in an infinite combination of possibilities. I'm a bundle of contradictions, just like everyone else.

**AB:** If one analyzes your work from the last 15 years, it seems to be related to speed, to the idea of escape. You're able to change subjects quickly and to maintain a tension within your inventions. What is it about?

*Mini-me*, 1999.
Resin, fabric, and mixed media, 12 in. high.

**MC:** I am always interested in discovering the service entrance and the back stair in each building, the back exits and secret passages. To confront reality face-to-face is sometimes just a way of showing strength and, as always, just another mask one wears in order to hide.

**AB:** Let's change subjects and talk about you. Your friends, even the ones who've known you for years, say that there is a part of you that is impenetrable and ungraspable, that there's a part hidden from everyone. Is that true?

**MC:** Rather than parts, there are some spaces that I like to keep hidden, leaving them to the imagination. For example, my home—even though there is nothing to imagine or see. It's just four bare walls, a carpet, no furniture, and no paintings. It's like with jam: when you are small and you know that there is a jar on the top shelf of the kitchen cabinet, but you can't see it and you don't know what flavor it is, so you always imagine it to be better than what it is in reality. Do you like jam?

**AB:** Yes, apricot jam. But I'm the one doing the interview here, you are the public figure.

**MC:** I'm not a public figure, I'm not a celebrity. The fact that artists, curators, and people from the art world know me doesn't make me a celebrity. The world out there is much larger than what you imagine. And besides, I have always done my job, I never went to the top of the Colosseum and had TV stations come with helicopters.

**AB:** What is contemporary art for you, apart from traveling, success, and money?

**MC:** I spend money, rather then accumulating it. For me, money is a transmission mechanism, something that should circulate rather than be stored in a mattress. And anyway mine is a water mattress, so it would molder immediately. Traveling is part of the job; it's a way of trying to accumulate images and ideas that other people have had. I don't know what art is. I'm a night-school electro-technician who, after cheating in the back row, managed to pass.

**AB:** Lightness, speed, desecrating irony. These words are recurrent in your vocabulary. Is this your legacy?

**MC:** Those words recur in the vocabulary of those who write about me, not so much in mine. And if I think of "legacy," the only thing that comes to mind is the TV quiz show. I believe that one can win a lot of money in it, but obviously they never invited me to participate.

**AB:** Apropos your itinerary: Wasn't it enough simply to be an artist without an artistic formation? Why did you also decide to publish two magazines, *Charley* and *Permanent Food*, become a collector, interview various artists for *Flash Art*, and now be a curator? Aren't you one of the curators of the Berlin Biennial?

**MC:** I'm interested in the possibility of changing masks and roles and seeing what happens. I'm preparing the next edition of the Berlin Biennial together with Massimiliano Gioni and Ali Subotnick. It will open in March 2006, so we still have lots of time to find the right direction. Although in the end it's not so much a question of where one goes, as much as what path one takes. I do things out of instinct. I never think of where they might take me, even though sometimes it takes me two years to make the most simple decision—like doing the Wrong Gallery or *Permanent Food* and *Charley*. We started as an experiment, to open a space almost like a game, and in the end it became a serious thing, and lots of work.

# Great Places to Take a Date: **Sue de Beer**

**by Ana Finel Honigman**
**2005**

Brooklyn-based Sue de Beer lures audiences into her disquieting sculptural constructions with blood-and-heartache-filled films. de Beer's installations pump up the volume on her emotionally throbbing videos and photographs, which reference the slasher movies, horror flicks, goth rock, and other nightmare genres that give voice to teenage fears and yearning. In 1999, after earning an MFA at Columbia University, de Beer collaborated with Laura Parnes to create the macabre unauthorized sequel to Mike Kelley and Paul McCarthy's *Heidi* video. At the 2004 Whitney Biennial, de Beer exhibited *Hans und Grete*, her single-channel video installation in which she interwove references to the 1970s German revolutionary gang Baader-Meinhof, the teenage shooters in Littleton, Colorado, and *Nightmare on Elm Street*. The kids are similarly restless in *Black Sun*, a two-channel video screened in 2005 at the Whitney Museum of American Art at Altria in the interior of a wooden house specially constructed to replicate the film's set. de Beer's contribution to P.S.1's "Greater New York" exhibition, *Dark Hearts* (2003), which tells the orphan-love story between a dreamy goth-boy and the preppy girl who meets him on the road and becomes fascinated by his wicked yet fragile appearance, captures the Leader-of-the-Pack beauty in all of de Beer's art.

**Ana Finel Honigman:** Why do you choose to display your videos in conjunction with sculptural elements?
**Sue de Beer:** It started as a purposeful accident. When I began making art, all of my pieces were either photos or videos, but in them, I often made use of some kind of extreme prop. Because I made these props myself, I now count them as my first forays into sculpture. For example, in *Untitled*, I took a photo of myself sliced in half. To make that image, I crafted a full-body cast of myself, sculpted the wound out of wax, and finally fused two photos of me around the sculptural object to make the final print.

**AFH:** When did your use of sculpture evolve from making props to installations?
**SdB:** I made my first sculptural installation for *Heidi 2*, my project with Laura Parnes. We made that installation because the video was so fucking long.

**AFH:** So, were you thinking of the installation almost like an incentive for viewers to stay and watch the whole video?
**SdB:** No, that would have been too much like us displaying some sort of aggression against the viewer. It was more about finding a rational use of the space. People were going to be spending at least a half hour in there.

**AFH:** What did you learn from that early experience of merging installation and video?
**SdB:** I learned never to cast again. When we were making that installation we did a lot of casting, and I developed an allergic reaction to the mold release: I was walking around looking like Freddy Kruger for a month.

**AFH:** Appropriate, right?

**SdB:** Yeah. Also, that piece traveled forever, so I learned a lot by following how the installation held up under foot traffic. That knowledge has been really helpful to me in terms of what I am doing now. I need to know that because I am making objects intended to be handled, sat on, and participated with.

**AFH:** Are people comfortable tactilely engaging with the sculptural parts of your work, or are they too shy?

**SdB:** People seem to know now that they can touch all of the objects, so they get excited. Sometimes they almost get too excited.

**AFH:** You don't mean what I think you mean, do you?

**SdB:** Sometimes people go a little crazy. At the Whitney Biennial, the

*Black Sun*, 2005.
Installation view at the Whitney at Altria.

stuffed animals ended up with some odd things stuffed under them. I even found a bottle of hand lotion and some magazines under Klaus, the purple lion. I was like, "Klaus! What have they been doing to you?" Things have to be built as if you were building for an insane preschool.

**AFH:** Couldn't "insane preschool" be a definition for art in general?

**SdB:** No. Actually art is the opposite of insane preschool in terms of materiality. The insane preschool analogy has less to do with content and more to do with the way that the objects are being touched. Things are delicate and fragile and rare in an art context. People can't use art, so instead they watch the things from a distance. Art is more like a zoo in that way. My experience so far is that if you let people touch and use your art, they can lose control and maul it a bit because that's what they've always wanted but have never been allowed to do.

**AFH:** Most of your installations evoke typical teenage ways of watching movies. At "Statements for Basel Miami"

in 2004, you constructed a drive-through setting complete with a constructed car, and at the Whitney Biennial, you invited viewers to snuggle with stuffed animals while watching *Hans und Grete*. Do you want your installations to draw people into the world of your adolescent characters, or are they designed to alert viewers to the artifice of your movies?

**SdB:** Well, I don't really see any artifice. My world is kind of real to me. The experience of shooting on my sets feels pretty real. What I mean is, I have driven in a regular car and a plywood car and both kinds of driving felt real to me. I think it is pretty engaging when I snuggle with Mr. Kitty. And, usually when I am building these installations, I am thinking about making something that I wish I had in my apartment.

**AFH:** What do you think links the experience of viewing while lounging on massive stuffed animals or soft, plush chairs with the more mysterious experience of climbing through a creepy clapboard house in order to watch a film?

**SdB:** I think that the link between the different installations is that they would all be great places to take a date. You could relax with your baby, hold hands, and cop a feel inside the sculpture.

**AFH:** Are you sure you want to encourage that kind of thing? Look what happened to Klaus.

**SdB:** Klaus loved it.

**AFH:** Demonic dolls and cursed toys are such a classic horror-flick motif. Why do you think there is a connection between stuffed animals and fear?

**SdB:** It is scary to love something unconditionally. When you are in love, or when you love, you are the most vulnerable you will ever be. You can love a toy safely because you know it won't fuck with you, but when the toys start fucking with you too—you know things have gotten extra bad.

**AFH:** But don't children also abuse their stuffed animals mercilessly? Aren't toys a little like clowns in that way? They are our victims, and on some level, we know they would be justified in taking revenge.

**SdB:** Pleasure comes in many different forms, and sometimes it comes for the wrong reasons. If we were Lacanians, this would all fall under the heading of *jouissance*. Sometimes it feels good to torture someone or something, sometimes it feels good to be loved or to love unconditionally, sometimes it feels good to be hated by someone or something.

**AFH:** How does this relate to your work?

**SdB:** Maybe this is why there was such a frenzy in the Biennial room—the audience internalized the angst in *Hans und Grete* and enacted it on the animals.

**AFH:** Do your other works provoke similar reactions?

**SdB:** People were not so abusive to the car at P.S.1, but the situation was different with the house at the Whitney Museum at Altria. There, people explored the installation in the weirdest way. They climbed in through the windows in order to see if they could get into the part of the gallery that had been blocked off. It was funny to be in that space because while you watched the video a head might peek in behind you and watch you watching.

**AFH:** That sounds terrifying.

**SdB:** Well, it is a situation that reflects the moods of the videos. I like it when that happens. When you watch *Hans und Grete*, you want to kick the shit out of something, abuse your environment. While watching *Dark Hearts*, you wait for someone to come kiss you because it has this waiting and observing thing. But *Black Sun* is about exploring places you aren't allowed to go, so I like that people climb it, trying to get to areas they can't reach.

**AFH:** So, would you say that the sculptural elements in your installations are successful when they represent the essence of the films?

**SdB:** Maybe, and maybe that is why I keep thinking about Minimalism right now.

**AFH:** Do you think that would further exaggerate the emotional experience? Can Minimalism articulate aspects of the videos that representation can't?

**SdB:** There is a psychological aspect to how people interact with a space—the way the space is delineated encourages people to do one thing or another.

**AFH:** I can't really see you doing pure white structures. Which Minimalist works affect or inspire you?

**SdB:** I guess I will get in trouble here because not all of these artists are strictly Minimalists, but I keep thinking about a Flavin show that I saw at Dia a long time ago. It was installed very well: the lights were given their own space, and you moved through the rooms guided by the color. I also think of when Robert Gober left a room empty except for a drain in the floor.

**AFH:** So, would you say that when you think of Minimalism, you're not referring to stripped-down forms but defining Minimalism as one idea perfectly executed to the exclusion of any other idea?

**SdB:** Maybe by "Minimalism," I mean a piece of sculpture that breaks down each architectural situation as if it were a Judd. This isn't reflected in my work yet, or at least I don't think it is, but it is on my mind.

**AFH:** Aesthetically and conceptually your work reminds me of the concerns addressed in Riot Grrl feminism. Am I right to think the theory and subculture of that movement have influenced your work?

**SdB:** That is an interesting question. I am a big fan of Johanna Fateman's 'zines. My friend Rachel just lent me

*Dark Hearts*, 2004.
View of installation at "Statements for Basel Miami."

*Artaud-Mania* and *My need to speak on the subject of Jackson Pollock.* And I had a studio assistant who got into a car accident in high school skateboarding to Bikini Kill. Isn't that great? She was hanging onto the back of a car.

**AFH:** Is it still relevant to interpret art from a feminist standpoint?
**SdB:** I guess the answer is that every woman who is actively making stuff and shaping culture is part of the dialogue defining and redefining femininity and feminine identity. There was a backlash against feminism in the '90s art world, but now there is a post-feminist discourse. The cultural theorist Slavoj Zizek says that the revolution isn't the most important thing, the day after the revolution is what matters.

**AFH:** Is "post-feminist" a term you are comfortable applying to your work?
**SdB:** I am part of the moment after the revolution, so I am participating in building the new. Sometimes that is confusing. I owe a lot to '70s and '80s feminism. Without that movement, I would never get to do big installations in museums. I mean, if I were 20 years older, things would have been much, much harder for me—not that things have been easy.

**AFH:** Why do you think there is a renewed interest in horror imagery or Gothic narratives in culture?
**SdB:** All of these things are social. Recently, I have also been surfing images of Glen Danzig [of the bands The Misfits and Danzig]. I am particularly fascinated by the way he looked in 1993. His look was kind of reassuring because he was so solid; even though he was really short, he seemed decisive. I think in that particular moment, he stood for the kind of direction that you could take.

**AFH:** He provided an image of ideological assurance that was non-existent in an era of moral relativism?
**SdB:** With this dark stuff, goth and horror, as it exists in pop culture, you are up against death, but the goth narrative provides a structure cradling you while you look into the abyss. I think this explains why there is an earnestness

in art right now. People want meaning and meaningfulness in life. Maybe this need is intensified because there is a void of structure and meaning.

**AFH:** What does the current wave of original and remakes of classic or foreign horror films say about our cultural concerns?

**SdB:** Maybe a new passivity.

**AFH:** Do you mean a political or creative passivity?

**SdB:** Maybe both. I think there is a general feeling that we're a generation incapable of changing anything. That makes this a good time for remakes and sequels.

**AFH:** Would you consider your films to be remakes or sequels?

**SdB:** No, I am not really interested in perpetuating the sequel problem. I made *Heidi 2*, but even then it felt important to try to make "the new" happen. I am against the impossibility of changing things.

**AFH:** How does your art relate to the cultural products—books, movies, and subcultures—that you reference?

**SdB:** I guess that the people/characters in my videos are coming face to face with cultural inertia and trying to sort it out. They are filled with yearning. They want change, newness, contact, and life. They're trying to build the new on a rocky footing.

**AFH:** Are you interested in making mass-market movies, a Hollywood or indie film?

**SdB:** I keep going back and forth on this. I have been asked a lot recently if I would do a film. I think the difficulty is that with film, you need a minimum budget of a quarter of a million dollars, and you need to get distribution for your project when it is complete. In a perfect world, with this problem solved, this feels like the plus and minus to me: in film, you have a burst of fame for your project, and it lasts for a couple of years, the whole world has access to it, and then everyone forgets about it in 10 years. My students, for example, do not know "Twin Peaks," which in its time was a ubiquitous pop-culture phenomenon. So, you have this massive ability to communicate, followed by the din of silence. Art reaches fewer people, but it unravels itself more slowly over time, and it stays in your mind in a more current kind of way. All of my students know who Jeff Koons is, for example, or Hannah Wilke and Francesca Woodman. Woodman was probably dead by the time "Twin Peaks" came out.

# Poetry in the Mundane:
## Mags Harries and Lajos Héder

**by Marty Carlock**
**2005**

Sculptor Mags Harries and urban planner/architect Lajos Héder, married for the past 27 years, formed the Harries/ Héder Collaborative, Inc., in 1990 to execute large, permanent public art installations. Welsh-born Harries, a graduate (and now on the faculty) of the Boston Museum School, is best known in Boston for her *Glove Cycle*, lost gloves cast in bronze and installed in a subway station. She first came to the public art scene in 1976 with *Asaraton*, trash she picked up at the Haymarket urban farm market, bronzed, and set into the sidewalk. Harries's work is so varied that it is hard to categorize. Her production ranges from the early *Fossil*, a subway standee bar seemingly deformed by a rider's grip, to performance works, to some 32 public commissions nationwide. For the past 15 years, she has collaborated with Héder, whose rehabs of historic buildings have created some 130 artists' cooperative live-work spaces in Boston.

In addition to large-scale commissions, the duo is known for environmentally engaged, participatory performance pieces. In 1998, to dramatize the sorry condition of the Bronx River, they floated a golden ball down the 10-mile waterway to the accompaniment of dancers and preplanned community festivals. In 1997–98, to make the presence of Boston's Charles River more palpable, they organized passersby to help wind a ball of yarn 78 miles long, the length of the river.

In 2003, the collaborative completed a major revitalization of a hydroelectric plant in Phoenix, Arizona, creating an aesthetic oasis in the desert. In 2005, their work at a new $60 million water treatment facility in Cambridge, Massachusetts, was dedicated.

**Marty Carlock:** When I want to identify you to people who don't know the art scene, I say, "The artist who did the bronze gloves," and they know immediately. Is this how people still think of you in Boston, even after 26 years?
**Mags Harries:** All the time. With public art, you do a project elsewhere, but no one here sees it.

**MC:** How long ago did you start thinking about the installation at the Cambridge Water Department?
**MH:** Eight years ago. We tried to think of it as a place to educate people about water, where it comes from, that it's important to understand the system. I lived in Cambridge for 26 years and had never visited the Water Department, which is within walking distance of five schools.

**MC:** In general, how do you approach a commission?
**MH:** It's a long process. We develop an idea, we start a dialogue with the client or the design team.

**Lajos Héder:** Or whoever represents the community.

**MH:** You look at the plan and try to identify opportunities and places where art would fit. What are the possibilities of how an artist can be part of a team? We try to go into a site without an agenda.

**MC:** Do your original concepts change a lot?

**MH:** Yes. The plans for the Cambridge water works included a little corridor gallery that they thought would be the exhibit. We thought that the whole thing could be the exhibit—glass walls on the control room and the pump room. We were coming up with ideas while the architects and engineers were still working. They took some of them. That's fine, that's what design teams are about.

**MC:** But 9/11 changed everything, right?

**LH:** Because of 9/11, no one can go into the plant, except into the lobby during normal operating hours.

**MH:** That's why we did the map of the Cambridge water system in the floor. It starts with the reser-

*Fossil,* 1982.
Cast stainless steel, life-size. Imprint of the artist's hand blended into a subway pole and installed in car #1506, Boston.

voirs out in the western suburbs, showing the different gauges of water pipes instead of streets.

**MC:** How else did you have to modify the project?

**MH:** We had an idea of taking the old aerator and doing something with the bathroom.

**LH:** The architects took that and did their version of an aerator for the fountain in the lobby.

**MH:** We had another idea, a listening pipe, where you could hear the water rushing through. Eighteen million gallons a day. They didn't like that one.

**MC:** Weren't there political problems too?

**MH:** We had the idea of opening the weir building—you couldn't see it—and cutting the pipe short to create

a waterfall, an acoustic weir. This idea they really embraced, and it was approved. Then a group surfaced—that always happens in Cambridge—with a petition to oppose it, because we were supposedly going to impact a meadow.

LH: We initiated a petition drive in favor of it—we each had 400 or 500 fans. We picketed. The thing just hung there for the better part of a year, but it became obvious that it wasn't going to happen, and we were basically going back to another idea, the map. It became more multi-part, but not as viscerally powerful.

MC: But you were able to use the waterfall idea in Phoenix, weren't you?

MH: The gods were kind in Phoenix.

LH: The site had been an old hydroelectric generating plant, abandoned about 50 years ago. As we got started, they decided to put back the generators, which provide power for 400 homes.

MH: We wanted to bring the local people to the water. Then they can be invested in how these banks should be used. There's terrific recreational potential. We built a Water Room where people come and meet.

LH: There are rules about what you can do with the water. You have to convey the water, but it doesn't say how. You can go up, down, or sideways. So we surrounded a room with water.

MC: I understand that at first, even when you were collaborating, Mags approached the creative problems and Lajos did the technical things—made it all happen. Is that true?

MH: I worked by myself for years and years. I still do sometimes. Lajos had an architectural office.

LH: We crossed over a lot. I'm better in some areas, visualizing unbuilt buildings, working with contractors. It's hard while bringing a project to actuality to see where ideas come from.

MC: When did you begin brainstorming the problems together, from the beginning?

MH: With *Wall Cycle to Ocotillo* in 1990.

MC: When did water become a focus for you?

MH: With *River Runes* (1990), a temporary installation at Art Park in Lewiston, New York. *Wall Cycle to Ocotillo*, although it wasn't on the water, came from our thinking about water, about what is important in the desert.

MC: So you designed bus shelters shaped like all kinds of water jars. What are you working on now?

MH: Two projects are being built right now: Miramar Park in Fort Lauderdale and *Baseline* in Phoenix. With Miramar, we're into the third version, the third client, the second contractor. It's called *Terra Fugit*. Things change so fast there, we argued for keeping a part of the land as it was, our little preserve, virgin land. There was a lot of consternation about that. People wanted to know why we didn't make it pretty, pave it over.

What happens is they begin by scraping every living thing off the land and blasting for housing. People move in and have no idea what the land looked like. We wanted to keep some of that. Then we found coral, fossilized limestone—it's all shells. We'll use it to build up the shore and have it cut for benches.

LH: We try to find available materials that are plentiful, possibly going to waste.

MH: And then Lajos built a burper. It's essentially a bucket that will be anchored upside down in the center of the lagoon, under water. In the gazebo is a handle you can pump. When the burper fills up with air, it turns over and lets out a bubble, which causes annular rings to move toward the shore, taking the shape of the shore. Everything is about time flying. Water to shore, fossils into pathway, grass into house lots, fossil time, man time, alligator time. *Asaraton* (removed during Big Dig highway construction) is going back in. And we're meeting with people in Maine about an ongoing project, a new ferry terminal in Portland. It's a theoretically contaminated site, where they just dumped what was dredged out. We have to keep all the stuff on site. We're consulting in Fort Worth, where they have a project to reroute the Trinity River. We're finalists for the South Bay Harbor Trail in Boston, which will run along Fort Point channel, one of the last parts of the Big Dig. Our proposal is to create islands of marsh grass. It will be one where people ask where the art is.

MC: What is your favorite project to date?

LH: Arizona Falls. Some sites are marginal; this one was inherently dramatic. The water works is a public utility, but it's run more like a private company. They were more welcoming to ideas. We got to go to the yard that housed all the old machinery and choose some pieces to recycle as decorative elements.

MC: Which of your performance works has been best received?

MH: My favorite was the *Golden Ball* that we floated down the Bronx River. We were hired by the National Park Service to draw attention to the condition of the river. It reaffirmed my faith that as an artist you can make a difference.

MC: Do you think that your work has had an impact, environmentally?

MH: It's hard to say. You hope that your ideas raise people's awareness.

LH: But *Golden Ball*, yes. The first year 10,000 people came to the banks of the river at various places; it runs through 27 communities. The park service created access where there hadn't been any.

MH: It was very poignant. In the Bronx, they built a typical New York park—very narrow, sheet metal on both sides, and they threw in a few plants. But it was the first access to the river there in 50 years.

LH: Governor Pataki came and announced an $11 million grant. There was more from the National Park Service, $33 million in all, in response to community and municipal initiatives, for land acquisition, parks, and access.

MH: We ran the river again for several years. They still run it every year, but the ball is retired.

*Waterworks*, 2003.
Water, land, sandstone, plantings, and metal, site 600 x 1,000 ft. Multi-part project at a hydropower station on the Arizona Canal, located in Phoenix, AZ.

**MC:** Education has become a component of your civic works. What else is important?

MH: We're always trying to reveal something that can't be seen.

LH: Place. A lot of my work in urban design is providing catalysts for community activity.

MH: Weaving the work into the fabric of the place so it can be loved, or looked after, at least.

LH: Poetry in the mundane.

MH: Sequence, pathways. Time is a constant element. Concern for the environment.

**MC:** About how many proposals do you make in a year? How often do you succeed in competitions?

MH: Basically I'm opposed to competitions. I prefer to be hired.

LH: I'd say four to six proposals. About 90 percent get built. The number of good projects is still exceeded by the ideas we throw away.

**MC:** What's your secret for working with bureaucracies?

MH: We both like people. You don't go into this unless you like going to new places and learning.

LH: Early on you come in with a pretty broad perspective and build up to specific ideas. People have to be seduced.

MH: First you listen.

LH: There are always tricky questions, for instance money or regulations. You try to develop a general consensus that something is worth doing and that it's worth figuring out how to do it. And you develop friendships with people very different from yourself, and sometimes they solve your problems in ways that you would never imagine. At Arizona Falls, an engineer for the utility company called me up and said he had an idea for what to do with the wire conduits that we had to run from the hydro generator to the electric power station next door—make a cascade out of them, to imitate the water cascades. And the concrete workers saved our butts: we had collected reeds that grow along the stream to lay in the surface of the concrete, and if it had been left to us it would have hardened up before we were done. They had a much better sense of their craft and helped time the setting of the reeds and the finishing of the concrete. This is just one example of a recurring issue since we work with new materials and techniques on practically every project. Finding others who know their craft, and using their knowledge, is critical for us. Public art projects split people into two camps: one, people who perk up and get excited about the possibilities. The other group gets put out and thinks we're trying to derail their everyday life. The interesting thing is that it doesn't change much, whether they're executives or janitors. You have to find your allies. With *Asaraton*, Mags walked into Haymarket and found one guy who liked it and mentored it.

MH: Somewhere there is someone who will say yes.

LH: You have to be prepared to compromise. But you have to decide the line beyond which you can't be pushed. You have to be aware of what the core is. You protect the center, not the periphery. We're incredibly persistent.

MH: Like little terriers.

# Something Happens: Richard Tuttle

**by Susan Canning**
**2005**

"Something happens when a viewer takes my work someplace never intended. Something happens, my work's practice is most intended to satisfy." For Richard Tuttle, the thrill and satisfaction of something happening, of making but not controlling, have sustained his exploration of the parameters and paradoxes of art-making for more than four decades.

Tuttle is interested in a broad range of topics—Greek *kouroi* and Afghan textiles, the study of Japanese and Chinese language and calligraphy, decorative arts, modern architecture, contemporary poetry, and the philosopher William James—that reflect his inquisitive mind and penchant for seeing things from a variety of changing or even contradictory viewpoints. Coupled with his desire to discover and to challenge, Tuttle's intense and engaged curiosity has produced works of broad range and varied circumstances, some of which were on view in a traveling retrospective exhibition organized by SFMOMA in 2005 and shown at the Whitney Museum in New York, the Des Moines Art Center, the Dallas Museum of Art, and the Museums of Contemporary Art in Chicago and Los Angeles. What follows is an interview of sorts, or, more aptly, a flow of words and ideas that might provide a context and some insight into the artist's practice but that can hardly encapsulate his enigmatic presence.

**Susan Canning:** In an interview you said that language and image are two different worlds, but a lot of your work has a syntax that relates to language. How do you think the object relates to language?
**Richard Tuttle:** I'm very interested in writing systems, calligraphy—I'm interested in the edge, the letters, in many different languages. It seems to me that there is a mysterious edge where the visual word touches the visual world in a certain way, which I find exciting. For the human mind to make the transformation from a character that could be printed to an idea in the mind, and then to act on that, is a very significant thing.

**SC:** Mallarmé focused on how words were situated on the page—how does the interaction between ways of presenting action, marks, and gestures relate to the presentation of your work?
**RT:** I've collaborated with the Greek-French poet Anne-Marie Albiach, who's marvelous because she's true not only to Mallarmé but also to the historical depths of French poetry. She writes with the space of the poems. I use the space of my page in a drawing as part of the picture. We did a collaboration: she has her double spread and I have my double spread, back to back. The reader goes through the experience of seeing space used for verbal expression and space used for visual expression. We reached the notion that my work is between calligraphy and architecture, but it really isn't calligraphy and it isn't architecture and it doesn't extend into those areas. It's exactly between, without touching either. And so, a discussion about calligraphy and other issues is not so much about what the work is as about what the work isn't.

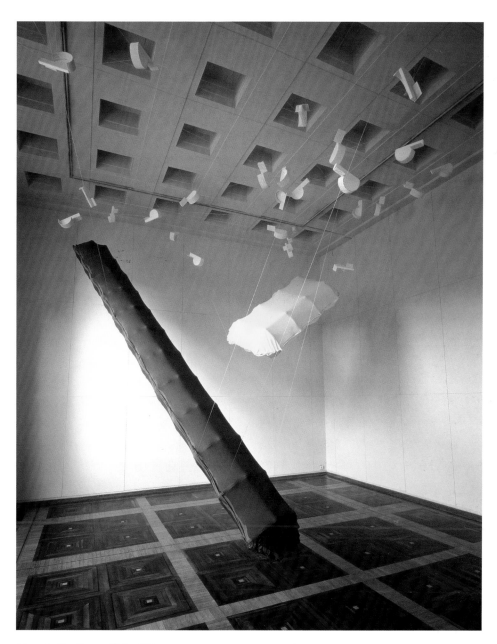

*Memento, Five, Grey, and Yellow*, 2002.
Mixed media, 2 parts, 16 x 24 x 193 in.; 20 x 39 x 76 in.

One of the strange characteristics of the work is that it produces what I call alphabets, as in 26 for the English alphabet, which happens to break very nicely into two sets of 13. Thirteen in my mind is also related to the moon, indirectness, the Romantic, sensuality. I have also made half alphabets of 13, like the alphabet I made at Crown Point Press in San Francisco, which breaks down the 26 into 13, but the first set of 13 is about half an inch larger overall in the paper size. The actual image stays within a two-inch square; but in the second group of 13, the paper is reduced slightly and there is a tightness. In sculptural dimensions, there's a compression. The notion of compression is a bridge between poetry and sculpture, because they are both arts of compression. When you can do that right, and I feel like I'm willing to devote a lifetime to doing it once and doing it right, it is very exciting. It has to come from some place that's outside any control or logic or rational world.

**SC:** I was struck by your control of the connection between seeing and experiencing in things that aren't defined as painting or sculpture, through both the placement and their relation to the hand.

**RT:** I always put the last things first, and the first things last. And it's all hidden behind the notion of learning by doing. It's a very American thing. Stumble along as long as you're sincere, then it's OK. I'm really not someone who's searching for the rules. I feel like I was born knowing the rules, and what's fun is playing with the rules or putting them together in strange combinations to discover something that historically wasn't possible, that maybe was over-looked. Or maybe it truly is at the edge of things. You get to play with time and space through these rules, and then you give the possibility of play to other people. It's a delicious opportunity if there's enough space and enough work, because you can offer the connection of seeing and their own experience to anyone who walks in the door.

**SC:** You don't have a definable style. In Western art there is a notion of making things that are equal to the self, and self is equal to style. In the process of drawing (and with the early wire pieces you are literally in the drawing, making the drawing), the object is the process itself. On the other hand, you said, "My work is to overcome identity." How do you see drawing as overcoming identity?

**RT:** There are times when I can say, "I didn't make this," and then a friend, who probably knows my work better than anyone else, says, "That's a real Richard Tuttle." If you think that identity is a limitation, which I do, he tightens the sense of restriction in a hopeless way. In my work, I consider that I have a line—there's a notion that each of us has a uniqueness, you don't know where it comes from or what it's for. Art has something to do with that uniqueness: what is achieving art for one person is completely different than what is achieving art for another person. I live a life in which I am sometimes in touch with my art. And I like to be in touch with that; I try to find it, I search for it every moment of my life. Even when it's there, there's anxiety because it has to be treated with care in an abusive world, a world that doesn't value that sort of thing. There's a lot of pain and hurt. There are very, very few people in the world who understand all of this. I'm lucky to have had Betty Parsons, Agnes Martin, and some other people in my life who knew something about it. I feel sorry for the young artists in the world who may not have someone like that.

**SC:** There's a lot of discussion these days about the "performing" of identity. Do you see your process as a performance of your identity?

**RT:** Really, it horrifies me even to leave a trail of that. I guess I was talking about a notion of shaping: I realize that the current show begins with the three-inch paper cube as a given, and then there are various invasions or operations performed on that cube, which then reduce the space in some way or connect the elements, as if to deconstruct the cube. The early work deals with the first side of the cube; from the '70s and '80s, it deals with interior space; and then the work from the '90s to now deals with back space: that would explain the variety of the work, and everything then falls into a dynamic system.

**SC:** In retrospect, do they come together? You were saying that while you were in the midst of making them you were also involved with something else.

**RT:** Yes, but I think that there's a possible simultaneity in time as well as in space, and there's a lot more time in time than you think. In terms of my overall work, I feel that any piece, whether a poem or drawing or sculpture, can be seen in any other work. Yes, the subject for the moment looks like Richard Tuttle, but the next moment the subject might not look like Richard Tuttle or it could look like some other artist. I'm following the work; it's a sense that's coming from the work.

**SC:** When you revise the work, reinstall it, or install it in a new way, this is a process, the work is not any fixed thing. That's what I meant by performance, and that relates to your Richard Tuttle/not Richard Tuttle. It keeps changing, even though overall it is all part of the same thing.

**RT:** I find that if you put it here, it's one thing, then if you put it over there, it's another thing. It's not like I'm saying anything new, because the work of art can be something that's purely revealed according to where it is. I feel that there is an extreme inconsistency of "made" and "found." Maybe that's what I'm saying about the sense that there are two worlds, which I feel need to be connected. There are certain people, born at the time when I was born, who have this in common: they have a sense that the world is broken and that they have to put it back together. I'm fond at the moment of saying that being an artist is a service job. And it's wonderful to be asked, even to be employed. I'm very comfortable with the notion of just putting it back together, in an almost ceremonial way, whether it be a Native American or a religious way, or some other thing. I've always preferred implicit over explicit—people can look at the wire pieces and see a kind of performance art. It's an early harbinger of the whole movement, however big it is. But it's not explicit.

For an artist who is working with inspiration—and that to me is about creating meaning—you can say, "Oh, I can create meaning because I have control," and then you can praise all kinds of artists who achieve thorough control. But then you find people who blew it because they had too much control. How do you find your way through that?

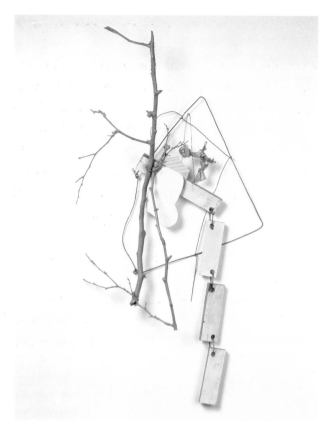

*Monkey's Recovery for a Darkened Room (Bluebird)*, 1983.
Mixed media, 40 x 20.5 x 12.5 in.

How do you do your job? It's the sense of inspiration and knowing inspiration; and then there's a point with really great, mature artists, when the sense of inspiration seems to replace inspiration. It's scary, but it's also very defiant, and that's why you work a lifetime, the big pay-off. I criticize myself because I had a bent for the abstract, and in language, most, I'd say 98 percent of language, is about concrete stuff.

**SC:** But does the soul need art?

**RT:** I think it is a kind of maturity. As a younger person, I focused on art exclusively, which was necessary, but now I feel that it's about "art into life." It's almost like the discussion of beauty. For instance, Louis Comfort Tiffany went completely off the track when he started getting into beauty, aestheticism. I cast my eyes from there to there—there's so much beauty that I'm staggered, I'm just overwhelmed. For me, to think of art as adding beauty to the world is ridiculous because it's clearly something we need to help us to deal with the beauty that's already there. Then, once we have that in place, you can go back into the world and you can make, or you can have a life in which you're connected with all this beauty in a way that's not overwhelming. That's what art can and will do for us. The fact that an artwork is beautiful is purely accidental. It's almost as if because there's so much beauty in the world, it can't help but be beautiful. The strategy is akin to making something that allows the viewer to process the beauty in the world through art.

The great dealer Betty Parsons said to me (she probably said it to a lot of people), "Richard! You must love art!" She was an artist, and she knew lots of artists, and her life was about art, so she was saying what I'm saying now: it's about art into life. It's just too bad that it takes us 60 years to figure that out.

**SC:** In a recent two-part show ("It's a Room for Three People" at The Drawing Center, New York), I was intrigued

by the aspect of architecture in your work. In terms of your earlier work, there's always a relation to the space. Would you say your work is like architecture?

**RT:** No, I'm trying to say that the work stops just before architecture. It doesn't, in fact, include architecture. In the same way, it doesn't include calligraphy; it stops just short of calligraphy. The artist has to choose limitations: you simply can't do everything. I did that when I was quite young, which I think is surprising. I chose these limitations—that the work would be between architecture and calligraphy. I think that gave me the possibility of working in a zone where painting, sculpture, and drawing all combine freely. But the history of the world is a very powerful thing, and it has given us certain forms like sculpture and painting. A smart person would say, "OK, when I limit myself, I better limit myself to painting or sculpture." But the paradox of my particular generation is that we could choose exactly those kinds of limitations which are not traditionally, formally delivered from history.

**SC:** I think it's interesting to say that you can limit yourself to what is outside the traditional form, because most people would think of it as freeing or liberating rather than limiting.

**RT:** We got to see what we thought was of an unlimited nature, and maybe for me and my puritanical roots, this is, in fact, more limiting than a choice of pure sculpture or pure painting. In the end, I'm going to have to say, "Well, what is this place, what is this thing?" I may have to admit that it's nothing. And therefore it would make the work of no value.

**SC:** No value in relation to what?

**RT:** To what's important in human history. The whole parade of the life and activities of humanity on earth. Clearly certain things seem important to us at certain times. Awareness is such a hall of mirrors. Ultimately, whenever we have awareness, we really don't know where it comes from or why it comes from there. And that's why I prefer a kind of object made with no awareness of itself. It's purer, it's inexplicable, it seems to be capable of expressing some inherent fundamental quality that more conscious, sophisticated, self-aware kinds of things can't express.

**SC:** Bachelard's *The Poetics of Space* has a certain language for the poetics of resonance, memory, and associations, in other words it's not a neutral, non-speaking place. I see the same poetics of space in terms of the interaction of things in your work: whether they're objects or sculptures, they bring a certain consciousness into view. But they also interact with their surroundings in many ways. So, space is experience rather than an object or scientific model. Do you see your work as providing a relation to experience?

**RT:** I'd have to say, "What is space?" I did a group of pieces titled "Space is the Frame for the Other." That's a very positive statement, but if you flip it, it has a negative side, our inability to know space. I think that one of the greatest horrors would come from a profound awareness of not knowing what space is. Then it flips to the other side, and it doesn't feel so horrible because I give you the idea that whatever our other is, it's space. People talk about

art and art experience, but part of an art experience is being free of experience. And I know that part of the discipline of having art in your life is to deal with experience. Knowledge is experiential; history is experiential. But at some point, you can't be a great artist until you've taken that experiential thing and let it go. All the great art historians are astonishing in their ability to move back and forth from the experiential to the non-experiential in a way that leaves the rest of us breath-taken.

**SC:** Do you see a connection between your work and theater, in terms of staging, or relating to experience?

**RT:** The more difference I see between what could be made in the studio as opposed to what can be in front of the world, I think there's a great need for the dramatic. That's inherent: if you have something to say, it's only natural that you'll look for a dramatic way to make people listen. But there's also, at the moment, a delicious concern for the visitor. Over and over again in these places, I'll say, "Remember, this is for the visitor." They've come, who knows how far out of their comfort zones and away from their TVs; it is a great honor to give something, have something to be seen that makes it worthwhile and shows that you respect their attendance. To me, it's completely natural and part of why we do it. There are things that we need that are as important, but they're not of a public nature. You can't really break forms unless you respect them; you have to show that you respect these forms and then go ahead and break them. I don't have any values of wanton destruction. I think it's very funny because artists were the ones who trashed the academies. And now artists are paying for what the academies offered, we have to make up the difference. Basically artists thought that they were going to find a better way, and they wound up paying a big price.

**SC:** Do you choose your materials or do they choose you?

**RT:** There were times when I would just settle on a material. Maybe you could say that they chose me. You go through the world and stuff looks a certain way, but then you want to make an artwork, which puts you in a different position. In that position, there's an energy that makes you see things differently than you would ordinarily. And so, the materials then appear unlike things would normally appear to you. Somehow that argues for the importance of art, the special place of art. I had a piece (*Two or More XII*, 1984) in which I knew there had to be different colors of jewels. I had to find them, and I thought of going to Tiffany or Cartier but I couldn't find them, and the only thing I could think of was to walk and walk and walk until I found them. In the end, I came back to my neighborhood very defeated and noticed the kids on the next block playing a game, letting cars break soda pop bottles in the street. The glass was broken by the tires in a special way, and there were the jewels. Their back surfaces just needed to be painted a certain color. If you want to try to imbue a piece with meaning, the very materials have to come from a dimension of meaning rather than from some lesser place, so that they are not one-dimensional. Part of what I strive for is to make something that has multiple dimensions and is free from the single dimension. If you think of materials in a non-one-dimensional way, you can be pretty sure you're going to make a piece that is not one-dimensional.

**SC:** One of the things that I noticed in the P.S.1 exhibition "Greater New York 2005" was the inventive use of materials. This younger generation is really exploring the possibilities of materials, as well as definitions of sculpture, the possibilities for installation, and how things are experienced. How do you see yourself in relation to younger artists and art practice today? Do you see yourself as having opened the doors? I wouldn't say that this new work is anything like yours, but the aspect of materiality and materials is evident.

**RT:** I'm pleased if it's evident, because I want to contribute a certain nature of things that can be employed to benefit others. Within the "notion of limitation" that you have to accept as an artist, giving permission to other artists seems to be truly unlimited. So, you arrive in a place where those polarities are in operation. But when I go to my own practice, I have to be focused on doing what it is I have to do. Whether it has an aspect of being ahead of its time, and whatever characterizes this time, is not of interest to me. In fact, my more recent work has been involved with a plain, almost Minimalist appearance.

One of the things I've come to notice is that human lives are wrapped up in the cyclical. Is there any moment when one can peek through and look at a world that is not cyclical? Materials that were interesting, specific materials in terms of that project would distract, almost like anti-interest materials. I'm also interested in the notion that there's something you need to make real, to put in terms of the real world. The same thing that might be drawn with a pencil might be just as well made if I put these two chairs together. Why does the world make things restricted? I want to push the limit of what you can get away with. I do think that art has to solve the problem of representation, which might be Aristotle's problem with imitation. It's not about imitating something, it's about what can you get away with, and the degree that you can get away with it. Then, even in Aristotelian terms, it becomes much more interesting. I find it almost suffocating to think that a poet or playwright is reduced to imitation. But at the same time, I admit that there's a certain truth to it. So how do you deal with it? You try to get away with as much as you possibly, possibly can. And that becomes an art—but it's not big art, it's an "art in itself" art.

# Rules for Growth: **Tara Donovan**

**by Collette Chattopadhyay**
**2005**

In 1999, the year she was awarded an MFA in sculpture from Virginia Commonwealth University, Tara Donovan mounted her first solo museum show at the Corcoran Gallery of Art in Washington, DC. Her poetic, beguiling installations, made from commonplace, mass-produced objects such as drinking straws, Styrofoam cups, and toothpicks, present a new type of sculpture that playfully reassesses the legacies of Pop and Minimalism. Patiently and laboriously creating stand-alone sculptures and room-sized installations, Donovan systemically transforms the ordinary into the extraordinary.

Now, several years later, her room-sized works such as *Haze*, shown at the Museum of Contemporary Art in San Diego in 2004 and subsequently re-created at Ace Gallery in Los Angeles alongside a bevy of other major projects, underscore her ongoing fascination with the making of things. Like early Serra works that once threatened the well-being of a New York gallery space with their imposing mass, Donovan's *Transplanted*, which weighed in at roughly 10 tons, prompted the gallerist to call in a structural engineer to assure the viability of the project.

Whether ethereally light or massively heavy, Donovan's sculptural accumulations ironically evoke such natural forms as fog banks, clouds, water, and sea cliffs. Creating lyrical, deeply contradictory works, she melds consumer culture's unending demand for toss-away items with a continued longing for nature. Returning to a labor-intensive process, Donovan reaffirms the importance of the physical world in the creation of sculpture.

**Collette Chattopadhyay:** Before viewing your show at Ace Gallery, I had seen *Haze* at the Museum of Contemporary Art in San Diego (MCA-SD). Was that your first wrap-around, room-sized installation?
**Tara Donovan:** Yes. I had done a straw installation at Ace Gallery in New York that was about 40 feet wide by 13 feet high. Then, when the MCA-SD asked me to do a piece, I saw the space, really liked the white floors, and thought the straw work seemed ideal. When I began that piece, I kept thinking about what would happen with the corners if the work went around the room. What happened is the corners became very soft, creating a shadowy effect.

**CC:** Some areas of the MCA-SD version seemed to have a yellowish hue. Did you add color?
**TD:** No, it's just the color that it is. All translucent materials have a fugitive color that exists and varies in different ways. The way that straws are extruded, sometimes a bit thinner or thicker, affects the color with more or less light getting through. If you hold two straws side by side they look identical. But when you stack them up, less light gets through so their color shifts.

**CC:** How many straws were involved in the San Diego museum installation, and did you get them locally or import them from New York?

**TD:** When I initially did the piece in New York, I worked with a company called Cell O Core that makes straws. The straws usually come in smaller boxes, but they're used to me ordering a gazillion straws, so now they package them for me in bags. It makes the installation easier. The San Diego installation took five or six days, with eight to 10 assistants helping me. There were about three million straws.

**CC:** In California the piece looks a bit like coastal bluffs, though I suppose in New York it might call to mind snow stacked up after a winter storm. It's interesting that while the finished works read as something naturalistic or organic, they emerge from industrial component parts.

**TD:** A lot relates to the fact that I'm using a material and assigning it prede-

Installation view with *40" Glass Cube, Pin Cube,* and *Toothpick Cube,* 2005.

termined rules. I'm relying on the strawness of the straws, the fact that each one is a long hollow thing. Basically, I'm not employing any tricks. I'm letting it do what it naturally can do. Within these rules, the construction allows the work to grow, similar to the way in which living structures develop. Rules for growth are encoded within each individual element, and the work winds up appearing organic because the process mimics basic systems of growth.

**CC:** How do you define the boundaries of the piece?

**TD:** I create the boundaries or I use the room—the architecture of the space—as the boundary. For the cube pieces, I make a mold that serves as an architectural element for the work. With the more organic pieces, the idea is that at some point my hands would disappear and these things would generate new forms and expand infinitely.

**CC:** What were the circumstances that first made you choose ordinary, industrially replicated materials to make art, and what do you regard as your "break-through" work?

**TD:** *Toothpicks* (2001) is an old piece that I did before any of the other pieces at Ace in Los Angeles. For that work, I built a plywood box, filled it up, and then took the box structure apart. A lot of art-making comes from just paying attention to accidental discoveries: in this case, recognizing that small units could adhere to each other and maintain a structural form without any kind of adhesive. It's no harder than making a sand castle.

**CC:** What led to the subsequent variations on the cube?

**TD:** With all of my work, from far away, the exact material is disguised by its sheer quantity and the way it's constructed. Then up close, there's the discovery that the sculptural object breaks down into discrete little units. As far as the cube goes, it's a simple form. I could make a triangle, but then it would allude to other things. The initial point of using the cube was to keep it as geometrically simple as possible.

**CC:** How did you get started with the glass cube?

**TD:** About two years ago, I began rethinking the toothpick piece. I had done the steel pin cube, and it had surprisingly different results. It reads as far more solid, which was interesting enough for me to keep it in the back of my mind. At one point, I had a studio across from a glass factory that removed store windows and replaced them with tempered glass. Of course, you can't reuse tempered glass and you can't cut tempered glass. The glass has to be cut and then tempered. It has to be made of two sides and then baked. Basically, they bake tempered glass so that it will all shatter when it gets broken. I was using the old store windows and layering them and breaking them in my studio. At the time, roughly eight years ago, I was thinking about mapping and structures and what happens when things break, but it never became a sculpture. Then, I began to think that if I did the cube with tempered glass and stacked it up, it might work. Honestly, until we actually did it, I had no idea if it would wind up being a big hill of broken glass or if it would maintain a form. The first time I ever tried it was in the gallery, figuring that if worse came to worse, we could just sweep it up, throw it away, and put something else there. There was no point in doing it in my studio because it's $6,000 worth of glass, and then I would have a bunch of broken glass in my studio. I thought, if I'm going to try it, I might as well try it in the gallery. So, I stacked up the glass, and we put a mold around it and exposed two corners. I alternated which side I broke the sheets of glass on each time, so the shift would balance. If you've ever broken tempered glass, you know that if you hit it on the side, it breaks away from you; it doesn't break toward you.

**CC:** How did the billowing Styrofoam cup installation, which looks like clouds, come about?

**TD:** It starts with the cup, and we glue them together. I have assistants glue very small sections, and once we make all the small sections, we glue them into larger sections that are hung from the ceiling. Then, it's just a matter of doing fill-in work on the ceiling. The L.A. show was the second time that I made the piece. The first time I built it over a skylight, so that it was lit from within by natural lighting. But there wasn't a skylight in the L.A. gallery, so it's

lit with lights behind the piece. I basically made a Dan Flavin on the ceiling. Getting the lighting right was a little tricky. It was the first time I'd used lights as an integral part of a piece.

CC: There's such tension in your work between improvisation and intention. How do you balance those opposites?
TD: It's very improvisational. I work with assistants and set the process in motion, give them rules to work within, and then let them make a lot of decisions. Once it starts rolling, it's like putting together a puzzle that has no rules. There's no way to map out something like that. There's no drawing. The material dictates the final form.

CC: It's interesting that the material elements of your work emerge from replicated, industrial parts, yet your one-of-a-kind installations flirt with allusions to nature and even concepts of originality. Aren't these ironic tensions in the work?
TD: My process is a mechanized process, but without the luxury of a machine. There is the idea that—in a primitive sense—my work is "manufactured." Yet it illustrates a kind of reversal of the intended fate of the material. Instead of this mass-produced item being individually distributed, it's amassed and remanufactured into one singular object. In *Nebulous* (2002), the Scotch-tape piece, the only thing I'm using about the tape is its transparency and the fact that one side is sticky and you can make it stick to itself. Then, I basically make units, but once they're amassed and accumulated, it reads like fog. I'm not intentionally trying to mimic or make things that look like nature. I'm mimicking the processes of nature, so that the final form winds up reading as such a thing.

CC: What about the colors that emerge? Are those just coincidences of the materials? The works at Ace come off at first as colorless, but they are made up of a number of sophisticated hues, from iced green, tan, and black to pale lilac, white, and diffuse gray.
TD: Things made of a specific color have a lot of baggage attached to them. That's not to say I won't use color, but I'm inherently attracted to transparent, neutral materials. If you pick up a piece of Scotch-tape it reads as clear. But if you put that piece of tape in sunlight, it has a purplish hue, as does fishing line. So light affects the pieces. A phenomenological thing occurs with transparent and translucent materials. The way that light travels through them can be very different. If those were all white plastic straws, it wouldn't read the same. The softness wouldn't occur. I am attracted to the fugitive color that exists in transparent materials. It's not a real color, it comes and goes.

CC: The tape piece is much smaller than many of the others. It calls to mind the issue of traditional maquettes and larger finished sculptures. Do you begin your works with maquettes? The large straw or cup-cloud installations, for example, did they begin as smaller pieces, or do you always conceive of them as large from the beginning?
TD: I will often make a unit, or section, of what a piece will become. With the Styrofoam cup piece, I made a section, hung it from my ceiling, and imagined it big. I didn't make the finished work in my studio. For the first straw piece,

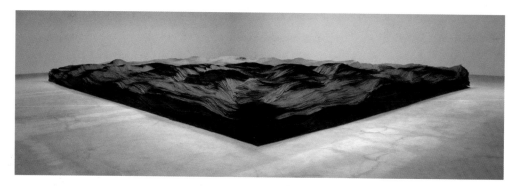

*Transplanted*, 2001.
Ripped and stacked tar paper, 32 x 404.25 x 294.5 in.

*Transplanted* (detail), 2001.

I made a little section on my studio wall, maybe five by five feet. Then, I sat on the floor and imagined it big. I rarely make those huge pieces in the studio. The only recent pieces I've made in my studio are *Untitled (Paper Plates)* (2003) and *Bluffs* (2005), which is made of buttons.

**CC:** So, your works are conceived and rehearsed to a certain extent in private, but realized in public?
**TD:** They're not really realized in public. The gallery is a private space until it opens to the public. I basically make the gallery my studio for a time.

**CC:** I understand that the weight of *Transplanted* threatened the floor at the Ace L.A. gallery.
**TD:** We had an engineer come in because the piece weighs something like 10 to 12 tons. It's like parking 10 SUVs

in the room. It's roughly 400 rolls of tar-soaked roofing paper, which is what they put on a roof before they install the shingles. It comes in big rolls from Home Depot, and then we rip it off the roll into smaller pieces and lay it like shingles. I've made that piece four times: at the Kohler Arts Center (Sheboygan, Wisconsin), Ace Gallery (New York), the IBM Building (at 57th and Madison in New York), and Ace Gallery (L.A.). It's been different every time. The scale is determined by the parameters of the room; in L.A., I changed the height, making it really tall. When I reinstall these pieces, because they are done intuitively and because I make them on site, they are never exactly the same. I'm exploring other possibilities of the same idea. On a small scale, the way you stack the paper tends to look choppy and angular like the earth itself. When it's larger—as in L.A.—it looks more like water. But I'm not setting out to illustrate some kind of land mass. It starts with the process of ripping, stacking, and using the ripped edge. We start on the outside and work up and inward, so it ends in a little piece of paper somewhere in the middle.

CC: This work explores forms that we haven't named, characterized by ebb, flow, and slump—things that are very interesting for sculpture.

TD: It all goes back to the making. The material does what it can do. If you stack the paper slightly forward it creates a kind of cliff. If you keep the ripped edges perfectly aligned it works upward, and you get a hill. It's impossible to have a plan.

CC: What do you find to be the most interesting thing about sculpture today?

TD: I'm interested in my own process, in the set of rules I've created. As far as sculpture today, there's definitely good work out there. For a while it didn't seem like people were making things, but I think people are getting back to making things.

# Social Structures and Shared Autobiographies:
## Do-Ho Suh

**by Tom Csaszar**
**2005**

Since 1997, after getting graduate degrees from Seoul National University (in Oriental Painting) and from the Rhode Island School of Design and Yale, Do-Ho Suh has created a body of work that focuses on issues of representing how we construct, and are constructed by, our private and public notions of space. Three recent works installed by the Fabric Workshop and Museum in Philadelphia extended this set of references, especially in terms of drama and emotion.

*Screen* consists of tiny individualized figures formed into an architectural element. For Suh, this site of interaction and interchange between people and space, ideas and expectations, places viewers in a dramatic environment affected by their own presence and ideas of relationship. The "Paratrooper" series, to which the other two pieces belong, is based on ideas that he had in the late '90s. In *Paratrooper V*, a lone stainless steel figure standing on a pyramidal base grapples with countless threads, gathering them into a single rope that connects him to a parachute on the wall. The parachute is embroidered with thousands of signatures, and each of the threads held by the paratrooper connects to a name. When the weight of these 5,000 threads started to pull the figure (and its concrete base) toward the parachute, Suh had to engineer his metaphor and bolt both figure and base to the floor. While some of Suh's earlier works involved what was left out, here the drama is portrayed directly, through a physical and visible play of force. In *Paratrooper II*, Suh weaves a mesh of white and red threads into a paratrooper suit, which is suspended from a parachute formed of progressively smaller suits, presumably of smaller paratroopers. Here, the paratrooper becomes the parachute and the parachute becomes the paratrooper through an intricately social and interconnected process—a web of implied parachutes and people that pass through each other in their transparent connections. In these new works, Suh continues to use forms and metaphors related to architecture and clothing as a means to render psychological, physical, and emotional spaces.

**Tom Csaszar:** One aspect of your pieces, whether they use dog tags as armor or nylon fabric for walls, is that the materials work so well with the images. Do you think in terms of materials and space, or in terms of image first?

**Do-Ho Suh:** The image is always first. I think that there is a danger: every artist has a love of materials, both painters and sculptors. I try not to get involved with the material too much. The idea of transparency in my work is very important, so I've been using materials that render transparency. It seems that I like transparent fabric, but it is not because I am in love with the particular material. I need that quality.

**TC:** It needs to be transparent to convey the idea you want.

**DHS:** More like transparency itself. There is no way you can make something that is transparent without physical

substance, so I am borrowing material that renders the idea of transparency. Beautiful things happen if you use a fabric: it drapes, and it moves. It has a reference to clothing, which is another one of the ideas that I have been interested in for a long time. But let's say I have a desire to create my piece without any material—like architects are tempted to create a building without walls, which they cannot do; glass is the closest thing, so it becomes the most popular material for architects. There are always physical limits. I think that the idea of transparency came from my background, education, and experience—I lived in a traditional Korean-style house with traditional paintings—but it materialized after I started painting.

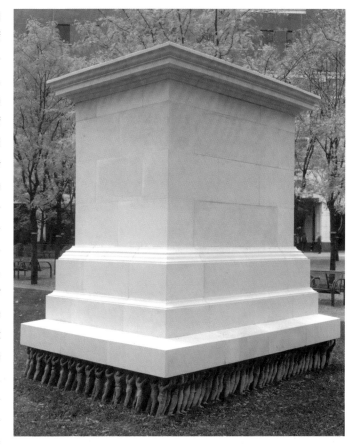

*Public Figures*, 2001.
Stone and bronze, 284 x 209.4 x 275 cm.

**TC:** In Korea?

**DHS:** No, here in the States, when I was able to compare the two different traditions, cultures, and ways of thinking. I started to see the differences, especially in terms of architecture. It's a very different approach. For example, in Providence, the first house I lived in was a typical 18th- or 19th-century New England building. What I found interesting in Western architecture was the distinct separation between nature and the artificial space: there's a wall. You create a space totally separate from the outside. In Korean architecture, there are many layers for intermediate spaces, gray areas that don't really belong to nature and the outdoors or to the interior of the building. In order to go to one place, you have to go through many layers of spaces. For example, in the Korean house where I used to live, there are not many walls. It's all windows and doors—and the way you configure those walls. You can reconfigure the space in different ways. And the material of the windows and doors is all semi-transparent rice paper, so there's a sense that architecture is very porous. There's a sense of permeability, versus, well, I don't know what to call it.

**TC:** Solidness or opaqueness?

**DHS:** Yes, opaqueness, exactly. It was made clearer when I came here and lived in American buildings. The way that you relate yourselves to the rest of the world is distinctively different. It was a negotiation with these new surroundings, becoming more aware of them and of myself.

There's a term in Korean that you "borrow landscape." That's how you create the environment around the house. That's why there is ambiguous space and the boundaries are blurry. I think it's almost a cliché, this comparison with Western individualism. A lot of people read in my work the individual versus the collective and Western versus Eastern. All those kinds of things are there, but I think that there is more a spatial experience—I experienced everything by going through different spaces.

**TC:** You've said that you want to deal with space as psychological and metaphorical as well as physical.
**DHS:** Exactly.

**TC:** Do you think of them as separate in your work or brought together?
**DHS:** Well, I think that it's all there.

**TC:** Blended.
**DHS:** Yes, it comes out differently from one project to the other. For example, sometimes you have to group certain works simply for conceptual reasons, but it may be due to physical restrictions of the space.

**TC:** Your works raise certain questions and issues. People look at *Public Figures* (1997) or the work in the current show and say, "It's presenting this point of view on this issue." I see your work, though, as bringing up issues, not resolving them.
**DHS:** They're very profound issues, issues of the human condition in general. It could be read one way or the other. But these profound issues or concerns are difficult to answer. Basically, there's no answer.

**TC:** So, to play devil's advocate, what's the value of bringing them up in artworks if there is no answer?
**DHS:** I think it's important to me to get to that point. After the long process of thinking and making, you learn certain things, and you try to define certain things, and at the end you realize that you are incapable of defining them. And then things get more blurry. You try this over and over again in different projects, and you hit the wall every time. But, for me, that process is more important than trying to reach the answer. I like not doing it anymore, not trying to understand or have some sort of answer. I don't think that's the way things work in the universe. It's the real experience, the physical experience in the space with the piece. I think that's different than reading a book. It might be an easier or better way to address issues or bring up the questions.

**TC:** In *Paratrooper V*, one figure pulls thousands of threads connected to thousands of signatures on a parachute. Are these people that you know?

**DHS:** Yes, they are somehow connected to me, through my work or through my life.

**TC:** Is the paratrooper a stand-in for you or a character in a narrative?

**DHS:** I would say that it's more like a self-portrait, but it could be anyone's self-portrait. The way the signatures were collected is that I started with my closest family and then relatives and friends. They make up about 10 percent of the parachute. And then it expands in different directions. Obviously I don't know 5,000 people. Some people left their names when they came to my shows, where I kept books that I was going to use for this project, and I asked my friends and relatives to collect signatures from their friends. In the end, I don't necessarily know them, but we're all connected one way or the other.

**TC:** The physical effort is portrayed in the threads, which is part of the drama to which the viewer responds, in relation to the social and the personal.

**DHS:** Yes that's all there, and it's really up to the viewer. It's more intangible or invisible, this relationship between people and how an individual becomes a person, a being. When you gather all those relationships to one point, that's the point where and when you become you. And other people have that web of invisible relationships as well. It's something that has passed through generations.

**TC:** The room is suffused with red light reflected from the threads, an intangible result of what you are looking at.

**DHS:** None of the threads touch each other, and when they meet it is at the point where the figure is holding them. I wanted to focus on that moment and the place where it all comes together. It's also related to an Eastern way of thinking and some thoughts from Buddhism. There was a moment when I felt that you don't really exist alone, there are so many factors, relationships, and supports that allow you to come to this point. I had to acknowledge that— whether they were good relationships or bad relationships. It's not something visible, but by making this piece, stitching each person's signature, and trying to bring each thread one by one to one point, it became a gesture to appreciate all the supports, concerns, and considerations of other people.

**TC:** A physical, spatial gesture?

**DHS:** Yes. These are a little different from my previous works, which were more cut and dry. Although at the core, they share the same ideas.

**TC:** Ideas of social values? Spatial or cultural ideas?

**DHS:** Let me try to explain. The starting point was a personal need to figure out identity. But you don't exist outside

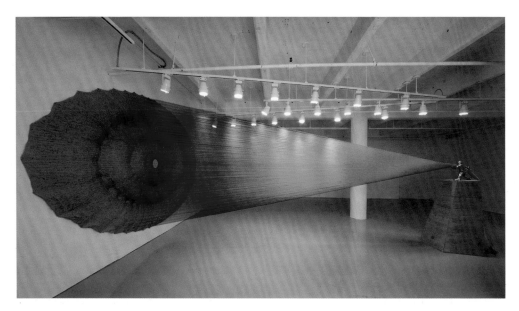

*Paratrooper V*, 2005.
Stainless steel, cast concrete, thread, linen, and polyester, 110 x 281.5 x 197 in.

*Paratrooper V* (detail), 2005.

of a context. So it was natural that this range of concerns and cultural issues came into the work. It's not separable, it's all mixed: you cannot separate the individual from the large picture. The beginning was an attempt to define what is individual and what is collective. Then it becomes more and more ambiguous as you make the work. It's not really about one issue. Sometimes I think that the "Paratrooper" pieces are more spiritual than the others. Until a writer reviewed the first version of the "Paratrooper" pieces, I didn't know that Japanese soldiers carried embroidered handkerchiefs during World War II. Each soldier had a white handkerchief prepared by his mom with red thread to make a collection of signatures from all the people he knew, his relatives and family. The hope was that carrying the handkerchief would protect him. I think that my piece has that desire, like that of people who send their sons and daughters to war. Somehow that is related to my desire to make the parachute pieces. But at the same time, as in my other works, you are

trying to gather these relationships, trying to quantify and materialize this thing, and struggling to hold on to it. At the same time, these are the relationships that pull you, and you struggle. Again, it's very ambiguous as to whether the figure is trying to gather this thing or escape it. I think that's what life is and what relationships are. I'm using the word "relationship" here, but I could not find the right word in English. I looked it up in the dictionary and in Korean it's *inyeon*.

Usually I make a piece and then show it either in the States or outside of Korea. "Paratrooper" was the first piece that I made in Korea and showed there for the first time. The opening was an overwhelming experience for me. People cried, really cried. When I showed the same piece in New York, I think that it was seen differently. People tried to project their ideas. It was in April, right after the Iraq war had started. A lot of people thought that it was an image of an American GI, probably commenting on the war in Iraq. But in Korea, no, it was not seen as being about the military at all. My understanding was that this was because of the history of Korea and the current situation, including that everyone has to go into the military. It's part of Korean culture. I think that there is less distance there probably. People can identify themselves in a wider way. I find that my work has always been read differently from one place to the other, which is fascinating. It brings more interesting meanings. I think that the idea of *inyeon* plays a great role. It's an ingrained idea in Eastern cultures, probably from Buddhism. *In* is a cause, as in "cause and effect," and *yeon* is like a relationship or "link," but it doesn't have to be a physical link. For example, you and I met for the first time today, but in order to meet and talk for an hour, we must have some sort of connection—it's not by accident. Either we knew each other in a past life or something was passed on to us from an older generation. It's not just one generation, this past life, it can go back beyond that. Nothing is really accidental, it's all related.

I think that people in Korea were able to project their lives onto this piece immediately and that it triggered a very emotional response. It was the response of many people. I met a Japanese curator who wants to show the work in Japan, she got it right away. In Japanese, *inyeon* is *eng*, which is from the same Chinese character. It's like the idea of karma, it's a karmic energy. When you see a person, you don't see just the person standing in front of you—you see their background, their family or ancestors, the invisible webs of relationship or information. In the U.S., it's more person to person, more on the physical level. Like when I was talking about architecture, I think that the way I see people is more blurry.

**TC:** And artists can give some sense of material quality to that web through their works?
**DHS:** That's why I've been using unconventional materials. In *Paratrooper V*, it's a weird combination, stainless steel and concrete, then the thread and fabric, it's fuzzy and you lose the sense of depth. Hopefully this takes you beyond the materiality of the piece.

**TC:** You often invert or suspend expectations. A parachute lets you float to the ground. Here, you are being pulled by your

parachute or struggling against it. In *Paratrooper II*, the figure is hanging from a parachute of smaller paratrooper suits.

**DHS:** When I came up with the idea I saw it as one whole thing, a whole process, from the dropping to the landing, not just a parachute in the air. Both a vertical and a horizontal image came into my mind almost simultaneously; it was more like one piece together. I can't really separate them. Without the parachute the soldier would crash to the ground and die, so it is crucial to survival. Then once you land the thing, you have to gather it, and it gives you a hard time, you can get tangled. So, the parachute works both ways.

**TC:** Would you see these works as connected more to the history of sculpture or to a sense of innovation?

**DHS:** I've never really thought about it.

**TC:** That's not an important consideration for you?

**DHS:** No. It's not my job, I don't think. There are things that you have to do no matter what other people say. If I knew anything different I would probably make better work, but I don't. I've been showing since '97, and my first solo show in New York was in 2000. It hasn't been that long a time. But I find that I go back to things that I studied before. I've kept a sketchbook since I was at RISD, and I was flipping through it the other day and found a series of doodles. I don't believe that I was thinking then what I'm thinking now, but those doodlings were related to this work. It's interesting how your mind works and how you get fixated on an idea. It comes over and over again. I don't know whether it's a gesture of trying to escape from that idea, but I find myself trying to see these issues from different angles. That could be a limitation, but I cannot help it. These are the things that interest me the most. I try to understand why, at the very beginning, did I want to address these issues in terms of personal space. Why did I start from architecture? I can explain it, but there are other things that I can't explain. Why something with something else? I think that it's because somehow there was a very traumatic experience at a subconscious level or I'm just very good at dealing with space—or comfortable with it. I don't know which one it is.

**TC:** You mean repeating structures or figures to make us feel the space?

**DHS:** No, maybe I was just jumping around. Somehow my work was generated by contemplating architecture. I started to think about the notion of personal space and tried to define the space between this person and other people. Usually when I place my work, it's very site specific. I don't make a sculpture in the Modernist sense. It's always very contextual. For example, the screen piece is a sculptural object, I guess. These three pieces are probably the most like sculptural works, but I make an effort to plan carefully and to think about viewers' movements, how they might interact with the piece, and how they might experience the space differently with my work. Depending on how I place the piece, it could be a totally different experience—I'm very interested in those ideas. Even if I'm not making site-specific work, I still put a lot of effort into placement.

*Screen* casts a shadow on the wall. I was playing with the lights and trying to bring it out, not too much, very subtly,

but hopefully people can see the shadow too. And they will realize when they see the other audience on the other side of the screen that their experience of or relationship with this piece changes constantly because of the other viewers, depending on the lighting. When you walk around, you start to see the shadow and the color and the three-dimensionality, and the figures come out more; but then as you turn around the corner, the figures start to lose color, and it becomes a silhouette, almost like a shadow on a wall.

**TC:** Do you want viewers to be most interested in the perceptual qualities of the piece, in the ideas they take away from it, or the emotions or spiritual ambience?

**DHS:** I want viewers to become part of the piece and more aware of their surroundings. For example, people can go into my other architectural pieces. I think the screen is less aggressive than the others. Meaning changes and experience changes as you see other people on the other side. I want the audience to experience my pieces more spatially. That would be a perceptual issue, but more through movement, more a physical experience. Then, hopefully, they get something out of the ideas behind the work, whatever they are. But it's also playful. It's easy to engage with my work on a very basic level. I'm very concerned about that part too. There are different levels of audience, some more educated in terms of looking at art and others who don't know anything about art history.

I try to make something that touches every level of the audience. If people find that a work is fun or the color beautiful, that's OK. But there are other things they can find in my work, and hopefully these thing cause them to pause for a minute and think about very fundamental issues.

# Transforming Energy: Jaume Plensa

**by Michael Stoeber**
**2006**

A young man once approached Jean Cocteau and asked the master what he should do to become a successful artist. Cocteau responded with three words: "Faites-moi étonner!" ("Amaze me!") Looking at Jaume Plensa's works, one gets the impression that he had been that young artist and had taken Cocteau's recommendation to heart. The amazement of his sculptures begins with the different and often disparate materials that he uses so gracefully and harmoniously. Not only steel and iron, bronze and brass, plastic and polyester, but also water and fire, light and darkness, sound and music, words and texts. Plensa was born in 1955 in Barcelona, where he still lives and works, except when he is in Paris, his second home. He has had numerous exhibitions all over the world, and his works can be found in museums and art institutes as well as in prominent public places. As a sculptor, he is less interested in defining space through weight and measure than he is in obtaining energy. For Plensa, sculpture means the spiritualization of matter, an interaction between mind and material. To achieve this, the concept of time becomes more important than that of space. Plensa's time is filled with personal and collective remembrances, becoming a mirror for the everyman in ourselves and hence for the human condition.

**Michael Stoeber:** How did you come to art?

**Jaume Plensa:** That's difficult to answer. My father played the piano and my mother was a singer for a while. So music and books were important at home, but not pictures. I wasn't good at music, but when I had problems or wished to be alone, sitting at the piano was a perfect way for me to hide. The darkness that surrounded me there and the smell of the piano taught me to experience space and music in quite a physical manner. My childhood memories revolve around music and books.

**MS:** Did you turn to art because the visual played such a small role at home?

**JP:** No, it was something else. You know, for years I wanted to become a doctor. I loved the body. In fact, I was obsessed by it. I had numerous medical books, which stimulated my imagination. But it was more a fantastic than a scientific interest. In the 18th century, people did wonderful etchings of the body, about the fluids inside and how the muscles worked. Later, I dreamed about becoming a writer. I even imagined myself as a musician. I wanted to be everything and everybody. Because I don't have the courage to be just one—that would be too difficult for me— art has probably allowed me to pursue all these aspirations.

**MS:** To what extent were the books and the etchings important?

**JP:** Books were important, but not in the way they may be for a conceptual artist. I loved the physical aspect of text. I remember leafing through books and being puzzled that while I was looking at one page, the previous page had already disappeared although it had just become part of me. I dreamed about transforming letters into something physical.

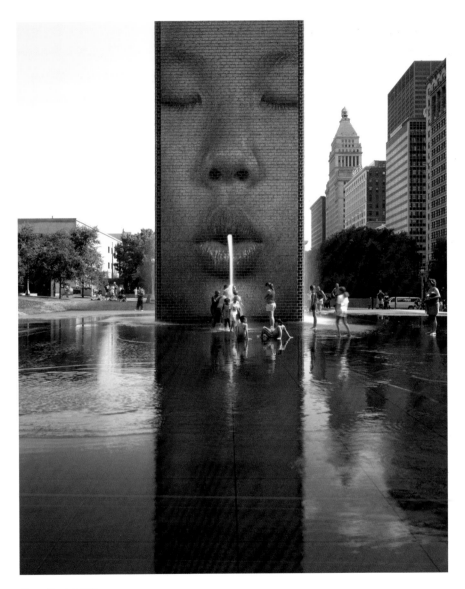

*Crown Fountain*, 2004.
Glass, stainless steel, LED screens, light, and water, 3,300 sq. ft.
Work installed at Millennium Park, Chicago.

**MS:** As you have repeatedly done in your later artistic work?

**JP:** Yes. In my works, words and letters are lent weight and volume. In this way, they endure and don't vanish. You know that I work with the opera. Everything from my childhood reappears in my art—the music, the books, the body. All of these elements are the essence of my work today.

**MS:** The body has experienced a radical and fundamental change in your work in comparison to classical mimetic concepts. Why is this?

**JP:** It has something to do with interaction. If you think about material, for example, you don't necessarily have to think about weight, you can think instead about energy. It is similar with the body. Everyone has a certain aura, and you can try to fill up space with this energy instead of filling it up with the body. In my work, I like to transform this energy into an object. Bodies appear and vanish and are subject to a process of permanent change. They acquire biographies and memories. I'm interested in this process—not as narrative, but as energy. I'm less interested in the individual than in the collective. Because I'm trying to proceed to the origin—not of shape, but of attitude—I regard myself as a classical sculptor.

**MS:** In another interview, you characterized the body as a vessel of information.

**JP:** That's right. I recently visited the National Gallery in London to view a fantastic exhibition of works by Raphael, obviously a master draftsman and painter. However, it's not his technical ability that overwhelms me but his genius to allow bodies to speak. Although my working mode is completely different, I feel close to him and to any artist capable of filling the body with information.

**MS:** You initially worked with iron and steel, later changing to paraffin wax, polyester, nylon, sound, and light, while words and text had influenced your life almost from the very beginning. In 1988 you created *Sleep No More*, which consists of three concave iron bricks on a metal plate with text.

**JP:** Yes, in the beginning, I used forged steel and cast iron, adopting an industrial technique for my sculptures. I was dreaming about the moment when the mountains were formed, the moment when everything was liquid and hot and suddenly started to cool, solidify, and take shape. For me, there's a mythical element in the way fire transforms things into liquid. Something solid becomes liquid and then becomes an object again. *Sleep No More* is a very important work because it represents the first time I used text, an excerpt from Shakespeare's *Macbeth*. I've always thought that *Macbeth* provides the best definition of what a sculptor can be. For me, a sculptor uses physical material to express abstract ideas. The moment that Macbeth kills the king he destroys his own ability to sleep. The act is an expression of a precious paradox: Macbeth touches a body, which he kills, and at the same time he kills something untouchable. So I used this sentence in *Sleep No More*, casting it in iron to fix this fragile idea. It was a very important moment in my artistic career.

**MS:** And the concave bricks?

**JP:** They show something you can still find today in my work: the idea of creating something large out of small elements, much the same way that cells join together to form a complex body.

**MS:** As parts of an absent whole, the bricks seem to represent a metonymic concept.

**JP:** The work deals more with something general than something specific. It's about the problem of allying vertical and horizontal elements, which are abstract representations of man and world. In a very archaic way, the work has a sacred dimension, too. The flat plate with the text could represent the territory of a priest, the hollow spaces sacrificial sites. But perhaps you have other ideas. It's similar to reading Shakespeare—each reader understands the same text differently.

**MS:** Three years later, in 1991, you added light to the cast iron in works such as *Désir* and *La Neige Rouge*. Why?

**JP:** While working in the foundry with cast iron, I was fascinated by the light of the glowing red substance. When iron is molten it is pure light. It completely loses its weight. *La Neige Rouge* works with light the exact color of the molten iron when it comes out of the oven. For the first time, I also added sound to a work—the sound of electricity amplified by the conical shapes of the work itself. People were struck by the aggressiveness of the light and sound in this piece.

**MS:** In all of these works, you use cones, cubes, cylinders, squares, and spheres, considered ideal aesthetic forms from Plato to the Minimalists. Are you participating in this tradition?

**JP:** In terms of geometry, these forms are the basis of everything. But my primary interest isn't in their aesthetic quality. I'm not a minimal artist. I want to provoke emotions in my works, and these forms help me to do so. Like the body, they are vessels of thought and feeling for me. In *Désir* and *Rêve*, you have a solid sphere of cast iron and in the center a small hole in which you can see red light. The relationship between the massive and the fragile is important: the massive element is protecting the fragile one. For me, the work depicts a narration of body and soul.

**MS:** Does this mean that your constructional forms have a narrative quality beyond the narration of formal ideality?

**JP:** Definitely so. I recently completed a piece, called *Breathing*, for the BBC in London, which again is conical but upside down; it's transparent, made of glass, with light emitting from inside. The BBC commissioned it for a new building in Regent Street, where it is visible from all sides. It is accompanied by a text on silence. I reverse things. The people at the BBC live by talking all the time, and I'm confronting them with a mode of existence praising silence. They understood this very well and were very excited about the idea. At night, a powerful beam of white light radiates out of the work into the sky.

**MS:** Like in your works for Gateshead, Stockholm, and Jerusalem?

*Seven Deities of Good Fortune*, 1999–2000.
Glass, stainless steel, wood, and light, 7 elements, 250 x 120–770 x 80–150 cm. Work installed in Daikanyama, Shibuya, Tokyo, Japan.

**JP:** Yes, the BBC piece will also count among my vertical bridges connecting heaven and hell. Obviously, this is reminiscent of Blake.

**MS:** Why do you appreciate Blake so much?

**JP:** Blake became very important for me after I became familiar with his *Proverbs of Hell*. They are a brilliant combination of high culture and low, of tradition and progress, matter and spirit, body and soul. And I feel close to Blake because he, too, was born mid-century: Blake in the middle of the 18th century, while I was born in the middle of the 20th. Thus we both function as bridges between different times, forces, and energies. Besides, I'm obsessed with the idea that art itself is something in-between. It has to take up and assimilate a wide range of influences, experiences, and strengths and make a whole out of them.

**MS:** To what extent does language have a sculptural aspect?

**JP:** I think that in order to conceive words and letters as sculptures I had to be influenced by another poet, Rabelais. In one of his books, he tells a wonderful story: Gargantua is at sea with his men, and suddenly they hear strange sounds and voices in the air. It's very cold, and the words and sentences freeze and fall down as objects onto the ship. Later, it becomes warm

again and they all melt away. The remaining drops look like diamonds, and the men ask Gargantua if he might sell them what remains of the voices. He responds by telling them that lawyers sell voices, but that he could only sell them silence, which is much more expensive. The physical aspect of language fascinates me. In my last gallery show in London, I had words like "day" and "night," "sweet" and "sour" engraved into two metal plates, which I connected to a scale. As the letters were incised into the metal, the weight of the plates changed and the scale's dishes went up or down accordingly. In this work, the weight is the absence of the word.

**MS:** You have previously worked with words and sentences cut into gongs and cymbals.

**JP:** Yes, the specific aspect of all these works is the material removed during the engraving process. It's like creating sculptures out of the negative, opening up quite a new space as an artist.

**MS:** You also present public artworks all over the world, including Barcelona, Breton Hall, Auch, Tenerife, Tokyo, Toronto, Potsdam, and Chicago. What distinguishes these works?

**JP:** Public space has its own laws and shouldn't be confused with a gallery or a museum. Public space is owned by a city's inhabitants, and the artist should keep this in mind. I have always refused to use public space as a site to install objects that interrupt people's customary movement. I try to produce something that invites them to come. In Chicago, where I was asked to take part in a competition, I wanted my work to represent an archive of the city's inhabitants. For this project, *Crown Fountain*, I filmed the faces of thousands of Chicagoans, which I projected together with images of nature onto two large-format LED screens on two opposing towers. In a way, the faces are like a mosaic representing the different cultures and ancestries of the city's people. The towers are located on a large plaza of black granite, cascades of water streaming down from them. Between the towers there's a pool that people can walk over—one of my dreams had been to invite people to walk on water. The towers radiate alternating, colored light. They are like transparent houses.

**MS:** *Crown Fountain* combines many of the elements and motifs that recur in your work, including water, light, the body, duality and dialogue, nature and dreams.

**JP:** Yes. With *Crown Fountain*, I attempted to create a place of beauty where people could meet, talk, and meditate. I wanted it to be a modern version of the traditional fountain. When water streams out of the mouths, one is reminded of the gargoyle, which is an old deity of life and a popular motif in the history of fountains. The flowing of water, images, and light represents permanent change and transformation. I think that this is the first time people did not stand in front of a fountain watching the water, but instead stood in the middle of it, becoming a part of it. They experience the water like they experience the images. They are so close to them that they distinctly see the red, blue, and green dots that constitute the images of the 50-foot-high faces.

**MS:** In a way you've created a monument to the average citizen.

**JP:** I suppose you're right. It's very interesting to view the work when the plaza is full of people. When the face of an old man or a young boy appears on the screen, it's as if they could be someone's father or son. The faces are icons representing all of the citizens of Chicago. But, for me, the beauty of the work consists of the fact that in the midst of this vast emptiness, the two towers produce enormous tension. I think that people go there in order to feel this magnetism. It's a great pleasure for me to know that Chicagoans have really integrated *Crown Fountain* into their lives.

**MS:** In 1993 you produced *Wonderland I*, which was followed by a second version in 1997 that included doors with words above them. The doors can indicate either an entrance or an exit and thus seem to represent a dualistic quality.

**JP:** *Wonderland I* was done in cast iron and *Wonderland II* in cast paraffin wax. Only the latter has words above the doors: words designating food. When I did *Wonderland I*, I was in Great Britain working on a project and an exhibition for the Henry Moore Sculpture Trust. I was reading *Alice in Wonderland* at the time and thinking about someone who could shrink her body to pass through small doors. Reading Carroll's book is like reading a book on sculpture. I recall a conversation I once had with Anthony Caro, who told me: "Jaume, there are three major issues in sculpture—scale, scale, and scale!" "Yes," I replied, "but I disagree completely. For me, the most important issue is time."

**MS:** Time?

**JP:** Yes. Time appears in the doors of *Wonderland* in the way your image is reflected, as in a mirror. When you stand in front of a door, the most important thing is that you are thinking about the other side, and what you are thinking depends on how old you are and what you have experienced in your life. *Wonderland I* is a very personal piece. When I was looking for information on doors, I came across a dictionary definition that said: "Door: the most important part of a house." I don't think that this is based on architecture, but because there's a decision connected to it: you have to decide whether and when to cross the threshold. That was the idea behind my work. When I produced *Wonderland I*, I was 38 years old. And because I decided to dedicate it to myself, I gave it 38 doors.

**MS:** Why did you use a different material for *Wonderland II*?

**JP:** Cast iron is so heavy, and the touch of it is so cold; it's like a gravestone, as if something is being sealed indefinitely. The paraffin wax for *Wonderland II* is the same substance people use to seal preserved food. The material is completely different, but the concept is exactly the same—the idea of sealing a place, which is the main purpose of a door—protection. The work was produced for Dallas and traveled to Caracas, Hannover, and Madrid. When it was shown in the Reina Sofia, a lot of people, mainly men, tried to open the doors, breaking a lot of handles. I was amused by their attempts, which seem so Mediterranean to me.

**MS:** Where did the idea originate to combine the doors of *Wonderland II* with the names of food?

**JP:** Several ideas flow together in this work. I spent two years in Dallas and Caracas taking photos of private kitchens.

In my opinion, kitchens and hospitals belong to the most uniform places in the world. Food in itself is a kind of door. It's hard to talk about ideas if you are hungry. Even the most sophisticated philosophers understood that before you can think, you have to eat. Feuerbach once said that we are what we eat. Today, many people have the opportunity to eat food from all over the world; national borders no longer pose a restriction. Exchanging food is like exchanging ideas. I think that this is a marvelous experience.

**MS:** Metonymically, the doors suggest houses, which in the form of cells, containers, and cabins play a large part in your work. There are houses made of polyester such as *Bedroom* (1995) and houses with texts such as *Winter Kept Us Warm* (1998), *Scholars of War* (1999), and *Komm mit! Komm mit!* (1999). Then there are the three houses made of brass, which are meant to be self-portraits (1997), as well as the four houses with body sounds, *Love Sounds* (1998). Are houses extensions of our personalities?

**JP:** Certainly. But I want my houses to extend in another direction. After all, a house is a place to be. The idea of a home is more essential for me than the idea of a house. That's the most important point for me. For me, a home is not necessarily a building. It can be the wife you love, the book you are reading, the music you like, or the nature you feel well with. It's a general concept. It's probably for this reason that people feel comfortable with my works regardless of where I show them—whether in Europe, the U.S., or Japan.

**MS:** To what extent are your houses self-portraits?

**JP:** Obviously not in a mimetic way, but they reveal something about me, my attitude toward humankind and the world. It's the idea of body and soul. A house is a body in the sense of it being a place to be. And when someone enters one of my houses, he or she furnishes it with a soul. The piece is not complete until someone enters it. Years ago I did an exhibition in Berlin with cells of polished brass.

**MS:** Which one could open and enter as in *Love Sounds*?

**JP:** Exactly. And it was wonderful to experience people disappearing into the cells, meaning inside myself. It felt like a love experience. In other, past cultures the idea was to disappear inside your lover. That was an ideal. Similarly, we have the idea to eat the person we love so that he or she may become part of us. You mentioned *Love Sounds*, the cells made of alabaster with the sound of my blood circulating, which I showed at the Kestner Gesellschaft in Hannover. They probably come close to an almost literal self-portrait with their body sounds. I continue to work in this direction. In Tokyo, I did a public installation in an amusement district.

**MS:** The *Seven Deities of Good Fortune*?

**JP:** Right. In Shibuya. I transformed myself into benches, into a place on which to sit, which is another form of a place to be. And now, when the work is illuminated at night, you see that it has become a favorite place for lovers

to meet. For me, it's only then that a public artwork has been successfully completed—when it has been embraced by the population and becomes part of their daily lives.

**MS:** You mentioned that you work as an artist for the opera. Do you feel that there is an affinity between the stage and sculpture?

**JP:** Yes, I think that working for the opera is a natural extension of my work in space. I described how beautiful it is for me to see my work alive, with people using it. This is a basic condition: what you create for the stage is used by other people. What also attracts me is that an opera is an amazing combination of different energies and knowledge. You have the author, the director, the composer, the singers and dancers, the conductor. I love the opera: it was born from the idea of creating a "total art," an idea that still fascinates me. But the best thing about opera is its ephemerality. It exists only for the transitory moments of its representations. It is born, and it disappears. Thus it's like a parable of life. I like the idea of the permanence of my works in public spaces, but I also like this concept of ephemerality.

**MS:** One of your last contributions to the stage, *The Children of Freud*, was shown as an artwork at the Dakar Biennial before it was used for a theater production in Rome.

**JP:** Yes, but this was an exception. A director saw it and wanted to use it. I gave my permission, but I had nothing to do with the production. I planned and created *The Children of Freud* for the Dakar Biennial. It was meant to transport my culture to Africa. I did an installation of 23 white faces and hands, casts of my friends made of white marble dust, with water falling from their eyes and their hands.

**MS:** Why did you choose the title?

**JP:** Because I hate Freud. I think he is responsible for a lot of misunderstandings in our culture, especially with regard to emotions. Plenty of generations are Freud's children in this respect. In spite of the title, when I had finished the work, I was thinking more about Dante than about Freud. It reminds me of the *Inferno*, where people are in the water suffering in squalor. But the piece is also connected to another idea that I have always explored in my work: as human beings and as artists we are like islands—isolated, probably in the same ocean, but with a very specific geography. *The Children of Freud* shows islands floating in the darkness with very little light, much like *Wispern*, which I showed in Hannover and Madrid. When you saw *Wispern* for the first time, it had only seven cymbals. Now it has been extended to include 41. I'm currently preparing an exhibition for the new museum in Malaga, where the installation will have 44 elements. The work is growing to fit each space. I hope that one day it will encompass 73 elements, exactly the number of Blake's *Proverbs of Hell*, which are engraved in the cymbals.

**MS:** What does art mean in your life?

**JP:** For me, art is nothing more than a body sound. Our bodies produce vibrations, and I view art as one of these vibrations. It belongs to me; it's a part of me. Without art, I'm not imaginable. I never took care to become a good artist, but I always took care to become a good person. I don't care about art as a problem of shapes. Art is a consequence. It's the breath of my experience. It helps people understand life. It helps people to grow up. But I'm not good at explaining what art is or should be. If I were able to do so, I probably could not continue to be an artist any longer.

**MS:** In a famous work by Bruce Nauman, we learn that the artist is a luminous fountain. Do you understand yourself in that way?

**JP:** Let me put it this way: every definition of an artist with regard to art and his or her role as an artist is right, subjectively right. Every single artist has his or her individual experience of art. Henri Bergson defined time as a combination of individual time. I think it's quite similar with art. In the end, combining all of the different experiences and definitions would probably sum up what art is and what an artist is. There is no such thing as one single definition.

**MS:** The Japanese artist Sugimoto once said that anyone could say anything they liked about his work and no one would be wrong. Do you share his opinion with respect to your own work?

**JP:** You know, that's something I don't think about and I don't even care about. No one asked me to be an artist, and no one asked me to make art. I wanted to be an artist, and I wanted to create art. So I'm the only one responsible. I'm not really sure if I'm interested in hearing opinions about my art—if it's good or bad, right or wrong. On the contrary, what I'm interested in are the emotions it provokes. Yesterday I was in a restaurant here in Goslar [Germany], and a little girl, the daughter of the proprietor, was playing near my table. She's a sweet little darling, and she looked at me with big questioning eyes, wondering who I was. I took a stone from my bag—I love stones and carry some with me all the time—and gave it to her, telling her it was from Spain. She was so fascinated by this ordinary little stone, you can't imagine. She showed it to all the people in the restaurant. Something extraordinary had enriched her life. The stone was nothing, but it was everything to her. A miracle. That's what art is for me.

# Kicking Out the Boundaries: Kiki Smith

**by Jan Garden Castro**
**2006**

We are in a living room filled with candelabras, sculpted birds, and female figures. Birdy, the 15-year-old dove, contentedly watches the rain through a back window. Kiki Smith leaves for Italy tomorrow to open a show and then travels to San Francisco to install a 25-year retrospective, yet she calmly draws as she discusses her career. Seated in front of two giant stacks of watercolor paper, Smith holds a pencil in her left hand and a photograph of her deceased mother in her right. Although I am eager to discuss the dark, bewitching roles she sometimes assumes in her self-portraits, as well as the irreverent ways she uses the body and its parts as potent metaphors, Smith has ways of shielding her artistic persona. In conversation, she uses the first, second, and third person. She occasionally talks looking into my eyes, but usually she gazes down at her drawing.

Smith's retrospective, organized by Siri Engberg at the Walker Art Center, opened at the San Francisco Museum of Modern Art in November 2005 and traveled to the Walker, the Contemporary Arts Museum, Houston, and the Whitney Museum of American Art, New York. The show revealed the myriad avenues of Smith's creative process, her array of materials, and historical and personal perspectives. According to Engberg, "With the body as its center, her work has drawn inspiration from art history, literature, decorative arts, and her own biography. Her process is one of constant reinvention—she never closes doors for herself."

**Jan Garden Castro:** I loved the images of women and domestic space in colonial America from your installation for the Querini Stampalia Foundation (summer 2005). A portion of this work, *Kitchen*, is part of your traveling retrospective. What are the processes and themes behind this installation?

**Kiki Smith:** The Querini Stampalia asked me to make an exhibition that would be up during the Venice Biennale. They are a house museum with a collection of Pietro Longhi paintings of 18th-century Venetian bourgeois domestic life and a contemporary art space on the top floor. I began thinking about that and about domestic life in New England at the time when people were colonizing this country. I was reading books by Laura Thatcher Ulrich, who wrote about colonial women's lives, and I was making a piece for the de Young Museum at the time—they have wonderful colonial American paintings in the Rockefeller Collection. This got me thinking about colonial American things, and I thought it would be interesting to play in some of those languages.

I tried to make things that had a relationship to the Querini Stampalia collection. For instance, they have a large Sèvres porcelain collection, so I made a kitchen room upstairs. I worked with a ceramicist named Marty Kendall—making pots in New York and in Aspen, Colorado—mimicking some New England motifs, and I bought a lot of things at flea markets, including some Amish floor runners. When I was on the plane coming over to install my show, there

*Pee Body*, 1992.
Wax and 23 strands of glass beads, 68.6 x 71.1 x 71.1 cm.

was an extensive article in the *New York Times* about American soldiers torturing Afghan people, which was hideous. I put it in *Kitchen*, because our foreign policies move out of our kitchens and seep into the world. The kitchen is the heart of a house and is not devoid of the outside world. I made photograms of New England scenes from paintings and had a girl looking out a window.

JGC: Were there any self-portraits?

KS: Just one of me looking stupefied in my backyard with a light bulb. I made it the year before, when I was interested in 19th-century photography.

JGC: The newspaper references violence brought into the home?

KS: Our foreign policy is coming out of our psyches, spilling out into the world, and then coming back in and affecting our domestic lives. It's going in both directions, but it's not separate from our domestic lives.

JGC: Did you write all of the narratives? I loved the tale about the woman who danced her way into the future.

**KS:** Yes, using the Pietro Longhi paintings of women doing ordinary things, I changed the narratives to mix it up a little bit—as though they were all up to something, although I don't know what that really was. Also, it's about being a foreigner. When you go someplace, you are reading from your own experience. As a tourist, you have convoluted understandings—or misunderstandings—about what you're seeing. In that sense, it also gives you the opportunity to make new narratives or other narratives out of misunderstanding, which affords you a way to jump out of your own culture into other cultures.

**JGC:** The woman dancing into the future is a perfect metaphor for being an artist, and it also suggests the role of the body in the creator's life. Could you talk about the ways that you have examined, classified, and mythologized the body?

**KS:** I don't think about it so much any more. When I was younger, I thought it was an interesting way to think about being here—through your body, through the experience of your body. A great deal of our experience is social-physical. I'm not trying to do anything in a methodical way; I'm just seeing what happens.

**JGC:** Around 1980, you started with *Gray's Anatomy* and an exhibition featuring diseased severed fingers, and you trained as an emergency medical technician in 1985. So it seems that very early on you got the idea to use art to examine bodily dysfunctions as well as functions.

**KS:** It seemed like something to pay attention to, which I did for a fair amount of time, and then I started thinking about other things, or not thinking about other things.

**JGC:** Then the body became bodies in mythological time.

**KS:** It's just following one's interests. You get into strange, tangential, interloping spaces that hold your attention. For instance, Pietro Longhi's art is not something that I would normally think about for more than five seconds, but for some reason, certain images have a dearness that is attractive, and you see a possibility of taking that image and transforming something. You can use other artists' work as a springboard for recontextualizing or for recognizing what still seems very vivid or vibrant about certain images or a type of historical form.

**JGC:** What was the genesis of *Pee Body*?

**KS:** At the time that I made it [1992], I had a show at the Österreichisches Museum für angewandte Kunst, a decorative arts museum in Vienna, so I tried to use historical decorative materials. I used Czech beads, but the Austrians were also involved in bead-making, chandelier-making, and glass, and beadwork is a big part of their history. They also have a history of using anatomical wax figures to teach medicine. I was reacting specifically to a particular place and making a piece that used decoration. Another interest was to make something between a solid sculpture and a drawing. A piece of my father's called *Source* is a big influence on me. It's a body and an appendage—

something coming precariously off of a mass. In *Pee Body*, one part has a solidity to it, and the other could be contingent and changing. Each time you install it, it makes a sort of Baroque line drawing on the floor.

JGC: How do your fluencies in different media influence each other?

KS: Beads are at the bottom of the glass chain, but they are historically important. In terms of world commerce, they have an incredibly developed history. In a perverse way, I like playing around with different media, materials, and techniques to make provocative references to those different histories, so that you're not caught in the conventional or the momentary contemporary reading of things. Situations are often culturally dictated, so it's interesting to keep shifting the reading around.

JGC: MoMA held a retrospective of your prints, books, and multiples two years ago, and now the Walker is organizing an even bigger, all-media retrospective. What are some of your favorite early works? Are there works you no longer like?

KS: Most of the time, I don't think about any of this. Certain things I wish would burn down in people's houses or disappear off the planet, but that's just a problem of self-acceptance. All of the things you're doing are experiments, ultimately, to see what happens. If you consider the whole thing as a process and as artifacts of process, you don't have to be attached to whether on a given day you think they're good or bad. In general, I'm the same person, but it's finding a language that seems to work appropriately. When I first came to New York, I made things that were very funky and somewhat comical, which is still a big aspect of my work. I think that my work has a lot of humor that's not really seen. I mean things seriously but also humorously. Sometimes I can see that I had no idea craftwise how to make things. I'm learning on the job.

Just as in one's personal life, you sometimes can't believe what you did two years ago, and you think, "Oh, I was so young then." Then you realize you weren't that young. It's the same with art: sometimes one feels appalled by what one has made; then sometimes one has tremendous affection for certain things and they are very important, but not necessarily what is particularly good. Lots of times I saved my worst drawings, because that's where the most struggle was—and the most energy, much more so than in things that were resolved. With other people's work, too, sometimes it's the things that I find the most problematic that stick in me the longest, that I have to grapple with—in the end, they give me the most energy because they're unresolved. Some great things one learns from the most, but some great things simply reiterate good taste. At times I move from curiosity, and I also move a lot from discomfort.

JGC: You told Lynne Tillman that in your work up to age 40 you were "vomiting up your childhood."

KS: I was working very automatically, having tremendous necessity for self-expression.

JGC: You're the daughter of sculptor Tony Smith and opera singer Jane Lawrence. Was your childhood difficult?

*Wolf*, 2001.
Bronze and sewn cotton, 44.25 x 46 x 12 in.

**KS:** Everyone's childhood is problematic for them. Everyone has insatiable desires as a child, and that gives one energy later in life. I had a very interesting childhood. Some stuff had something to do with my parents, and some very motivating things in my life had nothing to do with my parents. I feel very fortunate to have grown up around artists.

**JGC:** Your readings of Little Red Riding Hood and other girl and animal tales are fascinating. In one tale, she goes to bed with the wolf, there is wild animal sex, and she becomes the wolf.

**KS:** I have a friend, Mei-mei Berssenbrugge, who has had a big influence on my thinking about one's relationships to animals, trees, and the natural world— seeing what they mean to you in a meandering way with no particular direction. I sound cagey, but don't want to get trapped by language.

**JGC:** I love the transformations, the way the girl seems to be hurt or violated, but she also ends up as the wolf.

**KS:** I made all of these works of women being attacked by animals, but it was just a way to get out of being here, more like animal spirits coming into your body. They're just funny to me. Like the blue versions of Krishna, like in Artaud's drawings with blue holes in them—you could say he's attacking the portraits, but you could also say he's creating space to release internal pressure. The animals are a way to get out of being in the body.

**JGC:** Obviously, you're drawing, too, on meanings from other cultures; for example, Native American views of animals and spirits.

**KS:** I have a friend, a sort of shaman, who has communications with animals. In a way, I'm making a reference to my friendship and to that fluent spirit world of animism. And I was raised Catholic, which has similarities to animism. It's a spirit-worshipping religion that believes in a live universe and also in things being imbued with symbolic powers.

**JGC:** You variously address notions of beauty in your work. Siri Engberg suggests that you create a tension between your frank subject matter and your seductive uses of materials. What role has feminism played in your life and work?

**KS:** It shows the necessity to expand notions of beauty in an active or assertive manner. I don't have super big art

agendas, but I do have agendas of trying to have a good life here. Often our culture is more restrictive than our beings are psychically. Often there's not enough space for one's nature. One has to keep trying to kick out the boundaries so that one's nature can have space for itself.

JGC: What inspired your famous sculpture of a woman with sagging breasts painfully crawling, with what Linda Nochlin calls "a 'tail' of shit" or "perhaps a long, long intestine" dragging behind her (*Tale*, 1992)?

KS: I just thought it was funny. Basically, it references my father's *Source* sculpture, a body and an appendage. I thought that one's own history trails one around. One tends to hold on to unnecessary situations from one's personal past. Like a bad tale, one doesn't let go. A physical illustration of that seems insane, but in one's personal life, one won't let go of things one has outgrown. It was a humiliating but comical illustration.

JGC: Was your upside-down, hanging *Lilith* inspired by Rodin's *Je suis belle* (1882) as Nochlin suggests?

KS: No. It just came out of making something. I was making a mold of the body, and then I covered it with papier mâché. It's someone squatting or like a fly. Because it was papier-mâché, I realized that you could put it on the wall. What's nice about making things is that to some extent you can have intention and to some extent you have to be doing things in the present moment.

JGC: Could you discuss scale and fragility as two important aspects of your work?

KS: When I was young, my father was trying to teach me to draw, and he said that things had a particular scale that was important to their integrity and being. So, for the first big part of my work, I was intent to make things the size that they were. When I got interested in dolls, I made things to that scale. In general, I have made things that are body-sized at the largest. Lately, I'm making things in relationship to the scale of figurines and also to the scale of statues. Even though they are both objects of images of figures, each has a very different history. Like beauty, it's often deceptive what is fragile and what isn't fragile. Often, historically, things that seem fragile are more sustainable than things that have more body, more substantiality.

JGC: Siri Engberg has noted that your work permits us to re-examine ourselves, our history, and our place in the world. What is your personal philosophy about the relation between life and art?

KS: Art is a place where people express their consciousness, and it's an infinite space. It's a meeting space of different technologies and different thought processes, curiosities, and desires. Since it can have infinite forms and subject matter, it's an extremely free space.

JGC: One of my friends says that your gallery, Pace Wildenstein, is primarily a boy's club. Is this so? As a feminist, do you consider it ironic that you're one of the few women artists there?

**KS:** No. Arne Glimcher made his career, basically, showing Louise Nevelson. Some of those things are generational. I see my job as a female artist to be in as good a situation as I can. It's my social obligation. I like showing there because they're really professional. Lots of things have changed and will change enormously in my lifetime. Those are social processes. The fuller acknowledgement of women's cultural contributions changes only as a large consensus of the population realizes that this is a problem.

**JGC:** Your work addresses universal issues that our elders never even discussed. You've become a culture hero, and you've clearly influenced the next generations of artists. How do you balance the public and the private aspects of your life?

**KS:** I've loved having an art career. It's nice to think of oneself as being useful. It's great if you have given someone a sense of possibility for their own lives that's rich and meaningful to them. I'm a mixture of a private and a slightly gregarious social person, and having an art career is different from being an artist. There are different components, models, and ways one can be an artist. Maybe the best thing is that this next generation shows many more possibilities under the loose membrane of art.

One's interests as an artist change over time, too. My personal life is relatively undramatic, which is good for me. I mostly just work. My main interest is learning about things. I feel very privileged to be in the art community.

# Transmogrifications: Bryan Crockett

## by Brooke Kamin Rapaport
## 2006

Bryan Crockett was born in Santa Barbara, California, in 1970 and grew up in a home attached to the family business; his father was the local mortician. He dropped out of high school in his junior year to attend Santa Barbara City College and graduated with a BA from Cooper Union in 1992 and an MFA from Yale University in 1994. Today, he lives and works in Brooklyn. His 400-square-foot studio is crammed from ground to gable: drawings are pinned to the wall, parts of sculptures rest on shelving that stretches from floor to ceiling, and a work in progress sits on a lathe. In this diminutive environment, Crockett gives three-dimensional form to a world that swirls in his mind.

Crockett's body of sculpture is so diverse and complex, it is as if more than one artist were at work. He has created abstract installations using balloons, chiseled away at polyester resin to create classical human form, and riffed on historical subject matter by using cultured marble to shape larger-than-life mice. It is a wide range for a young artist. Crockett's work began to attract general attention in 1997, when he was chosen to produce an installation for the Whitney Biennial. He created a room-sized work, *Ignis Fatuus*, from long, stringy balloons of bilious grays, bloody pinks, and intestinal purples evoking human innards. By 2000, his human-scale mouse, *Ecce Homo*, was pictured in the Science Times section of the *New York Times* in a piece on genetics crashing up against art. *Portrait of a Lifetime* (2004) is a self-portrait of the human life cycle composed as a wood relief. Ultimately, subject matter unifies Crockett's project into an evolving whole of discrete bodies of production. What sets his work apart is a mastery of craftsmanship tied to the study of art historical precedents, specifically ancient, Renaissance, Baroque, and even contemporary art.

**Brooke Kamin Rapaport:** You rely on traditional materials and historical subject matter. Aren't those characteristics opposed to much of today's vanguard art practice?

Bryan Crockett: I don't think that any artist in modern art history—even the ones breaking tradition—was not going back into art history, scouring over the traditions. Being aware of art history is a necessity for the formation of an artist. What you're referring to are my stylistic references to classical figurative traditions. I ended up there because I was interested in the figure, and there isn't a huge amount of figurative sculpture in modern art. Auguste Rodin, Alberto Giacometti, or Hans Bellmer come to mind, but the figure dissolves into abstraction after Surrealism. Then it emerges again with Post-Minimalism and Photo Realism. However, the new figurative sculpture became more tied to issues of photographic representation and body art as seen in body casting and performance. Basic concerns of material and form seemed neglected. In dealing with the figure or body sculpturally today, one finds oneself going back to pre-modern history. I was also interested in religious sculpture, which is all but absent from modern figurative work. Right now, so many things are up in the air, it's almost more interesting to have a broad scope of reference.

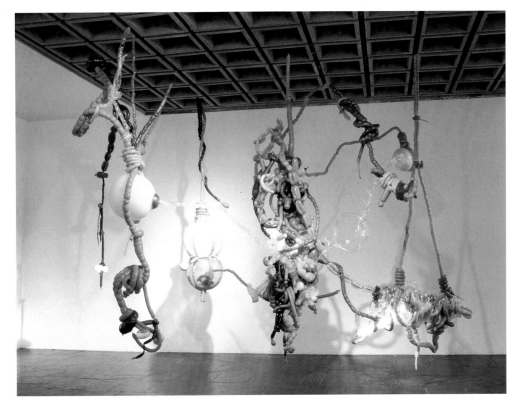

*Ignis Fatuus*, 1997.
Latex balloons, epoxy resin, wire, and light bulbs, 144 x 192 x 120 in. View of installation at the 1997 Whitney Biennial.

**BKR:** What do you mean by "up in the air"? Art historically? Worldwide?

**BC:** What I mean is: What is art now? There isn't such a defined aesthetic right now. There are so many different types of work being done. It's not like when Minimalism was the dominant force. Artists are borrowing from many different sources and pulling together references and making their own narratives. I am not exclusively making references to Baroque sculpture or classical sculpture, I am also trying to update them and mix in things from my world.

**BKR:** Did your undergraduate and graduate teachers influence your work? You studied during the 1980s and 1990s, when the significance of Minimalism was waning and political art was waxing, yet your sculpture embraces neither of those movements and charts an independent course.

**BC:** As far as my education, as an undergraduate, I studied under Hans Haacke at Cooper Union. This was between 1989 and 1992, when overtly political art was the trend. I was inspired by the rigorous discussions and readings that we were forced to follow, but the process of making that art was painfully clinical. When you showed a piece at a class critique, you were expected to give a talk to defend its meaning. These discussions usually focused on the

deconstruction of semiotics—almost like one would try to take apart and analyze an advertisement. The didactic atmosphere of Haacke's classes felt defensive and negative. At that time, political art had become almost a movement and its tight-fisted agenda had squelched the complexities from art.

From Cooper Union I moved on to Yale to study under Ron Jones and John Newman. I was inspired by Jones's work the first time I saw it in a 1990 show at the Whitney Museum called "Mind Over Matter." Jones's work (and his teaching) made you want to think rather than feel some kind of guilt. I always thought that if Marcel Duchamp had to make "political art" in the late '80s, he probably would have made work a lot like Jones's.

Although I grew to be much more inspired by the conceptual end of things while at Yale, I also realized that I liked to make things myself. I liked to walk a line between formalism and conceptualism. I wanted to explore conceptual narratives and philosophical ideas, but with my hands. John Newman was a very inspired Post-Minimalist whose work seemed to be drawn from his inner experiences. There was so much emphasis placed on content and controversy in the program that Newman's approach was refreshingly open. In retrospect, I think that his presence made it possible for me to explore the more formal side of my work.

**BKR:** Did your parents encourage you to become an artist? Did their professions influence your work at all? You have mentioned that you were also considering work as a scientist.

BC: My father was a mortician. When you're growing up you don't really think about how your life is different or about how your parents' professions might affect you in the future. But, obviously, they do. The most significant thing I have come to realize from growing up around death is that in and of itself death is not interesting. What is interesting is how the living come to terms with it in their mind and in their memory. I think that's why I have focused so much on preservation techniques and capturing my experience of life—and why I find myself drawn to materials that transform or seem to be growing.

From a very young age, I was on track to become a biologist. My interest in science began with a collection of reptiles and amphibians in my basement and developed into a job at the Santa Barbara Museum of Natural History while I was still in junior high school. Midway through high school, I realized that I didn't want to be locked away in a lab, alienated from the world. However, it wasn't until I went to graduate school that I became conscious of using my interests in science and biology in my artwork. As a student, I had made several pieces featuring lab mice. I made a video with them, took pictures of them, sculpted them, and even did a series of taxidermy lab mice. I took the archetypal hierarchies of domesticated animals and morphed them with their predators. There was *Swine Hound* (1995), a domesticated pig and wolf/dog, and *Unknown* (1994), a cat/rat/dog hybrid. I fully realized my interest in lab animals with the *Seven Deadly Sins* project (2001), a series of marble sculptures.

**BKR:** In your work, there is a devotion to classical, Renaissance, and Baroque art in which materials were crafted to create human figures and recognizable forms from religious subjects and everyday life. You have mentioned your fascination with Bernini.

**BC:** I suppose I started looking at more classical, Renaissance, and Baroque sculpture while in graduate school in the early 1990s, when I started working on my animal sculptures. At that time, figurative sculpture with clay and molds was the last thing you were supposed to do. Artists were doing a lot of multimedia installation and video. The closest thing to figurative sculpture in graduate school was performance art or some rare examples of body casting. The idea of actually sitting down and sculpting a figure in clay was uncool. But I was good at it and I liked it, so I set out to try to do it in a different way. I had always been attracted to the melodramatic narratives and finely crafted detail employed in Baroque sculpture, especially Bernini. One almost can't help but relate to them.

Bernini's sculptures are not just static objects: they are highly choreographed to create a sense of theater. In that sense, they are installations. I love how the *Ecstasy of St. Teresa* (1647–52) is installed in such a way (in Santa Maria della Vittoria, Rome) that natural light from a hidden window showers down to create a sense of divine light. His works seem to involve much more than just the representation of the figure in marble. They seem to breathe. It's more than a matter of realism: they capture some kind of life force. There are definitely narrative layers to Bernini's work that are as important as the formal ones. *Apollo and Daphne* (1622–25) probably fascinates me the most.

Bernini's version of the myth is so perfectly conceived and executed that no other sculptor could dare take it on. In my last show, "Drawn Out of My Mind," I attempted to play off this myth. Instead of depicting Apollo in the midst of the chase, I created a sculpture of a tree with a self-portrait. My head, embedded, was growing into a tree in *The Solipsist* (2004). I then made two figurative sculptures carved in faux logs depicting a male and a female figure in a sort of time lapse called *Male Ghost* and *Female Ghost* (both 2005). Both figures are sculpted in relief and depict a gradual shift from head to toe of the human body transforming from birth to death. The male figure stares at the female figure as his body transforms from the skeletal head and back of an old man into the body of an adolescent, into the legs and feet of a newborn. Conversely, the woman is depicted as aging from head to foot. She is represented with the head of a baby, her body aging by stages, until at last her skeletal foot is revealed. Creating these works in wooden material, I was thinking about the tree and the material of wood. And I was thinking of how wood, in the nature of its growth, is a record of the seasonal passage of time.

**BKR:** *Portrait of a Lifetime* and the male and female *Ghost* works encapsulate the entire human life cycle. The best Baroque sculpture captured a fleeting instant in one work. By contrast, you have telescoped a long period into a visual flash. What is the basis for condensing a person's long life into one visual moment in an art object?

**BC:** That's where you get to an interesting problem. There's been so much said and written about the fragmentation

*Pride*, 2002.
Cultured marble. From *Seven Deadly Sins*.

of the body, the destruction of the idealized whole entity of the representation of the body or gestalt. Whenever I sculpt a human figure, I always tweak it in some way to get you to approach it with a different logic. I wanted, with the *Ghost* sculptures, to show a figure transforming through time. Our bodies age, but our mental self-image doesn't. I think we all mentally carry around the child we once were; we struggle to deal with the eventualities of death and physical breakdown. In this sense, the sculptures represent a fragmented body image. Similarly, when I sculpted *Somatosensory Homunculus* (2002), I was interested in representing the body re-proportioned in relation to a hierarchy of the sense of touch. As with the neurological model, each part of the body has a different degree of sensitivity. There is a difference between our perception of ourselves, the way we feel and think, and the way we actually look if we were to take a picture or look in a mirror. In addition, the two *Ghost* sculptures represent bodies in some kind of time lapse. They are not intended to be living likenesses; instead, they are figures stretched out in linear transformation.

**BKR:** Are they made of wood?

BC: The figure part is not wood, but it reads as a wood-like material. *Portrait of a Lifetime* is all cast resin, and *Male Ghost* incorporates a real wood base. I also have certain material constraints due to money and time.

**BKR:** It looks like wood.

BC: Yes, what's important for me is that it "feels" like wood. It's my wood, from a tree that I created.

**BKR:** That work is also about technology and pushing things along fast in life—trying to encapsulate an image into one moment. Conceptually, this parallels the promise of electronic innovation, but you are dealing with the human figure and making it the receiver of collapsed time.

BC: That body of work is really about philosophy for me. In my previous show, "Cultured" (2002), the mice were about focusing on a token creature as a scientific model representing modernity. Mice represent mankind in a deep symbolic way and literally—every product we use is tested against the mouse. I became fascinated with the

mouse/man metaphor and what is going on now in science. I wanted to elaborate on that in a sculptural way by pulling classical, religious sculpture into it.

Lab mice are used to test medicines and products before they are tested in the human realm. This all happens out of the public eye, invisible yet also somehow present. I was interested in how, symbolically, the animal model also becomes a metaphor for us living in a kind of mass-consumer cultural experiment. I wanted to make these invisible little workers/prisoners more anthropomorphic or human. And the theme of the seven deadly sins was interesting to me because it was a way of merging religious ideas with scientific ones.

The *Seven Deadly Sins* were based on mice specifically engineered for research into different diseases. For instance, *Gluttony* (2001) was based on the ob, or obese, mouse. Jackson Laboratory in Maine engineered the ob mouse to study obesity and diabetes, and scientists can buy these mice, which are genetically programmed to become obese. I was fascinated by what this implied in terms of the religious idea of free will and the cautionary notions of the seven deadly sins. I spent a lot of time finessing the sculptures, basing them on actual genetically engineered mice and mixing classical sculptural references into each piece. I wanted these works to lead to a twisted web of issues surrounding free will, identity, ethics, and creation.

**BKR:** Are there living artists whose work you have followed? Are there any particular artists who compel, or repel, you?
BC: I have always had a great respect for Robert Gober, Mike Kelley, and Bruce Nauman. When I review Nauman's career, I am most inspired by how his work seems to evolve out of his messy studio. His work is very conceptual, yet it seems to grow partially out of a formal process with whatever materials he's working with at the time. I've always felt that artists who job-out or art-direct their work from the sidelines miss out on a tremendous realm of possibility inherent in the process of making their work themselves. In science, discovery happens almost as pure process. There is no guarantee of discovery. It is almost arbitrary, however it does seem to come out of the minutiae and mistakes of process. I have a particular interest in artists who have approached formal issues but in a more conceptual way.

**BKR:** There is a very complex narrative attached to your sculpture, which is tightly woven into your own psyche and the evolution of your body of work. When you display your work in group exhibitions—for example, the 1997 Whitney Biennial, "Open House: Working in Brooklyn" (2004) at the Brooklyn Museum, or "Mike Kelley: The Uncanny" (2004) at the Tate—how do you expect a general audience to understand this plan? Do you believe that the work must be interpreted via your singular vision, or do you allow for viewers to craft their own story around the work? What if they simply appreciate it formally?
BC: In terms of an audience, I feel pretty alienated from the art world. I don't expect much from gallery-goers. I just want them to look, feel, and think. I certainly don't expect anyone to walk away with my long-winded, twisted ideas.

My narratives are the conceptual framework that keeps me moving forward. Some of the most successful works of art elude rigorous analysis and the formation of a specific meaning. No matter how many theories I hear about Francis Bacon, I will always return to look at his paintings simply because they capture the human condition so powerfully. All of his references to art history and narrative give way to paintings that can be nothing other than art.

**BKR:** Where do you create your work? The various materials you have used—resins, plastics, embalming liquids, metals, marble, wood—conjure images of a chemist or alchemist. Have any of the materials disappointed or not realized your expectations for their inherent ability?

BC: All of my work is made in my studio. Because much of my study has revolved around metaphysics and the roles of science and religion in Western culture, the history of alchemy is also of interest to me. Alchemy had its roots in philosophy and religious mystical aspirations at a time when Western science and technology were burgeoning. I am interested in how modern science and technology challenged notions of metaphysics, in an emergence of a new hubris. There are a lot of new technologies today that reflect a lot of old problems. This is a lot of big talk: in terms of my work, I try to address these ideas in the way I make things. I try to suggest a connection between ideas of alchemy and the technologies of today. Isn't the desire to turn base metals into gold similar to the desire driving scientists in the field of artificial intelligence?

**BKR:** Figurative sculpture has seen a resurgence over the last few years. Yet some have spoken of an artificiality in the work and have even predicted its demise. Because it simultaneously refers to historical sculpture and looks into the future with blends of traditional and contemporary materials is it an optimistic gesture toward the field?

BC: In 1992, I took out a loan at Yale through Apple and bought an expensive new computer. I started taking classes in 3D animation and hoped to jump into this new technology in order to make art, and as a means of making money. After making a few models and pieces, I realized that there would soon be a huge onslaught of computer artists making digital art and that it had great potential. However, it was going to be very expensive, and I didn't have access to the high-tech capabilities of the day. Also, I had become skeptical of the hyper-utopian aura of the new technologies in the early '90s. Still interested in the possibilities of so-called "virtual" sculpture, I decide to drop the computer and go low-tech. I began making sculptures using latex balloons. They seemed to have an ephemeral, almost virtual quality and could strongly evoke the body and biological forms. I began to focus on the processes of preserving ephemeral forms. I liked the balloon sculptures such as *Ignis Fatuus* (1997) because they were just skins of color. It was almost like making sculpture with inflatable paint. For instance, by putting an orange balloon inside a blue balloon and inflating it, I would end up with a gray-blue that looked very intestinal. I realized that by controlling the color, I could make forms evoking different body parts such as intestines, stomachs, brains, penises, breasts, and amniotic sacs. By choreographing these forms, I could make a polymorphous figurative sculpture loaded with sexuality and life but abstracted and eviscerated. But I ran into a problem: my sculptures would deflate, shrivel, and die. Thus, my focus on meth-

ods of preservation. I would photograph my sculptures before they shrank, and sometimes I would inject them with resin to embalm them or stuff them into an urn where they would turn to dust. Documenting and preserving the material of the sculptures became my obsession. They looked like bodies and viscera, and I treated them in a sacred way— either I would embalm them or cremate them. This was a kind of homage to my exposure to mortuary science.

**BKR:** What is your next direction?

BC: There are still a couple of pieces to come out of this last body of work, but the next material that I want to focus on is metal. With the balloons, I focused on the fragmented body and techniques of preserving bodies, art, and our ephemeral nature. When I worked with marble, I wanted to focus on its material history in relation to the act of creation, biologically and sculpturally, religious ideas, the flesh. Wood is so much about the fact that it was once living, a record of time, connoting structure and breakdown, life and death. I ended up focusing on notions of philosophy and time. With metal, I want to revisit aspects of alchemy and science and maybe touch on issues of man and war. Who knows where it will take me.

# In Art, Anything is Possible: **Yinka Shonibare**

**by Jan Garden Castro**
**2006**

Visually arresting, Yinka Shonibare's art plays imaginatively with stereotypes of race, class, culture, gender, and sexuality in order to reveal their "manufactured" nature. His re-creations include *Diary of a Victorian Dandy*, a suite of large photographs based on Hogarth's *The Rake's Progress*, in which he portrays the Victorian dandy; a film with black and white ballerinas based on *Swan Lake*; and many three-dimensional tableaux of figures, both imagined and based on known people and paintings, such as Fragonard's *The Swing*. While Shonibare alludes to historical periods, artworks, events, and people, the differences between the originals and his own works are central to his message.

The tableaux usually feature headless figures dressed in exaggerated fashions. Shonibare favors the Victorian era for its aristocratic repression of high emotions behind lavish attire and manners. Yet his figures are not pure Victorians: their clothes are made of the kind of brightly colored fabric worn by working-class Africans in the '60s and '70s. And the cloth itself is hybrid, fusing Indonesian designs, British and Dutch manufacture, and the symbols and myths of African identity. Shonibare's range is enormous, from aliens and the drag queen RuPaul to a reverend and others skating on a pond, the sisters who founded New York's Cooper Hewitt Museum on stilts, and the European leaders who carved Africa into colonies in the 19th century.

Shonibare has shown in numerous exhibitions over the past 10 years. In 2006, his work was featured at the Cooper-Hewitt National Design Museum, where he curated the exhibition "Yinka Shonibare Selects," the Museum of Modern Art in New York, and the Royal Opera House and the Africa Center in London.

**Jan Garden Castro:** Your signature style employs "African" textiles that originated in Indonesia and were later manufactured in British and Dutch factories. Could you discuss how these fabrics play a role in the deconstruction of stereotypes?

**Yinka Shonibare:** On first seeing the fabrics, you assume that they are authentically African, that indeed they are produced by Africans and signify Africa. But on researching the fabrics, I realized that they were actually Indonesian-influenced. After the Dutch colonized Indonesia, they produced the cloth to sell to the Indonesian market. But industrially produced versions were not very popular in Indonesia, so the West African market was tried, and the fabrics were successful there. Subsequently, the British also started manufacturing them for sale in the West African markets.

What I find interesting about the fabrics is the fact that after independence in Africa, there was a need to assert African identity, and one way of doing that was not to wear what were regarded as European clothes. People wanted

Installation view of "Mobility," with *Man on Unicycle, Lady on Unicycle,* and *Child on Unicycle,* 2005.

to wear more "African" things. But traditional African fabrics were produced on the loom. Because of the modernization of Africa through colonial contacts, people had stopped making their own fabrics at home and would buy industrially fabricated cloth imported from Holland and England. Those fabrics were adopted. During the period of the Civil Rights movement in America and also during the Pan-African period in Africa, there was a desire to adopt those fabrics as a way of celebrating African identity. I like the fact that they are meant to signify Africa, but actually express global trade and the relationship between Europe and Africa. Of course, that is also a complicated political issue.

JGC: In 1997, you told students at the School of Oriental and African studies that your work is about the politics of representation and that the Ankara fabric you use challenges notions of authenticity in art. Could you discuss the ways you use the images?

YS: There is the question of appropriating or reclaiming your own idea of yourself. In other words, the way that certain objects might be used when they cross over to other cultures might be different. Take the example of modern things like mobile phones: they can be Africanized, appropriated, adopted, and used in a different way. There is an African way that the fabrics are produced, but the design is Indonesian-influenced and Dutch- and British-produced. They have been claimed as African because they are used by Africans, but, essentially, the origins of the fabric are

not African. The point I'm making is that all stereotypes are based on some idea of purity—no contamination. To retain the idea of authenticity, it is very important to retain the illusion of purity.

Africans are part of global trade like everybody else. Africans don't have a unique place or purity. Once you start to see Africans in that way, then we can start to see Africans as being equal to other people. There is no mythology separating Africans from everyone else in the world. So, in that sense, the hierarchical situation set up by stereotyping is erased. If in fact, the African is not that different from yourself, then the stereotyping becomes redundant. It no longer works.

**JGC:** In some ways you're talking about Western views of Africa. Could you discuss particular Yoruba influences growing up in Nigeria? Could you discuss your views about differences between race and culture in regard to living in England?

**YS:** I was born in 1962 in England. I went back to Nigeria with my parents when I was about three years old and lived there from about 1965 until about 1980. That particular period was one of modernization and building in Africa. I grew up in the capital city. I spoke Yoruba at home, but I spoke English at school. English is the official language of education in Nigeria. Culturally speaking, there was at the time a more or less modern African culture evolving. We mixed listening to local Yoruba music, watching Yoruba drama on television, and watching "Hawaii 5-0" and programs coming from the U.S. I drank Coca-Cola like everybody else. In my home, my father read *National Geographic*, *The Economist*, and *Time*. It was totally natural for a modern African. That's how I evolved as a child. There was nothing about my upbringing that was traditionally African, if you can put it that way. There were some cultural differences in terms of having access to two languages, but then a lot of children in the West are bilingual, so I would not say that my situation was very different from theirs. In the contemporary world, being bilingual is absolutely normal. That's the kind of upbringing I had.

In terms of my immediate environment, I had a driver who took me to school in one of my father's cars. My father was a lawyer, so there was nothing remarkably different from the upbringing of a child living in Manhattan or in London. I was brought up in a middle-class Nigerian family, Western-educated but also having access to my own language.

**JGC:** I loved your choice of objects for "Yinka Shonibare Selects" at the Cooper-Hewitt Museum, your fashions for the Hewitt sisters, and how you placed them on stilts. What is the symbolism behind your selections and your treatment of the sisters?

**YS:** I was looking at the style of the 19th century, when they were alive. What they would have worn was exaggerated. Making the costumes out of African textiles shows my own relationship to the sisters. They were regarded

as having faith and educating the public on taste and design. I wanted somehow to elevate them above the audience. I chose a playful way to do that because stilts would be associated with a circus or a performance. The interesting thing is that some traditional Yoruba masquerades also use stilts. The sisters were quite serious and studious, and I wanted to show them in a more playful, subversive way, I suppose. Since they traveled a lot, I chose objects related to the idea of travel and movement. They went to Venice, to London, to the Museum of Decorative Arts in Paris— they were trying to re-create a museum like the Victoria and Albert in New York. On their travels, they picked up objects, and I wanted my selection to reflect the interests of travel and collecting and to show the interdependence of different cultures.

**JGC:** John Picton says that some of your fabric prints employ subversive symbolism. For instance, the print on the *Cha Cha Cha* shoe was known originally as Nigger's Footprint, and the Bronte sisters wear a pattern based on female genitalia.

**YS:** It's interesting, because John Picton is a professor of African art. If I see a pattern, and it looks good and amusing or exciting to me, I will use it. I don't necessarily link thick symbolism with different cultures. Of course, there are times when I think a certain pattern will be amusing. If I see, for example, patterns with keys or cars or umbrellas, and if I think two things are incongruous, unexpected, or at odds with each other, I will use that. For me, it's not a fixed symbolism but a playful juxtaposition of things.

**JGC:** Your five images of the African Victorian Dandy form a series of photographic tableaux in which you act out the fantasies of a black dandy. Why did you create this role?

**YS:** I was making fun of Hogarth's *The Rake's Progress*. Usually when there are black people in period paintings, they are in some kind of subservient role, a servant or a barmaid. I wanted to re-create such a setting but put the black person, myself, in a more frivolous role. The dandy is not usually a member of the aristocracy, but through his wit and style, he somehow is admitted into society. It's pure fantasy on my part.

**JGC:** You hold papers in the gaming and parlor scenes. Do they have any meaning?

**YS:** Not particularly. Dandies tended to be writers who gambled and ended up penniless in Paris. In the billiard room, there is a picture of money and gambling, and in the study, the writer is a center of interest.

**JGC:** *Scramble for Africa* is a major work that shows 14 fiberglass figures in chairs around a table with the map of Africa. Are the 14 figures presumed to be white?

**YS:** Around 1850, there was a conference in Berlin attended by representatives of a number of European countries, including France, Germany, England, and Belgium. The idea was to decide who would own which part of Africa to stop conflicts among European nations; that's how the various territories in Africa came about. *Scramble for Africa* is my imaginary reflection of that conference.

**JGC:** Your figures are all intentionally and neatly headless.

**YS:** Yes, a lot of my work challenges the idea of hierarchy or aristocracy in some way. During the French Revolution, the heads of the aristocrats were chopped off using the guillotine. Basically, it started as a joke, because I take working-class fabrics from Africa, dress the aristocracy in those fabrics, and then take their heads off, but there's no blood or violence. It's witty in a knowing sort of way. It adds more ambivalence. The figures are never actually white or black; the skin color is gray or tan, sort of mixed race. I guess, again, that I'm challenging the idea of superior and inferior people. I try to dissolve that notion.

*The Swing (after Fragonard)*, 2001.
Life-size figure, Dutch wax-printed cotton, swing, and artificial foliage,
330 x 350 x 220 cm.

**JGC:** In addition to race, you also raise gender issues. Some of your figures, both adults and children, are promiscuous or display ambivalence about their gender and sexual identity and orientation.

**YS:** Again, I think gender and sexuality are socially constructed. In some societies, it's not acceptable to be gay; and in some societies, it is acceptable. Basically, all those ideas are constructed and are about the politics of class.

**JGC:** You are making a new work, *Garden of Love*, for the Musée du Quai Branly in Paris. How is the work progressing?

**YS:** I'm designing a labyrinth. The audience will have to solve the puzzle to find the lovers. They are based on Fragonard, who represents the height of aristocratic excess, wealth, and indulgence in France. Dressing the lovers in non-Western African fabrics, referring to people who are less fortunate, contrasts with the excesses of the Western world.

**JGC:** Do you work with one tailor or a crew?

**YS:** A number of assistants work with me, but two are constant. There is Mary Charlton, who is the head of costumes, and Anthony Bennet, who installs the work.

**JGC:** Some of your images are very fanciful—for instance, the aliens and *Big Boy*, a rather flamboyantly attired man in a long ruffled cloak.

**YS:** That was influenced by RuPaul, a well-known, tall, glamorous African American man who dresses like a woman. I also like the idea that I take something from the repressed Victorian era and create a hybrid person out of it. I don't have to produce things the way they are in the real world. I can produce things that don't exist yet. All the rules can be broken, and new fantasies can be created. In art, anything is possible.

# Out of West Africa: **El Anatsui**

**by Robert Preece**
**2006**

A "cloth" made by sewing thousands of recycled, crushed, and flattened liquor bottle tops. A 10-foot-tall installation of redundant newspaper printing plates used for obituary pages and reused as sculptural material to comment on temporary—and disposable—human lives. And rough, chain-sawed wood forming a line, an abstracted *Visa Queue*, depicting hopes, dreams, desperation, and global inequality. These are just three works spanning five decades of artistic production by El Anatsui, who is widely regarded as one of the foremost African artists of his generation. His work refers to the history of the African continent, drawing on traditional African idioms as well as Western art practices.

Born and raised in Ghana, West Africa, El Anatsui studied sculpture at the College of Art, University of Science and Technology, in Kumasi, central Ghana. Since 1996, he has been a professor of sculpture at the University of Nigeria at Nsukka in the southeastern part of the country. He originally joined the university's Fine and Applied Arts Department as a lecturer in 1975.

Over the years, El Anatsui has exhibited extensively around the globe. His work has been shown at the Liverpool Biennial of Contemporary Art (2002); the National Museum of African Art, Smithsonian Institution, in Washington, DC (2001); the Centro de Cultura Contemporania Barcelona (2001); the 8th Osaka Sculpture Triennale (1995); and the Venice Biennale (1990). In 2006, he participated in "Africa Remix: Contemporary Art of a Continent," which featured more than 70 artists from Algeria to Zimbabwe, as well as African artists living in Europe and North America. This exhibition was on view at the Hayward Gallery during El Anatsui's concurrent solo exhibition at the October Gallery, also in London.

**Robert Preece:** When I was in Barcelona reviewing the "Africas" exhibition (2001), I was particularly captured by *Visa Queue*. For me, it's one of those artworks that stays in your life—it provided an emotive, artistic representation of West African emigration to Europe, as resonant as the documentaries we see of people walking across the Sahara and risking their lives to cross the Strait from Morocco to Spain. You created a lyrical line of massed figures, a nondescript mass. Why did you choose such a small scale for this work? Why did you want the viewer to be so uncomfortably monumental in comparison?

**El Anatsui:** Scale here takes on an inflective dimension—a dimension of significance. A friend once related to me what his father-in-law told him when he informed him that he was migrating to a "greener pasture": "The lazy man says his own home is not good enough." Migration, especially for economic reasons, produces desperate situations in which people are ready to be subjected to all forms of dehumanization. These situations not only process them into a roughly hewn homogenous mass, but also miniaturize their stature. The figures, in assorted natural wood colors, are faceless, more like statistical data bound together by a dark gloomy fate. I have experienced real visa

*Wastepaper Bags*, 2004.
Aluminum plates and copper wire, dimensions variable.

queues in the '80s and '90s in Lagos, Nigeria, which were awfully long, where people were goaded along with paddocks and along barricaded paths. But *Visa Queue* is about any situation in which people are constrained by circumstances to compete in long queues—and this happens everywhere in the world. Everybody is reduced to the same height and scale, and at times identification by assigned numbers suggests the idea of statistics.

RP: Sometimes artists from non-Western lands feel that viewers can gain significant insight into their works by learning more about their locational/situational context. But this approach has its limits. And sometimes, it goes overboard and ends up isolating the artist as a maker of "specialist art." Where do you position your work in relation to the "context is necessary" continuum?

EA: People at times see my works without any knowledge of their context or even their titles, and they create their own meanings out of them. Some interpretations reveal how close we are as humans. I would agree that context is both an aid and a hindrance. In certain ways, it helps to anchor a message, and depending on the viewer's capacity and experience, he could go from there and expand or simply stop. I don't think that I define myself strictly in a locational context. People, galleries, and museums make these definitions for their various reasons—some of them necessary, others not.

RP: You studied in a Ghanaian university program that was affiliated with Goldsmiths College, University of London. Would your approach, at least during that time, be considered a fusion of Bauhaus-oriented influence and local/regional input? And if so, what range of input would this be?

EA: I went to the College of Arts of the Kwame Nkrumah University of Science and Technology at Kumasi, Ghana. In those days, the staff consisted of several British, German, and American teachers and a handful of Ghanaians. Certainly, foundation courses dealt with elements and principles of art and design, but like most art schools in West Africa at that time, there was not much local content. There was excellent teaching, but the content was simply what the times and circumstances offered. Most of us, after school and further exposure, now combine these experiences with local practices and other approaches. I don't know what to call it or how to characterize it. But the concern for principles and elements of design is probably discernible in my works. Take *Earth Cloth*, for instance.

RP: What were your influences?

EA: A pretty wide range of things, from media to processes, history, and other artists' works. I can only pick a few here. Initially, a particular cloth, the Adinkra served as a source, on account of the signs and symbols used on it. These attempted to give visual form to very abstract concepts like "the soul," "anger," and "seriousness." I employed the process of fire engraving or pyrography to work these signs into wood. I have returned to the cloth motif after many years with *Adinkra Sasa* (*Adinkra Patchwork*), which references the color schemes (but not the signs) of this funeral cloth.

One of the artists whose work influenced me early on was Akwete Kofi, who made massive, ponderous wood forms. As I became exposed to the rest of the world, several other artists' works have been references and inspirations: Anish Kapoor's engagement with the void or darkness; Gormley's work—especially the energy generated by many hands touching clay to realize his "Field" series; and Endo Toshikatsu's use of fire on massive wood sections in his earlier works. While influences continue to grow and expand, I am still interested in what goes on around me.

RP: How did you go about developing the *Wastepaper Bag* works?

EA: I anneal, or heat-treat, printing plates, so they are soft enough to crumple with my bare hands. These are stitched together into large sheets, which are then configured into bags of assorted sizes and shapes.

I approach printers to collect plates they want to throw away. Ninety percent turn out to be obituary notices or funeral announcements. Even when I collected newspaper plates, there were many obituary pages in addition to news, which has a shorter and shorter life span these days. The information on them provides a demographic profile of the location—very ephemeral lives averaging 45–55 years, like paper, so easily crumpled and disposed of too soon. But like so much printed material, which survives these plates, the lives they refer to are equally survived by many people.

RP: And what about *Ancient Wall*?

EA: The "Wall" series, with the rusty perforated metal sheets, came from thoughts about man's primary impulses and actions. These sheets were graters used in processing cassava into one of the major staples in West Africa—*gari*. When I came across huge piles of them in the wilderness, my initial thoughts were about consumption, about the huge quantities of *gari* that have come out of them. Later, thoughts about food as one of the motivations for man's primordial impulse to carve and control territory led to the idea of a series of walls.

*Ancient Wall* perhaps references not only how old this impulse is, but also how timeless. The perforations lend a significant perspective. I believe that walls do two things: they block views and hide things on one hand; and on the other, they provoke or activate the imagination and reveal things. Take the walls of China or of Berlin. Their physical presence aroused considerable curiosity in people living on both sides. Thus, walls are opaque to the eyes but transparent to the imagination. The perforations in my walls have the quality of indicating any movements behind them, while not being clear about what these movements are precisely. They hide as well as reveal.

RP: Looking back, are there key events in the development of your artistic and professional practice?

EA: My decision to go to art school, my relocation to Nigeria (in 1975), and several other events: an International Sculpture Conference in Toronto (1979) and a residency in the U.S. a year after that. I consider my decision to take up art as a crucial—and probably reckless—one at the time that it happened. I finished high school in a provincial location

*Many Came Back*, 2005.
Liquor bottle tops and copper wire, 213 x 277 cm.

and had almost no exposure to the world beyond. No idea about art as a career, profession, or practice as I know it now. There was glamour and the lure of established and prestigious professions—those with visible role models at that time, especially those with tertiary education. I only felt that I was going for something I would enjoy doing.

When I took the post at the University of Nigeria in 1975, my decision was based on a mixture of adventure and a quest to widen my artistic horizon. The few publications then on African art were replete with references to the Nigerian art scene. Certainly, physically seeing Nok terra-cotta works and the homes of ancient Benin and Ife, and meeting most of the key contemporary players on this scene, has been immensely worthwhile. Meeting so many sculptors in one place for the first time at the Toronto conference, I felt that there was quite a lot to experience and to do. At the Cummington Community of Arts in Massachusetts, I started with the idea of exploring the chain saw, which [I've worked with] for over two decades now.

RP: You've worked with found ceramic material, found metals, various kinds of tropical and other woods, and scorched railway sleeper ties during a recent installation in the U.K. Are there particular materials that you like to work with?

**EA:** Wood and clay have been my traditional media—and I still work with them, though more and more unorthodox materials attract me. They contain peculiar and different challenges, which I think open me up more. Take *Peak Project* for example. Milk tin tops gestated in my studio and mind for some time. For about two years, I searched for what to do with them, until the popular brand name of milk—Peak—suggested the idea. Subsequently, I belted these disks together into large sheets, which are picked up at a point, raised, and allowed to drop several times until they firm up into peaks—probably peaks of consumption.

I am drawn more to materials that have been subjected to considerable human use: mortars, trays, graters, tins, and, of late, liquor bottle tops. Apart from what their provenance has loaded into them, I subject them to the numerous touches of the many assistants who work with me. I believe that what I explore now is not only material, but also process and logistics, elements with which anybody dealing in huge quantities of material and difficult means has to grapple.

**RP:** What have you learned from using a chain saw in making some of your works?

**EA:** I was first taken in by the line—its making and clawing propensity—and I tried to configure C-scrolls and other organic lines but found that these were not in the chain saw's character. It lends itself to making straight lines, straight cuts, and can deliver many of these, fast. Also, its marks have a loud hustling quality or feel. In *Visa Queue*, I attempted to use this quality for significance, but I think that *Erosion* (1992) is perhaps more effective. Made in connection with the Rio Earth Summit, *Erosion* tried to put the fast summary lines of the chain saw next to slower hand engravings, contrasting man's mechanized, revolutionary technology with his slower organic, evolutionary culture.

**RP:** What issues are you currently facing in your artistic and professional practice?

**EA:** I am thinking about relocating and debating whether I should keep a studio in Nigeria and one in Ghana or operate in one location only. These are crucial questions because the decision will affect what kind of work I create in the future: the rural setting at Nsukka and the urban setting at Tema (Ghana) both generate their peculiar inspirations, materials, and opportunities.

**RP:** Future plans? Or future dreams?

**EA:** I have, for some time now, been dreaming of an art community with more interaction among people from different backgrounds, professions, and persuasions. There is no way that this synergy could not result in better understanding, not only of art, but also of the other disciplines. Something similar to this was enacted at the last Gwangju Biennale where we, the artists, were paired with viewer-participants. There were very innovative results in some of the pairings. I am thinking here of something more long-lasting, more intimate but informal. The emphasis is on the various disciplines, and not on working in exclusion.

# Accumulated Experiences: Mary Miss

## by Collette Chattopadhyay
## 2006

In the 1970s, Mary Miss, who was educated as a sculptor, chose to turn from the gallery and museum scene and create art in the public realm. Her early works include temporary site installations and percent-for-art projects. In the 1980s, she was among those who began to take on abandoned industrial infrastructures, transforming them into viable public places. Her ambitious solutions to place-making, which combine art, design, archaeology, landscape architecture, and urban planning, invite visitors to participate in a process of discovery as they sift the layers and history of a site by walking through it, viewing it from different perspectives, and interpreting its topography.

Miss's current team endeavors include the Railyard Park Project in Santa Fe, New Mexico, and the Orange County Great Park in Irvine, California, where she is collaborating with Ken Smith and a team of architects and designers. In Irvine, plans are to use the former El Toro Marine Corps Air Station as the site of an immense regional park spanning 1,749 acres. Larger than Central Park in New York City, the Great Park promises to transform the former airbase, which many locals deemed an eyesore, into a destination location scheduled to open in 2009.

**Collette Chattopadhyay:** What is the starting point for your work and for your current involvement with the Great Park project?

Mary Miss: My work goes back to the late '60s, reacting against the artists whom I followed. I was reacting against Smithson seeing the West as a fantasy, going out and marking the landscape almost as one would mark a canvas. If you know that landscape as I do—I grew up in Colorado and spent my childhood riding in the back seat of a Chevy—you can't mark that landscape. If you're out there, the sense of scale is so huge that an attempt to put a mark on it, I thought, was impossible.

What was more interesting to me was looking at fence posts and seeing how that very modest, little marker defined the landscape. I was interested in the human scale of the landscape and the conjunction between the built and natural environments and whether these were on a collision course. How to define that relationship was an early question in my work that continues to this day. In the beginning, the work was not about an abstract way of looking at that conjunction. But, as time has gone on, it's gotten to be about the elements involved in this meeting point. Besides that, there's the engagement of the public and the issue of art in the public realm.

**CC:** You're one of the forerunners in the development of art in the public realm. What have been the challenges in this area?

MM: Early on, there were a number of us interested in the public realm, artists stepping out of the museum and gallery framework. It was about trying to take on the issues of our time. To me that meant not being a respondent saying,

"This is what's happening in the culture, and I'm going to respond to it," as Warhol did by commenting on the soup can. I was curious about how an artist could shape the conversation. So, we went into the landscape and the world. To work in the public realm raised the critical issue of where one would get the money. It ended up that we could do it through percent-for-art programs.

**CC:** Which was in the '70s, or did it begin earlier?
**MM:** Some things started in the late '60s. But it was laughable. The building costs $400 million, and they divide up one percent between four artists. There's also the issue that you're given an assignment: "We need a better transition between this building and that one" or "This is a really ugly side to this building, could you do something?" The challenge was always limited to putting yourself into the pretzel position. You would ask yourself, "How can I make this into something interesting?" In the *Union Square Project*, I ended up doing something on the history of that station through a kind of framing. But it's very hard sometimes to get to a subject—as I did there—that you're interested in.

*Greenwood Pond: Double Site*, 1989–96.
Des Moines Art Center, Des Moines, Iowa.

Not only are the opportunities limited in percent-for-art projects, but they never had visibility. I'm lucky. A few of my projects got published. Many artists have done interesting things that no one knows about. There hasn't been a good critique of the work or of the idea of artists working in the public realm. It's really a vacuum.

**CC:** Your new project in California will address what you call the "layers" of the site as a former Marine base, lima bean farm, and Chumash habitat. How do you decide which layers to focus on?
**MM:** When I go to any site, I'm looking at what's there, what's available, and then taking cues about where to do research. For instance, in the wetland pavilion I did in Des Moines, Iowa, called *Greenwood Pond* (1989–96),

I started by looking at the history of the place. I went out to Indian reservations, looked at farming areas, and worked with botanists and wetland experts from Iowa State University. In the Great Park, I'm trying to accumulate all the layers of paleontology, geology, botany, ecology, hydrology, and cultural influences that have occupied the area. That's my way of researching, though I'm doing it on a more massive scale here in California. In Des Moines, I worked with the local garden club, and they were interested in doing a demonstration wetland. So, we worked together. Someone wrote an article in a landscape magazine, denigrating the garden club as a "lady's group." But these women were terrific. They helped in every way, from talking about what should happen to helping plant all the plants.

**CC:** How did the concept of a wetland evolve?

**MM:** Historically, 90 percent of the wetlands in Iowa were eliminated for farming. With the wetlands eliminated, the water runs off the land into the river. In 1994, when I was working on this project, all of downtown Des Moines got flooded. *Greenwood Pond* was an opportunity to have a wetland in the middle of the city park where kids could do their science or art projects. There's a science center across the street, as well as a museum, a walkway that goes around the end of the pond, and a pavilion where groups can gather. In the winter, it becomes a warming house for skaters. There's a very narrow corridor of grasses that gets you to a place where you can look at the water. When you arrive, you see water at your eye level. You are [visually] "in" the water, seeing it from a different point of view. There's also a ramp that takes you down, where you can reach over and feel the water. I put mirrors just under the surface of the water so that when you look down, you see all the little critters that you usually can't see. I came to these ideas after talking with people in the community.

**CC:** Photos of various sites you've created seem to suggest centralized districts of focus.

**MM:** I think that photographs lie, because they have to show the thing. What's more important to me is the passage through time and space. What's wrong with photographs is that they're just about the visual—what interests me is the visceral, the carnal. It's the experience of the time it takes for you to walk this circuit, to go through these experiences. You can go fast or slow, spend five minutes or an hour. But that accumulation of experiences is what has always interested me. I want to build layers of experiences into the site for the viewer. The '70s was such an interesting time, though it's completely disregarded now. It was an optimistic time, but we were deconstructing. We were taking apart all of these frameworks. It was about women being involved and about other stories being told. It was a vital time. Trisha Brown would line her dancers up on roofs, Gordon Matta-Clark would cut a building apart, I'd go and dig something out of the woods. It was a time without boundaries.

**CC:** What's also interesting about the area that you, Alice Aycock, George Trakas, and others were and are pursuing is that the works have tremendous sponsorship, something akin to what Renaissance artists enjoyed. That type of money is quite different from the artists of the '50s or early '60s who were…

**MM:** …independent equals. Yes, it's interesting. It's also very complicated. There was a period of decades in the

20th century and continuing now when artists saw themselves as detached. Though, of course, they were attached to critics, patrons, and money through galleries, museums, and the sale of individual works. But, there's another kind of patronage in the larger sense. There are bad things that go along with patronage: you're accountable to others, you're definitely working within a large system, and it's the real world. There are good things about it too because you are where the real questions get raised.

**CC:** How does that relate to the Battery Park project, which seemed to be a new crescendo in your work when it was finished in 1987?

**MM:** This was the first time I had access not only to a site, but also to money and people to collaborate with. So those things we've been talking about happened in this project. It also allowed me to connect New Yorkers with the Hudson River again, which we had been cut off from for so long. Remember, Battery Park City and the main park that's there now didn't exist then. At this site, you can walk through the project, get your feet wet when the tide's high, or walk onto the jetty and be out on the water.

**CC:** Water has been critical to many of your projects. What are your ideas about water for the Great Park?

**MM:** There are a lot of possibilities. Water is a mysterious thing. It has tremendous force. Most of the time, it's almost invisible. If it rains, the water disappears. Yet, the effects of water are tremendous. We need it, and it's an invisible thing you can make visible. In the *Jyvaskyla Project* (1994) in Finland, I used water to function as mirrors. In that case, I was invited to an architectural symposium about sustainability and the use of materials. I decided to celebrate the most basic building material, trees. In Finland, you're surrounded by forests. So, in a forest, I did troughs of water that functioned like mirrors among the trees. It makes the tree very apparent and visible.

**CC:** The issue of ecology weaves through various projects you've worked on, whether they're in Iowa, Battery Park, Milwaukee, or elsewhere. It was also important at the Arlington Water Pollution Control Plant in Virginia. What happened in Arlington?

**MM:** In Arlington, I was trying to make the sewage treatment plant a public place where people could come and understand how a plant works. I was trying to take a 30-acre site and transform it. You have upscale neighborhoods nearby, and they wanted the treatment plant to disappear. If they could wave a wand, they would have me magically erase it from their view. I held public meetings and got suggestions like, "Couldn't you hide the plant?" Well, there's not enough money in the world to hide this big plant. And, it's necessary. So, why not make people aware of the connections between their homes and what they do in their homes and offices, the plant, and the Chesapeake Bay, because this plant and 300 others like it are determining what the Chesapeake is and how it functions. I said, "Let's show the process." Let's put big numbers up on each plant building saying Step One, Step Two, and so forth. Let's make every surface green because it will cut down on the heat, the smell, and make it look better. We'll make as

*Milwaukee Riverwalk,* 1998–2001.
Milwaukee, WI.

many public spaces as we can—at the edge of the plant, in the plant, and at the recycling center. There were big pipes. I said, "Can I paint them?" They said, "No." Then I saw a repair band on one and I said, "What if I put strap bands on them?" And, they said, "That's OK." So, we adopted these things.

**CC:** What's your take on why the project fell apart?

**MM:** First, we were making an unprecedented effort. I thought, "You've got people and the way they live their lives, the Chesapeake Bay, and the plant in between. How can you make this apparent?" There was tremendous support from the county manager and the arts programming people within the hierarchy of the plant management. But the engineers were trying to run a plant renovation, and they didn't understand what we were doing. To me, it made perfect sense. They're spending $300 to $500 million for a plant upgrade. If people don't change their behavior, they're going to have to spend another $500 million, not in 25 years but probably in 10. Why not engage the public, get them to see what's happening, and maybe you won't need another upgrade? Maybe you can affect people's activities. When you talk about shaping dialogue in the public domain, that's what I'm trying to do. I'm trying to come in as an artist, have access to the issues, and shape them.

**CC:** Let's talk about the relationship between the Arlington project in Virginia and the Great Park project in California.

**MM:** The Arlington project serves as a preamble to the Great Park, in terms of taking on a huge piece of infrastructure.

Ken Smith is the landscape architect and lead person of the Great Park design team. Ken and I collaborated on the Railyard Park Project in Santa Fe, which was 13 acres. We've been working on it for four years, and it's going into construction. On the core design team for the Great Park are architect Enrique Norten, ecologist Steven Handel, landscape architect Mia Lehrer, engineering designer Craig Schwitter, lead engineer Patrick Fuscoe, project manager Yehudi Gaffen, Ken, and myself. Here, we have big, flat land. I was out there yesterday for several hours. It was hot. You couldn't plant enough trees to make it bearable. So, we had the idea of doing a canyon.

**CC:** Is there anything there that suggests the existence of a former canyon in this locale?

**MM:** No, but the canyon will make an area that's 20 degrees cooler on a hot day than it is up on the flat land. We thought of creating different zones. One will be a wildlife corridor that connects with the water system called Aqua Chynae. This formerly connected to Bee Creek. We think of these as being connections to the Santa Ana Mountain range and the natural systems beyond.

**CC:** The natural water systems are not presently visible?

**MM:** Part of the water is in a big pipe now. So we're day-lighting water. But some of these things were handed to us as a package. They said, "We want a wildlife corridor. Here are the park's boundaries. Here's Bee Creek and Aqua Chynae." We decided to see Aqua Chynae, the wildlife corridor, and Bee Creek as connections to the natural systems around the park. And we decided to see the central area, with the runways and fields, as historical references to the site's airbase and agricultural histories. Then we said, "Let's think of the canyon as a place that's going to make human habitation comfortable and pleasant, a human ecology of the place. There are other issues, like the severe drought here in the West. We have to be aware of sustainability. The community is demanding it, the situation demands it. One thing that's going to happen is a botanical garden. Botanical gardens in the 19th century were places where you collected plants from exotic places and put them in a glasshouse. The main subject of the botanical garden here will be the southern California bio. But how can you present it so it's closely seen? What grows here is not only native habitat; it's what's sustainable. We're trying to create zones that you can imagine yourself in, to understand and say, "OK, I could live with this." It turns out that 60 percent of the water in Orange County goes to watering grass. And, something like 40 percent of the energy goes to pumping the water.

We're also talking about setting up a place with access to sustainability issues, whether they're social, physical, historical, cultural, or ecological. I've suggested a research center where artists can access scientists, ecologists, historians, and sociologists, where there can be a social dialogue. We still need to find institutional support. We would like to make a place where artists could think about these things and possibly do some projects. We don't know what the structure is yet, but we're trying to make something possible here.

# Photo Credits

Cover     Rachel Whiteread, *Embankment*, [The Unilever Series: Rachel Whiteread, Embankment © Marcus Leith, Tate Photography]

p. 15     Judy Pfaff, *Moxibustion*, [Courtesy the artist]

p. 18     Judy Pfaff, *Round Hole, Square Peg*, [Rob van Erve]

p. 21     Beverly Pepper, *Horizontal Wedge*, [Courtesy the artist]

p. 24     Beverly Pepper, *Cromlech Glen*, [Courtesy the artist]

p. 27     Richard Deacon, *Smile*, [Courtesy Marian Goodman Gallery, NY]

p. 30     Richard Deacon, *After*, [Courtesy Marian Goodman Gallery, NY]

p. 35     Los Carpinteros, *150230 cms3 de oscuridad*, [Courtesy Cristina Vives, La Habana]

p. 38     Los Carpinteros, *Gavetón*, [Courtesy Cristina Vives, La Habana]

p. 45     Lynda Benglis, *Panhard*, [Courtesy Cheim and Read, NY]

p. 48     Lynda Benglis, *Migrating Pedmarks*, [Courtesy Cheim and Read, NY]

p. 53     Marc Quinn, *Paranoid Nervous Breakdown*, [© Marc Quinn, Photo: Stephen White, Courtesy Jay Jopling/ White Cube, London]

p. 56     Marc Quinn, *Peter Hull*, [© Marc Quinn, Photo: Attilio Maranzano, Courtesy Jay Jopling/ White Cube, London]

p. 59     Liliana Porter, *Untitled with Lamp*, [Courtesy the artist]

p. 62     Liliana Porter, *Dialogue/Limit*, [Courtesy the artist]

p. 67     Richard Wentworth, *The Loops*, [Courtesy the artist and Lisson Gallery, London]

p. 70     Richard Wentworth, *Roland Barthes' Desk*, [Courtesy the artist and Lisson Gallery, London]

p. 75     Wolfgang Laib, *Nowhere—Everywhere*, [Courtesy Sperone Westwater, NY]

p. 78     Wolfgang Laib, *Rice House*, [Private collection, Courtesy of Sperone Westwater, NY]

p. 81     David Nash, *Rip Out Column*, [Courtesy the artist and Gallery Lelong, NY]

p. 84     David Nash, *Sheep Space*, [Courtesy the artist]

p. 89     Fabrizio Plessi, *Simulation of Waterfire*, [Courtesy the artist]

p. 89     Fabrizio Plessi, *La foresta sospesa*, [Courtesy the artist]

p. 93     Maya Lin, *Wave Field*, [Tim Thayer, Courtesy Gagosian Gallery]

p. 96     Maya Lin, *Untitled (Topographic Landscape)* (detail with *Avalanche*), [Jackson Smith, Courtesy Southeastern Center for Contemporary Art]

p. 101     Tom Sachs, *Miffy*, [Tom Powel, Courtesy Art of this Century]

p. 104     Tom Sachs, *Chanel Guillotine (Breakfast Nook)*, [Courtesy the artist]

p. 107     Richard Serra, *Sylvester*, [© 2006 Richard Serra/Artists Rights Society (ARS), NY]

p. 110     Richard Serra, *Betwixt the Torus and the Sphere*, [© 2006 Richard Serra/Artists Rights Society (ARS), NY]

p. 117     James Turrell, *Milk Run III*, [Florian Holzherr. Courtesy the Mattress Factory, Pittsburgh]

p. 120     James Turrell, *Orca*, [Courtesy Mattress Factory, Pittsburgh]

p. 125     Xu Bing, *Glassy Surface of the Lake*, [Russell Panczenko]

p. 129     Xu Bing, *Book from the Sky*, [Courtesy National Gallery of Canada, Ottawa]

p. 133     Antony Gormley, *Field for the British Isles*, [Bob Berry, Courtesy the artist and Sean Kelly Gallery, NY]

p. 136     Antony Gormley, *Critical Mass*, [Bob Berry, Courtesy the artist and Sean Kelly Gallery, NY]

p. 141     Mimmo Paladino, *La montagna di sale*, [Courtesy the artist]

p. 144     Mimmo Paladino, *Hortus Conclusus*, [Courtesy the artist]

p. 147     Liza Lou, *Trailer* (detail), [Courtesy the artist and Deitch Projects]

p. 150     Liza Lou, *Kitchen*, [Courtesy the artist and Deitch Projects]

p. 153     Ron Mueck, *Untitled (Big Man)*, [Lee Stalsworth, Courtesy of Hirshhorn Museum and Sculpture Garden]

p. 154     Rob Mueck, *Two Women*, [Courtesy Brooklyn Museum]

p. 159     Pedro Cabrita Reis, *absent names*, [Courtesy the artist]

p. 162     Pedro Cabrita Reis, *Cidades Cegas Eco (Blind cities the echo) #5*, [Courtesy the artist]

p. 167     Cildo Meireles, *Strictu*, [© Cildo Meireles, Courtesy Galerie Lelong, NY]

p. 170     Cildo Meireles, *A Través*, [© Cildo Meireles, Courtesy Galerie Lelong, NY]